Scarecrow Soccer Series
Series Editor: Tom Dunmore

That soccer is the world's game is a cliché, but one that the breadth and depth of soccer literature—including that in the Scarecrow Soccer Series—shows very much to be true. It is the world's game not only because it is a wildly popular form of popular entertainment, with competitions such as the World Cup attracting billions of viewers and generating billions of dollars in advertising fees and broadcasting rights, but because of the depth of engagement that the sport generates. It is as much a part of the social fabric in dozens of countries as any cultural form, and this series explores how that is manifested across the world.

Titles in the Series

Soccer in Spain

Politics, Literature, and Film

Timothy J. Ashton

Scarecrow Soccer Series

THE SCARECROW PRESS, INC.
Lanham • Toronto • Plymouth, UK
2013

Published by Scarecrow Press, Inc.
A wholly owned subsidiary of The Rowman & Littlefield Publishing Group, Inc.
4501 Forbes Boulevard, Suite 200, Lanham, Maryland 20706
www.rowman.com

10 Thornbury Road, Plymouth PL6 7PP, United Kingdom

British Library Cataloguing in Publication Information Available

Library of Congress Cataloging-in-Publication Data

Ashton, Timothy J.
Soccer in Spain : politics, literature, and film / Timothy J. Ashton.
pages cm
Includes bibliographical references and index.
ISBN 978-0-8108-9173-9 (cloth : alk. paper)—ISBN 978-0-8108-9174-6 (electronic)
1. Soccer—Spain. 2. Soccer—Social aspects—Spain. 3. Soccer—Political aspects—Spain. I. Title.
GV944.S65A85 2013
796.3340946—dc23
22013019542

∞™ The paper used in this publication meets the minimum requirements of American
National Standard for Information Sciences Permanence of Paper for Printed Library
Materials, ANSI/NISO Z39.48-1992.

Printed in the United States of America

Dedicated to all my kin.

Contents

Acknowledgments

I'd like to thank all those involved in seeing this project through and making it a reality. But most of all, I'd like to thank Cindy Phelps, Francisco Cabanillas, Nathan Richardson, and Agustín Cuadrado from Bowling Green State University; Samuel Amell, Dionisio Viscarri, Ignacio Corona, Stephen Summerhill, and all those from The Ohio State University; Víctor Durán, Deanna Gore, and other Pacers from the University of South Carolina Aiken; and all my friends from Alcalá, Bowling Green, Columbus, Madrid, Valladolid, Quito, Perrysburg, and Aiken. *También muchas gracias a* Mallory Warmans, who coined the terms "Kick-Lit" and "Kick-Flicks." To my "collaborators," Carlota Rey (alias *Charcasso*), Robby Hagen, and Darren Niles, who with me so graciously designed the image that illustrates the cover of this book, many thanks!

I most assuredly offer sincere thanks to the pioneers of this field: Jorge Valdano, the "Philosopher of *fútbol*"; historians and scholars Liz Crolley, Vic Duke, and Duncan Shaw; and all other soccer writers for providing me with a framework from which to model this project and for documenting key historical facts. For without them, as well as my family, friends, and all those aforementioned, this book would not exist.

This is a book about soccer in Spain as it pertains to politics, literature, and film. My only advice is that you try to enjoy it because many are those who've fallen hard and fast for taking such absurdities seriously.

Mens sana in corpore sano

Introduction

Soccer is popular because stupidity is popular.
—Jorge Luis Borges

All of life's philosophies can be learned within the confines of a soccer field.
—Albert Camus

Since its inception roughly 150 years ago, the sport of association football has proven to be one of the modern world's most enigmatic cultural phenomena. This is easily recognizable through its unique ability to captivate and capture the dreams of millions of people. This ability is closely linked with its capacity to represent and strengthen different cultural identities and ideologies throughout the planet. The sport has also played an enormous role in globalizing the world's community and economy. However, its ability to captivate the masses has been exploited by the world's most powerful institutions, and the sport itself has in turn exploited its connection to these same institutions. This helped catapult association football into the globalizing community and establish it as one of the most important and prevalent cultural phenomena of our time. Association football is clearly one of the modern world's fastest-growing and most well-developed representations of globalization.

Since so many languages are spoken throughout the world, this sport, commonly called "the world's game," has a variety of different names. It is referred to as *football, association football,* and *footy* in England and other countries; *calcio* (meaning "kick") in Italy; *soccer* (a derivative of association football) in the United States; and either *fútbol* or *balompié* in Spanish-speaking countries.[1] Since this book is aimed toward an American audience, I will use the popular American term, "soccer," throughout the work to avoid confusion when referring to "the world's game."

Ever since the sport began being embraced on a global level, there has been an ongoing clash of ideals between the intellectual classes and the soccer community. Soccer's enormous popularity with the masses has caused many prominent intellectuals, not only in Spain but also throughout the world, to proclaim it an activity for the common and uncultured individual. One of soccer's earliest and most outspoken antagonists was the philosophically inclined Argentinean author, Jorge Luis Borges, who stated in an interview that soccer is "an English stupidity. . . . An esthetically ugly sport: eleven players against eleven running after a ball isn't

xi

especially beautiful."[2] This was like a knife to the chest of many soccer supporters, and for years it seemed that, as Miguel Alejo stated in his article "Soccer and Literature: Intellectual Romance with a Ball" (*"Fútbol y Literatura: Romance intelectual con la pelota"*), "writers scorned soccer and soccer players fled from literature." Although this seemed to be the popular school of thought, evidence shows that there has been a long-standing tradition of literature and soccer. The negative stereotype of the sport has recently caused a great number of soccer supporters to either stand up and defend the sport's legitimacy through literature or draw attention to the vast number of intellectuals that have done so throughout their careers. Many of the individuals to defend the sport's legitimacy, interestingly, are associated with the intellectual classes as writers and philosophers or are prominent figures of the soccer community. These individuals broke the taboo by crossing into what had come to be considered the opposite field. By creating works that encompass the two, they shed light on the fact that they are also captivated by both the sport and literature. In another capacity, many have addressed the dispute head-on and demonstrated that soccer can be dealt with on an intellectual level, just like any other social or cultural phenomenon.

One of the first intellectuals to embrace soccer as a topic for a novel was the famous Argentinean/Uruguayan writer Horacio Quiroga, who in the early 1900s published the tragic true story *Suicide on the Pitch* (*Suicidio en la cancha*), which was an account of a Latin American soccer player who committed suicide on the center spot of a soccer field. Quiroga's tale now appears in Omar Prego's compilation of short stories about soccer titled *Tales to Kick About* (*Cuentos para patear*). Another intellectual to write about the sport was a Frenchman of noble descent named Henry de Montherlant, who, prior to becoming a notable essayist, novelist, and playwright, was a goalkeeper in France. Montherlant wrote one of the first fictional tales dealing with soccer titled *Eleven in Front of the Golden Door* (*Los once ante la puerta dorada*). Years later, the famous French philosopher Albert Camus, who had also spent time as a goalkeeper in France, recognized the role that soccer had played on his intellectual formation as a philosopher. Camus made reference to the sport throughout his career as a philosopher, and in one article in particular titled "What I Owe to Soccer" (*"Lo que debo al fútbol"*), he wrote, "Quickly I learned the ball never arrives the way one expects it to. This helped me a lot in life, especially in big cities, where people often aren't who they claim to be."[3]

Although the defense to legitimize soccer as a topic for intellectual and artistic mediums (such as literature and film) has been fought worldwide, some of the movement's most prominent advocates hail from the Spanish-speaking world. Some of these defenders of soccer have conducted cultural, political, and economic studies dealing with the sport, while others have composed works of fiction that use soccer as the central theme. There is a long list of prominent figures of Spanish literature who

have composed works using soccer as a central theme, including Camilo José Cela, Rafael Alberti, Miguel Hernández, Francisco Umbral, Miguel Delibes, Manuel Vázquez Montalbán, Rosa Regàs, David Trueba, Soledad Puértolas, Rafael Azcona, Vicente Verdú, Javier Marías, Ana María Moix, Juan Manuel de Prada, Manuel Hidalgo, and Fernando Fernán Gómez, along with many others. The list of Latin American advocates of the genre includes the names Eduardo Galeano, Mario Benedetti, Juan Villoro, Osvaldo Soriano, Roberto Fontanarrosa, and many others. Some of these literary figures included soccer as a topic in their work because of their overwhelming passion for the sport, while others did so because they recognized its role as a cultural phenomenon. There are still others who have compiled works of literature that deal with soccer in an effort to draw attention to the presence of the genre and at the same time justify its legitimacy. Two such individuals are Jorge Valdano and Julián García Candau.

Jorge Valdano is recognized primarily as a figure of the soccer world. His successes on the field include scoring a goal to help Argentina win the 1986 World Cup Final alongside the famous Diego Maradona. Valdano began his professional career playing for the Argentinean Club Newell's Old Boys before entering the Spanish League, where he played for Deportivo Alavés, Real Zaragoza, and Real Madrid. He later became the manager of Club Deportivo Tenerife and Real Madrid. After his playing career came to an end, Valdano began working to dispel the stereotype that soccer and intellectualism are not compatible. In defending soccer's legitimacy, Valdano has written articles, books, and newspaper columns and has taken part in countless interviews, always defending the sport as an intellectually profound contribution to society.

Since beginning his mission in the defense of soccer, Valdano has earned the nickname "The Soccer Philosopher" ("*El filósofo del Fútbol*"). Two of his books that approach the sport from an intellectual standpoint are titled *Notes of the Ball* (*Apuntes del balón*) (2001) and *Stage Fright and Other Herbs* (*El miedo escénico y otras hierbas*) (2002). *Notes of the Ball* is a compilation of profound thoughts pertaining to the sport that Valdano had written over the years for his column in the Spanish soccer newspaper *Score* (*Marca*). *Stage Fright and Other Herbs* is another contribution by Valdano that defends the sport as an intellectually stimulating contribution to society that, among many things, serves to mold our youth and prepare them for adulthood. He defends it also as a realm where all of life's lessons can be learned and where differences in social status can miraculously vanish. In one section of the book, Valdano describes these aspects of the game by writing,

> The first cooperative in which I formed part was a soccer team: I had to put in an effort toward the service of a collective. As playing makes us authentic, our improvised matches in the vacant lots of my neighbor-

hood helped us get to know one another better. When the ball took motion, we began a battle and a party in which there were both treacherous kicks and glorious plays. Each of us always ended up demonstrating exactly who we were. It was easy to recognize the generous and the selfish, the valiant and the cowardly, the envious, the altruistic, the insecure, the melancholic and all those that comprise the complex human species. Since soccer doesn't distinguish in any other way than between good and bad players, on the teams coexisted fat players, skinny players, tall players, short players, strong players that fought, weak players that dribbled and, now that I think of it, the game didn't differentiate between the kids with new shoes and those with no shoes.[4]

In his work, Valdano makes a point to address the dispute between intellectuals and the soccer community to demonstrate that the two supposedly contrasting areas of society are in fact compatible. In *Stage Fright and Other Herbs*, he addresses and describes both sides of the argument by defining certain aspects of the sport when he writes,

> Soccer: trivial, suspicious and of undisputed social influence has always been used and tampered with. The intellectuals' answer to this popular force is appreciable. In large number they believe it's a blemish; through cultural prejudices (a game for the illiterate); politicians (a capitalistic snare); the sexes (a game for men); or for the fear they got from blending the individual and the masses. The truth is that between wise men such as these and soccer, there is a frustrated relationship at the origin; a pre-matrimonial divorce with two effects: some ignore it and others despise it. Sympathetic hostility was that of Jorge Luis Borges, who once gave a lecture in Buenos Aires at the same time of the Argentine National Team's debut in the 1978 World Cup. It was about immortality.[5]

In 1995, Valdano took a bold step and entered into the dispute between intellectuals and the soccer community by publishing a book that compiled twenty-four short stories about soccer written by some of the Spanish-speaking world's most reputable literary figures. The book, titled *Soccer Stories* (*Cuentos de Fútbol*), quickly garnered a great deal of attention because it combined soccer and literature, two contrasting realms of society. Three years later, Valdano compiled another book using the same parameters titled *Soccer Stories 2* (*Cuentos de Fútbol 2*). *Soccer Stories 2* consists of twenty-three soccer stories written by different literary figures of the Spanish-speaking world than those included in the first publication with the exception of Mario Benedetti. Valdano's use of different authors in these publications verifies the vast number of famous literary figures and intellectuals who have created works of literature with this theme. Since Jorge Valdano is one of the foremost advocates of intellectualism and literature as they pertain to soccer, I will make reference to his many contributions throughout this book. His contributions that overlap each

of these fields serve as evidence in my defense that proclaims that the taboo of soccer, as a legitimate literary topic, has been lifted and that it is now not only an acceptable theme among intellectuals but also a theme that is regarded favorably.

In 1996, Spanish sports journalist Julián García Candau published *Epic and Lyric of Soccer* (*Épica y lírica del fútbol*), a book dedicated to uncovering the long tradition of Spanish poetry that focuses on soccer. From the opening sentence of the study, García Candau acknowledged that the ongoing dispute between intellectuals and the soccer community is actually not as it seems when he wrote, "Soccer has not achieved unwavering adhesions among the intellectuality of the world, but it also hasn't been as despised as it might seem if we resort to examples from writers that still today consider it an encouraging spectacle, and almost indictable of occupation."[6] In 1980, sixteen years before publishing *Epic and Lyric of Soccer*, García Candau published a book concerning Spain's intervention of politics in soccer titled, *Soccer, without Law* (*El fútbol, sin ley*). One of the sections of his fundamental study, "Intellectuals and Politicians Confront the Phenomenon of Soccer" ("*Intelectuales y políticos ante el fenómeno futbolístico*"), was dedicated to this dispute. The opening lines of this section address the clash taking place in Spain between the world of soccer, Spain's leftist intellectual community, and Spain's right-wing politicians:

> Up until Franco's death, very few intellectuals dared to publicly claim their predilection for soccer. Until Franco's death, the leftist intellectuals hid their avocation even from their colleagues. Soccer in those years was an alienating spectacle-sport. It was the opiate of the masses. The old philosophy of bread and bulls had been substituted for bread and soccer.[7]

Since the masses have been so intensely drawn to soccer, the most popular team from any given region of the world often comes to represent that region's cultural and political ideologies. Politicians have recognized soccer's ability to capture and embrace these ideologies and have used the sport to promote their beliefs and/or minimize the beliefs of the opposition. This has been one of the key factors of the intellectual classes effort to nurture a lack of appreciation for the sport, claiming it has been associated with the individual who does not "think for himself." For this reason, many intellectuals who have approached the sport as a topic for study have done so in an effort to diminish its value and highlight it as a less-than-fruitful aspect of popular modern culture. They often call soccer the world's "new religion," or a "social drug" that is manipulated by the economy and the government to control the masses.

Part I of this book follows the format of a chapter in Vic Duke and Liz Crolley's book *Football Nationality and the State* titled "Storming the Castile: Footballing Nations in Spain." Following their structure, I give a

brief overview of the historical background to Spain's state of autonomies and make the connection between these historical, political, and ideological disputes of culture and identity throughout Spain and later demonstrate how they have been linked with soccer since the sport was formally introduced to the country. I demonstrate how soccer has been manipulated by different cultural and political ideologies throughout Spain and how certain Spanish soccer clubs have manipulated their connection with these ideologies to establish themselves as some of the most heavily consumed commodities in Spain. Some of the most important studies that reveal the link between politics and soccer in Spain are Duncan Shaw's *Soccer and Francoism* (*Fútbol y franquismo*), Carlos Fernández Santander's *Soccer during the Civil War and Francoism* (*El fútbol durante la Guerra Civil y el franquismo*), Vic Duke and Liz Crolley's *Football Nationality and the State*, Liz Crolley and David Hand's *Football and European Identity* and *Football Europe and the Press*, Alex J. Botines's *The Great Scam of Spanish Soccer* (*La gran estafa del fútbol español*), Felix Martialay Bernardo de Salazar's *The Biggest Lies of Spanish Soccer* (*Las grandes mentiras del fútbol español*), and Julián García Candau's *Soccer, without Law* (*El fútbol, sin ley*).

Part II is dedicated to demonstrating how soccer's connection to politics in Spain initially caused the aforementioned dispute between intellectuals and the soccer community. It then documents how a great number of literary figures in Spain (and throughout the world) have ignored the supposed taboo and made very rich and respectable contributions to the world of literature that use soccer as a central theme. In this part of the book, I define "kick-lit"—the term I have given to this literary genre—which is currently growing in popularity and respect.

Part III is dedicated to analyzing the existence of soccer in Spanish cinema, which I have labeled as "kick-flicks." Much like the situation with kick-lit, films dealing with soccer as the central theme have also gained a bad reputation, as the intellectual classes have been less accepting of films focusing on soccer. However, the argument that kick-flicks offer a poor representation of soccer holds true. This is because few, if any, fictional soccer tales portrayed on the big screen have been able to properly capture the beauty of the sport on film. One of the most important studies covering films of this genre is Carlos Marañón's *Soccer and Film: Soccer on the Big Screen* (*Fútbol y cine: el balompié en la gran pantalla*) (2005). In the study, Marañón highlights the fact that soccer and the world of cinema are two of the most powerful cultural phenomena of the past 100 years. He questions, if both elements of culture represent and encompass every aspect of our society, why do the intellectual classes readily accept one and not the other? He goes a step further and questions why these two cultural phenomena are viewed as incompatible. The prologue of the book was written by the famous Spanish sports journalist Santiago Segurola, who addressed the difficulties of properly depicting the beauty of the game on the big screen. He compares the task to con-

quering Mount Everest by claiming that it might seem impossible but that, once it is achieved, many will follow. Segurola offers a variety of explanations as to why this might be such a difficult task. One of his explanations is that the world's leading film industry—Hollywood—is in a country that has struggled with understanding and fully embracing soccer, unlike so many other countries around the world that have done so effortlessly. Segurola concludes that the lack of understanding of the sport in the United States might play a part in the difficulties filmmakers have had finding cinematographic techniques to properly portray the sport through film. He also points out that some of the most successful sports films—and kick-flicks for that matter—were successful in their approach to tackling the sport, which he describes as "from a lateral position."[8] Segurola's prologue begins by stating,

> I was always under the impression that soccer is a beast that resists film without knowing very well the reasons why the two largest elements of leisure and culture of our time repel one another. It's true that in recent years there has been a renewed effort to revisit the difficult relationship between these two universes. Soccer has definitively lost its condition as a pastime of the working class and it has been embraced by the intellectuals, especially in England, where there isn't a writer nor a filmmaker that doesn't proclaim his passion for a game that is now regarded as *chic*.[9]

This quote makes it clear that Santiago Segurola also recognizes that the conflict between the intellectual classes and the soccer community has been resolved, and, as with many things once considered "out of style" (since it has been reconsidered in the right frame of mind), it is now regarded as *de moda*. The recent addition of a category dedicated to sports films at the Tribeca Film Festival is a testament to this newfound respect for the genre.

Since its inception approximately 150 years ago, soccer has grown in popularity and become a phenomenal aspect of both Spanish society and the world. The phenomenal aspects of the sport can be argued from many angles, but chief among them is the sport's ability to embrace and connect with almost every other aspect of culture. The following pages will demonstrate exactly how that has happened in Spain with regard to the areas of Spanish politics, literature, and film.

Spanish soccer's relationship to politics has been a popular theme for investigation since the two have been so closely linked from the very start. This book uses these studies as its foundation to demonstrate that soccer (at the professional and international levels) in Spain involves much more than twenty-two individuals coming together to compete in a soccer match. Rather, within the game, there are many other implied social struggles with which the people of Spain identify. Many of these struggles that relate to soccer in Spain have been communicated through

literature and film. However, there are also countless other works that approach the sport from a very different angle and leave the political implications involved in Spanish soccer aside. Regardless, the enormous body of literary and cinematographic work that has been produced is so impressive that it seems incomprehensible that the genre does not yet have a solidified name, which I offer as kick-lit and kick-flicks. The fact that very few academic investigations exist covering analyses of Spanish kick-lit and kick-flicks demonstrates the lack of appreciation that the intellectual classes have for literature and films of this genre. The theme of soccer (whether it be the formalized sport we know today or its vulgar ancestor from the Middle Ages) has been covered throughout the entire history of Spanish literature by a number of Spain's most revered authors. The body of Spanish literature has become enormous over the years, demonstrating that many writers share a passion for literature, soccer, and the combination of both. Likewise, the connection of soccer and Spanish film has been apparent since the arrival of cinema to Spain. During the 1940s, 1950s, and 1960s, a number of Spanish films were closely connected to the world of soccer, and currently films in Spain dealing with soccer have experienced a resurgence in popularity. Through this book, I aspire to help those who are passionate about Spanish literature and film gain an appreciation for literature and film focusing on soccer (if they are not already inclined toward this genre). More importantly, I hope to expose the enormous body of Spanish literature and film centered around soccer to the English-speaking world. This is undoubtedly a legitimate, diverse, and fruitful contribution to the Spanish arts and therefore worthy of further academic investigation.

All translations from Spanish to English are the author's, unless otherwise stated.

NOTES

1. An explanation for the Spanish terms *fútbol* and *balompié* can be found on page 34.

2. Miguel Alejo, *"Fútbol y literatura: Romance intelectual con la pelota"* ("Soccer and Literature: Intellectual Romance with a Ball"), 2008, http://edant.clarin.com/suplementos/cultura/2006/05/27/u-01202161.htm (February 2, 2009).

3. Albert Camus, in Eduardo Galeano, *Su majestad el fútbol* (*His Majesty Soccer*) (Montevideo: Arca, 1968), 10.

4. Jorge Valdano, *El miedo escénico y otras hierbas* (*Stage Fright and Other Herbs*) (Buenos Aires: Aguilar, 2002), 277–78.

5. Valdano, *El miedo escénico y otras hierbas*, 274–75.

6. Julian Garcia Candau, *Épica y lírica del fútbol* (*Epic and Lyric of Soccer*) (Madrid: Alianza Editorial, 1996), 7.

7. Julian García Candau, *El fútbol, sin ley* (*Soccer, without Law*) (Madrid: Penthalón, 1980), 39.

8. Carlos Marañón, *Fútbol y cine: El balompié en la gran pantalla* (*Soccer and Film: Soccer on the Big Screen*) (Madrid: Ocho y Medio Libros de Cine, 2005), 11.

9. Marañón, *Fútbol y cine*, 11.

I

Tackling Spain's National Identity Crisis

How Spanish Identity Conflicts Are Repressed and Reinforced through Soccer

The notion of Spain as a unified nation was first conceived with the marriage of Isabel of Castile to Fernando of Aragon in 1469. Since that political merger of these two Iberian kingdoms, the idea of Spain having a single identity has been both vehemently supported and viciously disputed. Over the years, advocates from both sides have taken advantage of a wide range of opportunities to either support this notion or oppose it. This chapter will serve to demonstrate how, since its introduction to Spain, soccer has been utilized as a vehicle for individuals and communities to express their beliefs as to whether Spain is a single nation with a strong national identity or a conglomerate of nations with a variety of cultural identities:

> The historical and contemporary links between football and the sociopolitical fabric of Spain are complex. Some themes in the game today predate Spain's major twentieth-century upheavals of the Civil War (1936–1939) and subsequent periods of Franco's dictatorship (1939–1975). The balance swings from football being used to promote a single national identity (in the 1940's, during the early Franco years) to becoming a vehicle for nationalist/regionalist expression particularly during the late Franco period and early phase of the transition to democracy.[1]

The following chapters will explore the ways in which some Spanish soccer clubs have emerged as symbols that represent the ongoing social and political disputes within Spain that, depending on the political climate of the era, have varied in context. In order to provide a better understanding of exactly how the underlying sociopolitical background over the past century has come to so strongly affect the Spanish lifestyle, and in turn soccer within Spain, it is necessary to first understand the histori-

cal developments resulting in the formation of Spain's state of autonomies.

NOTE

1. Vic Duke and Liz Crolley, *Football, Nationality, and the State* (New York: Longman, 1996), 24.

ONE

Background to Spain's State of Autonomies

Spain was created over five centuries ago, and what some people now find interesting is undoing it and returning to the kingdoms of Taifa and Babel.

—Julián Marías

After Isabel and Fernando's marriage in 1469, it was decreed by the newlywed monarchs that their motto for equality, *Tanto Monta, Monta Tanto* (meaning: "they amount to the same" or "equal power"), be written throughout the land in an effort to reinforce the notion of one united kingdom. Unlike many other mergers of the era, all aspects of power within their newly formed kingdom of Castile were to be distributed equally between the Catholic monarchs, Isabel and Fernando. By all accounts, this promise was faithfully held throughout their reign.

The fusion of these two kingdoms was one of the most powerful political mergers the world has ever witnessed, and its achievements are still relevant to this day. Isabel and Fernando are known as *los reyes católicos* (the Catholic monarchs) because they joined forces principally to fight against the Moorish occupation of the Iberian Peninsula. Their consolidation subsequently led to the Christians officially "reconquering" the land in 1492. Coincidentally, 1492 is the very year that the explorer Christopher Columbus is recognized for having "discovered" the Americas—at least in the eyes of Europe. Columbus did so in the name of Castile, for his voyage was funded by Isabel and Fernando. These two monumental victories for the Catholic monarchs, although both extremely controversial and complex, were instrumental events that *almost* molded Spain into the single solitary nation that Isabel and Fernando so greatly desired. But while these triumphs may have enabled Spain to be recognized as a

unified nation in foreign lands, this sentiment may not have been completely shared by all the kingdoms within the Iberian Peninsula.

Although the Castilian effort played an enormous role in reconquering the Iberian Peninsula for the Christians, much of their success was due to the Catholic monarchs' ability to unite forces very quickly. This fast unification of forces was possible because of the high degree of autonomy the Catholic monarchs granted to the Catholic kingdoms of the Iberian Peninsula. These kingdoms are known today as the "historic nationalities" or "former kingdoms." The irony of this situation is that while the Catholic monarchs' very allowance of this high degree of autonomy (within the former kingdoms) played an enormous role in the Christian's reconquering of the Iberian Peninsula over the Moors, it also allowed many of the people of these former kingdoms never to consider themselves uniquely "Spanish." Therefore the concept of Spain never truly existed for many of them. For this reason, the people from the former kingdoms (which are essentially on the geographic periphery of Spain)—Galicia, Catalonia, and Valencia—maintained their own sense of identity and nationality, and preserved their own traditions, languages, and institutions while the Basques and the Catalans did all of the above and even sustained their revered *fueros*—their ancient fiscal and legal systems.

Since they maintained their traditional lifestyles, it was easy to distinguish between the different kingdoms and cultures throughout the land. The varying aspects of everyday life of these kingdoms, especially in the north, where the Moorish occupation was much less prevalent, served to strengthen each of these kingdoms' unique sense of culture and community. This caused many members of the historic nationalities to never fully consider themselves "Spanish" as the Castilian monarchs would have desired. The Castilian monarchs' vision/quest was not only to unify the country but also to globalize and catholicize the world in the name of Spain. At this same time, they were very concerned with bringing foreign riches back to the motherland—for it had recently been discovered that there was much gold to be had in the Americas. Clearly, at this point, the Catholic monarchs' focus and overall attention had shifted from "reconquering" the Iberian Peninsula for the Catholics to conquering, catholicizing, and controlling foreign lands. Meanwhile, since the historic nationalities were Castilian allies, they were essentially left to continue cultivating their already existing cultures, lifestyles, and institutions. Even though the historic nationalities greatly supported almost all of the Castilian/Spanish efforts of the time, many of the people from these regions still valued their homeland, their language, and their culture over that of Castile.[1]

Although the identity crisis within Spain is very complex and has taken many turns over the course of its history, this overview serves to demonstrate that Spain's struggle with identity stems back to the coun-

try's very foundation. Many of Spain's leaders have tried to resolve this crisis and to solidify the country into a single nation, but essentially all have failed. For example, during the seventeenth century, King Philip IV's adviser, Count-Duke de Olivares, worked to promote political, administrative, and legislative unification in an effort to solidify the nation. King Philip IV was unable to achieve this goal, and consequently the Catalans continued to officially use their own language and maintain their own local institutions. The Basques also managed to maintain what they considered, both then and now, essential elements of their identity — their language and their system of *fueros*.[2]

After the death of King Fernando VII in 1833 and the onset of the Carlist Wars, regionalist and nationalist issues once again came to the foreground in Spain. The "Carlists" supported Carlos — brother of the deceased King Fernando VII — as heir to the throne and opposed the idea that the monarchy be put in the hands of Fernando VII's daughter, Isabel II. Carlist issues were the dominating theme of Spain's political scene during the nineteenth century. Carlism was supported mainly in the regions of Spain that had their own political institutions and language, that is, the historic nationalities: Catalonia, Galicia, Navarre, the Basque Country, and Valencia. Therefore, Carlism nourished these recognizable differences in ideologies between central Spain and the periphery. Many of these unresolved disputes of the Carlist Wars eventually culminated into the Spanish Civil War and some of these disputes are still unresolved today.[3]

During the nineteenth century in Catalonia, a literary movement known as the *Renaixença* (Catalan Rebirth) was on the rise. This movement embraced the distinguished cultural and historical identity of the Catalan people and became very popular within the Catalan bourgeoisie, who in turn used it to promote their Catalan vision of the world. Shortly thereafter, the *Renaixença* came to influence much of the Catalan lifestyle and even gave rise to political parties, such as *la Lliga* — a uniquely Catalan political party that is still in existence.[4] Catalonia's newfound desire to cultivate their unique culture led them to push even harder for regional autonomy so that they could continue developing themselves without interference from the rest of Spain.

While the Catalans had the *Renaixença*, the Basque Country and Galicia had very similar renovating cultural movements that were also designed to strengthen their culture and community. The Galician form was called the *Rexurdimento*, and the Basque's was called *Eusko Pizkundea* — each meaning "rebirth" in the respective region's language. This desire for a fresh start had been building over the years, largely due to their frustration from having lost the Carlist Wars. But it wasn't until after the infamous disaster of 1898 that the people from the historic nationalities seized the opportunity to push for self-governance. The disaster of 1898 occurred when Spain was defeated in the Spanish-American War and

consequently lost its last remaining colonies outside of Europe: Cuba, the Philippines, Puerto Rico, and Guam. With this loss, the Spanish Empire that previously proclaimed itself *"el imperio en el que nunca se pone el sol"* ("the empire on which the sun never sets") had officially crumbled. Moreover, this meant that Spain's prestige as a world power was no more. Many Spaniards viewed the disintegration of their empire as a terrible embarrassment and caused the country to question its grandeur in the first place. Many artists and writers of the era addressed these issues head-on, and this newfound insecurity throughout Spain essentially led to the rise of its most recognized literary movement since the highly praised Golden Age: the Generation of '98:

> The new turn-of-the century artists and writers were called "the generation of '98," a group who responded to El Desastre (The Disaster [of '98]) by seeking to analyze and redefine the newly diminished Spain. Through paintings, novels, poems, and essays, they searched for the essence of Spain in the Castilian landscape, in the history of the golden age, in critical examinations of classic literature such as Cervantes's *Don Quixote de la Mancha*. The pivotal question was: How can Spain undergo a regeneration? . . . Curiously, this search for the soul of Spain was led by Basques. Experiencing the Spanish simultaneously as both "us" and "them" is essential to discovering the soul of Spain. Castilians, for whom Spain is only "us," are the exception. [Basque native, Miguel de] Unamuno was a central figure in the generation of '98, as was San Sebastián-born Pío Baroja.[5]

The disaster of '98 humbled Spain, causing a depression and a general pessimism to take over the country that many believe still plagues the Spanish national psyche today. Since the country was in a state of weakness, those who did not support the notion of Spain as a single nation with a single identity, much less as having a national psyche, saw this as an opportunity to strengthen their own community's identity and further diminish the notion of Spain as a single nation. Soon leaders rose that had the desire to spark regionalist/nationalist movements designed to separate themselves from Spain. This obviously caused supporters of a unified Spain to respond. Tensions soon grew, and violent measures were taken.

By the early twentieth century, both Catalonia and the Basque Country were demonstrating a certain level of elitism over the rest of Spain as they claimed themselves to be the only Spanish regions that were developing into modern industrial societies. Impressively, they managed this development while maintaining their strong economic roots in agricultural production. When the centralist government opposed certain policies that would have favored their industrial efforts, many people from these regions came to distrust the politicians in Madrid even more. The peripheral region's frustration with the central politics of Madrid, mixed with Madrid's resentment of the northeastern elitist attitudes, was simply fuel

adding to the fire of animosities that were growing within the Iberian Peninsula.[6]

It is clear why the Catalonians and the Basques considered themselves more advanced than the rest of Spain; they had strong agricultural production and an up-and-coming industrial revolution. This provided them with economic proof that they possessed a modern vision of the world and a "roll-up-your-sleeves" work ethic that in turn produced more than most other regions of the planet at the time. Not only did Catalonia prove itself to be extremely advanced economically, agriculturally, and industrially, but it was also the home of some of the world's most celebrated artists of the era. One fine example would be the world's most ambitious architect, Catalan-born Antoní Gaudí. Gaudí's work shows a strong sense of Catalan identity and marked the character of Barcelona as a modern city. Other world-renowned modernists who profited from this Catalonian vision for the twentieth century were surrealist painters Salvador Dalí and Joan Miró. Dalí was born in Figueras and Miró in Barcelona, and although Pablo Picasso was not born in Catalonia, in 1900 he held his first exhibition at a small Barcelona café named *Els Quatre Gats* (The Four Cats):

> Born in Málaga in 1881, Picasso moved to the throbbing Catalonian capital at the age of 14. Here he attended art school and spent several formative years before moving to Paris. His *The Young Ladies of Avignon* (*Les Demoiselles d'Avignon*) (1907), depicting a group of Barcelona whores, is cited as the first important Cubist painting, a major milestone for modern art.[7]

At the turn of the twentieth century, Barcelona also saw a music explosion that soon worked its way through Spain. This movement's most influential and most recognized leader was the famous Barcelona composer Felipe Pedrell. Another world-renowned Catalan musician was Pablo Casals. Many consider Casals to be the greatest cello virtuoso of modern times. The musical contributions of these men, as well as a number of other Catalonian musicians, gave rise to the Catalan saying, "If you pinch a Catalan, he or she will always cry out in perfect pitch."[8] This adage demonstrates not only that Catalonia was experiencing a very rich musical and cultural explosion but also that the Catalan people were conscious of it and were not afraid to let the rest of Spain know it.

Recognizing their wide range of cultural and economic achievements, the people of Catalonia came to consider themselves as more advanced than the rest of Spain. Many Catalonians and Basques continued to feel that the central government jealously took advantage of any and all opportunities to hinder their advancing efforts. This was the case in many aspects of Catalan and Basque life and eventually spilled over into the arena of soccer. In the following pages, I will give examples to demonstrate how, over the years, soccer has been used in Spain as a vehicle to

either promote the idea of Spain as a single unified nation or staunchly oppose this notion.

NOTES

1. Vic Duke and Liz Crolley, *Football, Nationality, and the State* (New York: Longman, 1996), 25.

2. Duke and Crolley, *Football, Nationality, and the State*, 25.

3. Duke and Crolley, *Football, Nationality, and the State*, 25.

4. Duke and Crolley, *Football, Nationality, and the State*, 25.

5. Mark Kurlansky, *The Basque History of the World* (New York: Walker, 1999), 172–73.

6. Duke and Crolley, *Football, Nationality, and the State*, 25–29.

7. Mark Williams, *The Story of Spain* (Madrid: Santana Books, 2000), 182.

8. Williams, *The Story of Spain*, 182.

TWO

Tensions Flair

Spanish Soccer during the Pre–Civil War Period (1900–1936)

Soccer was introduced to Spain just before the turn of the twentieth century by British mariners and steelworkers living in the country. Spanish students who had returned home from Great Britain also played an important role in the sport's introduction to the Iberian Peninsula. Many of them returned home with a newfound excitement to teach their friends and family this game, which in England was called "football." As the sport gained popularity, the Spaniards attempted to phonetically mimic this pronunciation within the confines of the Castilian alphabet and came up with the spelling "f-ú-t-b-o-l." "Fútbol" is what the sport is still called in most Spanish-speaking countries today, although purists of the Castilian Spanish language prefer the term "balompié"[1] as opposed to accepting words imposed on them from languages other than their own. However, I will continue to use the American term "soccer" throughout this work to avoid any confusion when referring to the sport.

Soon after soccer's introduction to Spain, thanks to the help of the aforementioned English immigrants working in Spain, a number of notable clubs formed as outlets for the sport, such as the Basque Country's Athlétic de Bilbao in 1898, Catalonia's FC Barcelona in 1899, and Sociedad Española de Football (or simply Español) in 1900. Shortly thereafter came representatives from the central state: Madrid in 1902 (to be named Real Madrid in 1920) and Atlético de Madrid in 1903. During its formative years, Spanish soccer was politicized by each club's respective region. This was essentially due to the fact that during this period there was no need for the centralized government to intervene in the politics of

9

soccer. Therefore, the clubs, along with the Royal Federation of Spanish Soccer (*Real Federación Española de Fútbol*—R.F.E.F.), which was founded by the clubs themselves in 1902, enjoyed nearly complete independence from the authorities in Madrid, something that, as we will see in the next chapter, would not always be the case. Upon the R.F.E.F.'s formation, its first point of business was to organize a Spanish championship, for which King Alfonso XIII graciously accepted the role of patron. In doing so, the Cup of His Majesty the King, also known as the King's Cup (*La Copa de Su Majestad el Rey*, or *La Copa del Rey*) was born. The King's Cup went on to serve as the only soccer championship within Spain until the formation of the League of Professional Soccer (*La Liga de Fútbol Profesional*) in 1928, which brought professionalism to the players, coaches, and administrators of the sport for the first time in Spain.[2]

This regionalism/nationalism issue had also been planted within soccer in Spain. For example, the club Athétic de Bilbao was officially formed after two early Basque clubs, Athletic Club and Bilbao FC, merged under the name Club Vizcaya and won the inaugural King's Cup in 1902. In 1903, they changed their name to Athletic de Bilbao, and immediately the club presented itself as an organization designed to represent the city of Bilbao, the province of Vizcaya, and the region of the Basque Country.[3] This idea of representing the community, culture, and region through the soccer club became so strong that in 1919 Athletic de Bilbao's directors implemented a caste system for the players on the club. The caste system excluded all players except those of purely Basque blood. This idea of a caste system was supported and then mimicked (to an extent) by other Basque clubs, such as Real Sociedad from San Sebastian. The major difference between Real Sociedad's and Athletic de Bilbao's caste systems was that Athletic de Bilbao abided by Sabino Arana's definition of true Basque heritage. Arana (the founder of the Basque National Party) claimed, "for people to be considered Basque, their four grandparents must all have been born in Euskadi [the Basque Country] and have Euskera [Basque] names."[4] While Real Sociedad simply required its players to have been born in the Basque Country, Athletic de Bilbao took this notion of Basque purity so seriously that it required that each of its players not only be born in the Basque country but also provide proof that both of the player's parents and all four grandparents had Basque names and were also born in the Basque Country. Real Sociedad abandoned its caste system in 1989, but Athletic de Bilbao has stayed surprisingly strong and has accepted only a few players over the years who did not fully comply with Arana's criteria of "Basqueness." While critics of these caste systems consider them a sad demonstration of xenophobic tendencies, they are without a doubt a testament to the quantity and quality of athletes, coaches, and administrators that a region as relatively small as that of the Basque Country has been able to produce, maintain, and succeed with over the years in such a competitive field.

While these Basque clubs chose not to look beyond their region of Spain for players, other clubs have taken a very different approach in this regard, such as Catalonia's Football Club Barcelona. FC Barcelona (also known as *"Barça"*) not only accepts players from all over the globe as members but also welcomes them with open arms. Since FC Barcelona's founding in 1899, the club has continually sought to serve as a symbol for the Catalan people. For example, the city's coat of arms was the club's crest until 1910, when the decision was made to create a crest that was different from that of the city. The club held a competition among its members to design a new crest, and the winner of the competition was a medical student who also played for FC Barcelona, Carles Comamala. Comamala was well aware of FC Barcelona's desire to be linked with the region and city, and therefore he combined the most representative symbols of Catalonia and Barcelona with the club. Obviously, he incorporated the city of Barcelona's flag, which contains the "bars of Aragon" that also appear on the Catalan flag, called the *senyera*. These bars of Aragon are also the traditional four red stripes of the Catalan coat of arms and historically represent the four regions of the kingdom of Aragon. The Barcelona city flag also contains the Cross of St. George, which throughout the world serves to represent bravery in the face of the enemy. The city of Barcelona's coat of arms has varied over the years, but it has never abandoned these two symbols. Comamala's crest for FC Barcelona, which is essentially the same as FC Barcelona's current crest, combined the bars of Aragon with the Cross of St. George on the top half, with the club's easily recognizable blue and claret stripes (modeled after the Catalan flag [*la senyera*]) on the bottom half, with a drawing of a ball in the foreground. The initials F.C.B. (Football Club Barcelona) connect the upper half of the crest (that represents the city and region/nation of Catalonia) with the lower half (that represents the club). Clearly, since its conception, this crest was designed to symbolically reinforce the union between the Catalan region, the city of Barcelona, their history, their government, and F.C.B.

The notion to mesh the ideals of the club with those of the city of Barcelona and the region/nation of Catalonia was officially documented in the club's statutes by its president, Joan Gamper, in 1908. It was (and is still) written in Article 4 that the club's second objective is

> the promotion and participation in social, cultural, artistic, scientific or recreational activities that are adequate and necessary for maintaining the public representation and projection that the club enjoys, the fruit of a permanent tradition of loyalty and service to club members, citizens and Catalonia.[5]

Many of the people of Catalonia agreed with Article 4 because, as previously mentioned, through the *Renaixença* (the Catalan Rebirth, or "Renaissance"), they were concerned with nourishing the Catalan culture in

any way possible. Therefore, many Catalans, including the intellectual classes, the middle/lower classes, and left-wing politicians, became Barça supporters and recognized its role in defending Catalonia's democratic rights and freedom.

Barcelona is Catalonia's largest metropolis, and therefore it naturally embraces, nourishes, and exports many Catalonian ideals. Over the years, both Barcelona and Catalonia have gained the reputation of possessing an international outlook. This is the case with regard to basically every aspect of life that deals with progression toward the modern. The reputation that Catalonia and Barcelona possess an extremely modern vision of the world holds especially true when compared with other parts of Spain. Their international outlook may be in part due to Catalonia's geographical location: tucked in the northeastern corner of Spain on the Mediterranean coast near France and Monte Carlo, making it closer to the rest of Europe than Madrid, for example.

Madrid, on the other hand, is often stereotyped as possessing a collective/conservative ideology. Madrid's stereotypical vision is centered around the notion that Spain need not look beyond its borders for the key to modernization. For this reason, people from Madrid have the reputation of embracing the notion that Spain, in and of itself, possesses all the necessary elements of a well-rounded and diverse culture with sufficient manpower, know-how, and natural resources to modernize itself as a single nation. This is considered a "centralist" ideal. The centralists believe that by overcoming, accepting, and embracing their cultural differences to modernize together, the concept of a single Spanish culture, community, identity, and nation will truly establish itself and flourish into the future. The problem lies in the fact that many people from the historic nationalities, such as the Basque Country, have little or no desire to form part of this globalizing community and culture. Rather, they prefer not to participate in central Spain's mission of catching up to the rest of the modernizing world and simply look inwardly to their unique history and culture to find the path to their future.

Soccer clubs throughout Spain have always served to represent the ideals of their specific city or region. Some clubs do this more than others, but these existing rivalries between many regional ideologies are more often than not expressed in part through their soccer clubs. This is the case since any given match will bring large numbers of representatives of two contrasting ideologies to center stage. At times, these political and ideological rivalries are simply underlying themes. Other times, they play a central role in the game itself. But most often it is the spectators who express these political rivalries, sometimes passively and unfortunately, other times violently.

A great example of how conflicting notions of community and culture have been expressed through soccer in Spain can be found at the very root of the intercity rivalry between FC Barcelona and Reial Club Depor-

tiu Espanyol de Barcelona, commonly known simply as "Español,"[6] meaning "Spanish." This intercity rivalry first took shape upon Español's very conception, primarily because Español initially chose to name themselves Spanish Soccer Society (Sociedad Española de Football) and therefore openly recognized and embraced their "Spanishness" rather than their Catalan heritage. Supporters of the already existing FC Barcelona considered this a blatant attempt to antagonize them and mock their ongoing struggle not only to reinforce all things Catalan but also to reject the centralist ideals of Madrid. Through their name alone, it is easy to see that Español chose to express their support for the centralist ideals and to promote the notion of Spain as a single nation with a single identity. Español actually chose this name to distinguish themselves from the other clubs because unlike the majority of the other clubs of the era, Español was formed exclusively by and of Spaniards.

Shortly after Español was founded, the club's administrators took an even bolder step to further demonstrate their desire for all that is Spanish, and like the aforementioned Basque clubs, they also implemented a no-foreigners policy. However, while the Basque Clubs excluded participation of players who were not from the Basque Country, Español's no-foreigner policy excluded participation only of players born outside of Spain. While both systems demonstrated similarly strong desires to nurture their community and culture, the difference lies in their contrasting notions of community and culture. In 1912, King Alfonso XIII added fuel to the fire of dissention and granted Español the patronage of the Spanish Crown. Español was therefore entitled to use "Real" in their name and the image of the Spanish crown on their crest.

Patronage from the Spanish Crown is something that many clubs throughout Spain have sought and been granted. It is no surprise that FC Barcelona has never sought such patronage from the peninsula's monarchy. Clearly, Español's unrelenting desire to be connected with central Spain, coupled with their no-foreigners/Spaniards-only policy, gave FC Barcelona supporters the opportunity to denounce their "narrow-minded" intercity rivals and label them "xenophobes."

One of FC Barcelona's first stances in this regard occurred in 1901 when they boycotted a tournament that did not permit the participation of foreign players (from outside of Spain). At the time, FC Barcelona's squad was made up of nineteen non-Spaniards. This causes one to question whether FC Barcelona simply was not permitted to play or whether they refused to play, illustrating the complexity of these issues. Surely, FC Barcelona could have fielded a team made up strictly of Spaniards, but that squad would not have represented the ideals that the club and the people from Catalonia were striving for: an international outlook toward modernizing in the face of what they considered central Spain's oppressive, traditional vision.

Although Español is historically FC Barceolna's fiercest interstate rival, the mutual hatred between Real Madrid and FC Barcelona is considered to be much stronger. Real Madrid is regarded as the polar opposite of FC Barcelona, and it is widely considered that Real Madrid is the embodiment of Spain's oppressive centralist ideals. This oppressor–resistor relationship is widely recognized throughout Spain. These animosities came to a head in the Spanish soccer arena on June 14, 1925, during the centralist/conservative dictatorship of Miguel Primo de Rivera, when the crowd at an FC Barcelona home game whistled and jeered throughout the playing of the Spanish national anthem. Primo de Rivera's regime accused Joan Gamper, FC Barcelona's president, of promoting Catalan nationalism and as punishment closed The Courts (*Les Corts*), FC Barcelona's soccer grounds, for six months. They later reduced the closure to three months, but more importantly they forced Joan Gamper to resign his position as FC Barcelona's president and expelled him from Spain entirely. While exiled in his mother country of Switzerland, Gamper committed suicide. Many consider this to have been the culminating result of the economic demise, mental anguish, and personal struggle that Primo de Rivera's severe punishment caused.

Many consider the closing of Les Corts and the banishment of Gamper to be one of the earliest active expressions of the centralist government's oppression of FC Barcelona. The consequences of this punishment led not only to the death of Gamper but also to a notable period of decline in FC Barcelona's success on the field of play. During this era of Spanish history, political unrest typically overshadowed sporting ventures, but, as is also the case in a great number of countries, politics and soccer became intertwined. It has been said that "in Latin America . . . the border between soccer and politics is so dim that it's almost imperceptible."[7]

However, due to Spain's centralist dictatorship, FC Barcelona faced a crisis on a variety of levels. First, the number of members who supported the club and were essentially responsible for its very existence had drastically dropped, causing a social and financial crisis that undoubtedly led to a lack of success on the field. FC Barcelona was eventually able to overcome this crisis, and after a championship with Real Sociedad (that took three games to establish a winner),[8] Barça took home the 1928 King's Cup. In this three-game championship, FC Barcelona's Hungarian goalkeeper, Franz Platko, had recently been assigned the task of replacing the legendary Ricardo Zamora. Platko's performance in the final game was instrumental in the club's victory and quickly established him as a hero in his own right. An article in *Sport Cantabria* described his heroic effort as follows:

> When Real was crushing the Catalan goal, their center forward Cholin, in an enviable position, advanced toward the goal. When the goal seemed inevitable, the goalkeeper Platko realized a great stretch and

dove into the feet of the Donostian player and thus possessed the shot, but in exchange he received the kick designed for the ball in his head. The kick was brutal, Platko was left shocked and they had to remove him from the field in order to apply six sutures on the bloody wound. [9]

After being stitched up, Platko returned to finish the match with a bandage around his head that was eventually knocked off in another series of dramatic saves. Fortunately, the famous Spanish poet Rafael Alberti was in attendance at the match. Alberti was so impressed by Platko's performance that he was inspired to write a poem titled *"Platko"* in the goaltender's honor. The poem was published on the cover of the local newspaper "The Voice of Cantabria" (*"La Voz de Cantabria"*) on May 27, 1928. In the poem, the elements of nature—earth, wind, fire, and water—join together to help Platko defend the FC Barcelona goal. This poem is now famous among Spanish soccer and literature aficionados. It serves not only as one of the first examples of Spanish "kick-lit" but also as a great example of how well the elements of soccer can be expressed through literature. Thanks to Rafael Alberti, Franz Platko is now immortalized in the annals of both Spanish literature and soccer as a hero.

PLATKO

(SANTANDER, 20 DE MAYO DE 1928)	(SANTANDER, 20th OF MAY 1928)
A José Samitier, capitán	To José Samitier, captain
Nadie se olvida, Platko,	No one will forget, Platko,
no, nadie, nadie, nadie,	no, no one, nobody, no one,
oso rubio de Hungría.	blonde bear from Hungary.
Ni el mar,	Not even the sea,
que frente a ti saltaba sin poder defenderte.	that jumped in front of you, unable to defend you.
Ni la lluvia. Ni el viento, que era el que más rugía.	Not even the rain. Nor the wind, that roared most of all.
Ni el mar, ni el viento, Platko,	Nor the sea, nor the wind, Platko,
rubio Platko de sangre,	Blonde and bloodied Platko,
guardameta en el polvo,	goalie in the dust,
pararrayos.	light-beam stopper.
No, nadie, nadie, nadie.	No, no one, no one, nobody.
Camisetas azules y blancas, sobre el aire,	Blue and white jerseys, in the air,

camisetas reales,	royal jerseys,
camisetas, contra ti, volando y arrastrándote.	jerseys, against you, flying and knocking you around.
Platko, Platko lejano	Platko, distant Platko
rubio, Platko tronchado,	blonde, battered Platko,
tigre ardiendo en la yerba de otro país.	blazing tiger in the grass of another country.
¡Tú, llave,	You, key,
Platko, tú, llave rota,	Platko, you, broken key,
llave áurea caída ante el pórtico áureo!	golden key fallen before the gilded gateway!
No, nadie, nadie, nadie,	No, no one, nobody, no one,
nadie se olvida, Platko.	no one will forget, Platko.
Volvió su espalda al cielo.	He turned his back to heaven.
Camisetas azules y granas flamearon,	Blazen blue claret jerseys blazed,
apagadas, sin viento.	extinguished, without wind.
El mar, vueltos los ojos,	The sea, eyes rolled,
se tumbó y nada dijo.	lied back and said nothing.
Sangrando en los ojales,	Bleeding in the eyelets,
sangrando por ti, Platko,	bleeding for you, Platko,
por tu sangre de Hungría,	for your blood from Hungary,
sin tu sangre, tu impulso, tu parada, tu salto,	without your blood, your impulse, your block, your jump,
temieron las insignias.	They feared the insignias.
No, nadie, Platko, nadie,	No, no one, Platko no one,
nadie, nadie se olvida.	nobody, no one would forget.
Fue la vuelta del mar.	It was the twist of the sea.
Fueron	They were
diez rápidas banderas	ten fast flags
incendiadas, sin freno.	set ablaze, out of control.
Fue la vuelta del viento.	It was the twist of the wind.
La vuelta al corazón de la esperanza.	The return to the heart of hope.
Fue tu vuelta.	It was your turn.
Azul heroico y grana,	Heroic blue and claret,

mandó el aire en las venas.	the air commanded in the veins.
Alas, alas celestes y blancas, rotas alas,	Wings, celestial white wings, broken wings,
combatidas, sin plumas, encalaron la yerba.	fought, without quills, whitewashed the grass.
Y el aire tuvo piernas,	And the air had legs,
tronco, brazos, cabeza.	a torso, arms, a head.
¡Y todo por ti, Platko,	And all for you, Platko,
rubio Platko de Hungría!	blonde Platko of Hungary!
Y en tu honor, por tu vuelta,	And in your honor, for your return,
porque volviste el pulso perdido a la pelea,	because you returned the lost pulse to the fight,
en el arco contrario el viento abrió una brecha.	in the opposite goal the wind opened a gap.
Nadie, nadie se olvida.	No one, no one will forget.
El cielo, el mar, la lluvia, lo recuerdan.	The sky, the sea, the rain, will remember.
Las insignias.	The insignias.
Las doradas insignias, flores de los ojales,	The golden insignias, flowers of the eyelets,
cerradas, por ti abiertas.	closed, for you opened.
No, nadie, nadie, nadie,	No, no one, nobody, no one,
nadie se olvida, Platko.	no one will forget, Platko.
Ni el final: tu salida,	Not even the end: your exit,
oso rubio de sangre,	blonde bear of blood,
desmayada bandera en hombros por el campo.	fainted flag on shoulders throughout the field.
¡Oh Platko, Platko, Platko,	Oh Platko, Platko, Platko,
tú, tan lejos de Hungría!	you, so far from Hungary!
¿Qué mar hubiera sido capaz de no llorarte?	What sea could not have cried for you?
Nadie, nadie se olvida,	No one, no one will forget,
no, nadie, nadie, nadie.	no, no one, nobody, no one.[10]

—Rafael Alberti

After even a single reading of this poem, one can recognize the respect that Alberti had for Platko as a foreigner in Spain, calling him a "blazing tiger in the grass of another country" in the seventeenth verse.[11] Alberti expressed his praise for Platko's bravery and level of play through metaphor and hyperbole. These techniques gave Platko superhuman qualities; in the tenth verse, Alberti calls him a "light-beam stopper." In the eleventh stanza, Alberti connects FC Barcelona's heroism in defeating Real Sociedad to the colors of the teams' uniforms—FC Barcelona's heroic blue and claret versus Real Sociedad's celestial white—as being representative of their efforts on that day.

> Heroic blue and claret,
> the air commanded in the veins.
> Wings, celestial white wings, broken wings,
> fought, without quills, whitewashed the grass. (45)

Alberti could not have made the point more clearly or have been more poetically correct than when he repeated that no one will ever forget Platko or his heroic efforts that day by stating that "no one, nobody, no one, no one will forget, Platko." Alberti made this point more than twenty-five times throughout the poem. He was correct in doing so because through this poem, praising him as a hero of Spanish soccer, Platko achieved immortality.

Although FC Barcelona managed to defeat Real Sociedad in the 1928 King's Cup, during these early years of Spanish soccer it was the Basque clubs that most often dominated play, winning more than half of the King's Cups before 1936. The Basque clubs' direct style of play was recognized and admired throughout Spain. They used tall and strong attackers who had a knack for getting their heads on balls that were strategically and repeatedly lofted into "the area," resulting in many of the goals they scored each game. The Basques were big and fast, and they played very aggressively and in turn were extremely successful. This "Basque style" was so successful within the Spanish League that the Spanish National Team adopted this style of play for when they took the field in the 1920 Olympic Games in Antwerp, Belgium. After they won the Silver Medal (which was in no small part due to this style of play), it quickly became recognized throughout the world as the "Spanish style" of play and thus gave rise to the Spanish National Team being labeled "The Spanish Fury" ("*La furia española*"). According to Félix Martialay, the French journalist, Henri Desgrange is most likely responsible for coining the term because it first appeared in an article he wrote for *The Auto* (*L'Auto*) covering the Antwerp games. The title of the article translates as "Denmark was beaten by the Spanish Fury."[12]

This concept of fury is one that has remained with the Spanish National Team to this day and is viewed mainly as a positive attribute. Since some of the words that can be associated with "fury" are "anger," "feroc-

ity," "courage," "rage," "violence," and "recklessness," it is no surprise that this style was first typical of the Basques since throughout history the Basques have been recognized as possessing a tenacious approach to their passions. Even in Miguel de Cervantes's *Don Quijote de la Mancha*, the Basque character named the "Basque Man" or the "Vizcayan" is depicted as a brutal warrior who carries a large sword and constantly insists on fighting. Mark Kurlansky points out at the beginning of his book *The Basque History of the World* that in one section of Cervantes's masterpiece, the Basque Man states (in broken Castilian Spanish), "Me kill you or me no Vizcayan."[13] This negative and brutal aspect of the concept of fury is what caused many Spaniards to desire a more technically advanced style of soccer. The struggle for the Spanish National Team to achieve a "Spanish style" of play was considered one of the key factors (if not *the* key factor) in their lack of success in the majority of their international soccer competitions. This inability to mesh on the soccer field was no doubt a clear reflection of their inability to unify as a nation. Regardless, although some disapprove, the term "fury" had been reinstated and was used by many as a positive moniker for the Spanish National Team. According to Crolley and Hand, "The concept [of fury] is perhaps the nearest the Spanish come to a sense of Spanishness."[14] This statement clearly reinforces the role soccer plays in the formation of a national identity:

> Soccer is a culture because it always responds to a determined way of being. The players act as the public demands, in such a way that soccer ends up reflecting the place from which it sprouted and developed. The Germans play with discipline and effectiveness; any Brazilian team has the creativity and rhythm of their land; when they gambled on order, they failed, because even if the players accept the imposition, they don't feel it. Argentina has an excess of individual exhibitionism and a lack of collective response as much on the field as in life. If these borders begin becoming diffused it is because soccer, aside from reflecting the place in which it is played, does not escape on its own time, and this is the era of standardization. The Spanish National Team does not have their own style, maybe due to the diverse identities that make up their autonomies and that have in soccer their correspondence.[15]

The Spanish National Team later reached the quarterfinal of the 1934 World Cup but aside from these two instances had little success on the international scene. Shortly thereafter, the Spanish Civil War broke out and the Spanish National Team's momentum in the soccer arena was put on hold. Although Spanish soccer historians tend to minimize the soccer efforts and competitions that took place during the Spanish Civil War, the next chapter will provide documentation that even though the country was in a state of turmoil, meaningful soccer matches were still being played, and some of these matches had meaningful political ramifications. The following pages will demonstrate not only the effect that poli-

tics had on soccer during the Spanish Civil War but also the effect that soccer had on politics.

NOTES

1. *Balompié* is a compound Castilian Spanish word that directly translates as "ball-foot."

2. Duncan Shaw, *Fútbol y franquismo (Soccer and Francoism)* (Madrid: Alianza, 1987), 20.

3. The terms "province" and "region" here have been given vague English translations simply because these notions are precisely what is under dispute.

4. Mark Kurlansky, *The Basque History of the World* (New York: Walker, 1999), 170.

5. "A Historic Slogan," http://www.fcbarcelona.com/web/english/club/club_avui/mes_que_un_club/mesqueunclub_historia.html (February 2, 2009).

6. Español has gone through a number of name changes over the years but is officially known today as Reial Club Deportiu Espanyol de Barcelona.

7. Ryszard Kapuscinski, in Winston Manrique, "*El fútbol da cancha al libro*" ("Books Give Court to Soccer"), *El País*, June 4, 2006, http://www.fcbarcelona.com/web/english/club/club_avui/mes_que_un_club/mesqueunclub_historia.html (January 23, 2009).

8. 1n 1928, the use of penalty kicks was not yet installed to determine a winner.

9. "*75 años de la* Oda a Platko, *de* Alberti" ("75 Years of the *Ode to Platko*, by Alberti"), http://www.laredcantabra.com/platko.html (January 5, 2009).

10. Rafael Alberti, *Antología poética (Poetic Anthology)* (Madrid: Espasa Calpe, 1993), 45–47.

11. Alberti was not from Catalonia, but the sentiment he expresses in this stanza obviously coincides with the Catalonian respect for foreigners on Spanish soil.

12. Martialay, in Liz Crolley and David Hand, *Football and European Identity: Historical Narratives through the Press* (New York: Routledge, 2006), 99.

13. Kurlansky, *The Basque History of the World*, 3.

14. Liz Crolley and David Hand, *Football, Europe, and the Press* (Portland, OR: Cass, 2002), 111.

15. Jorge Valdano, *El miedo escénico y otras hierbas (Stage Fright and Other Herbs)* (Buenos Aires: Aguilar, 2002), 276.

THREE

The Struggle to Survive

Spanish Soccer during the Civil War (1936–1939)

During the Civil War, Spain was divided into Republicans and National-ists, and after the Republicans were defeated in 1939, the Nationalist general, *"Generalísimo"* [1] Francisco Franco captured the role of dictator of Spain. The Spanish Civil War was a very deadly conflict, and like most men in Spain the majority of Spanish soccer players took up arms to fight. Some, however, left the country to continue their careers. Nevertheless, due to the extreme violence that took place over the course of the war, many of the players who stayed in Spain to fight were inevitably killed. The famous Spanish soccer historian Julián García Candau recognized this and dedicated the first chapter of his book, *Soccer, without Law*, to the great number of losses that Spanish soccer suffered during the Civil War.

In most books covering the history of Spanish soccer, very little atten-tion is given to soccer during the Spanish Civil War due to the limited amount of competition that took place on Spanish soil. In this time of limited competition, the majority of Spanish soccer matches taking place were regional tournaments, but there were also a few international com-petitions, including two friendly Spain–Portugal matches. Even so, politi-cal divisions within Spain continued to be represented through clubs. While FC Barcelona and Athletic de Bilbao represented the separatist ideals of Catalonia and the Basque Country, Club Atlético Osasuna from Pamplona, Navarre, and RCD Español served as representatives of cen-tralist ideals from within the historic nationalities. Clearly, Real Madrid and Atlético de Madrid served to represent the centralist ideals from within the central state. Of particular interest with regard to the state of Spanish soccer during its Civil War were the groups of players from the Basque Country and Catalonia that formed national teams from their

respective regions (or "nations") that participated in international tours. These tours were designed primarily to gather funds that could be sent back home to support the war effort against General Franco's rising Nationalist side. They also served to raise awareness around the planet of the atrocities taking place in Spain and gain sympathizers and supporters through their antifascist soccer campaigns.

At the outbreak of the Civil War, FC Barcelona's president was Josep Sunyol, who was a strong activist for Catalan tradition and heritage. He came from a long line of Catalan political militants and was a member of Catalan Action (*Acció Catalana*) and Catalonia's Republican Left (*Esquerra Republicana de Catalunya*), both left-wing Catalan groups. He also founded the leftist Catalan newspaper *The Boulevard* (*La Rambla*), which opposed the regime of the previous fascist dictator Primo de Rivera. When Sunyol was elected as FC Barcelona's president, clearly the tie between Catalan leftist ideals and FC Barcelona was brought to the forefront. Approximately one month after the Civil War broke out, Sunyol was arrested by Franco's troops and swiftly executed. The members of Sunyol's soccer squad avoided a similar fate because they had fortunately followed the lead of the recently formed Basque Country's National Team and left Spain to compete internationally.

When the Civil War became a reality, most players from the Basque Country set their soccer careers aside and took up arms in the war effort. Their time on the front, however, was short lived. The ex–Athletic de Bilbao central midfielder turned president of the Basque government, José Antonio Aguirre, felt their talents would better serve the Basque cause through an international tour on the soccer field and made plans to send a soccer team representing the Basque Country to foreign lands, which again demonstrates the link between politics and Spanish soccer. These players formed what many consider to have been a Basque "national" team called Euskadi.[2] Their mission was threefold and served as a model for FC Barcelona to follow: raise funds to be sent back home for the war effort, raise awareness around the world to the atrocities taking place in Spain, and gain sympathizers for the antifascist movement. The members of Euskadi considered this assignment from Aguirre nothing short of a military mission and took it very seriously. They left Spain not to "play" soccer but rather used soccer to fight fascism:

> We converted ourselves into errant travelers—Zubieta would remember years later—and our arms were quality athletics. We were like a company of artists subjected to the highest bidder. No one could complain that they lacked a contract. We were beginning, without knowing it, a new life, without possible knowledge of the outcome and I believe that when we crossed the border and entered into the French territory, there was no discouragement within us, since we were hoping to return soon.[3]

Euskadi played its first match in France on April 26, 1937, against Racing of Paris, which they won 3–0. When they returned to the locker room to celebrate their first victory, they were informed that while they were playing, German planes had bombed the Basque town of Guernica. The bombing of Guernica is now famous for being one of the single most deadly and destructive attacks to take place during the entire Spanish Civil War. Needless to say, all euphoric emotion was stripped from the members of Euskadi, who were quickly and coldly reminded of the importance of their mission.

Euskadi went on to play in Prague, Poland, Russia, and Oslo. In Oslo, the players learned of the fall of the city of Bilbao. Shortly thereafter, they received orders from the Franco regime to return to Spain. Only one player chose to return. The others decided to continue the tour and headed to the Americas, playing in Mexico and Argentina. For two years, the players of Euskadi played on foreign soil, and all profits were sent back to the Basque government. When the war ended, each player was given ten thousand *pesetas*[4] by the Basque government, and shortly thereafter the team dissolved. Although most of the players from Euskadi decided to stay in exile in Mexico and Argentina, where they could peacefully finish their careers as professional soccer players, two Euskadi players returned to Spain.[5]

FC Barcelona's American tour was also a modest success in that it managed to provide the club with sufficient funds to avoid financial ruin. In 1938, the fascists bombed FC Barcelona's social club, causing serious structural damage to the building. A few months after that bombing, the city of Barcelona had been seized and was officially occupied by Franco and the fascist Nationalists. At this point, hope for the Catalan people and inspiration from FC Barcelona (the symbol of Catalonia) was meager and caused the number of *socios* (paying members of the club) to dwindle greatly. As a result of these setbacks and because Franco's mortal hand was unrelenting to anyone opposing his vision, most of the members of the team sought exile in other countries (primarily France and Mexico) where they could also continue playing soccer professionally. The players from both Euskadi and FC Barcelona are considered heroes of Spanish soccer for the hardships they endured during their careers as soccer players during one of Spain's darkest eras. They are also recognized for using soccer not only to raise political awareness but also to participate in fighting a war. The Mexican writer Juan Villoro refers to the heroic efforts of these men in his short story "The Phantom Winger" (*"El extremo fantasma"*) when he calls them "the mythological Basques that were in Mexico and still filled the mouths of the connoisseurs."[6]

Soon after the Civil War, Spain's national team was reestablished in order to counter the propaganda of the Basque and Catalan tours. Their soccer capabilities were limited since many players were no longer available due to deaths and injuries from the war and disgruntled players

who chose exile. Their political success was limited because many coun-
tries refused to even play against fascist Spain. Interestingly, in 1937, the
Spanish National Team had its uniforms changed from red shirts and
blue shorts to blue shirts and white shorts—discarding the red, as it was
seen to sympathize with the Republicans, and adopting blue, as it was
the Nationalists' color. For this reason, many soccer historians symboli-
cally refer to the state of Spanish soccer under Franco after the Civil War
as the "blue period."[7]

NOTES

1. *"Generalísimo"* is a term invented by Franco himself and loosely translates to
"Ultimate-General" or "Extreme-General."

2. *Euskadi* is the Basque word for both the Basque nationality and the Basque
language and was therefore also used to refer to their soccer team.

3. Carlos Fernández-Santander, *El fútbol durante la guerra civil y el franquismo* (*Soccer
during the Civil War and Francoism*) (Madrid: San Martín, 1990), 27.

4. The *peseta* was Spain's monetary unit before the introduction of the euro in 2002.

5. Julian García Candau, *El fútbol, sin ley* (*Soccer, without Law*) (Madrid: Penthalón,
1980), 20.

6. Jorge Valdano, *Cuentos de Fútbol* (*Soccer Stories*) (Madrid: Extra Alfaguara, 1995),
362.

7. Vic Duke and Liz Crolley, *Football, Nationality, and the State* (New York: Long-
man, 1996), 32.

FOUR

The Opiate of the Masses

Spanish Soccer during the Franco Regime (1939–1975)

After the Civil War had come to a conclusion, one of the Franco regime's first orders of business was to bring normalcy back to Spanish society, and they saw the opportunity to do so through soccer. Franco's regime looked to the old Latin phrase *"panem et circenses"* (bread and circus), which was popularized by the Roman poet Décimo Junio Juvenal of the first century. Through this saying, Juvenal conveyed that the best way for a government to control its people was to offer them "bread and circus"—bread (sustenance) to keep their bellies full and circus (some sort of diversion) to keep their attention away from governmental endeavors. In 1812, a Spanish version of the phrase appeared in León de Arroyal's pamphlet titled *Apologetic Prayer in Defense of the Flourishing State of Spain* (*Oración apologética en defensa del estado floreciente de España*), in which the final sentences proclaimed, "Let there be bread and let there be bulls, above all else. Learned Government: bread and bulls is what the people ask for. Bread and bulls is the talk of Spain. Bread and bulls must be provided to the extent the people desire forever and ever. Amen." These final sentences illustrate the importance that the Spanish people placed on bullfighting. The expression "bread and bulls" (*"pan y toros"*) has been widely used in Spain since Arroyal's publication, always depicting the same sentiment. One notable reference to the expression was made by the famous Basque writer and philosopher Miguel de Unamuno, who addressed the state of Spanish society in the late nineteenth century by writing, "Bread and bulls, and tomorrow's another day! Get your fill and enjoy while you can, and later on . . . who cares!" in his article "The Castilian Spirit" (*"El espíritu castellano"*), which was published in an 1895 edition of *The Modern Age* (*La edad moderna*).[1] The Spanish composer

Francisco Asenjo Barieri also wrote a zarzuela titled *Bread and Bulls* (*Pan y toros*) in 1864.

As the Spanish people's attention turned from bullfighting to soccer, the expression changed from "bread and bulls" to "bread and soccer" ("*pan y fútbol*"), indicating that the times had changed and that the "circus" that now captivated the masses was soccer. Bulls and bullfighting have always been a symbol of Spanish culture, but soon after the Spanish Civil War ended, many believed that Spanish society's passion for soccer was turning into an obsession. Some even considered their fanaticism to be an epidemic that they called "Socceritis" ("*fútbolitis*"). Franco's regime and many soccer administrators (placed mainly by the Franco regime) were well aware of this nationwide epidemic and attempted to use it to their advantage. The true sentiments of club presidents supporting the regime can be seen in the following quote of Real Madrid's Santiago de Bernabéu, who stated, "We are offering a service to the nation. What we want is to keep the people happy. I tell you that we are offering a service because the people like soccer a lot, and with soccer the Spanish people's daily problems become more bearable."[2] This quote clarifies the connection that Real Madrid had with the Franco regime as well as their conscious effort to use soccer to help accomplish their goal of offering the people of Spain a way to forget their problems. For this reason, many people in Spain came to refer to soccer as a "social drug" or an "escape valve" or to claim that it parallels Karl Marx's reference to religion, calling it the "the opiate of the masses."

The ploy of using soccer as a means of keeping the masses ignorant to the happenings of the "real world" was even more boldly expressed by Atlético de Madrid's owner Vicente Calderón in an interview that took place in November 1969. When he was asked, "Don't you believe soccer makes the country dumber?" Calderón responded, "I hope soccer makes the country dumber and I hope people think about soccer three days before and three days after each match. This way they will not think about other, more dangerous things."[3] The legendary goalkeeper Ricardo Zamora made it clear in his biography, written by Francisco Gonzalez Ledesma, that this truly was the sentiment among soccer administrators. Zamora also made it clear that the people of Spain were well aware of this fact and that they chose to look to soccer as an escape because the realities of the aftermath of the war were simply too much to withstand. Ledesma wrote that Zamora said,

> When the civil war ended, the panorama of national soccer was as somber as the country's general horizon. . . . The people craved normalcy, to return to the life that the war seemed to have destroyed forever, and above all they wanted to forget. Soccer in this sense had always been a sort of opiate that offered relief during the bad times and helped people forget many situations that in other ways would have seemed unbearable. Aware of this, the directors of the new state dedicated a

good part of their efforts to the reorganization of soccer, and there's no need to doubt that they had success. For almost forty years, the Spanish people—in a general sense of masses—concerned ourselves less with the realities of our country than with where our favorite team would end up in the rankings.[4]

Through these quotes, it is easy to recognize that, because of its popularity, the Spanish authorities were exploiting soccer in an effort to redirect the Spanish people's attention away from the harsh realities of the world. These citations also draw on the fact that the Spanish people were aware of this but still chose to use soccer as an escape, similar to many drug users who are aware of the negative repercussions of the drug but still choose to use it as a temporary escape from reality. Although the Franco regime's promptness in reinstating the Spanish National Team and its role in getting the Spanish League back on its feet may have been considered by some as a legitimate offering of a peaceful and harmless escape to the people of Spain, to others it was viewed as a calculating effort to control and politically demobilize the working class. Julián García Candau clearly saw it this way when he proclaimed, "The previous regime took advantage of the televised soccer matches in order to draw the citizens out of the streets during specific dates such as the 30th of April and the 1st of May."[5]

When General Franco seized control of Spain in 1939, all of the political power within the country was subsequently centralized. Franco therefore came to symbolize all that was Spain's staunch conservatism. Upon winning the Civil War, he immediately began to follow through with the regime's plan to push for Spain to come together as a single solitary nation with one language and one culture. He immediately prohibited any signs of regional autonomy and the use of any language that was not Castilian Spanish. However, Franco was rather lenient in this regard when it came to an individual expressing support of or a connection to his historic nationality if it was through the passion he held for his soccer club:

> [Franco] tried to get rid of all regional rivalries in Spain apart from in the [*soccer*] context. He promoted [*soccer*] as a healthy way for the regions to relieve their tensions. But with Barça the dictator made a mistake. As the Catalans had no political parties, or regional government, or any right to use their own language, they put all their cultural pride into Barça. At a Barça match, the people could shout in Catalan and sing traditional songs at a time when they couldn't do it anywhere else.[6]

Franco did, however, prohibit the use of all historic/regional languages in all institutions and among all individuals in his attempt to unify Spain. He then passed a decree that all soccer clubs within Spain comply with this rule and use Castilian Spanish names. Consequently, Football Club

Barcelona (as it was initially named by its expatriate founders) had to change its name to Club de Fútbol de Barcelona, as it would properly be written in the Castilian language. Likewise, they were forced to change the initials on their crest from F.C.B. to C.F.B. accordingly.

In the end, Franco's efforts to obliterate all regional symbols and languages were in vain because throughout his thirty-six year dictatorship, the members of the historic nationalities secretly maintained their culture and language under his radar. More importantly, much of their success in maintaining their language and culture was due to the fact that they were able to publicly display their unwavering support for region/nation and culture through soccer. Franco was aware of this and looked to Real Madrid (the club that was most preferred by and also served as a symbol of Franco's regime) and other clubs that shared his vision for Spain to dominate the Spanish League and therefore reinforce the notion that the centralist vision was culturally superior. Since Franco made the conscious decision to use Real Madrid as a public symbol of centralist superiority, their success on the field was paramount. This in turn caused rumors to fly that less-than-fair tactics were being practiced in order to ensure their success.

In Duncan Shaw's fundamental study, *Soccer and Francoism*, the author claims that the relationship between football and politics during Franco's reign had primarily three political outlets: (1) as a vehicle to promote fascist attitudes and propaganda, (2) as a tool to better the unsavory image of Franco's regime in foreign lands, and (3) as a catalyst to spark regionalist oppositions fighting against the centralist regime of Franco. Clearly, the regime saw the opportunity to use soccer to reflect their ideals in the public sector. According to Shaw, these three political outlets can be illustrated through three different events that took place during the years of Franco's reign.

The first, he claims, took place on Sunday, June 25, 1939, when Sevilla FC and Rácing Club de Ferrol played in the first Cup of the Generalísimo (*Copa del Generalísimo*) (with the fall of the monarchy, the patronage of the King's Cup was transferred from the king to General Franco). The match took place in Montjuic Stadium in Barcelona less than three months after the conclusion of the Civil War. In this anecdote, Shaw conveys (as many other Spanish soccer historians have) that the two teams lined up before the start of the match and lifted their right arms to a forty-five-degree angle to appropriately make the fascist salute as the *falange's*[7] hymn "Face to the Sun" ("*Cara al Sol*") played over the loudspeaker. Shaw states that the players sang along enthusiastically as the entire crowd that filled the stadium (which Shaw claimed consisted of many military men) got to their feet and followed suit, singing as one.[8] Through the creation of this image, one can clearly see how during the Franco regime, soccer was used as a vehicle to promote fascist propaganda:

[Soccer] had a dimension that was not simply to do with sport. It was the best catalyst for promoting Spanish nationalism. The [soccer] victories against England in 1950 and Russia in 1964 were immensely important historical landmarks for official propaganda.[9]

The second incident, according to Shaw, took place on Wednesday, October 21, 1959, after Real Madrid had beaten Luxembourg's AS la Jeuneusse d'Esch 5–0 at the Estadio Bernabéu. Shaw states that after each home victory, it was customary for Real Madrid's administrators to invite their opponents to a lavish supper. The regime's representative at this event was Secretary Minister of the Movement José Solis, who at the commencement of the meal quickly got to his feet and addressed the players of Real Madrid in front of the administrators and players of the Luxembourg club. Solis's speech was the following:

> You all have done much more than most embassies scattered throughout God's villages. People that hated us now understand us, thanks to you all, because you all broke down many barriers. . . . Your victories constitute legitimate pride in all Spaniards, both in and outside of our country. When you all return to the locker room, after each match, know that all Spaniards are with you and that they accompany you, proud of your triumphs, which have raised the Spanish pavilion to great heights.[10]

This speech clearly demonstrates that Minister Solis seized this opportunity to use soccer to improve the regime's negative image in foreign lands, which was initially what the regime proposed to do through reinstating the Spanish National Team after the Civil War. However, the effort to use the National Team to promote Spain's national image abroad was problematic on some levels because many teams refused to compete against Spain due to its fascist government. For this reason, Franco's regime looked to Real Madrid instead to better Spain's image abroad.

It should be noted that the Spanish National Team was able to find at least a few competitions. But of particular interest in this regard is the way these matches were depicted by the Spanish press. According to Duke and Crolley, during Franco's regime,

> all Spain's victories were presented as a victory for Franco and contributed to his glory. They were attributed to the Spanish national character, to the *furia española* ("Spanish fury"), and invariably achieved for patriotic reasons. They were achieved with the help of the Virgin and numerous Saints.[11]

Carlos Fernandez Santander also noted in his book *Soccer during the Civil War and Francoism* that after Spain defeated Ireland 4–1 in 1949, the Spanish press wrote,

> The match realized by Spain is something all Spaniards can be proud of, because in it not only did the inherent virtues of the race prevail,

such as energy, vehemence and decision, but also united to this was a technical level that highlighted the momentum and the excellent natural class of the Spanish players.[12]

From the opposing perspective, according to Duke and Crolley, during Franco's regime any losses by the Spanish National Team were attributed to poor refereeing decisions or jealousy from outside Spain.[13] This expression through the Spanish media is founded on the notion that since the previously mentioned Disaster of 1898, Spanish society has suffered from a weakened national psyche and inferiority complex. Many call this Spain's sickness of "outrageous victimism" and "pessimistic fatalism." Spanish society's chronic state of "victimism" was probably reinforced more through the National Team's continual underachievements than any other aspect of Spanish society.

The third event Shaw points out took place on Saturday, February 18, 1974, when FC Barcelona embarrassed their mortal rivals, Real Madrid, defeating them 5–0 in Barcelona. Shaw notes that men and women, young and old alike, made their way to the streets to celebrate. Shaw also claims that there were more red and yellow Catalan flags waiving in the streets than blue and claret Barça flags. Shaw said that throughout Barcelona's famous boulevard (*las Ramblas*) and the Plaza of Catalonia (*la plaza de Catalunya*), people continually sang the Catalan hymn "The Reapers" (*"Els segadors"*). Many Barça supporters still celebrate the date, referring to it as "nineteen hundred and five-zero" (*mil novecientos cinco-cero*). This image, offered by Shaw, demonstrates that the sport also served as a catalyst for regional animosities against the centralist regime. Shaw could not have been more correct that these three events graphically illustrate the level that politics played in Spain's professional soccer sector from 1939 to 1975.

Under Franco, basically every aspect of Spanish public life was subjected to a tremendous level of governmental intervention. This was clearly the case with regard to soccer as well, and as soon as Franco had control, he began appointing military figures (that had helped him win the war) to run the country's major institutions. A military man, Colonel Troncoso, was appointed to the position of president of the Royal Spanish Soccer Federation (*Real Federación Española de Fútbol*), and the position of minister for sport was given to General Mascardó. Upon receiving his new appointment, in his inaugural speech Moscardó explained how he considered the position to be a part of his military responsibility, stating, "I am a soldier and I accept the orders that I am given."[14] The most prominent example demonstrating military intervention in soccer was the preferential treatment of Atlético de Madrid.

When the Spanish League resumed play in 1939, Atlético de Madrid merged with Aviación Nacional from Zaragoza. Aviación Nacional had recently been founded by members of the Spanish air force and was

promised a place in the league's First Division. When the Royal Federation of Spanish Soccer later denied them the position in the First Division that they had been promised, it decided that as a compromise Aviación Nacional could combine with Atlético de Madrid (who had lost eight players in the war) and compete in the First Division. The new club was named Atlético Aviación de Madrid, and due to this newly formed club's connection with the military, they were awarded the right of first refusal to any player who had been in the military, free transportation and gasoline, along with other subsidies. The positive results that came from this semi-militarization of the club caused many to consider it an underhanded effort by the central state to offer one of the clubs that paralleled their vision, an enormous advantage. This uneasiness was based on the fact that Aviación Nacional was initially promised a place of their own in the First Division. Many other clubs had also suffered casualties in the war and struggled to field a team, so, of all the clubs in this situation, why was Atlético de Madrid awarded such a great advantage in such desperate times? The answer lies in the fact that soccer authorities were under the control of Troncoso and Moscardó (as well as other military figures). It is no surprise that Atlético Avación de Madrid dominated play and won the first two league championships that took place after the war.

Political divisions and regional animosities that existed during the Franco era were obviously represented and reinforced through soccer. FC Barcelona and Athletic de Bilbao represented the ideas separate from the central state that supported their respective nations/regions—Catalonia and the Basque Country. On the other hand, Osasuna from Navarre and Español of Catalonia were representatives of Franco's Spain from within these historic nationalities. A similar example of the Franco regime expressing favoritism toward clubs that were supportive of the regime is the case of Osasuna, who after the war should have been relegated to the Second Division but instead were given permission to continue to play in the First Division. After the decision was contested, a playoff game was set up to determine who would ascend to the First Division; Osasuna was defeated 3–1 and rightfully relegated to the Second Division after all.[15]

Clearly, the soccer club that optimally represented Franco's Spain was Real Madrid. For political reasons, Spain is divided between allegiance to either Real Madrid or FC Barcelona. While Spaniards are passionate about other clubs, nothing compares to their support for these two teams. This obsessive concern for and popularity of these two clubs gave rise to the expression "Real Madrid and Barça; everything else, just stuffing" (*"Real Madrid y Barça; lo demás, puro relleno"*). The Spanish journalist Alex Botines even used this expression as a title for one of the chapters of his book *The Great Scam of Spanish Soccer*.

The importance that FC Barcelona held for the people of Catalonia began with the club's conception and grew throughout the Franco years.

This sentiment was best captured by Narcís de Carreras in 1968 after being voted in as the club's president. In his acceptance speech, Carreras wisely highlighted the club's social importance in Catalonia and proclaimed that "Barça is something more than a soccer club" ("*Barça es quelque més que un club de fútbol*").[16] In 1973, Agustí Mantal i Costa adopted Carreras's statement to make it the slogan for his FC Barcelona presidential campaign. The slogan has since been changed to "more than a club" ("*més que un club*") and is used to promote the club and reinforce its connection to the people of Catalonia, its international supporters, and its political stance as a staunch supporter of what they consider democratic rights and freedom. As is the case with any symbol or political slogan, the meaning behind "more than a club" is open ended and serves to encompass a multitude of aspects. The slogan is now written within the seats of the FC Barcelona's stadium, Camp Nou.

On November 27, 1974, before the game that marked the end of the club's seventy-fifth anniversary celebrations, 3,600 fans gathered at Camp Nou to offer all those in attendance the club's new anthem, "Anthem of Barça" ("*Cant de Barça*"), which was written entirely by natives of Catalonia who made a point to emphasize Catalonia and FC Barcelona's coinciding social values within its lyrical content. The song's lyrics wholeheartedly reflect the importance that the region and club place on accepting outsiders into Catalan society and nurturing an international culture. The "Anthem of Barça" was quickly embraced by fans, and it has since become a tradition that before every home match, the song is played over the loudspeaker and sung by all Barcelona supporters. The lyrics are as follows:

"El Cant de Barça"	**"The Anthem of Barça"**
Tot el camp	The whole stadium
és un clam	loudly cheers
som la gent blaugrana	we're the blue and claret supporters
Tant se val d'on venim	It matters not from where we hail
si del sud o del nord	whether it's the north or the south
ara estem d'acord, ara estem d'acord,	Now we all agree, we all agree,
una bandera ens agermana.	one flag unites us in brotherhood.
Blaugrana al vent	Blue and claret blowing in the wind
un crit valent	a valiant cry
tenim un nom el sap tothom:	we've got a name everyone knows:
Barça, Barça, Baaarça!	Barça, Barça, Baaarça!

Jugadors, seguidors,	Players, supporters,
tots units fem força.	united we are strong.
Son molt anys plens d'afanys,	Much we've achieved over the years,
son molts gols que hem cridat	many are the goals we've cheered
i s'ha demostrat, s'ha demostrat,	and we've shown, we've shown,
que mai ningu no ens podrà torcer.	that no one can ever break us.
Blaugrana al vent	Blue and claret blowing in the wind
un crit valent	a valiant cry
tenim un nom el sap tothom:	we've got a name everyone knows:
Barça, Barça, Baaarça!	Barça, Barça, Baaarça![17]

As it is expressed within the "Anthem of Barça," an individual does not necessarily need to have been born in Catalonia to form part of the Catalan culture. Rather, a person may come to form part of the Catalan culture if his or her actions and ideals support and coincide with those of the people of Catalonia. The story of the Dutch soccer star Johan Cruyff is a great example of the Catalan people truly accepting a foreigner as one of their own. In 1973, Cruyff left his hometown club of Ajax in Amsterdam and came to play for FC Barcelona. He immediately found himself in good standing with Barça fans when he stated to the press that he chose FC Barcelona over Real Madrid because he could not play for a club that was associated with Franco. Throughout his career, his actions demonstrated his support of Catalan ideals. However, Julián García Candau claims that Cruyff truly won over the hearts of the people of Catalonia when he was unjustly expelled from a match in Camp Nou. García Candau explains that the Barça fans were furious with the referee's decision, and as Cruyff left the field, he took off the captain's armband, which consisted of the yellow and red stripes of the Catalan flag, and kissed it. Cruyff embraced all things Catalan. He learned and spoke the Catalan language and also gave his son a Catalan name, Jordi. After his career as a player for FC Barcelona, Cruyff became the manager of the club. His tenure as manager lasted longer than any other coach of the club. During this time, Cruyff also accumulated more trophies for the club than any other coach, giving him the honor of being considered the most successful manager in FC Barcelona history. After two consecutive years without a trophy and a falling-out with Josep Lluís Núñez, the club's chairman, Cruyff's tenure as manager came to an end. Cruyff vowed he would never coach again, but he played an important role in helping Joan La-

porta become the club's new president. Cruyff continues to serve as an adviser to Laporta even though he does not hold an official position within the ranks of the club. This unwavering support of Barça demonstrates that Cruyff truly held the club and its vision extremely close to his heart.[18]

While FC Barcelona celebrates Johan Cruyff as an example of the club's commitment to accepting foreigners into their culture, Real Madrid has done the same on a variety of occasions. An early example of this would be the case of the Argentinean-born Alfredo di Stéfano. Although di Stéfano arrived at Real Madrid from foreign lands, the club's success under his leadership quickly established him as the embodiment of Real Madrid. He therefore became a symbol of the Franco regime's superiority.

Di Stéfano's arrival to Real Madrid was highly controversial. In 1953, while on loan from Argentina's River Plate to the Colombian club Millonarios, he signed a new contract with FC Barcelona and FIFA. However, FIFA was unaware that River Plate owned his rights through 1954 and that consent from both Millonarios and River Plate was necessary before he could sign with anyone else. The Spanish Federation (made up mainly of Franco's men) did recognize this and refused to acknowledge the trade. Millonarios contacted FIFA and informed them of the problem, but FIFA washed their hands of their mistake and ordered the Spanish Federation to resolve the situation as quickly as possible. During the clubs' discussions with the Spanish Federation concerning how to resolve the issue, Real Madrid's president, Santiago Bernabéu, seized his opportunity and convinced di Stéfano to sign with Real Madrid. While controversy surrounded the issue as to whether Millonarios and River Plate did or did not agree to release di Stéfano, Real Madrid's administrators somehow were able to negotiate his release from the clubs. This infuriated FC Barcelona because they claimed that they had properly negotiated the player's release. They accused the Spanish Federation of not recognizing what was from the beginning a perfectly fair trade. Unable to decide whether FC Barcelona or Real Madrid was in the right, in early September the Spanish Federation announced their resolution to the problem and declared dual proprietorship for the clubs. This resolution had been agreed to and signed by both club presidents—FC Barcelona's Carreto and Real Madrid's Bernabéu. The contract allowed di Stéfano four seasons in Spain in which he would alternate between Real Madrid and FC Barcelona. Carreto's agreement to this deal created such an upheaval among FC Barcelona fans that he resigned the following week. FC Barcelona's interim board of directors, who took over after Carreto submitted his resignation, decided that Real Madrid could have the player indefinitely for the exchange of 4 million pesetas.

The reasons behind exactly why and how FC Barcelona allowed the star to be snatched away by their rivals are still under dispute. While Real

Madrid has always maintained that FC Barcelona voluntarily turned di Stéfano over, others claim that their decision was influenced by pressure from the Franco regime. Still others claim that FC Barcelona lost interest after watching di Stéfano's poor play in friendly matches during the negotiations and decided that they would be better served if they took the money. Regardless, just days after di Stéfano became official Real Madrid property, the two clubs met, and he seemingly used the match to break out of his slump, tallying three goals to secure Real Madrid's victory. Whatever the case, FC Barcelona never forgave Real Madrid or the Spanish Federation for causing them to lose one of the greatest players of all time to their most bitter rivals.

FC Barcelona's failure to lock di Stéfano down is considered by many as the club's greatest failure because not only did di Stéfano's tenure with Real Madrid lead to years of dominance in the Spanish League, but it also won them five consecutive European Championships from 1956 to 1960. Real Madrid became the soccer envy of Europe and the Franco regime's symbol of fascist Spain's superiority. Di Stéfano has often stated that his affiliation with the club had no political basis. All politics aside, the matches that took place between Real Madrid, under di Stéfano, and FC Barcelona, under the Hungarian superstar Ladislao Kubala, produced a more technical brand of soccer. Fans recognized it as a new approach to the sport and quickly embraced this more skilled style of play as "spectacle soccer" ("*fútbol espectáculo*"). With the Spanish National Team's lack of success, many were becoming unconvinced that "fury" was the most positive attribute or successful tactic. Instead, spectacle soccer was deemed the best attribute because it embraced technique and skill over the reliance on fury. The introduction of spectacle soccer added another aspect to the makeup and evolution of Spanish soccer. Each of these attributes—fury, victimism, and spectacle—has played an important role in Spanish soccer's evolution and is a key element in the foundation and evolution of the Spanish National Team and the Spanish style of play. For many years the National Team's lack of success had most commonly been attributed to their inability to have a solidified style of play or a cohesive vision of the game. An example of this was expressed in an article in the Spanish newspaper *ABC* which stated, "Spain must define its identity. . . . It needs to know whether it is the bullfighter or the bull."[19]

During di Stéfano's professional soccer career, he became a naturalized Spanish citizen and played for the Spanish National Team on numerous occasions but he never competed in a World Cup. After his retirement in 1966, he coached a variety of teams and eventually found his way back to Real Madrid from 1982 to 1984. In 1999, di Stéfano was recognized in a poll to determine the "Soccer Player of the Century" conducted by the renowned soccer magazine *France Football*. He was chosen fourth,

behind Péle, Maradona, and Cruyff. Today he serves as Real Madrid's honorary president.

Although Jorge Valdano came to Real Madrid after the years of Franco's dictatorship, he serves as another example of a foreign player who has been embraced as a Spaniard through his affiliation with the central state's most representative club. In describing Valdano, Carmelo Martín claims, "His mother country is soccer, but with his passport in hand he's also Argentine and Spanish."[20] To many, Valdano is to Real Madrid what Johan Cruyff is to FC Barcelona. Valdano played for Real Madrid, and among the many accolades garnered during his tenure are two UEFA Cup championships. Cruyff later became manager of FC Barcelona, and Valdano later became manager of Real Madrid. Cruyff was named European Soccer Player of the Year three times, in 1971, 1973, and 1974. In 1999, he was named European Soccer Player of the Century. Jorge Valdano scored a goal in the 1986 FIFA World Cup Final to give Argentina the edge over Germany 3–2.

The role of soccer in Spain during the years of the Franco regime was unique in that it was heavily influenced by politics, adored by the masses, and infiltrated by foreign superstars. Spanish soccer from 1939 to 1975 was used by the Franco regime in three ways: as a vehicle to promote Spanish nationalism (both within Spain and abroad); as an opiate to soothe the Spanish people's pain from the atrocities caused by the Civil War; and to distract them from concerning themselves with the country's political endeavors. However, since politics and soccer were so closely linked, in many ways soccer during the Franco era raised people's political awareness rather than sedated it, especially in the historic nationalities, because after the Spanish Civil War, soccer was the only outlet permitted to release pent-up political frustrations.

NOTES

1. *"Pan y toros."*

2. Duncan Shaw, *Fútbol y franquismo* (*Soccer and Francoism*) (Madrid: Alianza, 1987), 106.

3. Shaw, *Fútbol y franquismo*, (*Soccer and Francoism*), 106.

4. Shaw, *Fútbol y franquismo* (*Soccer and Francoism*), 107.

5. Shaw, *Fútbol y franquismo* (*Soccer and Francoism*), 96.

6. Vic Duke and Liz Crolley, *Football, Nationality, and the State* (New York: Longman, 1996), 37.

7. The Phalanx (*falange*) was Spain's conservative right-wing party supported by Franco. It is often generalized as being comparable to Italy's Fascist Party.

8. Shaw, *Fútbol y franquismo* (*Soccer and Francoism*), 17–18.

9. J. P. Fusi and R. Carr, in Carlos Fernández-Santander, *El fútbol durante la guerra civil y el franquismo* (*Soccer during the Civil War and Francoism*) (Madrid: San Martín, 1990), 34.

10. Shaw, *Fútbol y franquismo* (*Soccer and Francoism*), 18.

11. Duke and Crolley, *Football, Nationality, and the State*, 34.

12. Fernández-Santander, *El fútbol durante la guerra civil y el franquismo* (*Soccer during the Civil War and Francoism*), 98.

13. Duke and Crolley, *Football, Nationality, and the State*, 34.

14. Fernández-Santander, *El fútbol durante la guerra civil y el franquismo* (*Soccer during the Civil War and Francoism*), 54

15. Duke and Crolley, *Football, Nationality, and the State*, 32.

16. "Narcís de Carreras," http://es.wikipedia.org/wiki/Narc%C3%ADs_de_Carreras (February 12, 2009).

17. "Cant de Barça," ("Anthem of Barça,") http://football-tickets.barcelona.com/the_club/el_cant_del_barca (February 12, 2009).

18. Julian García Candau, *El fútbol, sin ley* (*Soccer, without Law*) (Madrid: Penthalón, 1980), 22.

19. Liz Crolley and David Hand, *ABC,* October 12, 1997, in *Football and European Identity: Historical Narratives through the Press* (New York: Routledge, 2006), 108.

20. Jorge Valdano, *Sueños de fútbol* (*Dreams of Soccer*) (Madrid: Aguilar, 1994), 9.

FIVE

Hoping to Bury the Hatchet

Spanish Soccer during the Transition (1975–2000)

Franco dead, it was advisable to also bury the "Spanish Fury," a sign of archaic identity. The Transition was designing a new model for the country.

—Jorge Valdano

When Francisco Franco died in 1975, his would-be successor, Juan Carlos de Borbón, defied Franco's wishes and turned the political power of Spain over to the people, making it a modern-day democracy. When the 1978 Spanish Constitution was written, the people from the historic nationalities saw the inclusion of a liberating new policy that granted varying degrees of regional autonomy to each of them—each was now considered an autonomous community (*comunidad autónoma*). The second article of the constitution recognized the differences between "regions and nationalities" within Spain and their right to self-governance and proclaimed "indissoluble unity of the Spanish nation." The people from the autonomous communities were not only granted the freedom to openly celebrate their distinct culture, language, and history but also encouraged to do so. Through the Constitution of 1978, the autonomous communities were also granted control over their own health services, the right to have their own television channels, and almost complete control of their educational systems. The Basques were able to reinstate their legal and fiscal system, called the "*fueros*," that had been abolished during the Franco years, and both the Basques and the Catalans were granted the right to have their own police forces.[1]

While some considered the granting of these differing levels of autonomy to the newly recognized autonomous communities very accommodating to the citizens and governments of these regions, others felt that

there should be no ties between the central government of Spain (which resides in Madrid) and their historic nationality. But overall, the longtime frustration of the people from these autonomous communities seemed to have been sedated. For many, all they ever wanted was the recognition that they are from a different culture and the right to openly express their uniqueness.[2] This viewpoint, however, has been disputed for centuries. In the following pages, I will demonstrate how, since Franco's dictatorship, soccer in Spain has been reshaped in ways that reflect the government's transition from dictatorship to democracy as well as a new approach to exploiting the connection between club and the historical-political ideologies.

The liberties granted to Spain's newly recognized autonomous communities resulted in an increase of expression from these cultures. While Franco was in control, any expression of cultural difference was strictly prohibited in all aspects of Spanish life with the exception of soccer. Therefore, with the arrival of the constitution, the soccer arena was no longer the only outlet for expression of cultural differences or political frustrations. With the introduction of infinite avenues through which an individual could express his or her cultural identity and political beliefs, the previously tumultuous use of the soccer arena began to somewhat dissipate. The transition to democracy was taking place in all facets of Spanish society and in all of Spain's institutions, including soccer. One of the first changes to occur regarding soccer administrations was the reinstitution of the democratic structure that had previously existed at the club level before the Civil War, allowing club members (*socios*) to elect the president for their club.

The newly granted freedom of expression to the autonomous communities resulted in these regions developing a stronger sense of identity than they had during the Franco years. Soccer clubs throughout Spain are viewed as representing not only the city from which they hail but also the entire autonomous communities. Many club colors represent regional flags: Real Betis from Seville wears the green and white stripes of Andalusia, Las Palmas wears the yellow and blue of the Canary Islands, and Celta de Vigo wears the sky blue and white of Galicia. This heightened sense of regional solidarity (along with the Spanish National Team's lack of success) caused many to be more concerned with the well-being of their local team and the rivalry between Real Madrid and FC Barcelona than with the National Team. Due to the political differences regarding their identity, many did not consider the National Team to represent their nation. This sentiment is most felt in Catalonia and the Basque Country, where regionalist/nationalist disputes have historically been more controversial and complex. Many consider FC Barcelona to be the Catalan National Team and Athétic de Bilbao to be the National Team of the Basque Country. Although others have claimed this idea with more conviction, in a conference in London in 2005, FC Barcelona's president

Joan Laporta is quoted as saying, "Barça is a bit like the Catalan National Team."[3]

With this increased interest in local clubs, many officials recognized the potential of their soccer club to promote their region. As Franco did with Real Madrid, politicians from the autonomous communities began to use the success of their local clubs as a vehicle to foster their region's sense of identity and pride. For example, in 1994 when Zaragoza won the King's Cup and then in 1995 the Cup Winners' Cup over Arsenal, the Aragon government stressed the connection between club and autonomous community by proclaiming, "A victory for Zaragoza is a victory for Aragon" in their self-promotional campaign.[4] Spain's transition from dictatorship to democracy led to increasing value being placed on regional identity and the autonomous communities, causing less concern for the well-being of Spain as a whole. This sentiment was evident in many areas of Spanish life, including their regard for the Spanish National Team.

Although much of the turmoil throughout Spain had lessened with the formation of the autonomous communities, the situation was by no means resolved. The rivalry between Real Madrid and FC Barcelona was still very heated throughout the transition to democracy. Each club remained aware of the sociopolitical animosities that had been historically represented through their clubs, but Spain's transition to democracy caused these hostilities to become more tamed. FC Barcelona is still considered one of Catalonia's most important and representative institutions, and Real Madrid is considered to represent centralist Spain's repressive nature—although to a lesser degree than during the Franco years. Many Spaniards support FC Barcelona simply because they view it as the opposition to Madrid and all that Madrid represents. Other Spaniards support Real Madrid because they agree with central Spain's vision of a unified nation and detest FC Barcelona for their separatist ideals, which can be seen in the following popular chant:

Somos españolistas	We are Spain-ists
de la corona,	of the Crown,
de la corona,	of the Crown,
somos especialistas	we are specialists
en dar palizas	at giving wallops
al Barcelona[5]	to Barcelona

Clearly, throughout the transition to democracy, the underlying ideals of the various clubs were still prevalent. After Franco's death in 1975, FC Barcelona immediately changed its name from Club de Fútbol de Barcelona (as was demanded by the Franco regime) back to F.C.B.—Fútbol Club Barcelona. The Catalan soccer institution holds its slogan "more

than a club" very close to its heart and it is still representative of the beliefs of the people of Catalonia. FC Barcelona's official website describes the connection between the club's slogan, outlook, and supporters as the following:

> The slogan "more than a club" is open-ended in meaning. It is perhaps this flexibility that makes it so appropriate for defining the complexities of FC Barcelona's identity, a club that competes in a sporting sense on the field of play, but that also beats, every day, to the rhythm of its people's concerns. FC Barcelona is "more than a club" in Catalonia because it is the sports club that most represents the country and is also one of its greatest ambassadors. Also, for different reasons, FC Barcelona is "more than a club" for many people living elsewhere in Spain, who see Barça as a staunch defender of democratic rights and freedom.[6]

The Catalan vision of embracing an international culture also remained intact through the transition to democracy. With Johan Cruyff as FC Barcelona's manager, he assembled what became known as the "Dream Team," named after the U.S. men's basketball team that won the 1992 Summer Olympics in Barcelona. Cruyff's Dream Team consisted of Catalonia's own Josep Guardiola and Basque players José Mari Bakero, Txiki Begiristain, and Ion Andoni Goikoetxea. FC Barcelona also obtained international superstars, such as Romania's Gheorghe Hagi, Bulgaria's Hristo Stoichkov, Holland's Ronald Koeman, Denmark's Michael Laudrup, and Brazil's Romario. With these international superstars, Barça was spending enormous amounts of money importing players not only to ensure success on the soccer field but also to promote the club as an international ambassador. Many of these players quickly adapted to Catalan society, formed part of the Catalan vision and culture, and are now regarded as legends of Catalan society. The approach of recruiting international players to seize a portion of the global market was not possible to Athlétic de Bilbao since it was written in the club's statues that they accept only players of Basque heritage.

The influx of blue-chip foreign players to the Spanish League in the 1990s resulted in many people referring to the Spanish First Division as the "League of the Stars" (*la liga de las estrellas*). Liz Crolley claims that it was in the 1980s that soccer clubs in Spain began marketing themselves as a commodity. Before satellite television, few Spanish clubs were profitable. Their social position was that of a local institution, and they did not necessarily focus on the bottom line or profit margins. In the 1980s, FC Barcelona took its slogan "more than a club" and began using it as a tool to effectively catapult the club into the international market. In doing so, people around the world have become more aware of FC Barcelona and Catalonia's mission. Real Madrid, FC Barcelona, and Athlétic de Bilbao are the Spanish clubs that have had the most success in marketing them-

selves within Spain and are also the clubs that most strongly represent Spain's various historical and political viewpoints. Many who support centralist ideals support Real Madrid, and those who do not will often support FC Barcelona or Athétic de Bilbao simply because they represent "anti-Madridism." In this sense, these clubs have exploited their connections to the historical and political struggles of "centralism" versus "decentralization" in their marketing campaigns and are essentially reinforcing the issue and perpetuating one of Spain's most problematic struggles.

While FC Barcelona held strong to its initial doctrine during Spain's transition to democracy, other clubs made a variety of modifications in an attempt to shape their image to more politically suit the times. RCD Español took steps to alter its image from one that supported centralist Spain and opposed all that is Catalan to one that is more regional. They attempted to change their name to Real Club Deportivo de Cataluña and began focusing their recruiting efforts on players from within Catalonia, hoping to gain more Catalan sympathy and support. The large number of Español supporters who disapproved of these changes, however, left the club no option but to abandon these efforts. During Franco's dictatorship, supporters of the regime who were assigned to work in Catalonia adopted Español as their local club (since they had been distanced from their primary club—Real Madrid), and they did not approve of this "new image" the club was trying to establish. For this reason, many consider Español to be an extension of Real Madrid since both clubs represent the same ideals.

During the transition, Español's fan base became divided between sympathizers of the more politically correct ideologies tolerant of the Catalan vision and supporters of ultra-right-wing ideologies who held strong to Franco's fascist doctrine. These champions of fascism, having become a minority after Franco's death, needed to unite with others who shared their vision. Like so many others, they used the soccer arena as a vehicle to express their political ideologies to the masses. Español's ultra-right-wing group calls itself the "Blue and White Brigade" ("*Brigadas Balnquiazules*") and continues to express its desire for a unified Spain.[7]

After Franco's death, Spain saw the rise of a great number of extreme right-wing political groups. They used soccer as a platform, or outlet, to express their extreme nationalism, racism, or xenophobia. Neofascist groups using the soccer arena to express pre–World War II ideologies exist throughout Europe, especially where fascism once reigned, and are therefore not unique to Spain. In Spain, there is evidence of neofascist groups and extreme separatist groups called skinheads (*cabezas rapadas*), such as the "Blue and White Brigade" from RCD Español. Some other examples of these groups are the "Mob Boys" ("*Boixos Nois*") of Barcelona, the "Ultrasouth" ("*Ultrasur*") of *Real Madrid*, the "Athletic Front" ("*Frente Atlético*") of Atlético de Madrid, the "Mujika Gang" ("*Peña Mujika*") of Real Sociedad, and "North Town" ("*Herri Norte*") of Athletic de

Bilbao. A number of extremist groups have also risen in autonomous communities less commonly associated with turmoil than those of Catalonia, the Basque Country, and Madrid. There are now groups such as "Celtland" ("*Celterra*") of Celta de Vigo and the "Blue Razors" ("*Raizor Blues*") of Deportivo de la Coruña, both from Galicia, and the "Ultra Boys" ("*Ultra Boix*") of Sporting de Gijón from Asturias. Supporters of the Basque Country's most recognized and violent separatist (or terrorist) group, Basque Homeland and Freedom (*Euskadi Ta Askatasuna*), commonly known as ETA, have also used the soccer arena as a public stage to mount protests. Although soccer's return to democracy produced a number of positive changes, it has created a variety of complex issues. Since paying club members have once again been granted the right to vote for their club's president and administrators, the undeniable presence of these ultra-right-wing groups has played an important role in many of these clubs' elections.

With the transition from dictatorship to democracy, the need to express nationalist viewpoints through soccer decreased. The constitution afforded alternative avenues for people to express their sentiments besides simply through soccer—as was the case under Franco. Although many of the ideologies still remain, a number of clubs took steps to modify their approach during the transition. For example, the Basque clubs Athletic de Bilbao and Real Sociedad kept their Basque-only policies but began to rethink their definitions of "Basqueness." They opened their doors to players with looser ties to Basque heritage than had previously been the policy and began accepting players of Basque heritage who were born outside of the Basque Country as well as players from the French Basque region.[8] When Luis Fernandez was appointed as Athlétic de Bilbao's head coach, the definition of Basque heritage became even more flexible. Under Fernandez, anyone who had either Basque ancestry or spent time in the Basque Country's youth development system (known as the "*cantera*") could play for the club. This approach proved a bit more successful, and even though Athétic de Bilbao was still in the shadow of Real Madrid and FC Barcelona, under Fernandez Athétic de Bilbao saw its most successful era. In 1998, the club achieved second place in the Spanish League and qualified for the UEFA Champions League. Regardless of Athétic de Bilbao's success, many of the club's supporters feel that its identity is more important than its success on the field.

While Spanish soccer at the club level went through a transition from dictatorship to democracy, the Spanish National Team also went through a transition of its own. People saw the need for the National Team to reassess its approach to international competition, and many felt the first step was to do away with the notion of "Spanish Fury." These people considered "fury" a characteristic representative of the Franco era and a trait of those with less ability, lacking in skill and talent, who needed to rely on rage and brute force to compete. Many felt that the emphasis

placed on fury during the Franco era bred a less than sophisticated brand of soccer:

> In Spain regional identities exist, but a national soccer personality doesn't; this is why it is easier to feel better represented by a club than by the Spanish National Team. "Fury" is a state of anger and rage that can give a momentary satisfaction but it never favors the expression of soccer values. Fury is blind and it often serves to hoodwink a stadium, it is fleeting and can feign potency, it's not patrimony to anyone and it can, for example, be Czechoslovakian and be used, even, against Spain . . . successfully. [9]

It was, however, during the Franco years that the Spanish League saw the arrival of a number of international soccer stars, such as the Hungarian Ladislao Kubala to FC Barcelona and Alfredo di Stéfano to Real Madrid. These international soccer stars played an important role in changing the face of Spanish soccer, and their contribution laid the foundation for what would become Spain's alternative to fury: "spectacle soccer." The attraction to spectacle soccer was the opportunity to witness a more beautiful, skillful, technical, and artistic form of the sport. Spectacle soccer embraced the qualities of a bullfighter: poise, patience, swagger, and talent. Spain, as the cradle of spectacle soccer, enjoyed an influx of international superstars signing lucrative contracts to play in the Spanish League, which soon found itself as one of the most powerful professional soccer leagues in the world. In 1990, when Spain established various private television channels, namely, *Antena 3*, *Telecinco*, and *Canal+*, Spanish soccer clubs were able to amass much larger revenues due to the deals they made with these channels to more extensively broadcast the games. This new avenue for income provided many clubs in Spain's premiere division the ability to sign even more of the world's greatest players than before, and the Spanish League soon became known as the "League of the Stars." Some of the best players to arrive in Spain during the 1990s were Bulgaria's Hristo Stoitchkov and Brazil's Rivaldo and Ronaldo at FC Barcelona, Argentina's Diego Maradona at Sevilla FC, Denmark's Michael Laudrup at both FC Barcelona and Real Madrid, Brazil's Roberto Carlos and Sávio Bortolini at Real Madrid, Argentina's Fernando Redondo at CD Tenerife and then Real Madrid, Chile's Ivan Zamorano at Sevilla FC and then Real Madrid, Brazil's Romario at FC Barcelona and Valencia CF, Colombia's René Higuita at Real Valladolid, Holland's Patrick Kluivert at FC Barcelona, Brazil's Djalminha at Deportivo La Coruña, the Cameroon-born Samuel Eto'o at Real Madrid, England's Steve McManaman at Real Madrid, Holland's Phillip Cocu and Frank de Boer at FC Barcelona, and Brazil's Darío Silva at RCD Espanyol, among many others, thus making the Spanish League a social and marketing phenomenon as it headed toward the twenty-first century.

Another interesting aspect of Spain's modernizing social efforts occurring during the transition to democracy that was demonstrated through soccer was the introduction and acceptance of the involvement of women in the game. Prior to the mid-late 1970s, soccer was an area of Spanish society designated for men. Traditionally, soccer in Spain was an activity that embraced "unfeminine" characteristics, such as competitiveness, aggressiveness, and fury. As the face of the sport in Spain began to transform and change to a more democratic institution, it embraced the aspect of "spectacle," which caused female interest in the sport to grow. Women began participating in soccer not only as spectators but also as players. Spain's first women's league was formed in 1980 and has since grown into a multilevel system with the Spanish Superleague (*La Superliga Española*) founded in 1988 by the Royal Federation of Spanish Soccer at the top. Spain also saw the formation of their Women's National Team in 1983. Clearly, the acceptance of women in the soccer arena in Spain is indicative of the changing gender roles that have occurred throughout Spanish society since Franco's death and is also evidence of Spain's modernizing efforts.

While soccer at the club level (both masculine and feminine) was experiencing the effects of democratizing and modernizing and the Spanish League was flourishing, the Spanish National Team was struggling. Eventually, the National Team began to adopt spectacle soccer as a style of play. In González Ramallal's article "The Configuration of Spanish Soccer as a Spectacle Sport" (*"La configuración del fútbol español como deporte espectáculo"*), he claims that spectacle soccer came to flourish in Spain in the 1980s and 1990s and that the National Team's efforts to transform their game to a more modern, progressive style was first noticeable during the 1982 World Cup, which coincidentally was hosted by Spain:

> That which we can call the "spectaclization" of Spanish Soccer, in a modern sense, is directly configured within the process of political transition with the 1982 World Cup that was celebrated in Spain serving as its initial reference. In that moment the traditional structural properties of our soccer [i.e., fury] began to coexist with other forms of more modern character, and gradually, were substituted by them.[10]

Although Ramallal indicated that the National Team substituted fury for spectacle, many considered the National Team to have added spectacle as a new dimension to their style that still included fury. The National Team is most commonly characterized as possessing and embracing both styles—as positive traits. However, too much spectacle is often ineffective, and fury used the wrong way is a disadvantage. This is a complex style of soccer because it is difficult to be graceful and artistic while at the same time infuriated and tumultuous. However, when the chemistry of

these two elements properly combines, it is a nearly lethal combination for the opponent to withstand.

A great example of a Spanish team that successfully incorporated fury with spectacle is Real Madrid in the 1980s. During this era, one of Real Madrid's youth players, Emilio Butragueño—"The Vulture" ("*El Buitre*")—used both his skill and his tenacity to come up through the club's ranks and eventually play for Real Madrid's first team. Along with Butragueño, four of his youth-level teammates arrived on Real Madrid's main stage: Manolo Sanchís, Martín Vázquez, Míchel and Miguel Pardeza. Real Madrid's coach at the time, ex-Real Madrid superstar Alfredo di Stéfano, brought these youngsters in from the very beginning, and the chemistry felt between the five soon became recognized as "The Vulture's Five" ("*La Quinta del Buitre*") and the engine behind Real Madrid's first team. Under the Vulture's Five, Real Madrid took Spain and Europe by storm, winning the Spanish League five consecutive times and two UEFA Cups. Unfortunately, the Vulture's Five will always remain in the shadow of Real Madrid's greatest success stories since they were unable to win a single UEFA Champions League title. The club had won five consecutive UEFA Champions League titles between 1956 and 1960 with di Stéfano at the helm as a player.

Although from the transition until the turn of the twenty-first century there have been conscious efforts by the Spanish National Team to incorporate the successful attributes of teams from the Spanish League, the Spanish people still demonstrated a certain level of indifference toward the National Team. This is a complex issue. Some feel that their local clubs serve as better representatives of their notion of nationhood than the National Team. Others feel that soccer at the club level is of a higher caliber than that of national teams since national teams are forced to select players from within specific geographical and political boundaries. Another important factor in the Spanish people's lack of interest in the National Team was due to what the Spanish people considered their continual lack of success in international competitions. Since the Spanish Fury's second-place finish in the 1920 Olympics (their first international competition), the National Team had been largely considered an underachiever until recently. The National Team's lack of achievement and the Spanish League's overwhelming success left many supporters of the National Team frustrated and perplexed. However, the definitions of success and failure are a matter of opinion. For example, through the year 2000, the National Team had qualified for nine of the sixteen World Cup Final Tournaments and six of the eight European Championships—both impressive feats considering the strength of European soccer. Their consistency in qualifying for these tournaments shows a very strong soccer foundation, but with the Spanish League being recognized as a world powerhouse, the Spanish people expect the National Team to bring home awards from these competitions on a regular basis, which had not been

the case until after the turn of the twenty-first century. Up until Spain's recent success, their highest achievement in World Cup play was fourth place in 1950, and aside from this, they had reached the quarterfinals only twice: in 1986 and 1994. Spain did, however, win the European Championship in 1964, and in 1984 they reached the final match again but were defeated by France. Since Spain has the reputation of being a soccer hotbed with a world-renowned professional league, the National Team's inability to consistently achieve positive results in international competitions led many to consider Spain as a long-time underachiever. This sentiment resulted in the National Team being overshadowed by the success of Spain's international club teams.

The conscious effort by both the Spanish National Team and the Spanish League to add the dimension of spectacle to the Spanish style of play demonstrates a desire to draw fans and make the soccer experience an entertaining event for spectators. This also has ties to the notion of "bread and circus" and could be considered a reflection of certain archetypical aspects of Spanish culture, such as the arts of flamenco dancing and bullfighting. This concern with the crowds' enjoyment might represent, to an extent, a lack of concern with the final result. Jorge Valdano, who played at Real Madrid with the Vulture's Five and whom many refer to as the "Soccer Philosopher" for the philosophical approach through which he analyzes the sport, addresses this ongoing dispute in his book, *Notes of the Ball*, by writing,

> Do I prefer to play well or win? Well, one cannot choose between things of different natures. Dear reader, if we multiply five apples and three bears, the result is nothing. Understand? I want it all: the apples and the bears.[11]

Many soccer enthusiasts have tried to find the answer to why the Spanish National Team seemed to have been plagued by a "lack of success" for such a long time in the European Championship and the World Cup. Many consider the country's lack of solidarity to have been directly related to the team's lack of unity, chemistry, and identity. Others believe that players on the National Team were more concerned with the success of their club than they were with the success of the National Team. Some claim that the National Team was jinxed, along with Spain, since the Disaster of 1898 and the collapse of the Spanish Empire. Whether any of these issues played a role in their lack of success, one thing is certain: as Ariel Burano (the professional soccer–playing protagonist in David Trueba's 2008 novel *Knowing How to Lose*) points out, "When you lose, excuses are plentiful."[12] On the other hand, winning resolves a lot of problems. In Spain, however, a country very concerned with soccer and very critical of failure, it would be nearly impossible to please the masses. Soccer at the international level is extremely competitive, and consistent championships are unlikely. The "magic" of soccer lies in the fact that there is no

scientific equation to guarantee success. In Trueba's *Knowing How to Lose*, Ariel's mentor, Dragón, reminds him of this by saying, "Soccer is for the humble, because it is the only office in which you can do everything poorly in a match and win and you can do everything well and lose." [13] Intangibles such as these are what make both soccer and life beautiful and interesting. Some claim they would rather be lucky than good. Others believe an individual creates his or her own luck. Whatever the case, luck plays a factor in both life and soccer. If during the transition Spain had been "lucky" and won the World Cup, would the skepticism and Spain's polemic theories of identity within the National Team (and the country) still exist? Would Spain's chronic "fatalism" have ended there? Would the nation have begun to come together as one? Would it have led to even more success in international competitions and molded Spain into a soccer powerhouse and further develop the country's solidarity? [14] Jorge Valdano addresses the question of the sport's complexities in *Notes of the Ball* by stating,

> You all might say that in today's game patience is impossible. Lie. Now, as before, soccer only overcomes time from organization and style. One has to win, clearly: what a novel idea! The error is that in the desperate search for victory we often distance ourselves from the simple things and we go about leaving shreds of credibility. The soccer gods, all the while, die from laughter because they know there is nothing simpler than this game. [15]

A simple twist of fate was all Spain needed to change all the elements considered to be her longtime Achilles' heel and are now deemed as the keys to her success. Focusing on the negative (in anything) brings negative attitudes, outlooks, and results. In *Knowing How to Lose*, Ariel's mentor, Dragón, reminds Ariel of this by referring to an old Chinese proverb that says, "When things go poorly, your cane will convert into a snake and bite you." [16] Spain's biggest problem lies in the fact that many Spaniards consider anything short of a championship to be a failure. Soccer (like life) is a funny game; those most deserving do not always prevail. There are an infinite number of factors that play a very important role in the outcome of any given match that are completely out of the control of the players and coaches (even when the contest is played fairly and not plagued with corruption). If these outside factors did not exist, there would be little need to play the game because the outcome would be more predictable. The only way for Spain to eliminate this "curse" was for the Spanish National Team to achieve an acceptable result (first place) in either the FIFA World Cup or the European Cup Championship so that they could then begin building a reputation as winners rather than being seen as underachievers. With this in mind, we are left to ask a variety of questions concerning the state of the National Team: Did the World Cup and European Cup Championships provide some closure to

Spain's inferiority complex? Has Spain's recent success on the soccer field helped Spain to see itself more as a single unified nation, or are her internal disputes too deeply rooted? Whatever the future holds for Spain, it is clear that a country's achievements — or lack thereof — in international soccer competitions play an enormous role in its collective self-perception. This social phenomenon is clearly evident through the case of Spain.

NOTES

1. Vic Duke and Liz Crolley, *Football, Nationality, and the State* (New York: Longman, 1996), 40.

2. One major difference between the Basque and the Catalan struggle is that the Basques claim an ethnic and cultural difference, while the Catalans simply claim a cultural difference.

3. Joan Laporta, in Duke and Crolley, *Football, Nationality, and the State*, 125.

4. Duke and Crolley, *Football, Nationality, and the State*, 41.

5. Julian Garcia Candau, *Épica y lírica del fútbol* (*Epic and Lyric of Soccer*) (Madrid: Alianza Editorial, 1996), 218.

6. "History of the FC Barcelona," http://fc.barcelona.com/the_club/history (January 4, 2009).

7. Duke and Crolley, *Football, Nationality, and the State*, 45.

8. Duke and Crolley, *Football, Nationality, and the State*, 46.

9. Jorge Valdano, *El miedo escénico y otras hierbas* (*Stage Fright and Other Herbs*) (Buenos Aires: Aguilar, 2002), 207.

10. Manual E. González Ramallal, "*La configuración del fútbol español como deporte espectáculo*" ("The Configuration of Spanish Soccer as a Spectacle Sport"), 2008, www.efdeportes.com/efd66/espect.htm (February 17, 2009).

11. Jorge Valdano, *Apuntes del balón* (*Notes of the Ball*) (Madrid: La Esfera de los libros, 2001), 15.

12. David Trueba, *Saber perder* (*Knowing How to Lose*) (Barcelona: Editorial Anagrama, 2008), 112.

13. Trueba, *Saber perder* (*Knowing How to Lose*), 71.

14. I often wonder to what extent the world of soccer (and the world itself) would be different if the referee in the 1986 World Cup Quarterfinal had witnessed Diego Maradona's intentional handball against England. Many argue that an intentional handball to score a goal should warrant a red card. Had that been the case, he would have been forced to leave the match. He would have therefore not scored the famous "goal of the century" later in the match, and furthermore Argentina would have possibly not won the World Cup. He would have become regarded not as the "living god" as he is today but rather as an underhanded cheater, a waste of talent, and a failure that is to blame for ruining Argentina's chances at the World Cup. England, on the other hand, might have advanced and turned out to be the champions. The change of events would have been enormous. The reality of the situation is that Maradona was in the wrong. It was illegal — and intentional — and in committing the offense, he disregarded the primary rule of soccer. Maradona's teammate Jorge Valdano has said that those who cheat do so because they are not good enough to win by competing within the rules of the game. If Maradona had been caught and punished, he might be somewhere now speculating how his life might have turned out if he hadn't been caught. Like many others, he might speculate that he could have even scored the goal of the century later that very game, become a World Cup Champion, and subsequently been transformed into a living god. But to his credit, as the saying goes, "If my aunt had balls, she'd be my uncle." But in the end, this is one of life's (and soccer's) most interesting phenomena — the defining moments that sneak up on us, through which

our dreams can be either realized or lost. These moments can catapult us into great-
ness or lead us to our demise. We can recognize the consequences (or the multitude of
possible consequences) of the opposite outcome, but we can never return to relive that
defining moment. The famous Latin musician Manú Chao has a song about Maradona
that expresses this idea titled, "Life Is a Lottery Wheel" (*"La vida tómbola"*). The case of
Maradona is unique in that it was the referee's negligence that decided his fate. Al-
though I feel character will override and outlast anything gained or lost from these
defining moments, these defining moments can either make or break our character if
we allow them to. Maradona's character was on display when he resorted to cheating
to win, and it has revealed itself in many other ways since. These phenomena are not
unique to Maradona, but they exist in all aspects of life. The Spanish National Team
had been waiting for years for the "ball to bounce their way" during these defining
moments, and up until that recently happened, their character was left in limbo for
people to question. As soon as things began to go their way, Spain was quickly consid-
ered one of the all-time genius nations of the sport.

15. Valdano, *Apuntes del balón* (*Notes of the Ball*), 16.
16. Trueba, *Saber perder* (*Knowing How to Lose*), 123.

SIX

A New Day Dawns

Spanish Soccer Moves into the Twenty-First Century

The arrival of the twenty-first century marked the modern world's entrance into the "Age of Communication," which produced a number of changes to the face of Spanish soccer. Affiliates of the Spanish League saw the opportunity to use the sport's ever-growing international popularity to launch the "League of the Stars" into the world market. This was made possible by relying on the Spanish League's reputation for producing "spectacle soccer," securing even more of the world's most famous players and marketing the heated club rivalries within Spain to the international audience. Today, the Spanish League is one of the most lucrative and prestigious professional soccer leagues in the world. This prestige and marketability attracts many of the world's greatest players. The Spanish League's craving for superstars is almost as pressing as many of the superstars' craving to play in the Spanish League—it seems that for a player to be considered one of the world's greatest, he needs to have spent time in the League of the Stars. Much of the league's marketability and international appeal relies on its success in obtaining these international superstars. Their ability to "sell" in the international market not only attracts viewers and fans to the Spanish League but also raises a worldwide awareness of Spain and its historical and present-day social and political issues. The connection between certain soccer clubs throughout Spain and their historical and political affiliations, whether real or symbolic, still exist today. These historic political/soccer rivalries now play a very important role in many of these clubs' marketing campaigns both throughout Spain and internationally.

After being selected by FIFA as the "Most Successful Club of the 20th Century," Real Madrid continued to prove itself in the twenty-first centu-

ry as an international juggernaut both on the field and in the market-place. The new century saw Real Madrid win the Spanish League in 2001, 2003, 2007, and 2008 as well as the UEFA Champion's League in both 2000 and 2002. In 2000, under the presidency of Florentino Pérez, Real Madrid made efforts to become the world's richest professional soccer club and began by selling part of its training ground (to eliminate the club's debt) and pave the way for what came to be known as the "Galactic Era of Real Madrid" (*"Era Galáctica del Real Madrid"*). In this era, Pérez managed to sign a new international superstar to the club for four consecutive years. He began by obtaining Portugal's Luis Figo in 2000, then France's Zenadine Zidane in 2001, Brazil's Ronaldo in 2002, and England's David Beckham in 2003. When these newcomers combined with the club's veteran "galactics," Raúl and Casillas, both from Spain, and Brazil's Roberto Carlos, Real Madrid became an international marketing phenomenon. The club went on to sign England's Michael Owen in 2004 and Holland's Ruud van Nistelrooy in 2006. Not only did the approach of recruiting international superstars lead Real Madrid to greatness on the field, but the worldwide popularity of these superstars helped the club grab an enormous portion of the international soccer market as well. The downfall of the Galactic Era was that while the conglomerate of international superstars ruled the soccer market, the team's chemistry suffered, and the galactics lost a number of matches that, on paper, were "sure things." The difficulty to gel as a team could have been due to the variety of different cultural backgrounds represented on the field at any given time, ego problems, differences in style of play, or simply bad luck. Whatever the case, the final result was often not equivalent to the value of all of the team's parts.

In 2005, Real Madrid followed in the footsteps of its archrival, FC Barcelona, to further its international marketing campaign and launched its own television channel. *Real Madrid TV* now broadcasts twenty-four hours a day and is accessible through both satellite and digital media. The station provides its subscribers with coverage of Real Madrid's soccer matches, news reports, interviews, game summaries, analysis, and debates. *Real Madrid TV* serves to market the club in Spain and internationally as a household name brand.

The first Spanish television channel that was owned by and dedicated to the endeavors of a soccer club was FC Barcelona's *Barça* Channel (*Canal Barça*). The groundbreaking soccer channel was launched in 1999, and FC Barcelona again put the Catalan progressive and modernist vision on display for the rest of Spain and the world to follow. The channel, now called *Barça TV*, airs twelve hours a day, is broadcast through Terrestrial Digital Channel (*Televisión Digital Terrestre*) in Catalonia, and can be subscribed to through satellite transmission or accessed online for those not living in Catalonia. *Barça TV* airs in the Catalan language, but subscribers of the channel have the option to select a simulcast translation in Castil-

ian Spanish. *Barça TV Online* was launched in 2007 and is offered in Catalan, Castilian Spanish, and English.

In 2006, FC Barcelona took its motto of being "more than a club" beyond the region/nation of Catalonia and Spain to the global market. Realizing that soccer is a global phenomenon, Barça has recognized its opportunity to seize an international fan base, which it has achieved, and now markets itself as "more than a club around the world." In 2006, Barça demonstrated itself as a philanthropic institution and pledged to contribute 0.7 percent of its income to the FC Barcelona Foundation. The foundation set up international cooperation programs for development and support of the UN Millennium Development Goals and donated 1,500,000 euros over five years to UNICEF's humanitarian aid programs. Until joining with UNICEF, Barça had been one of the few European soccer clubs that continually refused to wear a sponsorship logo on the front of their jerseys. Sponsors offer clubs the size of FC Barcelona multi-million-dollar/-euro contracts to wear their logo in this space, but the Barça administration always felt that this sort of business deal did not fit the institution's ideals. In 2006, for the first time in club history, Barça agreed to put a label in this space of their jersey, but instead of receiving money, Barça donated to the foundation's humanitarian aid program. This was a strategic decision that fit the parameters of the club's historical and modern vision. It is an effort to give back to the club's fans, promote a good cause, and raise awareness while gaining support around the globe for taking a humanitarian approach to their "sponsorship." FC Barcelona's alliance with UNICEF demonstrates the club as an international business that recognizes its potential of globalizing as an institution that is supported worldwide.

However, the turn of the century saw FC Barcelona suffer a number of setbacks when compared with the club's success of the late 1990s. In the 1996–1997 season, FC Barcelona won the King's Cup, the Supercup of Spain (*Supercopa de España*), and the UEFA Cup Winners Cup under the direction of the newly appointed manager Bobby Robson. He was appointed after Johan Cruyff had been ousted for failing to accumulate any trophies for two seasons and losing 4–0 to AC Milan in the UEFA Champion's League final. Despite Robson's success, he was always considered a short-term solution to the problem. After one year, Barça replaced Robson with the Dutchman Luis van Gaal, who had been extremely successful as the manager of Holland's Ajax. With van Gaal, a new group of heroes emerged for the club: Portugal's Luis Figo, Spain's Luis Enrique, Holland's Patrick Kluivert, and Brazil's Rivaldo. This unit won both the Spanish League and the King's Cup. In 1999, the club celebrated its one-hundredth year of existence by winning their sixteenth league championship and seeing their striker Rivaldo become the club's fourth player to be crowned European Footballer (Soccer Player) of the Year. Despite Barça's success within Spain, they were unable to match the international

success of Real Madrid. FC Barcelona's inability to win the UEFA Champion's League led both van Gaal and Barça's president, Josep Luís Núñez, to resign in 2000. But when Barça's Portuguese vice captain Luis Figo (who had come to be considered by many Catalans as one of their own) left the club and joined their archrivals, Real Madrid, it was as if he had personally poured salt in the wounds of millions of Barça fans. It is no surprise that Figo was greeted with extra hostility at his subsequent visits to compete at Camp Nou as a member of Real Madrid. While Real Madrid began forming its Galactic Era from 2000 to 2004, FC Barcelona suffered and went through a period of decline.

In 2003, FC Barcelona started its comeback by naming the young and vibrant Joan Laporta as the club's new president and ex-Dutch international and AC Milan superstar Frank Rijkaard as the club's new manager. With Laporta and Rijkaard at the helm, Barça recruited a number of international stars, such as Brazil's Ronaldinho and Deco, Argentina's Lionel Messi, Sweden's Henrik Larsson, France's Ludovick Guily, Cameroon's Samuel Eto'o, and Mexico's Rafael Márquez. They combined with the club's Catalan and Spanish superstars Carles Puyol, Xavi Hernández, Victor Valdés, and Andrés Iniesta to lead the club back to the road of success. Barça won the Spanish League and the Supercup of Spain in both 2005 and 2006. In 2005, Ronaldinho was voted the FIFA World Player of the Year, and his Cameroonian teammate Samuel Eto'o was third in the voting. Rijkaard also became the first FC Barçelona manager ever to defeat Real Madrid in the Santiago Bernabéu more than once. The second defeat was a decisive 3–0 victory that came in November 2005. In 2006, Barça achieved the international success it had been looking for and won the UEFA Champions League for the first time in fourteen years.

Despite being one of the most favored clubs in the world heading into the 2006–2007 season, FC Barcelona saw themselves fall short in almost every category. Although they started strong in the Spanish League, they were eventually overtaken by Real Madrid for the championship. Barça reached the semifinals of the King's Cup but were ousted by Getafe CF. Barça was defeated in the final of the 2006 FIFA Club World Cup by a late goal from the Brazilian club SC Internacional, and in the UEFA Champions League the club was knocked out of the round of sixteen by England's Liverpool FC, the eventual runner-up. In 2007–2008, FC Barcelona finished third in the Spanish League and reached the semifinals of the Copa del Rey as well as the semifinals of the UEFA Champions League. After being defeated 4–1 by Real Madrid, Joan Laporta announced that Rijkaard would be replaced as the club's manager by the ex-Barça captain and member of Cruyff's "Dream Team," Josep Guardiola.

At the turn of the century, La Liga Española saw the arrival of new challengers for the "The Big Two" (Real Madrid and FC Barcelona). While Athlétic de Bilbao, historically one of the most important and successful clubs in the Spanish League, continues to suffer in the twenty-first

century (when compared with their past), new Spanish clubs have emerged to compete for the title of the Spanish League, such as Deportivo de la Coruña, Villarreal CF, Real Sociedad, Sevilla FC, and Valencia CF (who won La Liga in 2002 and 2004 and finished second in the UEFA Champions League in both 2000 and 2001).

Surprisingly, neither Real Madrid nor FC Barcelona won the King's Cup during the first eight years of the new millennium. RCD Espanyol won the King's Cup in 2000, Real Zaragoza in 2001, Deportivo de La Coruña in 2002, RCD Mallorca in 2003, Real Zaragoza again in 2004, Real Betis in 2005, RCD Español again in 2006, Sevilla FC in 2007, and Valencia CF in 2008. Then, in 2009, FC Barcelona was back on top after winning the King's Cup. In 2010, Sevilla FC took the cup home, and in 2011, Real Madrid won it for the eighteenth time. In 2012, FC Barcelona took the cup back to Catalonia for the twenty-sixth time. FC Barcelona has the most King's Cups with twenty-six, Athlétic Bilbao has the second most with twenty-three, and Real Madrid has the third most with eighteen.

Despite Athletic Bilbao's difficulty succeeding within the League of the Stars, the club, which is one of the Spanish League's founding members, continues to be a pioneer when it comes to breaking new social ground through the sport. Although Athletic Bilbao's men's team has struggled recently, their women's team has dominated play in the newly formed Women's Superleague (*Superliga Femenina*). Women's soccer (*Fútbol Femenino*) has been growing in numbers and popularity in Spain since it was founded in 1983. The Superleague, which was founded in 2001, contains sixteen teams, most of which are affiliated with already existing men's clubs. The Women's Superleague is run by the Royal Federation of Spanish Soccer, and like the men's league, the bottom two teams are relegated to the lower division after each season. In the case of the women's league, the second level of competition is the First National of Women's Soccer (*Primera Nacional de Fútbol Femenino*), which is the equivalent to the men's BBVA League (*Liga BBVA*), and consists of six groups of fourteen teams for a total of eighty-four teams. Since the formation of the Superleague in 2001, Athletic Club Emakumeen Fútbol Talde (commonly known as Athletic Bilbao) has won the title four times, in 2003, 2004, 2005, and 2007, and very much like their masculine ancestors, they were the dominant club during the league's formative years. Although Athletic Bilbao dominates in league play, Levante Unión Deportivo Femenino from Valencia possesses the majority of Queen's Cups (*La copa de la reina*, the feminine equivalent to the King's Cup) with six, all coming after the turn of the century, in 2000, 2001, 2002, 2004, 2005, and 2007. Rayo Vallecano won the title over Levante in 2008, and RCD Español took the title home in 2006, 2009, 2010, and 2012. FC Barcelona beat their inner-city rivals, RCD Español, to win the Queen's Cup in 2011.

The Spanish Women's National Team debuted in 1983 and has suffered much of the same lack of success that the men's National Team had

struggled with over the years. This might be due to the fact that Spain is somewhat new to the sport of women's soccer when compared to northern European countries, North American countries, and other stereotypical leaders of modernity. Spain's Women's National Team has yet to qualify for the Women's World Cup, and their highest finish in an international competition was to reach the semifinals of the Women's European Cup (*Eurocopa Femenina*) in 1997. Although they have struggled with the competitiveness of northern European countries, they are coming of age. Interestingly, the Spanish Women's National Team proudly looks to their masculine equivalent's historical image for inspiration and has adopted the nickname "The Fury."

Spanish women's interest in soccer both as participants and as spectators has grown exponentially over the past twenty-five years. There are now over 1,800 female players in the top two divisions of Spanish women's soccer alone. If in the next hundred years the women's league grows to even a fraction of what the men's league has become, there will be an even more stable place for women in the arena of soccer. Soccer is a beautiful game that is capable of inspiring passion in all of us, male and female alike.

Since 2000, the Men's National Team has competed in three European Cup tournaments and two World Cup Final tournaments. In the European Cup of 2000, Spain started strong by winning their group, which was comprised of Norway, Slovenia, and Yugoslavia, but fell short when they met France, their longtime rivals, in the quarterfinals, losing by a score of 2–1. The National Team perpetuated its reputation as underachievers when Raúl missed a penalty kick late in the game that could have led them into overtime.

The Spanish National Team nearly overcame its negative stereotype in the 2002 World Cup in Korea/Japan, qualifying for the tournament with ease. Spain looked very strong in group play by winning their group with three victories, defeating both Slovenia and Paraguay 3–1 and South Africa 3–2. In the second round, Spain met Ireland, and after giving up a goal late in the match, they found themselves in a penalty shootout. The Real Madrid galactic goalkeeper, Iker Casillas, saved three penalties and sent Spain into the quarterfinals against the host country, South Korea. Spain and South Korea were tied 0–0 after regulation time, and in the penalty shootout South Korea defeated Spain. This caused many Spaniards to recount the various "refereeing favors" that South Korea received throughout the tournament. Some claim that South Korea benefited from a number of home-field advantages, which again perpetuated Spain's reputation of inevitable victims.

In the European Cup of 2004, Spain found themselves in a group with the host country, Portugal, along with Greece and Russia. Determined to overcome their curse of bad luck, Spain came out strong and defeated Russia 1–0 but then had a disappointing 1–1 tie with Greece. This put

Spain's back against the wall, needing a win over their neighboring country, historic rivals, and the host country, Portugal, to advance to the next round. In the end, Spain lost to Portugal 1–0, which again brought up the claim that Spain suffered the disadvantages associated with having to play the host team. Greece, the team Spain tied in their second game, went on to win the European Cup. This elevated Spanish frustration for the National Team's lack of ability to overcome narrow circumstances and bad luck. Many wondered if Spain would ever break out of this "slump" or if they were destined to always be unfortunate victims.

In the 2006 World Cup in Germany, Spain found themselves the favorites of their group, which consisted of Ukraine, Saudi Arabia, and Tunisia. In group play, Spain lived up to this consensus and defeated Ukraine 4–0, Tunisia 3–1, and Saudi Arabia 1–0. In the second round, the Spanish National Team was faced with the defending World Cup champions, neighboring country, and historic rival, France. France, captained by Real Madrid's galactic Zenedine Zidane, defeated Spain 3–1. Although the score would imply that Spain was handily defeated, they played well and were strong through most of the match, giving up their last two goals late in the game. France went on to reach the World Cup's final match but was defeated by Italy in a penalty shootout. This again caused Spain to feel they were dealt an unfortunate hand since they faced the eventual finalist in the round of sixteen and competed well against France before eventually being overtaken. Although Spain still felt they were the victims of unfortunate losses, they had the confidence that they were competing on the level and that, if they kept on this path, their bad luck was bound to change at some point.

In the European Cup of 2008 in Austria and Switzerland, Spain found themselves paired with two members of their group from the European Cup of 2004, Russia and Greece, the latter having been the defending European Cup champion. The fourth team in the group was Sweden. Spain again came out strong and handily beat Russia 4–1, then took Sweden 2–1 before defeating Greece 2–1 to advance as the winners of the group. In the quarterfinals, Spain again found themselves against an international powerhouse and the 2006 World Cup champions, Italy. Italy played their stereotypical defensive-minded game, but Spain was very conscious not to give anything up on a counterattack. The game ended in a 0–0 tie, and in the penalty shootout Spain's superstar goalkeeper, Iker Casillas, again came up big and saved two penalty kicks. Spain advanced over Italy 4–2 in the penalty shootout. In the semifinal match, Spain met Russia again, who turned out to be very strong throughout the tournament since the first game when the two teams met. Nevertheless, the Spanish style was too much for Russia, and Spain outscored them 3–0 to advance to the final match for the first time since 1984. Spain then won the 2008 European Cup final over Germany 1–0. Many saw this success as evidence that Spain had finally overcome what seemed to be a never-

ending curse. This success could help unify the country and help establish it as a cultural powerhouse of the twenty-first century. Julián Ramos best described this in his article titled "Union, Passion, Fanaticism, Spain Champion" ("*Unión, pasión, afición, España campeón*"), which he wrote after Spain's baptizing 2008 European Cup championship:

> Today Spain is a different country, a united nation, without divergences. The borders between the Autonomous Communities are blurred and form a uniform total, with one homogenous color. The diverse dialects are transformed into a single language, the language of the common dream. [1]

And clearly, Spain's national self-image has been altered even more since they won the 2010 World Cup and subsequently the European Cup of 2012, thus solidifying themselves as the perennial world soccer power of the times, not only in international competition but also through FC Barcelona's massive success at the club level during the famed "Guardiola Era." But clearly since its introduction to Spain, soccer has not only served as a vehicle to express certain national and cultural ideologies within Spain. It has also served to mirror Spain's cultural, political, and social preoccupations. These preoccupations have played such a vital role in the history and makeup of Spain that it seems impossible to imagine her without this enigmatic identity crisis. Only time will tell if Spain comes to see herself as one country, with a single (although complex) national identity. However, until some other cultural phenomenon comes along that is of greater relevance, soccer will surely play an essential role in shaping the identity of Spain.

NOTE

1. Julián Ramós, "*Union, pasión, afición, España Campeón*" ("Union, Passion, Predilection, Spain Champion"), 2008, http://julianramos.blogia.com/2008/070101-union-pasion-aficion-espana-campeon-p-.php (March 3, 2009).

II

The Phenomenon of Spanish "Kick-Lit"

Soccer is one of the few certainties that exist within relativism that invades everything. A game which we have come to take seriously as a business and as a social phenomenon, but also as a sentiment in which our identity is rooted. An infinite game that literature explores everyday with less mistrust and more audacity.

—Jorge Valdano

It would be difficult to prove but not outlandish to claim that soccer probably occupies more newspaper space on a daily basis across the planet than any other topic. This enormous amount of coverage is due to the sport's extreme popularity around the globe. Few intellectuals have the confidence to confess to reading the newspaper as the famous Irish writer Samuel Beckett did. He claimed to always "make a quick pass of the world's disasters before meticulously studying the table of goal scorers."[1] Needless to say, there is no lack of soccer coverage in the press or reception of the coverage for that matter.

In recent years, there has been a growing appreciation of and respect for literature where the central theme is soccer. The topic of soccer was viewed unfavorably until very recently—possibly with the arrival of the twenty-first century. There have been countless numbers of literary works throughout history that have either referred to soccer or directly used the sport as a point of departure. As to why soccer was considered to have been a taboo subject for the field of literature is a difficult question to answer. Could it have been that many intellectuals considered soccer an activity for the commoner and felt they needed to elevate themselves above participating with the masses? Was it because soccer's presence had been overemphasized through the mass media? Possibly those intellectuals were focusing on only the negative aspects of the sport. Maybe they were simply unfamiliar with the realities and profundities of the game. Or was it simply because those intellectuals possessed a snobbish insecurity and feared what they were unfamiliar with? Jorge Valdano describes his frustration with regard to this topic as follows:

In this medium the body continues being more important than the mind. That same absurd duality—physical/mental—was what distanced the intellectual from soccer. It hurts me to believe that the passion from which I live generates unfair mistrust. Culturally despised, politically utilized and socially reduced to a popular expression of lesser amount, soccer continues to trap the Sunday emotion of fans around the world, converted into an entrancing phenomenon of mass mobilization it is worthy of more respectful attention. [2]

Whatever the case, more people have probably played soccer than any other sport in the world. Ironically, many of the game's participants have become writers and intellectuals. In turn, many of them were and are aware of the sports profundities (both negative and positive), and therefore an incredible number of intellectuals, writers, philosophers, poets, and playwrights have dedicated a considerable amount of work to soccer.

Today, the growing demand for literature about soccer is a worldwide phenomenon. It is especially popular in the Latin world. There is an immense body of work that has been accumulating "underground" for years but that only recently is experiencing a breakthrough of mass recognition. The only thing this genre lacks is a proper name. Since this boom is most strongly felt in Spanish-speaking countries, some have referred to it as *"literatura de la pelota"* ("literature of the ball"), *"literatura del balompié"* ("literature of ball-foot"), and *"literatura del fútbol"* ("literature of soccer"). I, however, refer to this growing literary phenomenon as "kick-lit." I use the English word "kick" for three reasons: (1) English is the planet's lingua franca, and as the genre grows, it could be used for generations to come in all countries throughout the world; (2) soccer is already Anglicized in its foundation; and (3) this term coincides with the present trend of labeling literary and cinematic genres, such as "brit-lit," "chick-lit," or "chick-flicks" and, like these other genre's kick-lit rhymes, is catchy and is easy to pronounce for people throughout the world. Aside from all this, the body of work using soccer as a point of departure is too large, the literary styles covered are too vast, and the genre's popularity is growing far too rapidly for it not to have an immediately recognizable name.

Although we are presently experiencing a kick-lit craze, literature dealing with soccer was not always accepted among literary critics or intellectuals. It took a considerable amount of time and persistence from its supporters for the genre to emerge. Some of kick-lit's most notable pioneers that defended its legitimacy and patiently spent years waiting for its recognition are Uruguayan writers Eduardo Galeano and Mario Benedetti; Mexico's Juan Villoro; Peru's 2010 Nobel Prize in Literature Laureate, Mario Vargas Llosa; Colombia's Gonzalo Medina Pérez; Spain's 1989 Nobel Prize in Literature Laureate, Jose Camilo Cela, Javier Marías, Julián García Candau, Fernando Fernán Gomez, Rafael Azcona,

and Manuel Vázquez Montalbán; and Argentina's Roberto Fontanaroso and Osvaldo Soriano. While there are many others deserving of mention on this list, there is one individual who stands out for playing the most important role in having kick-lit recognized throughout the world of literature. He is the modern-day Renaissance man Jorge Valdano. Among his many achievements, Valdano scored the second goal against Germany to help Argentina win the 1986 World Cup. He also won multiple UEFA and Spanish League Championships as both a player and a coach of Real Madrid. He is now wisely using his celebrity and his poised intellect to promote the kick-lit genre to both the masses and the intellectual classes. Thanks to the persistence of these pioneers, promoters, and defenders of kick-lit, the world of literature has gained another genre worthy of exploration. Jorge Valdano, who many consider to be the philosopher of soccer, addresses this very issue in the prologue of *Soccer Stories 2* when he writes that he admires authors who were prepared to break the taboo, claiming that "projects are only successful when they're long-lasting, and prejudices are only overcome through insistence."[3]

On June 4, 2006, an article titled "Books Give Court to Soccer" (*"El libro da cancha al fútbol"*) appeared in the Spanish newspaper *The Country* (*El País*). The article, written by Winston Manrique, was dedicated to the enormous presence of kick-lit at the Sixty-Fifth Book Fair of Madrid (*65ª Feria del Libro de Madrid*). In the article, Manrique discusses the typical kick-lit arguments but shows that against the objection of many intellectuals, soccer has now established itself within the field of literature. He notes that even the sport's most outspoken philosophical opponents (such as Jorge Luis Borges) can't escape the power or the passion that the phenomenon of soccer encompasses. Manrique pokes fun by claiming,

> The *Aleph* is now here. It is what the World Cup of Soccer has been converted into. Into the center of the universe every four years, much to the dismay of Jorge Luis Borges, the creator of that tale about a mythic literary-existential sphere which he called *Aleph*, whose center is everywhere and contains the entire universe.[4]

A recent study titled *Passion, according to Valdano* (*La pasión según Valdano*), by the Argentinean journalist and kick-lit writer Ariel Sher, recognizes this growing genre and explores four of its key aspects in the chapter titled "Soccer, Intellectuals and Literature" (*"Fútbol, intelectuales y literatura"*). First, the chapter explores the many ways intellectuals have rejected soccer over the years citing Jorge Luis Borges's ironic scorn of the sport as well as the aggression in José Sebrelli's *The Era of Soccer* (*La era del fútbol*), a comparative study of soccer and theater. The second aspect of Sher's "Soccer, Intellectuals and Literature" covers how the sport has been considered by many as a social phenomenon that has been expressed in the work of a number of highly recognized authors throughout the world. The third aspect that Sher covers is how the "soccer

dream" is nourished through different forms of journalistic expression when accompanied by works of great quality, such as those written by journalists Osvaldo Ardizzone, Borrocotó, Dante Panzeri, and others, that have appeared in the Argentine soccer magazine *The Graphic* (*El Gráfico*). The fourth aspect deals with the belief that soccer serves as a metaphor of life. Sher contends that soccer serves as a vantage point from which one can observe the social, enterprising, cultural, and anthropological realities of the world. This idea is expressed in many works of kick-lit and appears in Martin Casariego's story "Soccer and Life" (*"El fútbol y la vida"*) when a veteran on the club tells a youngster, "In the end, or very soon, you will come to realize that soccer and life are the same thing."[5]

The writers and consumers of the kick-lit genre hold one thing in common—a passion for two of the world's most popular phenomena: literature and soccer. Why these two extremely powerful cultural phenomena did not popularly intersect earlier is yet another phenomenon in and of itself. Jorge Valdano describes it as follows: "The game is, like literature, a recreation of reality. If the two universes were slow to merge it must have been because their paths were always parallel."[6] The double-barreled passion of kick-lit enthusiasts can be experienced on a variety of levels, such as reading or writing about playing the sport, watching the sport, experiencing success or failure through the sport, cheering for it, crying about it, hating it, being frustrated or embarrassed by it, or any other emotion that the sport/life provokes. On the other hand, kick-lit enthusiasts can tap into the genre to ignite their literary passions. Again, through either reading or writing, an individual can focus on the language, structure, tone, narration, characters, story line, and any other literary aspects that are also capable of provoking a wide range of human emotions. Kick-lit enthusiasts can also approach the genre from an academic standpoint and analyze it, write about it, and have conversations about it endlessly. The fountain for personal satisfaction and pleasure that can be derived from kick-lit is endless—more so than most genres of literature. "On and off the field, soccer is an infinite game that will never be able to cover nor unravel itself."[7]

The phenomenon of kick-lit is very unique in that it perfectly fuses two of the world's most dynamic cultural phenomena: literature and soccer. Each phenomenon embraces the infinite aspects of life by itself. The painting by the Italian futurist Umberto Boccioni in 1913 that is currently on display in New York's Museum of Modern Art titled *Dynamism of a Soccer Player* (*Dinamismo de un jugador de fútbol*) serves as a visual representation of the dynamic qualities of a soccer player. Clearly, this dynamism becomes exponential when combined with twenty-one other players, coaches, media, and a stadium full of fans that make up the soccer arena.

There is only one body of work of which I am aware that surpasses kick-lit in that it combines two cultural phenomena of equal dynamism

as those of soccer and literature and is as compatible as soccer and litera-
ture. It is that of the love story. I feel the worldwide phenomenon of
soccer is second only to the age-old phenomenon of love. Many people's
first love is soccer. Many people's most profound dreams can be achieved
only on the soccer field. This idea is expressed in the following excerpt
from Mario Benedetti's short story "The Grass" ("*El césped*") when the
protagonist Benja says, "I've never confessed it to anyone, . . . but I'd like
to tell it to you. I have dreams, ya' know?" "We all have dreams," said
Ale. "Yes, but mine are dreams about soccer."[8] Surely this idea could be
compared to the countless literary works that focus on art, dance, music,
literature, and every other cultural phenomenon that people are passion-
ate about. However, the fact that these themes were never rejected by
intellectuals as legitimate subject matter for literature resulted in their
never needing to be brought to the foreground as a group to have them
recognized, as is the case with kick-lit. There is also literature about every
other sport that exists in the world, but because soccer is the world's
game and causes more craze than any other sport, it receives the majority
of the attention and the brunt of the scorn of intellectuals who do not
consider a sport so manically embraced by the masses as a valid topic for
intellectual ground. The uniqueness of kick-lit lies in the simple fact that
there are those who are passionate about soccer and those who are pas-
sionate about literature. When these two immensely dynamic phenome-
na merge, the possible avenues for exploration and reflection become
boundless.

One of my favorite kick-lit poems that encompasses this passion for
both literature and soccer was written by the Argentinean international
soccer player turned journalist and poet, Quique Wolff. Wolff represent-
ed his country in the 1974 World Cup and later won two Spanish League
Championships with Real Madrid in 1978 and 1979. This poem is inspira-
tional for both soccer and literature fans and taps into the main vein of
the multifaceted passions that only kick-lit can provoke. Wolff describes
soccer as a metaphor for life, claiming that only through soccer can an
individual experience the purest form of all human emotions. In this
sense, the soccer arena could be considered the all-encompassing prover-
bial Petri dish of life—the place where one can go to experience all that
life has to offer. This idea was also expressed in Luis Miguel Aguilar's
"The Great Touch" ("*El gran toque*") when the coach tells his players,
"Soccer is like life. What happens here will happen to you all throughout
the rest of your lives, there . . . outside of soccer."[9] Quique Wolff encapsu-
lates this notion into the form of a poem so that his ideas will be more
powerfully expressed.

¿Cómo vas a saber lo que es el amor?	How will you know what love is?
Si nunca te hiciste hincha de un club	If you've never been a fan of a club

¿Cómo vas a saber lo que es el dolor?	How will you know what pain is?
Si jamás un zaguero te rompió la tibia y el peroné	If a fullback never broke your tibia and fibula
y estuviste en una barrera y la pelota te pegó justo ahí	and you were in a wall and the ball hit you right in the . . .
¿Cómo vas a saber lo que es el placer?	How will you know what pleasure is?
Si nunca diste una vuelta olímpica de visitante	If you've never taken a victory lap as a visitor
¿Cómo vas a saber lo que es el cariño?	How will you know what affection is?
Si nunca la acariciaste de chanfle	If you never kissed a bender
entrándole con el revés del pie	with the back of your foot
para dejarla jadeando bajo la red	to leave it spinning in the net
¡¡Escúchame!!,	Listen to me!!,
¿Cómo vas a saber lo que es la solidaridad?	How will you know what solidarity is?
Si jamás saliste a dar la cara	If you never stood up
por un compañero golpeado desde atrás	for a teammate tackled from behind
¿Cómo vas a saber lo que es la poesía?	How will you know what poetry is?
Si jamás tiraste una gambeta	If you've never faked out an opponent
¿Cómo vas a saber lo que es la humillación?	How will you know what humiliation is?
Si jamás te metieron un caño	If you've never been nutmegged
¿Cómo vas a saber lo que es la amistad?	How will you know what friendship is?
Si nunca devolviste una pared	If you've never rounded up a wall
¿Cómo vas a saber lo que es el pánico?	How will you know what panic is?
Si nunca te sorprendieron mal parado en un contragolpe	If they never caught you off guard on a counterattack

¿Cómo vas a saber lo que es morir un poco?	How will you know what it's like to die a little?
Si jamás fuiste a buscar la pelota dentro del arco	If you've never had to get the ball from the back of the net
¡Decime viejo!	Tell me old man!
¿Cómo vas a saber lo que es la soledad?	How will you know what loneliness is?
Si jamás te paraste bajo los tres palos	If you've never been stuck between the sticks
a doce pasos de uno que te quería fusilar	twelve steps from someone wanting to rifle one at you
y terminar con tus esperanzas	and end all your hopes
¿Cómo vas a saber lo que es el barro?	How will you know what mud is?
Si nunca te tiraste a los pies de nadie	If you've never slid into anyone's feet
Para mandar una pelota sobre un lateral	To clear a ball out of bounds
¿Cómo vas a saber lo que es el egoísmo?	How will you know what selfishness is?
Si nunca hiciste una de más	If you've never taken one touch too many
cuando tenías que dársela,	when you should have passed it
al nueve que estaba solo	off to nine who was all alone
¿Cómo vas a saber lo que es el arte?	How will you know what art is?
Si nunca, pero nunca inventaste una rabona	If you've never ever improvised a rabona[10]
¿Cómo vas a saber lo que es la música?	How will you know what music is?
Si jamás cantaste desde la popular	If you never sang with the stadium
¿Cómo vas a saber lo que es la injusticia?	How will you know what injustice is
Si nunca te sacó tarjeta roja, un referí localista	If you've never been red-carded by the home team's ref

Decime, ¿Cómo vas a saber lo que es el insomnio?	Tell me, how will you know what insomnia is?
Si jamás te fuiste al descenso	If you've never been relegated
¿Cómo, cómo vas a saber lo que es el odio?	How, how will you know what hatred is?
Si nunca hiciste un gol en contra	If you've never accidentally scored an own goal
¿Cómo, pero cómo vas a saber lo que es llorar?	How, but how will you know what it is to cry?
Sí llorar, si jamás perdiste una final de un mundial	Yes cry, if you've never lost a World Cup Final
sobre la hora con un penal dudoso	after regulation time on a questionable penalty
¿Cómo vas a saber querido amigo?	How will you know dear friend?
¿Cómo vas a saber lo que es la vida?	How will you know what life is?
Si nunca, jamás jugaste al fútbol.	If you never played soccer.

—Quique Wolff[11]

Wolff contends that in order to truly understand life, an individual needs to have played soccer and experience all the human emotions that are so purely extracted through the sport. I, on the other hand, feel that through poetry's phenomenal ability to re-create life (similar to that of soccer), one can simply swallow the pill that Wolff offers us in the form of a poem. Many soccer players who have experienced the feelings Wolff relates are probably unable to fully appreciate them or reflect on them in the same light that Wolff offers until, of course, they read his poem, which describes so well (especially in its native language) the range of emotions that are experienced through soccer. If an individual is unable to physically experience the world of soccer, he or she can simply enter the universe of kick-lit (which describes the universe of soccer so vividly) and find a decent substitute. This is just one example of the multifaceted and dynamic aspects that the phenomenon of kick-lit offers its readers.

While the primary focus of this book is on the phenomenon of kick-lit in Spain, it would be remiss not to at least make reference to some of Latin America's kick-lit contributions. In the prologue of *Toe-poke* (*De puntín*), a compilation of eleven short stories about soccer with illustrations by Roberto Fontanarrosa, Jorge Valdano tackles the question of the relevance of kick-lit when he writes, "How many things fall within soccer? The game, the spectacle, the business. . . . How many games exist? The recreational, the formative, the professional. . . . What does soccer

produce? Suspense, passion, conversation. . . . A feast of lyrics."[12] On the back cover of the book is the following poem by Eduardo Galeano, in which he addresses the reader directly and brings to the foreground kick-lit's characteristics. The poem reminds the reader of the multitude of elements that merge in a work of kick-lit such as *Toe-poke*. In kick-lit, parallels about the game's structure, technique, and style are often made with literary technique, content, language, structure, and the style of the book itself. Through this poem, Galeano also celebrates the book's illustrations, and the enjoyment felt on appreciating both the sport and literature when it is performed at a high level. Essentially, this is a kick-lit poem about kick-lit itself: the first of its kind, as far as I know.

Son once	They are eleven
Juegan con palabras, en cancha de	They play with words, on the field
papel, y los dibujos de Fontanarrosa	of paper, and drawings by Fontanarrosa
comenten el partido.	they commentate the match.
Cada cual se luce según su maña y	Each one shines in their skill
manera, pero los once forman,	and way, but as eleven they form,
juntos, un lindo equipo.	together, a fine team.
Ojalá encuentren la hinchada que la	Let's hope they find a fan-base
buena prosa, como el buen fútbol,	that good prose, like good soccer,
merece.	deserves.

—Eduardo Galeano[13]

Two of Latin America's most well-known individuals are Pelé and Diego Maradona. Both earned their fame through their success and the beauty with which they played soccer. By dominating play and winning World Cup Championships, each has elevated his status to that of a mythological figure in his respective country, in Latin America, and throughout the world. Mario Vargas Llosa wrote the following regarding this phenomenon: "The common people need contemporary heroes. . . . It's also the least alienator of the cultured, because to admire a soccer player is to admire something very similar to pure poetry or an abstract painting. It's to admire form for form's sake, without any rationally identifiable content."[14] In referring to the respect that even opposing players had for Pelé, "The Black Pearl" ("*La perla negra*"), Eduardo Galeano wrote, "When he took a free kick, the opponents in the wall wanted to turn around and face the net, so as not to miss the amazing goal."[15] This citation comes from Galeano's canonical kick-lit book *Soccer in Sun and Shadow*, which tackles a great variety of aspects from which the sport can be approached through literature.

In Spain, the first forms of kick-lit stem back to the Roman Empire, before Spain was Spain and before soccer was soccer. Writings about *harpastum*, an ancestral form of soccer that was played throughout the Roman Empire, first appeared in the writings of Lucio Anneo Séneca, the famous first-century philosopher from what later would become Córdoba. In *The Benefits* (*Los beneficios*), Séneca wrote the following excerpt explaining the cultural phenomenon that was taking place. It is easy to recognize the enjoyment that Séneca experienced while expressing this phenomenon through pen and paper. The reader easily feels his enthusiasm and awe of the activity:

> I want to offer a comparison that our Chrysippus makes about the ball game: If this one falls there's no doubt that it's the fault of he who takes [the ball] or from whom it's returned, and that one maintains himself in movement while sent away and received as such by each player. It is also necessary that the good player pass it differently according to the stature of his counterpart, be him tall or short. The same reason is valid in the benefits if both people don't adapt themselves, those who make a pass and those who receive it, they will not leave the meek and they will not arrive to the hands of the other as they should. If we find ourselves confronted with an exercised and able player, we will carry the ball with more energy, since, wherever one goes, an agile and ready hand will return it; but if we play like an ignorant beginner, we will not carry it with as much zeal or potency but rather more softly and with more precision to their hands, and therefore we could return it more easily. One should do the same in the benefits; it's necessary to teach some and demonstrate ourselves as satisfied if they exert themselves, if they risk themselves, if they so choose.[16]

In the early fourteenth century, when the phenomenon of Spanish literature first began to take shape, a game similar to that of *harpastum* was still being practiced. This activity's popularity was widespread and had become such a cultural phenomenon that it was recognized by a number of classical authors who deemed it culturally relevant enough to refer to it in their literary works. The medieval writer Juan Ruiz, "The Archbishop of Hita" ("*El Arcipreste de Hita*"), made reference to this popular game in *The Book of Good Love* (*El libro de buen amor*). His reference to the sport is meant purely for the reader's amusement. He is trying to lure a woman back to his home on the pretense that should she accept the invitation, he will offer her the opportunity to play ball games and participate in other pastimes. Through his play on words, it is obvious that he really has a sexual encounter in mind:

> 861 *Verdad es que los placers conortan a las deveses:*
> *Por ende, fua señora yd a mi casa a veses;*
> *Jugaremos a la pella, e otros juegos rreheses,*
> *Jugaremos, folgaremos, darvos he y de nueses*[17]

861 It's very true that pleasures do drive the cares away;
Therefore my lady I hope you'll come into my house some day;
There we'll knock the ball about and other pastimes play;
And I will give you many treats, we'll frolic all the day

During the Spanish Golden Age of Literature, a number of writers referred to the activities involving the Olympic Games in their works: Miguel de Cervantes in *The Works of Persiles and Segismundo* (*Los trabajos de Persiles y Segismundo*), Luis de Góngora in *Solitudes* (*Las Soledades*), and Agustín de Salazar in *The Olympic Games* (*Los Juegos Olímpicos*). Others who alluded to this popular activity (which was an early ancestor of soccer) in their works were Lope de Vega, Gaspa Gil Polo, Padre Mariana, Luis Pacheco, Tirso de Molina, and Juan Ruiz de Alarcón. References to the sport stem all the way back to Spanish literature's earliest phases. Although the sport had not yet evolved into what it is today, authors of the time still felt a need to express its role in the culture. As time passed, the sport was depicted in a negative light by many authors. During the European Renaissance and the Spanish Golden Age, European culture was focused on leaving the brutal past of medieval times behind and embracing more civilized activities. Soccer eventually civilized itself, but this early reputation remained with the game, plaguing it for years to come, although there have been a great number of Spanish writers who rejected this negative opinion and chose to defend the sport's legitimacy and their love for the game in their works. Many authors have not only come to refer to soccer (as we know it today) in their works but also used the sport as a central theme. It is these works that I am most concerned with—not particularly whether soccer is represented in a positive or negative light, but rather whether one of the work's essential elements is directly related to soccer. In order for a literary work to fall into the kick-lit genre, it must meet this criterion. The next chapter will be dedicated to analyzing a number of these texts that have appeared in both Spain and Latin America.

This section of the book served two purposes: (1) to proclaim kick-lit's legitimacy as a genre and a present-day worldwide phenomenon and (2) to extract the root that helped establish a solid foundation for the genre in Spain and therefore further legitimize it. With *The Book of Good Love*, the Archpriest of Hita planted the seed for many literary genres and styles that would later take shape in Spanish literature. Kick-lit can now join that list. Although it is a genre that has been hindered throughout history by politics and intellectuals, it is finally coming of age.

NOTES

1. Secretaría de Cultura Jalisco, *Umbral* ("Threshold"), *Verano-Otoño*, no. 3/4 (1992), 3.

2. Jorge Valdano, *El miedo escénico y otras hierbas* (*Stage Fright and Other Herbs*) (Buenos Aires: Aguilar, 2002), 252.

3. Jorge Valdano, *Cuentos de Fútbol 2* (*Soccer Stories 2*) (Madrid: Extra Alfaguara, 1998), 12.

4. Winston Manrique, "*El fútbol da cancha al libro*" ("Soccer Gives Court to Books") *El País*, June 4, 2006, www.fcbarcelona.com/web/english/club/club_avui/mes_que_un_club/mesqueunclub_historia.html (January 23, 2009).

5. Valdano, *Cuentos de Fútbol 2* (*Soccer Stories 2*), 134.

6. Valdano, *Cuentos de Fútbol 2* (*Soccer Stories 2*), 12.

7. Jesús Castañón Rodríguez, "*La pasión del fútbol infinito, según Valdano*" ("The Infinite Passion of Soccer, according to Valdano"), 2006,http://www.idiomaydeporte.com/scher.htm (January 2, 2009).

8. Jorge Valdano, *Cuentos de Fútbol* (*Soccer Stories*) (Madrid: Extra Alfaguara, 1995), 77.

9. Valdano, *Cuentos de Fútbol 2* (*Soccer Stories 2*), 40.

10. A *rabona* is a soccer move for which there is no English word. The *rabona* is used when a player finds the ball on the outside of his planted foot. In order to kick the ball, the player swings his opposite leg around the back of his planted foot to make contact with the ball, normally to send a lofting pass, cross, or shot.

11. Julian Yanover, *Poemas al fútbol* (*Poems to Soccer*), 2006, www.poemas-del-alma.com/blog/especiales/poemas-al-futbol (January 12, 2009).

12. Roberto Fontanarrosa et al., *De puntín: Cuentos de fútbol* (*Toe-poke: Soccer Stories*) (Buenos Aires: Al Arco, 2003), 9.

13. Fontanarrosa et al., *De puntín: Cuentos de fútbol* (*Toe-poke: Soccer Stories*), back cover.

14. Mario Vargas Llosa, in Manrique, "*El fútbol da cancha al libro*" ("Soccer Gives Court to Books").

15. Eduardo Galeano, "*El fútbol a sol y sombra*" ("Soccer in Sun and Shadow") (Madrid: Siglo XXI de España Editores, 1995), 236.

16. Julian Garcia Candau, *Épica y lírica del fútbol* (*Epic and Lyric of Soccer*) (Madrid: Alianza Editorial, 1996), 38.

17. Felipe Maldonado, *Edad Media Española: Textos escogidos* (*Spanish Middle Age: Selected Texts*) (Madrid: Taurus, 1959), 240.

SEVEN

The Ball Begins to Roll

The Early Years of Spain's "Kick-Lit" Phenomenon

Up until Franco's death, very few intellectuals dared to publicly claim their predilection for soccer. Until Franco's death, the leftist intellectuals hid their avocation even from their colleagues. Soccer in those years was an alienating spectacle-sport. It was the opiate of the masses. The old philosophy of bread and bulls had been substituted for bread and soccer.

—Julián García Candau

One example of "kick-lit" that was written during the Franco years came from the highly praised conservative intellectual José María Pemán. Pemán was one of the few well-known intellectuals to support Franco. Some of his duties and achievements include being commissioned by Franco to rewrite the lyrics of Spain's national anthem (that remained until Franco's death), receiving a great number of literary awards and forming part of the Real Academia Española, serving as the personal adviser to the Count of Barcelona, and being knighted to the Order of the Golden Fleece. The following poem is a good example of Pemán's contribution to "kick-lit."

Dime, Poeta:	Tell me, Poet:
Si el mundo es como un balón	If the world is like a ball
redondo por la ilusión	round by illusion
de llegar pronto a su meta:	arriving quickly at its goal:
¡Vale la pena jugar!	It's worth the effort to play!
Silencio del altamar,	Silence from the high seas,

73

luna llena . . .	full moon . . .
mar serena;	serene sea;
viejo amigo	old friend
en secreto te lo digo,	I'll tell you secretly
¡que lo que vale la pena	what's worth the effort
es ganar![1]	is victory!

—José María Pemán

While Pemán's poem serves as an example of kick-lit from the Franco era, two examples of early-contemporary Spanish kick-lit predate Franco's arrival as dictator. They are poems by two of Spain's most prominent writers from the era and are considered key contributors to The Generation of '27 (*La generación del '27*)—Miguel Hernández and Rafael Alberti. The works of Hernández and Alberti are canonic kick-lit texts because they gave the genre a presence during early-contemporary Spanish literature. Miguel Hernández broke the mold and became one of the first contemporary Spanish writers to be widely recognized for meshing the phenomenon of literature with soccer. He wrote an elegy in the form of a poem for a heroic goalkeeper named Lolo, who was from the poet's hometown of Orihuela, Alicante.

ELEGÍA—al guardameta	ELEGY—to the goalkeeper
A Lolo, sampedro joven en	To Lolo, sampedro youngster in
la portería del cielo de Orihuela.	the goal in the heavens of Orihuela.
Tu grillo, por tus labios promotores,	Like a grasshopper, from your promoter lips,
de plata compostura,	of silver composure,
árbitro, domador de jugadores,	head ref, player-tamer,
director de bravura,	director of bravery,
¿no silbará la muerte por ventura?	Won't it be death that whistles luck?
En el alpiste verde de sosiego,	In the green birdseed of serenity,
de tiza galonado,	covered in chalk,
para siempre quedó fuera del juego	always far removed from play
sampedro, el apostado	sampedro, always posted-up
en su puerta de cáñamo añudado.	in his goal of knotted twine.

Goles para enredar en sí, derrotas,	Goals to entangle in themselves, losses,
¿no la mundial moscarda?	Is this not the world of cluster flies?
que zumba por la punta de las botas,	that tingle through the tip of the cleat,
ante su red aguarda	before his web he guards
la portería aún, araña parda.	the goal still, a poised spider.
Entre las trabas que tendió la meta	Between the tethers that tended the goal
de una esquina a otra esquina	from one corner to the other corner
por su sexo el balón, a su braqueta	via his sex the ball, to his shorts
asomado, se arruina,	a'bulging, it spoils itself,
su redondez airosamente orina.	its roundness jauntily pisses.
Delación de las faltas, mensajeras	Delation of fouls, messengers
de colores, plurales,	of colors, plural,
amparador del aire en vivos cueros,	protector of the air in living leather,
en tu campo, imparciales	in your field, impartial ones
agitaron de córner las señales.	agitated the signs for corner.
Ante tu puerta se formó un tumulto	In front of your goal formed a riot
de breves pantalones	of brief shorts
donde bailan los príapos su bulto	where the Priapus dance their bulk
sin otros eslabones	without other echelons
que los de sus esclavas relaciones.	than those of their bonded relations.
Combinada la brisa en su envoltura	The breeze mixed well within his cover
bien, y mejor chutada,	and better shot,
la esfera terrenal de su figura	the earthly sphere of his figure
¡cómo! fue interceptada	how?! it was intercepted

por lo pez y fugaz de tu estirada.	by the shark-like fugacity of your dive.
Te sorprendió el fotógrafo el momento	The photographer surprised you at the most beautiful
más bello de tu historia	moment of your sporting life
deportiva, tumbándote en el viento	tumbling in the wind
para evitar victoria,	to prevent victory,
y un ventalle de palmas te aireó gloria.	and a flabellum of palms gusted your glory.
Y te quedaste en la fotografía,	You were stuck in the photograph,
a un metro del alpiste,	a meter above the bird seed,
con tu vida mejor en vilo, en vía	with your life better in air, en route
ya de tu muerte triste,	to your surely sorrowful death,
sin coger el balón que ya cogiste.	without catching the ball that right thereafter you caught.
Fue un plongeón *mortal. Con ¡cuánto! tino*	It was a mortal dive. With such finesse
y efecto, tu cabeza	and effect, your head
dio al poste. Como un sexo femenino,	hit the post. Like the feminine sex,
abrió la ligereza	the swiftness of the blow
del golpe una granada de tristeza.	opened a pomegranate of sadness.
Aplaudieron tu fin por tu jugada.	They applauded your end because of your play.
Tu gorra, sin visera,	Your cap, without visor,
de tu manida testa fue lanzada,	from your ordained head was launched,
como oreja tercera,	like a third ear,
al área que a tus pasos fue frontera.	the area within your steps was a boarder.
Te arrancaron, cogido por la punta,	They pulled you away, by the arm,

el cabello del guante,	the hair of the glove,
si inofensiva garra, ya difunta,	if inoffensive claw, now defunct,
zarpa que a lo elegante	paw which elegantly
corroboraba tu actitud rampante.	corroborated your rampant attitude.
¡Ay fiera!, en tu jaulón medio de lino,	Oh beast! In your half-linen crate,
se eliminó tu vida.	your life was eliminated.
Nunca más, eficaz como un camino,	Never again, effective like a journey,
harás una salida	you will make an exit
interrumpiendo el baile apolonida.	interrupting the dance of Apollonides.
Inflamado en amor por los balones,	Inflamed in love for balls,
sin mano que lo imante,	without a hand to magnetize it,
no implicarás su viento a tus riñones,	You will not implicate his wind to your reins,
como un seno ambulante	like a wandering bachelorette
escapado a los senos de tu amante.	fleeing to the bosom of your lover.
Ya no pones obstáculos de mano	Now you won't have hindrances of hand
al ímpetu, a la bota	to impetus, to the boot
en los que el gol avanza. Pide en vano,	of those that the goal advance. Beg in vain,
tu equipo en la derrota,	your team in defeat,
tus bien brincados saques de pelota.	your well-leaped deflections of the ball.
A los penaltys que tan bien parabas	To all the penalties you blocked so well
acechando tu acierto,	watching your aptness,
nadie más que la red le pone trabas,	no one but the net obstructs it,
porque nadie ha cubierto	because no one had covered

el sitio, vivo, que has dejado, muerto.	the place, alive, that you left, dead.

El marcador, al número al contrario,	The score, to the opposite number,
le acumula en la frente	accumulates on his brow
su sangre negra. Y ve el extraordinario,	his black blood. And he sees the extraordinary,
el sampedro suplente,	sampedro substitute,
vacío que dejó tu estilo ausente.	a void that left your absent style.

—Miguel Hernández (316–18)

The sincerity and tenderness of Miguel Hernandez shines in this poem celebrating the life of one of his town's local soccer heroes. As a poet, Miguel Hernández was able to identify, to a certain extent, with the goalkeeper. The prominent Spanish kick-lit contributor Almudena Grandes describes the position of the goalkeeper as the most literary and interesting, saying the goalkeeper is "always alone. Thinking and suffering during the match. While everyone else goes from side to side, he has to wait, and his reaction is crucial."[2] This theory is legitimized because of all the players, the goalkeeper is the odd man out—he wears a different color shirt than his teammates and stands alone, isolated. The goalkeeper is also responsible for a different set of tasks than those of his teammates. The goaltender's role is essentially to defend the club's dignity. In this sense, the goalkeeper's role is similar to that of the idealized poet—to defend the dignity of humanity. According to this theory, Hernández's "Elegy to the Goalkeeper" could be analyzed from the viewpoint that the role of the goalkeeper in the poem serves as a metaphor of the poet himself. Hernandez's ability (as a poet) to identify with the goalkeeper might also have inspired Rafael Alberti, a year later, to write a poem about FC Barcelona's goalkeeper Franz Platko. I covered Alberti's "*Ode to Platko*" in chapter 2 to highlight FC Barcelona's combative spirit in the face of adversity. The poem also serves as a great example of the compatibility of soccer and literature. Although the kick-lit genre would largely be on hiatus during the Civil War, these two poets returned to this theme previously touched on by their medieval and golden age predecessors and are largely credited for bringing kick-lit to the general population of Spain during the twentieth century.

Interestingly, Spain's Miguel Delibes, Argentina's Che Guevara, and France's Albert Camus all spent time in their lives as goalkeepers. It is not surprising that their time "between the sticks" played an important role in the formation of their character. Camus wrote, "What I know most, in the long run, when it comes to the morals and obligations of men, I owe to soccer."[3] While this citation demonstrates how Camus was grateful for

the role soccer played in molding him into an upstanding citizen, the following quote demonstrates just how close to his heart he held the responsibility of defending his team's dignity. He wrote, "This was why I loved my team so much, not only for the joy of victory when combined with the fatigue produced from effort, but also for the stupid desire to cry at night after each loss."[4] Both Delibes and Camus went on to become kick-lit contributors and defenders of the genre's legitimacy.

One of Spain's Nobel Prize–winning authors, José Camilo Cela, also spent a large part of his formative years on the soccer field.[5] The role that soccer played in his life was also reflected in the literature he produced as an adult. Cela is one of the most prominent Spanish authors to pursue kick-lit during Franco's dictatorship with his *Eleven Soccer Tales* (*Once cuentos de fútbol*) (1963). Cela's *Eleven Soccer Tales* is comparable to the distinguished work of another Nobel Prize–winning Spanish author, Juan Ramón Jiménez, who received the award in 1956. Jiménez's distinguished work was *Platero and I* (*Platero y yo*) (1917). I find *Eleven Soccer Tales* to parallel Jimenez's *Platero and I* in that both were presented under the guise of children's stories, but under more careful review it becomes clear that they were actually dealing with more profound social issues. Years passed before the hidden meanings and symbolism in *Platero and I* was discovered, and I believe that Cela's *Eleven Soccer Tales* may also one day have the same belated recognition. *Eleven Soccer Tales* has been overlooked for years simply because it appears to be a children's story about soccer. Not only does Cela's work address the role of soccer as a social phenomenon through his eloquent use of the language and advanced writing styles, but he also offers his readers a number of life lessons that can be connected to soccer and reflected on.

One particularly interesting aspect of Cela's *Eleven Soccer Tales* is the narrative technique he uses, which has a Quixotic verisimilar quality, and in his language he evokes a sarcastic, ironic, and humoristic tone. A single narrator (that seems to be Cela himslef) tells each of the eleven stories to his implied audience—a child who sporadically interrupts him to ask questions typical of those that a child listening to a story might ask. Their relationship is one of mutual respect. In the book's dedication, Cela alludes to whom this implied audience might be when he writes,

> To my collaborator don José Sáinz González, alias Pepe, who painted the paintings that illustrate this book. In 1962, date of the paintings, don José Sáinz González, alias Pepe, was eight years old. In 1963, when these pages were written, yours truly walked with forty-seven, which aren't all that many after all.[6]

The relationship between Pepe and Cela throughout the stories adds to the book's verisimilar quality and creates a story within the stories making the text that much richer. This relationship also demonstrates that literature and soccer serve to bridge what would otherwise be a wide

generation gap. Each story is accompanied by a color illustration, drawn by Cela's young friend, who he continuously refers to with affection, as don José Sáinz González, alias Pepe.

Cela's humor emerges in a number of ways throughout the text, but one comical aspect that he seems to use frequently is in the names he gives his characters. As is the case with don José Sáinz González, alias Pepe, almost every character throughout the text not only has an extremely long, often abnormal name (containing a mouthful of syllables that somehow manage to flow from the tongue in an oddly enjoyable way), but also has either a nickname, a descriptive secondary title, or an alias—like Pepe. Cela continually refers to these characters using their full name—alias and secondary description well after all names have been clearly established. His avoidance of pronouns adds drama to the story and prestige to the character for a youngster, but it is blatantly comical to an adult. Some of the names he repeats are don Teopempo Luarca Novillejo, alias Pichón, and don Leufrido de Escondidas y Oprí, conde de Casa Lahorra. Other names include Exuperancio Exposito, who is a soccer hero, and Estanislao, a soccer-playing golden ram.

In *Eleven Soccer Tales*, Cela was one of the first kick-lit authors to structure his book to represent the sport of soccer itself. The book consists of eleven parables to represent the number of players that a soccer team puts on the field. The first story serves as the introduction to the book and is titled "The Foot and the Ball or Parable of Childhood for Life" ("*El pie con la bola o parábola de la juventud de por vida*"). The book is then divided into four sections that he calls "notebooks" (*mamotretos*). Each notebook consists of three stories, with the exception of the fourth notebook, which has only two tales. He closes the book with a story titled "Colophon Wrapped in 'Monday's Page'" ("*Colofón envuelto en 'la hoja del lunes'*"), in which he addresses the sport as a social phenomenon in Spain. The first notebook is titled *The Slicer* (*La lonja*) and contains three parables: "Applications of the Theory of Free Trade" ("*Aplicaciones de la teoría del librecambio*"), "The Little Deal" ("*El tratillo*"), and "Fable of the Golden Ram" ("*Fábula del carnero de oro*"). Each parable is in some way related to the economic market and is connected to soccer in a fantastical way. For example, "The Little Deal" tells the story of Teopespo Luarca Novillejo, who is an agent dedicated to making his living by embalming soccer players and selling them on the black market. Many other kick-lit authors have also designed the structure of their books to resemble the structure of soccer. One example is the previously mentioned *Toe-poke*, which is also a compilation of eleven stories about soccer.

Through *Eleven Soccer Tales*, it's clear that Cela considers soccer to be a source of enjoyment—that, in its purist form, it is a place where an individual can find innocence and revert to that innocence as an active participant no matter what his age. Cela's introductory story, "The Foot and Ball or Parable of Childhood for Life," defends this very idea. Cela opens

his story with a quote from Pablo Picasso in which the painter proclaimed, "When one is truly young, one is young throughout his entire life."[7] Cela then tells the story of a girl named Gildarada, who lived as if she were a widow from the day she was born. He describes her by saying, "Gildarada was born a widow, she's now actually been widowed for three years . . . maybe one day she'll discover that calendars don't measure age."[8] Cela then interjects himself into the story when telling of the hypothetical event in which later in life Gildarada searches for her childhood friend who (unlike her) never seemed to grow old. As a child, Gildarada could always find this friend at (what she considered) the disgusting deserted fields on the outskirts of town where folks would often gather to play soccer. When she looks him up again, she finds him playing at the same fields in the same condition as when he was a youngster, full of life and passion and coincidentally screaming at the top of his lungs, "C'mon!! Shoot, Camilo!! We're tied at eighteen!!!"[9]

Like a number of other Spanish kick-lit authors, Cela uses bullfighting (a cultural aspect that is deeply rooted in Spain) as a metaphor to explain Spain's approach to soccer. In "Fable of the Golden Ram," Cela (the narrator) tells Pepe (the implied audience),

> That which in the bulls is called caste, in soccer players is called class. There are bulls with caste, lots of caste, and soccer players with class, lots of class. Others, are livestock, meat for the matador, left over cowbulls to be liquidated at the end of the season. The caste, in bulls, is not bravery, or at least, it's not only bravery. It's the same when it comes to class in soccer players. There are submissive soccer players with lots of class that supplement courage with science (like Madam Curie). Estanislado [the protagonist] is very complete. Estasnislao, aside from class, has personal valor and shakes oakum with enthusiasm and without discrimination. Estanislao is what is called a complete athlete: strong, tireless, aggressive, intuitive and creative.[10]

The moral of "Fable of the Golden Ram" conveys to Pepe that these personality characteristics lead to success in both soccer and life. Through this story, Cela, like many other kick-lit authors, recognizes and defends soccer as a metaphor for life, claiming soccer and life embody the same aspects, positive and negative.

In the final story of *Eleven Soccer Tales*, Cela addresses another popular kick-lit topic—that of the sport being a social phenomenon in Spain. Cela describes this phenomenon by telling Pepe,

> Various hundreds of thousands of Spaniards, or maybe even various thousands of thousands, spend Monday, Tuesday, and Wednesday licking their wounds from their teams' previous match, and Thursday, Friday, and Saturday anxiously anticipating the upcoming match. Sundays, they rest and go watch soccer: to suffer, or to bask in watching others suffer.[11]

Cela contributed more than just *Eleven Soccer Tales* to the kick-lit genre. He also wrote a poem called "Trip to the USA" (*"Viaje a USA"*), in which he uses one of his favorite clubs, *Celta de Vigo*, to convey the notion that patriotism is strengthened when traveling abroad. Cela has a number of other short kick-lit stories, such as "Trip to Another World" (*"Viaje al otro mundo"*) (1949), which tells the story of the journey that two Basque men have when traveling to Madrid on a donkey to attend the Cup final between *Athlétic de Bilbao* and *Valencia*. Another approach to the kick-lit genre by Cela was written in 1991 titled "Maradona." This work chronicles the events leading to the descent from greatness of the Argentinean superstar Diego Armando Maradona. However, *Eleven Soccer Tales* is clearly special in that it combines the key elements that make up a work of Spanish kick-lit. First, as a work of literature, Cela makes a connection between *Eleven Soccer Tales* and the work of other famous Spanish writers previously mentioned—Cervantes and Juan Ramón Jimenez. Julián García Candau even stated that Cela's *Eleven Soccer Tales* "has an ironic and at times *esperpentic* vision."[12] Candau therefore connects *Eleven Soccer Tales* to the most radical dramatist of the Generation of '98; Ramón del Valle Inclán's defining literary creation *"El esperpento"*—a uniquely Spanish literary style in which distorted visions of reality are used to criticize society. Second, in *Eleven Soccer Tales*, Cela makes comparisons between soccer and an aspect of culture that is deeply rooted in Spain—bullfighting. Third, he shows soccer in Spain as a social phenomenon. Fourth, he shows how the sport is used as an escape mechanism, which in turn reinforces the popular Spanish theory of "bread and bulls." Fifth, like many others, he presents soccer as a metaphor for life. Interestingly, some Spanish kick-lit writers refer to the soccer arena or stadium as the "field of life" after the popular concept of the "tree of life," which communicates the idea that all aspects of life on earth are symbolized through the metaphor of a multibranched tree. They claim that the soccer arena can serve as a replacement for the symbolic multibranched tree.

NOTES

1. Julian Garcia Candau, *Épica y lírica del fútbol* (*Epic and Lyric of Soccer*) (Madrid: Alianza Editorial, 1996), 13.

2. Almudena Grandes, in Winston Manrique, *"El fútbol da cancha al libro"* ("Books Give Court to Soccer"), *El País*, June 4, 2006, www.fcbarcelona.com/web/english/club/club_avui/mes_que_un_club/mesqueunclub_historia.html (January 23, 2009).

3. Albert Camus, in Eduardo Galeano, *Su majestad el fútbol* (Montevideo: Arca, 1968), 12–13.

4. Camus, in Galeano, *Su majestad el fútbol*, 11–12.

5. Cela was awarded the Nobel Prize for Literature in 1989. His distinguishing work was *La Colmena* (1951).

6. Camilo José Cela, *Once cuentos de fútbol* (*Eleven Soccer Tales*) (Madrid: Editorial Nacional, 1963), 13.

7. Pablo Picasso, in Camilo José Cela, *Once cuentos de fútbol* (*Eleven Soccer Tales*), 17.

8. Cela, *Once cuentos de fútbol* (*Eleven Soccer Tales*), 17.
9. Cela, *Once cuentos de fútbol* (*Eleven Soccer Tales*), 18.
10. Cela, *Once cuentos de fútbol* (*Eleven Soccer Tales*), 34.
11. Cela, *Once cuentos de fútbol* (*Eleven Soccer Tales*), 81.
12. Candau, *Épica y lírica del fútbol* (*Epic and Lyric of Soccer*), 309.

EIGHT

David Trueba's *Knowing How to Lose*

Knowing How to Lose (*Saber Perder*) is a Spanish "kick-lit" novel by David Trueba that was published in 2008 and has since received quite a bit of attention. The story is grounded in contemporary Spanish society. Throughout the novel, Trueba touches on many of Spain's current social issues, such as the economic recession, poor working conditions, black market labor, racism, immigration, the rupture of the nuclear family, the lackluster educational system, the disillusionment with religion, and the growing power of the soccer industry. The story line of *Knowing How to Lose* intertwines the lives and families of a multitude of characters, making the novel rich and complex. The number of characters that Trueba introduces and develops is reminiscent of Cela's *The Hive* (*La colmena*). Trueba's characters appear to be ordinary people with normal goals, desires, complexities, and problems, but through an omniscient narrator, Trueba offers not only a special insight into his characters' lives, inner thoughts, and voices of reason but also a front-row seat to their most intimate secrets, insecurities, fears, and failures. The novel's rhythm is very well balanced and is written in a simple, straightforward language. Throughout the novel, Trueba exposes a wide range of foreign languages, in which he demonstrates a certain level of sensitivity toward the accents and colloquialisms of these immigrants from countries such as Argentina, Ecuador, Nigeria, and Brazil.

The central figure of the novel is Sylvia, a girl disillusioned with high school and ready to move on to a more mature existence. Sylvia is about to turn sixteen when she learns that her mother is leaving the family since she has fallen desperately in love with her boss. Sylvia is forced to become independent more quickly than she ever imagined. Her father, Lorenzo, has trouble coping with his wife having left him and blames her departure on his current economic situation—Lorenzo had been a very

successful businessman until Paco, his well-to-do business partner, swindled him into bankruptcy. Unable to control himself, Lorenzo commits a crime he never imagined himself capable of and murders his ex-partner. This leaves Lorenzo in a state of constant paranoia for the rest of the story. Sylvia's grandmother, Aurora, falls while getting out of the shower and is hospitalized for the remainder of the novel. She fluctuates from being on the brink of death to stable throughout the story. Sylvia's grandfather, Leandro, is a man who has led a respectable life as a classical pianist but now faces the difficulties of growing old. The only way he feels he can sedate this fear is by secretly visiting a nineteen-year-old Nigerian prostitute named Osembe. While his wife lies dying in the hospital, Leandro spends over 60,000 euros of his retirement money on Osembe. In the end, Osembe has Leandro set up to be beaten and robbed by her pimp. This results in his secret life being discovered by Lorenzo, who is extremely disappointed in his father, but recognizes that as a murderer he is no one to pass judgment.

After celebrating her sixteenth birthday, Sylvia is struck by a drunk driver while crossing the street. The driver of the car turns out to be Madrid's newest phenomenal soccer player from Argentina—twenty-year-old Ariel Burano. After hitting Sylvia, who is rendered unconscious, Ariel calls the club's administrators, who quickly clean up the mess and save him from a tarnished reputation. Against the club administrators' wishes, Ariel puts himself in contact with Sylvia so that he can apologize for the harm he has caused her. She soon discovers he is a star soccer player, but since she is completely unimpressed by the world of soccer in Spain, she treats him like an ordinary person. Ariel later returns to the hospital with a check for 25,000 euros as compensation, but Sylvia rips it up—something she probably would not have done had she been fully aware of her father's current economic crisis. Sylvia keeps Ariel's identity secret and their relationship eventually develops into a love affair. The affair must be kept secret because although Sylvia is very independent and mature, she is only sixteen and Ariel is twenty. If discovered, this would put more in jeopardy than just his reputation as a professional soccer player.

There are a number of secondary characters that Trueba develops with the same care and precision that he does the primary characters. Dani and Mai are Sylvia's friends from school. Dani is a typical adolescent—insecure and looking for love and acceptance among his peers. Mai is Sylvia's closest confidant and because Mai has experienced a variety of sexual escapades, she serves as Sylvia's sex mentor. Mai's identity is largely determined by whoever is her current boyfriend. Daniela and Wilson are Ecuadorian immigrants whom Sylvia's father, Lorenzo, befriends. Lorenzo becomes involved in numerous black market operations with Wilson, who is eventually murdered. Lorenzo also reignites his desire for love and develops a relationship with Daniela, who is deported

just as the love affair begins to turn serious. Although Osembe makes a living as a cold and calculating prostitute, her sad existence in Spain is a paradise when compared to the life she was subjected to as a child in Nigeria. Charlie is Ariel's brother and accompanies him on his journey to Spain. Charlie is quickly sent home after being accused of sexually assaulting a girl in a hotel room while traveling with his brother's new club. Pujalte is the club's director and is the hand that exploits and extorts Ariel whenever it suits his needs. He threatens to expose Ariel's drunk-driving accident, his brother's sexual assault accusations, and his statutory love affair with Sylvia—for which Pujalte provides photographs. Dragón is Ariel's ex-coach and continues to serve as his mentor from across the Atlantic. Dragón's son becomes involved in drugs and eventually dies from an overdose. Dragón is devastated and says, "All my life dedicated to developing kids, and it turns out the one I did the worst job with was my own."[1] Amilcar is a Brazilian veteran of the club who serves as a friendly mentor to Ariel. One night after dining together, Amilcar leaves on an errand, and his ex-supermodel wife seduces Ariel, inviting him to join her for a nap. Ariel falls into the trap and soon discovers it was a trick designed to prove he has a tendency toward sin. Through this scheme, she attempts to convince Ariel to join their religious cult. Trueba develops a variety of other characters, with backgrounds of similar profundity throughout the novel. It's sufficient to say that he gives almost all of them a dark secret.

The common thread of the story is that all the central characters are going through life-changing episodes that they do not know how to deal with. Their attempt to soothe the anxiety caused by their inability to cope with these situations results in their reacting in immoral and illogical ways. Trueba expresses these transitional phases as the essence of life— the moments when we find ourselves most emotionally vulnerable that expose the purest aspects of human nature.[2] The book's four-part structure reinforces these uncertainties and presents them in the form of questions that the characters might be asking themselves: (1) Is this Desire? (2) Is this Love? (3) Is this Me? (4) Is this The End?

The characters in *Knowing How to Lose* are depicted as sincere people who want to be good and kind to one another. They are simply struggling with life and the difficulties of modern society. Their reactions to these situations are instinctive, and although these characters recognize them to be immoral and harmful, they seem to think there is no other way to sedate the pain, struggle, and fear that they are dealing with. When analyzed from this perspective, Trueba's novel is a critique of modern society.

The novel has a very pessimistic vision of the world. Each of our antiheroes is overwhelmed either with life's harsh realities or with the injustices of today's society. The antiheroes recognize that it is only a matter of time before their biggest fears are realized. Sylvia and Ariel

know their love affair will last only until soccer takes Ariel elsewhere, which turns out to be after just one season. Nearing the end of his life, Leandro knows it won't be long until he and his wife are overcome by death. Although Lorenzo is never convicted of his crime in the story, it's implied that he will spend the rest of his life feeling guilty and looking over his shoulder fearing his eventual capture and conviction. Throughout his book, Trueba communicates that people in today's society need to accept the world's injustices and loss. *Knowing How to Lose* is a text that adds to the body of Spanish work that depicts the sense of chronic fatalism within Spanish society.

After Lorenzo murders Paco, he attends a home soccer match to take his mind off of the torment he is experiencing. The match happens to be Ariel's debut with the club. Trueba's description of the scene highlights a number of interesting social topics that can be observed while attending a soccer match in Spain. The narrator describes the scene, putting the majority of the focus on Lorenzo:

> Converted into a murderer he watches soccer. . . . The coach orders a quick change and substitutes the outside left midfielder with a recently acquired Argentinian who's received with jeers from the fans. Lorenzo also gets up to heckle. Go back home, Indian, go back home, a group of kids sing. The player doesn't run all the way to the touch-line and that upsets the fans even more. Run, you South American piece of shit, someone yells. Lola and Oscar laugh. Is he too cool? Why doesn't he run? We're losing. The protest relaxes Lorenzo, he reconciles with himself. Participating in general indignation is a form of evasion. And those five minutes in which the stadium pushed for the local team to get the tie that never came were the only five minutes that he enjoyed over the past few days.

Throughout this paragraph, Trueba addresses the fact that racism runs rampant in modern society and that, for many, the soccer arena serves as a platform from which certain people choose to express their pent-up racism. Trueba also alludes to the idea that soccer serves as "the opiate of the masses" because, while Lorenzo cheers for his team, he is temporarily relieved of worrying about his problems.

After losing the match, Ariel is distraught by the less-than-warm welcome he received during his first performance with the club. He goes to dinner, gets drunk, and reflects on his arrival in Spain. This leads him to contemplate the complexities of the economic situation involved with the sport. Ariel thinks about when the club's administrator, Solórzano, tried to sum up the business side of things to him, saying,

> If the public squeezes, you put the president against the ropes and he pays whatever he has to, as long as you let them win a little, redirect a pinch of money to his account in the Caymans and everyone's happy. The important thing is that everyone is happy, right? Isn't soccer's ultimate goal to make people happy?

This citation communicates that Spanish soccer administrators still rely on the theory of "bread and bulls" to control the fans. However, Trueba suggests that now administrators approach this idea from a different angle: keep the masses happy, and the industry will continue to function—allow them to believe they have the upper hand every so often, and the money will continue to pour in.

After the dinner, Ariel is intoxicated and speeds home in an attempt to relieve his frustrations resulting from the loss of the match and his less-than-adequate play, the racial jeers he received from his own fans, and the controlling economic powers of the sport. He pushes the pedal even harder and decides to play Russian roulette with the traffic lights and eventually loses and hits Sylvia. His real problems are now about to begin.

Later in the story, Trueba again deals with the problem of racism in soccer. This is currently an issue that many advocates of the sport are addressing. The French captain Thierry Henry is one of the most outspoken activists against racism, as it affects both soccer and life. Trueba's narrator tells the substory about how every time Matuoko, one of Ariel's teammates from Ghana, touches the ball, a group of young fans make ape-like movements and monkey noises to insult the player. These same youngsters, who form part of an ultra-right-wing fascist group called Young Honor (*Honor Joven*), also greeted Ariel with racist jeers during his debut. Groups like Young Honor see the soccer arena as an outlet where they can express their political and racist beliefs. The narrator describes the club's connection to Young Honor in the following excerpt:

> The management pampers them because they're faithful and enthusiastic, they accompany the team on trips for ridiculously low prices and they even reap the benefits of having an office for their organization in the stadium. Last season, they brought an assault to the team bus during the return trip of a game that ended in a loss. They threatened players and insulted them with shrieks of mercenaries and vagrants.

Before Ariel was aware of Young Honor's fundamentals, he was scheduled to give an interview and do a photo shoot with the group. But the morning before meeting Young Honor in their stadium office, Ronco, one of Ariel's teammates, approaches Ariel to fill him in. Ronco explains their background by showing Ariel their website, which is filled with Nazi symbols. He describes it as "the typical threatening tone of a bully protected by the team's colors. The majority of the players on the roster pose for photographs with the group's scarfs and insignias in an exercise of submission." Ariel finds an excuse not to attend the photo shoot with the help of one of the club's employees. The narrator describes that from that point on, when Ariel hears the racist shouts of "Indian" and "*sudaca*" (a derogatory term for a South American) from the stands, it doesn't bother

him as much. The narrator sheds light on a sad fact by saying, "The environment around soccer is the same everywhere. Matuoko, for example, fights against an assumed fact: a black player has never been successful on this team."

By addressing this problem in his book, Trueba is taking a step to raise awareness that throughout Spain and Europe, clubs turn a blind eye toward fascist groups like Young Honor. The tolerance of this behavior nourishes racism. This is by far the ugliest aspect of the sport and is directly connected to hooliganism. Racism and hooliganism have plagued soccer and have caused many civilized people to avoid being associated with it in any way. The fault does not lie with the sport or the players; rather, it is a problem that exists in society and therefore cannot be expected to be absent from soccer. When it is extinguished in one, it will be extinguished in the other. Clubs such as Ariel's that nourish racism are unacceptable. When they nurture a hostile environment, the players suffer because a beautiful game turns ugly. The irony lies in the fact that when the players have finally reached the highest level of the sport, they become the target and recipients of society's harshest insults:

> Even the fans have a certain sense of belonging when they cheer on their team, because soccer has a great capacity to serve as a collective identity reference between what we can call urban popular culture. This is all true but as soon as something compromises man's passion it becomes easy to fall into excesses, and the integrating capacity begins to become depraved when fanaticism (the most dangerous derivative of intolerance) makes the game a question of honor and he ends up believing that a jersey is a motherland. Bad. For a long time soccer has been going down a dangerous path toward becoming a worrisome social tendency. The racism that is winning in the street has a festive extension on the soccer fields which is an offense to the intelligence and the essence of all sport. And in the newspapers it's common to see stadiums painted with legends in which players are denounced as "Indians," "*sudacas*" or "blacks" or to hear cynical tribal calls from the stands every time a player of color touches the ball. It's repugnant disdain toward anything different taken to the world of spectacle with the intention to humiliate. It is, plain and simple, a fascist act.[3]

Another issue that Trueba addresses is the notion that Spanish society is largely disillusioned with the Catholic Church and all that is religious. This is expressed through Lorenzo, who notes how profoundly religious many Latin Americans are, such as Daniela, his new Ecuadorian girlfriend. Lorenzo ridicules her for her beliefs, considering them behind the times. This is ironic since it was Spain that subjected Latin America to Catholicism in the first place. A number of writers have made the analogy that soccer is the new religion in Spain. For example, in José Luis Sampedro's "That Saintly Day in Madrid" ("*Aquel santo día en Madrid*"), the observation is made that Spaniards flock to soccer stadiums and are

mesmerized by the game as if they were in a cathedral, overcome by religion. Soccer's enormous fan base is considered by many to have proportions comparable only to that of religion. In *Knowing How to Lose*, when Ariel returns home for Christmas, he has a conversation with Dragón in which Dragón advises him, saying,

> Score goals, Spaniards only want goals. . . . The most important businesses dedicate themselves to those things that can't be touched, that are intangible. Look, the most profitable business in the world is the Church and then there is the soccer team. They both survive by people with faith, nothing more. Isn't it crazy?

Though Ariel has made a number of very poor decisions, Trueba still manages to offer the reader a sympathetic view of the struggles that a star soccer player is faced with. Not only does Ariel have to deal with threatening racist groups that are supported by his own club, but he is manipulated as a piece of the club's property. When he is offered the opportunity to play for Argentina's under-twenty National Team in a competition in Colombia, Pujalte calls him into his office and says,

> You're talking to me about a youth championship, for kids . . . but we aren't able to lose you for four very important matches of our own and send you to Colombia for an elimination match so that you will stand out among the other promising youngsters. . . . Here you have to decide between professionalism or pleasure. . . . You have to forget about your country. . . . It's time to grow up. You came to Spain to grow, fuck, to become a man, not to play in youth matches. What if you got injured? An injury now would be a catastrophe.

When Ariel reminds him that the Federation has the right to obligate the clubs to turn their players over for international competitions, Pujalte says, "Well of course they obligate, that's what we're talking about, your renunciation has to be voluntary." Pujalte then reminds Ariel of the jeers that he receives from his home crowd and says, "The fans will appreciate your gesture, your sacrifice. It could be the way that you win over the fans, that you overcome your reticence."

The narrator tells us that Ariel does not even respond since he knows that the battle is lost. "He knows it's nothing more than power, if he were having tons of success and was known by everyone, he could challenge. But not now, his is a different place. He has to accept it." Already, Ariel is learning how to accept loss—which is fitting considering that the book's title loosely translates as "Knowing How to Lose," "Learning Loss," "Knowing Loss," or even "Accepting Loss."

Throughout the novel, Trueba reinforces the notion that soccer at the professional level is an industrial juggernaut that is much bigger than any individual. The perspective that Trueba gives the reader into all these social issues that find their home in the soccer arena essentially presents the world of soccer as the true embodiment of modern-day society.

In many ways, it could be said that the character of Ariel is modeled after Jorge Valdano—both came to Spain from Argentina at a very young age: Valdano at nineteen and Ariel at twenty. Both were selected to play for their youth national teams, and both are enthusiasts of art and literature. Ariel goes to Madrid's famous museum, The Prado, and is spotted by a group of teenagers on a class tour. He quickly gains the reputation as a soccer player who breaks the stereotype because he appreciates high culture. In another scene, Ariel attends a birthday party of one of his Argentinean friends who was also playing in Spain. When the man celebrating his birthday opens his presents, he receives a book and the entire party is shocked to find someone giving a book to a soccer player. Soon they realize that the gift came from Ariel. Throughout the novel, although Ariel makes many typical mistakes of a twenty-year-old, Trueba portrays him as a very levelheaded, contemplative, and sincere soccer player—much like the reputation Valdano has gained in real life.

When Ariel goes to Dragón for advice about the difficulties he is experiencing as a professional soccer player, Dragón's advice almost exactly parallels a passage from Jorge Valdano's *Stage Fright and Other Herbs* (2002), in which Valdano addresses a distraught professional soccer player directly. Valdano writes,

> Soccer player: Remember when you used to dream? You were twelve years old and through your illusory mind ran volleys, goals and applause. How sad to return from such a beautiful idea, so distant, so impossible. . . .
>
> And do you remember when you went to see your idol? It caused you to feel a hole in your stomach and your admiration was bordering on envy. How ugly to leave the field and discover you're human; it was unbelievable, impossible, who could have imagined it. . . .
>
> And do you remember the first day you practiced with the first team? Your desire to be on their level was seen through your enthusiasm, hoping no one would notice the difference. . . .
>
> What fear to not arrive, to not be capable, to not reach them. . . .
>
> And you signed your first professional contract. It must have been a mistake: who could have compelled an owner to featherbed you with happiness? You looked all around, you abandoned privacy for a certain sense of embezzler, you put on a face to deserve it and gave yourself fully over to being a professional without knowing very well with what right. What memories, right? How new everything was.
>
> Now, you feel like you hold a certain office. The routine has fallen on top of you and overcome you with its patient obligations. You become tired, you become bored, you complain. Soccer is your job. Your job!
>
> Listen well. If you get bored or if you get tired, remember when you used to dream, when you were a fan, when you began. But, above all, remember not to complain. Remember, in the end, about those who

truly work and give something up, whatever it may be, in order to buy a ticket for the match on Sunday. Just to watch you.[4]

When Valdano's advice is compared directly with the advice Dragón gives Ariel, the similarities are very noticeable. Dragón tells Ariel,

> You, play. Don't take any responsibilities upon yourself. There's no reason to ever forget the pleasure of playing. Yours is an absurd job. If you don't enjoy yourself while doing it, there's no point. You can't allow yourself to think. You'll become paralyzed. This is why the smart thing to do is gesture the proper anguish. Look at what happens in the world, if you stop, if you stop to think, it will be suicide trying to juke someone and think back to those dim-witted Cro-magnons trying to tell you how you're supposed to play.

In an interview about the book, Trueba mentions that his friendship with the manager of FC Barcelona, Josep Guardiola, helped him better understand the game and see it in a different light so that he could more precisely and profoundly convey the world of professional soccer in Spain. This demonstrates Trueba as an intellectual who felt that he needed to delve even further into the game to better understand and uncover its truths. In the novel, Trueba addresses the clash between the intellectual classes and the soccer community. Trueba's depiction of this clash demonstrates a newfound friendship between the two, and he uses his characters in the book to represent the different sides of the dispute to show how each are presently becoming more interested in and accepting of the other. For example, Sylvia represents a young, bright intellectual who initially adheres to the notion that soccer and intellectualism are not compatible. Being the intellectual that she is, when presented with the opportunity, she puts all stereotypes aside and attempts to experience the game for herself. In doing so, she overcomes the negative stereotype, to an extent, and finds aspects of the sport that she enjoys, although she finds that, like life, soccer has its positive and negative attributes.

Ariel, on the other hand, forms part of the soccer community, and his character therefore represents the anti-intellectual. However, Ariel proves to be one of the members of the soccer community that does not reject intellectualism; rather, he is drawn to certain aspects of it. For example, Ariel gains the stereotype among his soccer peers to be the one who actually chooses to read books, go to museums, and pay attention to the profound lyrics of his favorite artists. Ariel is an intellectual simply for the fact that he sees things with a very open mind, as does his girlfriend, Sylvia.

One tie that links all the characters of *Knowing How to Lose* is that they are going through a transitional stage in their lives. It is possible that through this, Trueba is trying to express that, in life, change is always occurring and that as soon as an individual enters into a comfort zone, he will soon be forced to move on. This is demonstrated by the fact that

Ariel is learning about what he appreciates most in life, Sylvia is coming of age as a woman, Lorenzo is coping with having been cheated by his business partner and subsequently losing his wife, the grandmother is in the hospital and near death, and Leandro is having trouble accepting the notion of growing old and blows his life savings on a prostitute. At one point in the story, Leandro expresses his concern to his son Lorenzo and proclaims that his problem lies in the fact that we are never taught how to grow old. These characters do not cope well when dealing with the new situations that life presents, and neither do real people. Trueba's *Knowing How to Lose* is a contemporary novel that is very closely linked with Spanish society toward the end of the twenty-first century's first decade, thus making it an important contribution to contemporary Spanish literature.

NOTES

1. Unless otherwise noted, all quotes in this chapter are from David Trueba, *Knowing How to Lose* (Barcelona: Editorial Anagrama, 2008).

2. This is a recurring theme in other works done by the Trueba brothers such as in the films *Welcome Home* (*Bienvenido a casa*) directed by David as well as *Year of Enlightenment* (*El año de las luces*) and *Beautiful Era* (*Belle époque*), which were directed by Fernado.

3. Jorge Valdano, *El miedo escénico y otras hierbas* (*Stage Fright and Other Herbs*) (Buenos Aires: Aguilar, 2002), 297.

4. Valdano, *El miedo escénico y otras hierbas* (*Stage Fright and Other Herbs*), 280.

NINE

Soccer Stories

In 1995, Jorge Valdano, the world's leading "kick-lit" advocate, compiled twenty-four short stories about soccer written by some of the Spanish-speaking world's most reputable authors. This compilation of "kick-lit" stories is titled *Soccer Stories* (*Cuentos de fútbol*) and offers the reader a glimpse into the infinite possibilities from which soccer can be approached through literature. In the book's prologue, Valdano addresses the ongoing conflict between intellectuals and soccer by telling a fictional anecdote about a fictitious intellectual named "Alcides Antuña Caballero," who goes to great lengths in his attempt to discover exactly what makes soccer so special and why this game captures the hearts of so many people around the world. Alcides conducts an investigation that takes him to all corners of the globe. Through his travels, he arrives at a number of conclusions about soccer: it is a universal phenomenon, it connects people from different generations, it is blind to social status, it is a cultural expression like any other, it is a vehicle for communication, and it is an escape mechanism and means for distraction. After his investigative travels fail to produce a satisfactory answer, Alcides goes to the library and finds that philosophers and writers such as Marx, Sartre, Camus, and Borges had all addressed the topic of soccer in their work, but the complexity of their writings confuse Alcides even further. Eventually, Valdano relays that Alcides began turning every soccer conversation he had into a philosophical discussion. Soon, Alcides came to annoy even himself. His frustrations grew to insomnia, which then turned into complete madness. In *Soccer Stories*, a number of tales address these philosophical conclusions that Valdano's character, Alcides, had arrived at about the sport, and they are almost always grounded in cherishing the ineffable pleasures of these two cultural phenomena: soccer and literature. Valdano explains the purpose of his fictional anecdote stating,

The tale of Alcides will serve as the prologue for this book and I have
chosen to share it with you even though it's more endearing than good,
with no other pretense than to wet the readers' appetites and to warn
the intellectuals out there of the risks involved in taking a game too
seriously. Science has dedicated itself to demonstrate that intelligence
has many ways of expressing itself, however it is still incapable of
breaking stereotypes. This book will defend this cause.[1]

Valdano describes his compilation as serving as common ground for
where both muscle and thought can merge and, it is hoped, overcome
their differences. He writes that *Soccer Stories* is "a game, dropped into
another game—that of literature. Man escaping reality with the task of
finding his most profound aspirations."

Soccer Stories is a unique and important contribution to the kick-lit
genre because through it Jorge Valdano commanded recognition and re-
spect for literature containing a central theme of soccer. He compiled
twenty-four preexisting works of kick-lit written by twenty-three of the
Spanish-speaking world's most recognized and celebrated authors, along
with one fun-loving tale written by himself. In this chapter, I will give a
brief summary of the stories written by Spaniards that appear in *Soccer
Stories* before offering a more in-depth analysis of four stories I have
selected that were also written by Spaniards. But first, Valdano's contri-
bution to *Soccer Stories* titled "I'm Pretty Sure, Ma'am, Your Son Really
Shit the Bed on That One" ("*Creo, vieja, que tu hijo la cagó*") is a story of a
goalkeeper named Juan Antonio Felpa who finds himself having to de-
fend his club's honor and save a penalty kick in order to win the cham-
pionship for his hometown club. As the kick is about to be taken, the
narrator flashes back to how Felpa had arrived at this point and describes
some of the struggles and adversity that Felpa overcame to become the
goalkeeper for his hometown club. Felpa was determined to save this
penalty kick and prove everyone wrong who told him he was not good
enough to be the goalkeeper. As the shot came, the crowd chanted, "Fel-
pa! Fel-pa! Fel-pa!" and he jumped so far to the left that the hat he was
wearing to block the sun flew off his head and into the goal. Miraculous-
ly, Felpa caught the ball with both hands, and his dream of being the
hometown hero had seemingly come true. Overcome with joy and not
knowing exactly how to react, Juan Antonio Felpa proudly stood up with
the ball under his arm and, as the crowd cheered for him, walked into the
goal to retrieve his hat. At this point, one of Felpa's friends turns to the
goalkeeper's mother and says, "I'm pretty sure, Ma'am, your son really
shit the bed on that one."

Soccer Stories covers a wide range of kick-lit topics. Valdano's contri-
bution is clearly a fun-loving tale demonstrating certain lessons an indi-
vidual can learn through soccer. At the same time, his story embraces the
sport at the amateur level and gives the reader a glimpse into the inten-
sity of the soccer rivalries between neighboring towns in Latin America.

The other stories from *Soccer Stories* tackle the kick-lit genre from a variety of angles. The well-known Galician writer Manuel Rivas's "The Coach & Iron Maiden" (*"El míster & Iron Maiden"*) is a story that depicts soccer as a mechanism that can connect people from different generations.

"The Coach & Iron Maiden" is a tale that is divided into two parts. When the story begins, the reader is immediately thrown into the first scene, where a teenager whom the narrator calls "the youngster" is reacting hysterically to a goal given up by his favorite team, Deportivo de la Coruña. The youngster wears a black T-shirt from the heavy metal rock band Iron Maiden. This T-shirt symbolizes both the hostile temperament typical of a teenager and the generation gap between he and his father, with whom he is watching the match. Throughout the story, the father (whom the narrator refers to as "the grey-haired man") and the teenager argue vehemently about the soccer match. The youngster blames the late goal his team gave up on the coach's decision to substitute an attacker for a defender late in the game by saying, "What a donkey! . . . We were winning and there he goes subbing a forward for a defender. He always recoils. Doesn't anybody recognize that he always ends up being intimidated and recoiling?" The grey-haired man stands up for the coach and says, "You don't even know what you're talking about! . . . Aren't there eleven players out there? Why do you always put all the blame on him?" The teenager claims the coach deserves the blame and yells, "Retire old man! Retire already!" This comment clearly affects the grey-haired man, who identifies with the team's coach. The youngster storms off and yells, "That's it. Now we're fucked! This game's fucked." The mother shouts to the teenager from the kitchen, "Don't use that kind of language in this house!" The youngster yells back, "I'll speak however I damn well please!"

In the second scene, the youngster and the grey-haired man are driving a boat through the sea near Galicia's Coast of Death (*Costa da Morte*). The youngster is trying to return home before the tide is at its lowest. The grey-haired man is the passenger on the boat. It's an eerie evening, and both the grey-haired man and the youngster are having dark, existential thoughts when the boat bottoms out:

> The boat was hit on the broadside and sent flying like a pool cue against the storm wall. But the youngster, as he remembered, didn't feel any pain. He ran and ran waiving his arms along the sideline, electrified like the Iron Maiden ghost. He had just dribbled the whole team, one after the other, and scored the third goal in the last minute, and at this moment he is running along the sideline in slow-motion, mullet in the breeze, as the Blue Razors bounce and wave their white-and-blue flags. He runs and runs along the sideline with his arms stretched wide open to hug the grey-haired coach.

With the final scene of the story, it's clear that Rivas was depicting what heaven might be like for someone as passionate about soccer as the youngster. It's through soccer where many people's dreams lie in their purest form. It is for this reason that Rivas makes the analogy between heaven and the feeling one might have on scoring the goal of his dreams, because scoring such a goal is as close to nirvana, euphoria, or heaven that some people can earthly imagine. "The Coach & Iron Maiden" depicts soccer as an unburnable bridge between generations and the euphoric sensation of victory as the closest that humankind can come to experiencing heaven on earth. Clearly, "The Coach & Iron Maiden" defends soccer as a social phenomenon.

Other short stories by Spaniards that appear in *Cuentos de Fútbol* are Agustín Cerezales's "Offside" (*"Fuera de juego"*), Miguel Delibes's "The Championship" (*"El campeonato"*), Fernando Fernán Gómez's "The Manager" (*"El directivo"*), Julio Llamazares's "So Much Passion over Nothing" (*"Tanta pasión para nada"*), Javier Marías's "The Hesitant Moment" (*"El tiempo indeciso"*), Justo Navarro's "The Soul to the Devil" (*"El alma al diablo"*), Rosa Regàs's "Wanting to Complain for Real" (*"Ganas de quejarse de verdad"*), and Manuel Vicente's "Deep South" (*"Fondo Sur"*). With "Offside," Agustín Cerezales tells the tale of a man fed up with life who, early in the story, has an argument with the clerk at the bakery over the fact that he did not receive the correct change. After this argument, which seems insignificant, the protagonist is so overwhelmed that he decides he has had enough of this life. Because of this encounter, he plans to commit suicide when he arrives home from work that night. The fact that the story is narrated in the first person by the protagonist offers the reader the ability to identify with the protagonist, although it is easy to see that his voice of reason is completely distorted. Just before heading home, the protagonist is invited to attend a soccer match between Atlético de Madrid (whom he has supported for years) and Real Madrid. The protagonist decides to attend one last "derby"[2] with his colleague from work. While at the match, the protagonist is less than interested in anything taking place until he spots a young woman walking through the stands selling concessions. The protagonist describes her as the following:

> She was a young girl that had blossomed into a woman, brunette, with enormous black eyes and a thick braid that fell down her back. She carried the bucket of beer and soda, never hunching over or losing her smile. No one could have looked so good in that little white and red Coca-Cola jacket. Beneath her jeans were long, fit legs and a heart-breaking backside. And whenever she raised up her arms to hand a fan a drink sitting a row or two above her, her belly-button would show. Her belly-button . . . I'm not even going to try to describe it. I'll simply say that woman illuminated the most erotic of enchantments and the most spiritual beauty.

It is from this encounter that our protagonist regains his desire to live. He pursues the woman over the next few months. As he gets to know her, he informs the reader that her name is Marí Carmen and that she was working as the concession girl to fill in for her sick father, whom she regularly took care of at night and made lunch for on a daily basis. During the day she worked in a beauty salon, and in the evenings she studied computer science. The protagonist adores her and states, "Oh dear woman!! So strong, happy, clean and valiant! And above all: she's not a fan of Real nor Atlético Madrid, but she's a Rayo Vallecano fan!" Clearly, the fact that she supports Rayo Vallecano over Real Madrid or Atlético de Madrid is symbolic of her modesty and demonstrates that in Spain, an individual's morals and personality, in many ways, can be determined by the team he or she supports.

Miguel Delibes's "The Championship" is a short story about a conversation three individuals have in a bar while watching Spain versus Uruguay in the World Cup. Delibes's tone, insight into his characters, and anticlimactic story line is reminiscent of the work of Ernest Hemingway. The characters are Juan, who smokes cigarette after cigarette hoping Spain can pull off the win and advance to the next round; the blonde bombshell girl, who accompanies Juan; and Simón, the bartender. After Spain gives up the tying goal late in the game, Juan is obviously distraught because a tie will cause Uruguay and England to advance over Spain. Minutes before the goal, while Spain was winning, just imagining putting England out of the tournament gave Juan goose bumps. He says, "I wish I could hear the Englishmen, now. And those lazy Uruguayan oafs. . . . What were they thinking? That we were like Bolivia!?" Eventually, Spain losses their lead, the game ends, and Spain is knocked out of the tournament. Juan then asks Simón the bartender for two glasses of white wine. Simón strikes up conversation trying to help Juan look at things differently and overcome his disappointment by saying, "How crazy this world is! No matter where you go, no one talks about anything but soccer. And what does soccer do for us?" Simón reinforces his point by saying, "And for those twenty-five million Spaniards listening to the radio all evening like fools. Fifty million hours . . . down the tubes. Do you realize how much can get accomplished from fifty million hours of work?" Juan responds by saying, "A whole heck of a lot." "That's right. A whole heck of a lot. For example, plant ten million trees. Or wouldn't that impress you?" Simón asks. Juan gives it right back to the bartender and asks, "Did you plant a tree during today's game?" Juan doesn't get a response from Simón and asks for two more glasses of white wine. Once they finish their drinks, they leave the bar and the blonde bombshell, who supports Juan throughout the entire story, says, "That man's rude." Juan responds by saying, "I'm just imagining what the English are saying right about now." The story ends as the narrator tells us that "the blonde bombshell began thinking that twenty-five million Spaniards were a lot

of Spaniards, and that fifty million hours sure were a lot of hours, and that ten million trees sure were a whole heck of a lot of trees. . . . And then she thought about how the white wine from Simón sure was going straight to her head."

This anticlimactic short story by Miguel Delibes reveals a different side of soccer. "The Championship" reinforces the fact that soccer is a social phenomenon in Spain, but at the same time it demonstrates the sport as a point of departure for contemplative social thought and discussion, although Delibes argues that people in general are filled with hot air and, in the end, act only on what truly interests them.

Fernando Fernán Gómez's "The Manager" is a story about a young boy who grows up with an intense passion for soccer. His only problem is that when the kids from the neighborhood gather to play, he is the worst of the bunch. After he comes to the realization that his skill as a player is not his greatest asset, he manages to monopolize the only ball in town and begins to charge the other kids to play. This approach eventually leads him to become a very powerful soccer administrator. Therefore, this story serves to demonstrate soccer as a social phenomenon with many dimensions and many opportunities for an individual to become involved. As the Uruguayan writer Eduardo Galeano wrote, "This beautiful spectacle, this feast for the eyes, is also a nasty bitch of a business."[3]

Julio Llamazares's "So Much Passion over Nothing" tells the story of a player for Deportivo de La Coruña named Djukic who prepares for his team's biggest game of the season against Valencia CF. The story describes Djukic's pregame routine, and the reader is invited to enter into his inner thoughts. Djukic's thoughts and preparations are centered around the fact that his club needs a win over Valencia CF to be crowned outright champions of the Spanish League. Llamazares takes the reader through a number of pages dealing with Djukic's pregame nerves, the different angles through which he assesses certain aspects of the game, and his voice of reason. Eventually, Djukic finds himself at the end of the game, when the referee has called a penalty kick in his teams favor. The narrator relates to the reader that

> Djukic was ready to shoot that penalty kick. He didn't have, for that matter, any other option. He could, truthfully, still withdraw himself (someone else in his situation may have thought about it) and pass off the responsibility to another teammate, to Bebeto, for example, who was the star of the team and earned the most money, but Djukic wasn't the type to crack under pressure. Ever since he played in Savac as a fifteen-year-old, he was always one to stand up for the team. And, anyway, his teammates would never forgive him. Just as—he thought—they would never forgive him if he missed.

As the tension grows, the narrator takes the reader through each of Djukic's thoughts leading up to the moment of the kick,

Djukic began his approach without even knowing where he was going to shoot. At this point he wasn't even able to think; it was too late for anything. He kicked the ball without looking at it, as if he were kicking at air, and for a few seconds, which to him seemed like forever, super-long, never-ending, he watched how it went in the direction of the goal where the big blue blob of a goalie began slowly moving.

As it turns out, the Valencian goalkeeper saves Djukic's shot, and the Valencian team runs to their goalkeeper to celebrate with him. Djukic is left at the penalty kick spot alone and stupefied as the narrator finishes the story:

Djukic's teammates were a bit slower to do the same for him, but he still couldn't figure it out. On his knees in the grass, like a fallen boxer, alone he thought of fleeing the scene while he repeated the same thing to himself, like when his brother killed himself, which was the same thing his dad would say when life was unfair: so much passion over nothing.

With "So Much Passion over Nothing," Julio Llamazares reinforces the fact that soccer is a social phenomenon that brings out many emotions in its players and followers. But he also argues that in soccer, as in life, one should not become overly excited about success or overly disheartened by a failure. This is also a central theme in David Trueba's *Knowing How to Lose,* and therefore, in an interview with the author conducted by Nuria Azancot, the topic of success came up. Azancot asked Trueba what success meant to him. In part because of the success of his novel and because the struggle for success in the face of failure is one of the central themes of his story, Trueba responded by saying, "Success isn't as enormous as everyone makes it out to be, nor is failure so depressing."[4]

In "The Hesitant Moment," Javier Marías describes the amicable relationship he had with the Hungarian goal scorer Miklós Szentkuthy from Real Madrid. Whether the numerous encounters with Szentkuthy that Marías relates to the reader actually took place we may never know, but we have no reason to believe that they did not. Marías begins his account by saying, "I met him twice in person and the first was the happier and the more wretched." Marías describes his first encounter with Szentkuthy at Joy, a popular discotheque in Madrid. Marías tells the reader that he did not want to annoy the soccer star with typical questions about his profession. "He seemed to appreciate that I didn't instantly start talking to him about the team nor the coach nor the championship, and maybe that's why he replied without shyness and with an almost child-like smile." The two men go on to have a conversation about the women accompanying Szentkuthy (Szentkuthy claims he has been with three of the four women). Szentkuthy boasts that he collects goals and women, saying, "Every goal, a different woman, it's my way of celebrating them." Szentkuthy tells Marías he is currently dealing with a problem with one

of the girls in that she mistakenly believes she will be with him forever and wants him to proclaim his eternal love for her. Szentkuthy describes how his perception of love is similar to his perception of soccer. He tells Marías that he prefers not to talk about love or soccer but, rather, simply prefers to perform: "They always want me to talk to them, afterward above all, I'd prefer not to say anything after or before, just like in soccer, you score a goal and you cheer, there's no need to say or promise anything, everybody knows you will score more goals, and that's it."

Marías's next encounter with Szentkuthy comes when he was invited to watch a Real Madrid match in the presidential box. Szentkuthy was also there watching from the box because he had been injured. Szentkuthy did not recognize Marías but was with a young girl who seemed to be a very serious girlfriend. Marías states that it appeared Szentkuthy had outgrown his stage of "collecting girls," and due to his injury, he clearly was no longer "collecting goals." Shortly after Marías' second encounter with Szentkuthy, the soccer player was dropped from Real Madrid and then spent a season or two in France before eventually falling out of the spotlight. Eight years after his last encounter, Marías assumed Szentkuthy was finishing his career in Hungary (playing for one of the lesser-known teams) when he learned of his death. Marías finishes his account by writing,

> A thirty-three year old man at the time of his death, a young man without new goals and with his videos over-watched, could only collect women in his native Budapest, there he would continue being an idol, the boy who moved far away and triumphed and would now live forever off the pride of his distant exploits which became more and more blurred with each passing day. But he's no longer alive because she shot him in the chest, and just maybe there was a split-second in which his convinced, yet timid wife's will was weakened and she doubted if her two fragile fingers would actually pull the trigger, although at the same time she knew deep-down she would end up pulling it. And just maybe there was a second in which she denied the forthcoming, and time was marked, and she became hesitant, and in that moment Szentkuthy clearly saw the normally invisible dividing-line that separates life and death, the famous, "still not yet" and "now that's it," that people talk about.

Marías's first-person account of his encounters with this famous soccer player and the subsequent events that took place in the soccer player's life is another approach to the kick-lit genre. Marias's tale tackles the kick-lit genre from the same angle that Carlos Casares did with his anecdote about his encounter with Alfredo di Stéfano, "How Old and Fat You Are" ("*Qué viejo estás y qué gordo*"), which will be analyzed later in this book. I find these autobiographical anecdotes interesting because they offer the reader a view of the author's insight into his actual encounter with a famous soccer player. At the same time, the reader is afforded a

glimpse into the star soccer players' attitudes, comportment, activities, and the conversations they have. This image tends to be very different from the soccer players' public image we witness on the soccer field and are privy to through the media.

Justo Navarro's "The Soul to the Devil" is very different from Javier Marías's and Carlos Casares's autobiographical anecdotes. "The Soul to the Devil" tells the tale of a player who sells his soul to the devil in order to be in the spotlight once again. Navarro recounts his tale in the third person through an omniscient narrator who tells the story of a young soccer player in Spain who is brought to Real Madrid after scoring many goals during the league's previous season. Navarro never offers the reader the name of the protagonist or the name of his previous club, but he does tell us that after the young player was brought to Real Madrid and did not score a single goal in five and a half games, the club disregarded him completely. Two depressing years go by for the frustrated soccer player, who, like everyone else, comes to see himself as an embarrassment and a failure.

The night before one of Real Madrid's games, against the team rules, he decided to go to an out-of-the-way bar on the side of the highway where no one would recognize him. He went there to drown his sorrows because he was not asked to dress for the game the next day. While drinking alone at the bar, he is approached by a large, scary man who tells him to stop drinking because he has to play the next day. Our protagonist attempts to avoid the situation and heads for the parking lot, where the man approaches him again. The man tells the frustrated soccer player that in exchange for his soul, the large, scary stranger will see to it that he will not only play the next day but that he will score and that he will continue to do so in many games thereafter. The soccer player therefore signs the pact in blood and heads home.

The next morning, our protagonist receives a call from one of his coaches telling him that the team's starting striker fell in the shower and that they will need him to fill his place in today's game. He can hardly believe his ears, and later that day he scores a goal, has an assist, and plays an integral part in one of the game's monumental strategic attacks. Throughout the rest of the season, he scores many goals, bringing Real Madrid back to the top of the league and into the Champions League final against Milan. Recognized as one of Europe's leading goal scorers, the protagonist had seemingly redeemed himself. However, before heading to England's Wembley Stadium to play the Champions League final match, he is drawn to the hotel's receptionist, who passes him a note telling him he must miss the penalty kick that he will take in the final minute of the match. Perplexed and distraught, the player goes through the normal motions of the game, and exactly as the receptionist had written on the note, he is fouled in the box in the final minute and is left to take the most important penalty kick of his life. He is left with a terrible

decision. On the one hand, he may comply with what the devil demands of him and miss the kick, which will cause him to be remembered forever as the failure who missed the penalty kick in the Champions League final. On the other hand, he could take advantage of this once-in-a-life-time opportunity and make the shot and be remembered forever as the player who, after being disgraced, rose back to the top of the Spanish League and scored the winning goal in the Champions League final. Navarro describes the scene of the penalty and what takes place immediately after:

> He looked at the goalie and he seemed feeble, dwarfed. He heard the whistle from the referee. He shot. The goalie threw himself to the right and the ball went in low, not very hard, through the left side of the goal. Then the stadium exploded:
> "Goal!"
> He ran toward the stands where a thousand crazed Real Madrid fans were piling up. His teammates were hugging him now, they pulled him down to the ground, they were suffocating him, the shouting from the fans was suffocating him. He never felt so much joy in his blood, the joy pumped through his veins, it was going through him, he vibrated from joy: it was a joy that could be heard, if he breathed, it was tangible, it weighed on his chest. With his face smashed into the ground, he bit and smelt the grass of Wembley. At that moment he was lacking air, he gasped, the world silently became dark, his teammates were getting up, they left him alone and the grass turned to dirt. His chest hurt. He hadn't fulfilled his pact with the devil. He touched his chest, he looked at his hand, he saw blood. Everything became dark. He was in a clearing, on a miserable November Friday night, he saw tires from old cars. He attempted to get on his feet leaning up against the car, a rented Volkswagen. He slipped, got blood on the bodywork. He begged for help. He saw the legs of the man. The man turned his head: wearing a Real Madrid jersey under a green tuxedo, he had one eyebrow divided in two, he was laughing. The man said something, but the soccer player couldn't make it out, because he was dying.

This tale by Justo Navarro is an eerie approach to the kick-lit genre because it takes the reader into another dimension where all the protagonist's dreams come true—until the devil returns to collect his due. When the protagonist does not honor his part of the contract, he slips back in time to when he initially sold his soul to the devil. At this point, he dies, leaving the reader to wonder if all his dreams had come true, or if they were simply figments of his imagination. When presented with the option of death and honor or life and disgrace, like any self-respecting Spaniard in the world of literature, our protagonist chose the romantic ending to his life—death and honor. The devil, however, tricked the protagonist and brought him back in time to when he first signed his soul over, thereby erasing all the glory he had experienced throughout the season. As in Calderón's Golden Age play *Life Is a Dream* (*La vida es*

sueño), Navarro causes the reader to question his perception of reality and ponder whether thought conquers reality.

"Wanting to Complain for Real" by Rosa Regàs could be considered another autobiographical anecdote pertaining to soccer. In the story, Regàs recounts in the first person the time she invited a male friend to her home to watch Spain versus Bolivia in the 1994 World Cup, which was being held in the United States. The game was very important because a win assured that Spain would advance to the next round. Regàs invited her friend to watch the match and have dinner so he could explain some of the intricacies of the sport to her. She wanted to better understand this sport that has so many people captivated.

One of Regàs's first observations about the soccer experience is the continuous flow of beer commercials. She says, "All this with the beer is confusing because with all the noise from the crowd, you can't tell if the match has begun or if what they're watching is merely a commercial." Throughout the match, Regàs maintains that the simple fact that she is a woman has nothing to do with her ability—or inability—to grasp both the magnitude and the subtleties of the sport. However, whenever she asks a question that her friend is incapable of answering or explaining, he snaps at her by saying, "What do you know? Soccer is much more complex than you can imagine. . . . Don't bother getting involved. You don't understand what it's about." Clearly, this chauvinistic attitude frustrates her, but she is able to let it slide since she is well aware of the *machista* (male chauvinistic) attitudes that traditionally accompany sports in Spain, especially soccer.

Overcome with nerves for Spain to perform well and win, and in an attempt to avoid her friend's chauvinistic insults that are no doubt provoked by his nerves, Regàs heads to the kitchen to occupy herself with something else and distance herself and her mind from the game. In the kitchen (a place where she obviously feels more comfortable since it is traditionally an area of the house designated for the woman), she listens to the game as she prepares their supper. When she returns, Spain has won the match 3–1, and has locked a place in the next round of the World Cup. She brings a high spirit to her friend, who is disgruntled with Spain, claiming that they are not playing well and that everyone knows it and that they won only because Bolivia's strategy failed and that even the announcers were commenting on Spain's poor performance. Completely frustrated, Regàs says, "Hang on a second, you're not happy if they win due to the failed strategy of Mr. Azcargatora? [Bolivia's coach] What do you want, then, thirty goals?" Her friend responds by reiterating, "It's not that, woman. It's not that at all." Regàs ends the story by writing that she spent the entire evening "wanting to complain, for real."

This story by Rosa Regàs reveals that she understands the game (on two levels) more profoundly than her friend. First, she sees that her friend demonstrates a less-than-modern vision of the game in that he

feels that women are incapable of understanding its intricacies and that soccer is a space designated only for men. The second is that her friend suffers from the Spanish plague of victimism—the notion that even when Spain wins, they lose. It is widely held that many Spaniards see the game in a different light than the rest of the world in that there are two competitions taking place. In one competition, the game must be played well (which is an opinion) and provide spectacle to the spectators. The other competition is decided on the scoreboard. If either of these goals is not accomplished, the game is essentially a failure. Many other schools of thought on soccer adhere to the fact that it is important to play well (not necessarily provide spectacle) but above all else, to win. This stereotypically Spanish approach to the game pursues ideological perfection but in actuality is very difficult to achieve on a regular basis. I feel this notion is rooted in the bullfighting culture of Spain, in which only a perfect kill can truly be celebrated. However, this is unreasonable because even an extremely talented bullfighter is probably capable of a perfect kill only a few times in his life. Ernest Hemingway shed light on this notion in his book *Death in the Afternoon*, dedicated to analyzing and describing the intricacies of bullfighting. In the following passage, Hemingway describes the difficulty of achieving the perfect kill:

> You may never see it because the *volapié*[5] (flying foot), dangerous enough when properly executed, is so much less dangerous than the *suerte de recibir*[6] (luck of receiving) that only very rarely does a fighter receive a bull in our times. I have seen it properly completed only four times in over fifteen hundred bulls I have seen killed. You will see it attempted, but unless the man really waits out the encounter and gets rid of the bull with an arm-and-wrist movement rather than by tricking with a sidestepping at the end it is no receiving. Maera did it, Nino de la Palma did it once in Madrid, and faked it several times, and Luis Freg did it.[7]

With regard to soccer, some cultures might recognize that it is wonderful to play beautifully in the streets, in practice, and in the game, but at the level of World Cup competition only one thing matters—winning. How this win is achieved is secondary—the only requirement is to play within the rules of the game and find a way to win. One of soccer's phenomenal elements is that the game is open for each individual's interpretation. Whether a group or culture prefers to play well by their terms or to simply win by any means is up to them. Jorge Valdano addresses this issue throughout his work as a writer on the philosophy of soccer. In the prologue of *Soccer Stories 2*, he addresses the sport's complexities and explains that "the long road of soccer over the past century is full of paradoxes like this."[8] After witnessing Spain dominate and win, Rosa Regàs is frustrated from listening to her friend complain because he felt Spain did not play well. For this, coupled with her being disrespected for

being a female who doesn't see the game in the same light as her friend and considers the final result the most important statistic, Regàs is in the right to want to complain. And possibly for the first time in her life, Regàs experienced the contradictory, complex, paradoxical, and frustrating world of soccer, which are essentially the traits that have so many people around the world so captivated.

Manuel Vicente's "Deep South" is a unique story in that it offers the reader the rare opportunity at a glimpse into Real Madrid's extremist followers, *Ultra Sur*. Vicente communicates an insider's knowledge of the group's social hierarchy and what many would consider a misguided voice of reason and logic that "ultra" groups such as this maintain. Whether his account of this mysterious subculture is accurate is difficult to determine, but the reader is left to assume that Vicente either has been involved with one of these groups, knows someone in one of these groups, or has done extensive research to understand the infrastructure of the group. This is similar to Miguel de Cervantes's short story *The Little Gypsy Girl (La Gitanilla)*, which offers the reader a unique vision into the mysterious subculture of the gypsies in Spain during the sixteenth century.

Manuel Vicente relates his tale through an omniscient narrator that recounts the story in the third person. This narrator explains to the reader that the members of this group come from all areas of the city and have no other form of friendship or contact than through the group. The narrator states a number of times how this group has no desire to befriend the other members of the group, but that they exist simply to heckle and terrorize people according to "their laws" throughout the game, which have no real connection to the game itself. The two elements that these individuals have in common that connect them are their young age (under nineteen) and their desire to live on the periphery of society (being drawn to criminal behavior and trouble).

The story is centered around the group's abnormal social structure, which is led by a teenager who earned his position through unwarranted violence. This individual makes the members of the group draw the letter "B" with a blue marker on their foreheads. This will differentiate them from the rest of the fans not only as they enter the stadium but also while the game takes place. The "B" that the members of the group write on their foreheads stands for "*Berberecho*" (Cockle), the leader's nickname. The narrator describes that, during a match played earlier in the season, after Real Madrid scored a goal, one of the members of the group kissed Berberecho on the lips in celebration. Unbeknownst to this redheaded member of the group, Berberecho vehemently despises and punishes anyone who demonstrates any sign of love or sexual behavior toward another member of the group. After kissing Berberecho, the redhead received a vicious beating and was kicked out of the group. Despite being shunned, the redhead continued to still hang around the group, watching

them from a nearby section. At the end of the game that Vicente invites us to witness, a goal is scored by Real Madrid. Vicente's narrator describes what happened in the Deep South section of the stadium as the following:

> The ball went into the corner and while his comrades became infused in an embrace of joy, Berberecho felt that something similar to a flaming tongue had entered into his ribs. He fell with his jersey bloodied and the cries of horror were mistaken, for a moment, with the howls the goal had created. Next to the ensanguined body was the guy with the red hair smiling. Berberecho perished from that stabbing since the blade of the knife was not made of the same immortal matter that the scream had generated from the victory. While Berberecho's cold meat was being carried away, the guy with the red hair demanded the stretcher be detained, and he laid a lengthy kiss directly on Berberecho's mouth.

This contribution to the kick-lit genre shows a different aspect of the sport and reveals what is widely considered the most negative side of soccer. In his story, Vicente makes no attempt to justify the behavior of these teenagers; rather, he uncovers the error in logic through which these groups operate. If anything, Vicente argues that these groups are simply adolescents who use the football arena as a social space where they can wreak havoc. Vicente's story demonstrates the thoughtless actions of these groups as being similar to adolescents who vandalize and commit senseless crimes. It is possible that Vicente's account is inaccurate and that there is actually more structured thought to the actions, the violence, and the crimes these groups commit. Regardless, the important fact is that a work of kick-lit does not have to defend soccer and all that goes along with it as legitimate or respectable. Rather, an author can highlight the negative aspects of the sport if he or she so desires.

This summary of the stories written by Spaniards in *Soccer Stories* demonstrates the variety of ways the genre can be approached and defends the genre as being as respectable, as profound, and as enjoyable as any other thematic approach to literature. *Soccer Stories* offers the reader fictional stories, verisimilar stories, nonfiction stories, and what could be considered autobiographical anecdotes. Some are directly related to soccer, and in others, the sport occupies a more distant aspect of the narrative's development. *Soccer Stories* also contains a variety of extremely rich stories written by some of Latin America's most respected writers: Mario Benedetti's "The Grass," Alfredo Bryce Echenique's "Pasalacqua and Liberty" (*"Pasalacqua y la libertad"*), Roberto Fontanarrosa's "The 19th of December, 1971" (*"19 de diciembre de 1971"*), Eduardo Galeano's "The Referee" (*"El árbitro"*), Julio Ramón Ribeyro's "Antiguibas" (*"Antiguibas"*), Agosto Roa Bastos's "The Stud" (*"El crack"*), Juan Villoro's "The Phantom Winger," and Osvaldo Soriano's "The World's Longest Penalty Kick."

"The World's Longest Penalty Kick" is important for this study in that it was adapted into a feature-length film by the Spanish production company Ensueño Films and was directed by the Spanish film director Roberto Santiago. Another story that appears in *Soccer Stories*, "The Dishrag Ball" ("*La pelota del trapo*"), was also adapted to the big screen. The film *The Dishrag Ball* (*La pelota del trapo*) (1948) was directed by the famous Argentinean director Leopoldo Torres Ríos, who made another film dealing with soccer, *The Son of the Stud* (*El hijo del crack*) (1953).

The story "The World's Longest Penalty Kick" was written by the famous Argentinean journalist and author Osvaldo Soriano. Many of Soriano's works have been adapted to film, and he contributed to the production of the cinematic adaptation of this kick-lit story, which has a number of variations from the original tale that will be analyzed in the section covering soccer and Spanish cinema. The literary version of the story is a fictional anecdote told by Soriano's narrative voice as an adult looking back on his childhood. Soriano's opening sentence is reminiscent of the famous opening line of Miguel de Cervantes's *Don Quijote de la Mancha*, which reads, "Someplace in La Mancha, whose name I don't care to remember."[9] Soriano's omnipresent yet unreliable narrator begins his tale by proclaiming that, "The most fantastic penalty kick that I've ever heard of took place in 1958 in some long lost place of the Black River Valley in Argentina, on a Sunday evening in an empty stadium." The narrator goes on to recount the comical tale of a pathetic group of over-aged soccer players in this small town of Argentina, that year-in and year-out were the laughingstock of their men's league. These antiheroes play for the club Polar Star (*Estrella Polar*), and during this particular year they miraculously find themselves winning more matches than they lose. Eventually, they make it to the final match of the league against Sporting Belgrano (*Deportivo Belgrano*), who earlier in the season had humiliated them by defeating them by seven goals. In the final match, which was played in Sporting Belgrano's home stadium, Polar Star held strong and late in the match scored the go-ahead goal, which would give them the league championship for the first time ever. However, Sporting Belgrano needed only a tie to capture the title since they had a better goal differential throughout the season. After Polar Star took the lead, the epileptic referee, who was hired by Sporting Belgrano and also lived in the hometown of Sporting Belgrano, felt pressure to see to it that his hometown club not be embarrassed by a club as pathetic as Polar Star. He therefore called what those from Polar Star considered a completely unjust penalty in the last minute of the game. Overcome with frustration, one of Polar Star's defenders socked the epileptic referee, Herminio Silva, in the nose and knocked him unconscious. Not surprisingly, a brawl ensued, and officials declared the match suspended until the following Sunday. This suspension was due to the fact that tempers were high, the referee was unconscious, and by this point there was a lack of sunlight.

Throughout the following week, the upcoming penalty kick was all the people from these two rival towns seemed to talk about. The goalkeeper for Polar Star, *el Gato Díaz* (the Cat Díaz), began to enjoy being in the spotlight and took advantage of his newfound fame by declaring his love for his town's beautiful blonde girl, who was known as "The Blonde Ferreyra." She succumbs to his sweet yet pathetic effort to live the life of a true soccer star and consents to accompany him to the movies during the week prior to the kick. The warped vision that the broken men of Polar Star have of themselves is clearly meant to be comical. One hysterical scene that communicates a slapstick approach to humor is reminiscent of Abbott and Costello's famous "Who's on first?" baseball skit. This scene of "The World's Longest Penalty Kick" takes place halfway through the week leading up to the final penalty kick and underlines how serious yet pathetic the members of the club are. The team is playing cards together in the club after a training session in which they focused solely on practicing penalty kicks with Gato Díaz. Soriano communicates the scene as follows:

> Diaz didn't speak the whole night, throwing his thick white hair back, until after eating when he put a toothpick in his mouth and said:
> –Constante always shoots to the right.
> –Always –said the club president.
> –But he knows that I know.
> –So therefore we're fucked.
> –Yea, but I know that he knows –said el Gato.
> –So dive to the left and we're good –someone at the table said.
> –No. He knows that I know that he knows –said el Gato Díaz and he got up to go to bed.
> –El Gato is weirder every day –said the club president when he saw him leave pensive, walking slowly.

The night before the match, Gato invites The Blonde Ferreyra to go on a bike ride by the river. When they stop for a break, he attempts to steal a kiss from her, and she says she might allow him to kiss her at the dance on Sunday night provided he saves the shot. On hearing this, Gato changes the subject of the conversation, which Soriano describes as follows:

> –And how will I know? –He said.
> –How will you know what?
> –If I have to dive to this side or that.
> –The Blonde Ferreyra grabbed him by the hand and took him to where they had left their bicycles.
> –In this life no one ever knows who's tricking who. –She said.
> –And if I don't block it? –He asked.
> –Well, that will just mean you don't love me –The Blonde responded and they went back to town.

On the day of the penalty kick, our protagonist, Gato Díaz, is successful and saves the shot. However, just before the kick was taken, the epileptic referee had a seizure from blowing the whistle too hard in the hot sun. The line judge disqualified the shot, and another kick had to be taken. Soriano describes the final and official penalty kick that took place as follows:

> The shot went to the left and el Gato Díaz dove to the same side with an elegance and security that he would never possess again in his life. Constante Guana looked to the heavens and began to cry. We jumped over the fence to get a closer look at Díaz, the old man, the legend, who was looking at the ball he held in his hands as if he had caught the brass ring on the merry-go-round.

Soriano concludes the tale by telling of his encounter with Gato a few years after the epic save in which he found himself facing an even older and more broken-down Gato Díaz in a similar penalty kick situation. Soriano describes how after the shot was scored, the goalkeeper, convinced of his grandeur, said, "Alright, kid. Some day, when you're old, you'll walk around telling the story about the time you scored a goal on el Gato Díaz, but by then no one will remember me." The warped sense of stardom that Gato Díaz and the others in this men's soccer league feel is reminiscent of Cervantes's most famous character, Don Quijote de la Mancha, who delusionally sees himself as an errant knight. Another aspect of "The World's Longest Penalty Kick" that is very similar to Cervantes's "El Quijote" is Gato Díaz's courtship of the blonde girl from the neighboring town, The Blonde Ferreyra. In Cervantes's masterpiece, Don Quijote decides that if he is to be like the errant knights he so obsessively read about, he must also have a beautiful blonde to whom he can dedicate both his virtue and his love. It seems that Gato Díaz also considers having a beautiful blonde girl by his side as a necessary component to achieve true soccer stardom. The entire scene of the adult soccer league has a Quixotic feel to it in that the players are equally as passionate yet equally as pathetic and delusional about being soccer stars as Don Quijote was about being an errant knight. Both sets of characters become so overwhelmed with their passion that they come to see themselves and their approach to their passion through a distorted lens. The literary version of "The World's Longest Penalty Kick" varies in a number of ways from the film that will be examined in the section covering the presence of soccer in Spanish cinema.

The following sections of this chapter are dedicated to providing an in-depth analysis of four of the stories written by Spaniards that appear in *Soccer Stories*: Fulgenico Argüelles's "When the Balls Became Invisible" (*Cuando los balones volvieron invisibles*), Bernardo Atxaga's "Concerning Time (Round-Table with a Hooligan)" ("*Sobre el tiempo [Mesa redonda con*

hooligan]"), Carlos Casares's "How Old and Fat You Are," and José Luis Sampedro's "That Saintly Day in Madrid."

"WHEN THE BALLS BECAME INVISIBLE"

Soccer Stories opens with a story written by Fulgenico Argüelles, a recognized psychologist and author from Asturias, Spain. Argüelles's story is titled "When The Balls Became Invisible," which brings the issue between intellectuals and soccer advocates to the foreground through a fictional tale that poses the question, "What if the sport of soccer ceased to exist?" The protagonist of the story is Héctor Guerrero, an ex–soccer player turned coach who is dealing with the loss of his passion and reflecting on the current state of society at large. Prior to the disappearance of soccer, his country's political parties, government, educational system, religion, press, health care system, entertainment industry, and entire economic infrastructure was focused on the people's passion for soccer.[10] One day, for no logical reason, all the balls used for soccer simply vanished into thin air. More balls were imported, but as soon as they crossed the border, they immediately evaporated. This caused mass hysteria. The market plummeted, there were mass suicides, the factories closed, and there were various attempts to overthrow the government, which had fallen into the hands of intellectuals that considered soccer the plague of mankind. When soccer disappeared, these intellectuals quickly formed a group called "The Government of National Salvation." Their first order of business was to outlaw all activities dealing with soccer. Eventually, they established the death penalty for any demonstration of support for soccer. This caused the value of all soccer memorabilia on the black market to skyrocket.

Hector, having been a famous soccer player and coach, does not know what to do with himself. Throughout the story, he attempts to accept this new world that surrounds him. He takes his last remaining soccer album to the black market, where he will make a respectable profit that his family can live on for quite some time. This process is very difficult because both parties need to ensure their safety and anonymity. However, he eventually finds a suitable buyer and negotiations are under way. Although since so much time elapsed to make this deal, his children have died due to lack of nourishment. As a result of this, his wife leaves him and finds refuge with members of the terrorist group, "Thirteenth of May," who had elevated the importance of soccer to that of a religion. This group consists largely of members from the political party previously in office, "Power to Soccer." Earlier, she had attempted to convince Héctor to join the terrorist group because their beliefs coincided, but he declined. Essentially, the world around Héctor was crumbling. War had been declared against Thirteenth of May, and the country was in ruin: "it

was like an inordinately long nightmare that ended converting the lee-way nation into the kingdom of grief."

"When the Balls Became Invisible" was clearly written to provide the reader with an enjoyable text, but it can also be analyzed from a more profound perspective. Although these extreme beliefs and devastating repercussions from the loss of soccer are simply to amuse the reader, it gives the reader the opportunity to truly grasp the role that soccer plays in many counties throughout the world, as well as in Spain. The way the country's pastime is presented in the story as turning into an obsession seems absolutely ridiculous, but one quickly comes to recognize just how much the fictitious country that Argüelles created actually resembles his country of Spain.

Argüelles also takes the two contrasting schools of thought, those who support soccer and those who do not, and pits them against each other. The final result is the outbreak of civil war. This is obviously meant to be ridiculous and therefore humorous, but it also forces the reader to step back and realize just how ridiculous the root to many of the world's wars are. Many begin with a difference of opinion, then sides form, and before anyone knows what happened, what was once a slight variation in opin-ion becomes "good" versus "evil." In this sense, the way in which sides were drawn and the quickness with which the war escalated in "When the Balls Became Invisible" is representative of the Spanish Civil War. Although the presentation of the war was meant to be humorous on the surface, Argüelles's representation of the radicalism of war expresses a more profound vision: the fanatical tendencies of man.

By the end of the story, Héctor is very distraught because although he has tried to accept the world without soccer, there is no longer anything that excites him, nothing that moves him, nothing to ease his mind or distract him from the atrocities that are taking place all around him. This causes the reader to step back and imagine what the world might be like without sport, soccer, or leisure activities. The narrator describes Hector's emotions as follows:

> Hector Guerrero felt shame for that seedy preacher, and for himself, and for the entire world, and he thought that even hope is a kind of religion that doesn't bring anything more than pain to the heart and that it is something like the antechamber to Hell, and he desired with all his strength to convert himself into a soccer ball so he too could become invisible.

"CONCERNING TIME (ROUND-TABLE WITH A HOOLIGAN)"

The second story of Valdano's compilation is titled "Concerning Time (Round-Table with a Hooligan)" and was written by the Basque philoso-pher and writer Bernardo Atxaga. "Concerning Time" again pits intellec-

tuals against soccer fans. The story begins with the narrator making prep-
arations for an intellectual round-table discussion that he plans to host.
He wants the discussion to be centered around a general yet difficult
subject. He ponders a few possible topics, such as the depression caused
from the breakdown of the nuclear family, the problems with violence in
soccer, and the relationship between adolescent violence and violence on
television. However, he determined that none of these topics would suf-
fice. Eventually, he decides to hold the round table on what he calls "the
topic of all topics"—time. He then invites all the letters of the alphabet
(who are personified in the story) to attend his round-table discussion
concerning time. Every letter makes sure to attend this round table be-
cause they are convinced this topic will produce a very stimulating dis-
cussion. During the discussion, they touch on theories of time from some
of the world's most renowned philosophers. The letter "K" supports the
theories of Kant, while the "B" argues for Bergson. The "P" then states
that he perceives time as always playing a trick on people and that time
persistently passes without being noticed. After the "P's" monologue, the
"H" stands up and says,

> Well hello, I'd like to say three things. First of all, that I am a huge fan,
> or to put it in more modern terms, a hooligan. Secondly, that I don't
> fully understand the theme that is being covered today, but as far as I
> can see time has only two parts, the 1st part and the 2nd part.[11]

The "D" interjects, "And downtime,[12] right?" The "H," upset by the
"D's" interruption, shouts, "How come no one ever lets me finish! What
the Hell!!" and goes on to make his third statement, which is to inform
the round table that Paris St.-Germain and Milan are playing in the Euro-
pean Cup final at the very moment this round-table discussion is taking
place. On hearing this, a vast majority of the alphabet finds an excuse to
join "H" and watch the game at a nearby bar. The few remaining letters
continue the round-table discussion contemplating a variety of theories
of time until the rest of the letters return from the game intoxicated with
beer and passion. They continue to celebrate for a few hours, and when
almost all the letters have headed home to soothe their hangovers, the
narrator offers the few remaining letters the opportunity to add any clos-
ing comments. Then "H" raises his hand and says there is an aspect
regarding time that has him fully perplexed. The narrator asks him from
what perspective, and "H" says, "From the perspective of a hooligan, I
suppose." "H" then proceeds to tell his story:

> Well it just so happens that when my team is winning 1–0, every min-
> ute seems like it lasts forever. It's as if the clock stops and the other
> team has all the time in the world to tie. But from the opposite perspec-
> tive, when it's us that is losing 0–1, it seems like time is flying by so fast
> that it's nearly impossible for us to get the result. I don't know. I'd just
> like it if someone could explain this mystery to me.

When no one is able to offer a logical response to this phenomenon, "E" recommends that "H" write a letter to Einstein because he is the only intellectual that "E" considers capable of tackling "H's" question.

Clearly, "Concerning Time" is a humorous tale not only for its content but also, in large part, because Atxaga manages to eloquently string sentences together with words (in Castilian Spanish) that either begin with or are made up of the letters that each of the characters represent and embody. I attempted to illustrate this technique when possible through my translation, but could do only so much and still get the point across. But within this interesting tale, Atxaga also offers an overview of many of the philosophical theories of time. In the end, the intellectually unassuming, self-proclaimed hooligan, of all people, offers the simplest yet most intriguing contribution to the round-table discussion through the analogy of soccer, leaving everyone to question the perception of time. In "Concerning Time," Atxaga uses the phenomenon of soccer and a fan swept away with passion during a game to question the perception of time and support the notion that the soccer arena is like the petri dish of life. Interestingly, this notion coincides with the quote from Albert Camus, who proclaimed, "All of life's philosophies can be learned within the confines of a soccer field."[13]

"HOW OLD AND FAT YOU ARE"

"How Old and Fat You Are" (*"Qué viejo estás y qué gordo"*), by the recognized Galician intellectual Carlos Casares, is another story that made Valdano's selection. Casares studied as a philosopher and was an editor and writer who formed part of the Royal Galician Academy (*Real Academia Gallega*). One of his contributions to the kick-lit genre is an autobiographical anecdote about his efforts to meet the god-like Real Madrid star of the 1960s, Alfredo di Stéfano. The story is written in the form of a hate letter directed at di Stéfano. Casares makes his impression of the ex-soccer star clear from the opening sentences, in which he writes,

> How fat you are, old man. And how bald. O.K. fine, you never had much hair to begin with, but now you're pretty much completely bare up top, clean as a whistle if you like, soft and smooth like a baby's butt. It's funny to think that once upon a time they compared you to a blonde dart.

Casares ridicules all physical aspects of di Stéfano in a manner reminiscent of the famous poem that Francisco de Quevedo dedicated to his Golden Age rival, Luis de Góngora, and what Quevedo claimed to be Góngora's unnaturally large nose. Casares clearly found the famous opening line of Quevedo's poem, "There once was a man attached to a nose" (*"Érase un hombre a una nariz pegado"*),[14] as a point of departure for

his story dedicated to ridiculing everything from di Stéfano's lack of teeth to his "pock-marked-frog-face."

In his letter, Casares reminds di Stéfano of the time they came face-to-face after a game that Casares attended as a youngster with his friend and Real Madrid fanatic Manolito Romero. Casares tells how the two rode a motorbike through the cold rain to attend his match and waited around for an hour after the game to secure di Stéfano's autograph for their friends in their *peña* (the common term for a tight group of local friends in Spain). This adventure turned out to be disastrous because Casares saw his idol in an entirely different light than he had hoped and in the process caught a terrible cold.

Casares explains that his inspiration to write di Stéfano came to him spontaneously, when as an adult he was watching a match that the ex-soccer player was arrogantly commentating on television. Casares brings out every flaw about di Stéfano that he possibly can. Regarding his eyes and mouth, Casares tells di Stéfano that "your eyes are popping out and your mouth is way too wide, like a crack across your face from ear to ear." He describes his Argentinean accent by saying,

> That shitty Buenos Aires accent that seems like you invented just to piss people off. An accent that hasn't gone away after all these years. . . . I don't deny that at times you're funny, because that same shitty accent that at times seems invented to piss people off, also at times seems like it was invented for hysterics.

Casares ridicules di Stéfano's complexion by saying,

> The unfortunate treasure-trove of wrinkles you've been gathering over the years. . . . The color of your skin . . . , in my land we call people that possess it *rubiales* (people with fair-blonde-skin), it's to say *sonrosada* (rosey-red-skinned). Or better put, it's as if you had just been thorough-ly scrubbed with soap and steel wool. I should say those people we call *rubiales* (people with fair-blonde-skin), those people that are halfway between blonde and redheaded, are considered to be of the lowest race, which means they are descendants of Judas, who was covered in freck-les, just like you, the color of a carrot.

Casares comically explains that he is well aware of the character people of this complexion possess because, as he proclaims, there are two of them in his town, and, according to Casares, "neither of them are good, fulfilling the stereotype, actually they're a couple of jerks, as a matter of fact, they're both genuine sons of bitches."

Casares describes his frustration with di Stéfano's excessive use of soccer Anglicism's while announcing the game as a *"mamarrachada."* [15] According to Casares, di Stéfano refuses to conform to the proper Span-ish terms that have been designated for the game. For example, while announcing the game, di Stéfano says *"córner"* instead of *"saque de esqui-na," "dribling"* rather than *"regate"* and *"referee"* in place of *"árbitro."* Ca-

sares continues to mock di Stéfano's Argentinean accent, saying, "This, along with your lack of teeth, makes it difficult to understand you when you speak. Moreover, you say stupidities like '*referee*' and '*dribbling*,' just like that disgusting custom in your country of calling your money dollars, another idiocy."

In describing di Stéfano's physique, he begins by saying, "I could care less to acknowledge that you've turned into a monstrosity, a real piece-of-shit-of-a-man." He then describes in detail di Stéfano's belly to the ex-superstar himself. Casares claims that di Stéfano not only has a sizable belly, but also bellies on top of bellies:

> The first one bulges out in an arc from your sternum to your belt-line, which is to say, about to the top of your naval. The second one lies below your pants. One doesn't need to be too imaginative to assume that below that, there's another, at minimum.

Casares further describes di Stéfano's poor choice of clothes by saying,

> Sometimes you dress like a pitiful shame, like in tonight's broadcast— You look like a mix between an athlete and an old man. To begin with, the polo shirt you have on doesn't work, neither for its color nor for the style of clothing that it is. Fat guys like you look better in light colors, not that vermillion tragedy you put on today that clearly inflates you.

Although throughout the anecdote Casares seems continuously side-tracked by his need to point out di Stéfano's personal and physical flaws, he eventually reaches the climax of the tale. He tells di Stéfano how regal he and his friends thought the soccer player was and of the difficulties they went through to finally be afforded the face-to-face opportunity to obtain his autograph for their *peña*. Casares describes the scene as a vivid memory that has stuck with him for years, but as something that di Stéfano probably does not even recollect in the slightest. Casares remembers di Stéfano leaving the stadium and signing a few autographs for those who put a pen in his hand. Casares tells di Stéfano about their efforts to get his autograph by saying,

> Then you made it to Manolito Romero, who yelled to you that it was for *la Peña*. But you didn't pick him, because at that moment you had successfully been pushed and shoved just enough to arrive at the car. And before we knew it, you were sitting inside. So I ran up to the window and I put my arms in, all the way, past my elbows, so it couldn't be rolled up, and I begged that you *please* sign us an autograph, that it was for *la Peña*. You looked up at me with a stink-milk face and said: "Hey kid, let me get out of here before I sock you one." It was in that very moment, so up-close-and-personal, that I finally realized for the first time that you had the face of a frog.

Carlos Casares's "How Old and Fat You Are" tells the author's own account of how he came to realize that his childhood idol was human

after all. Casares tells an interesting anecdote of how he once perceived his hero and how, on meeting his idol, all that he once felt for him was lost forever. "How Old and Fat You Are" also tells the tale of the fallen hero and reminds the reader that although many of our idols seem super-human when in front of a camera, many times they are not so majestic in everyday life. This story demonstrates Casares's evolution from youth to young manhood because it is during this time that he came to the realiza-tion that the glorified world that he was presented with was not as won-derful as it seemed. He no longer considered his childhood hero the embodiment of all that is good and therefore chose to leave the obsession behind and seek a different breed of role model and therefore a different path through life.

"THAT SAINTLY DAY IN MADRID"

"That Saintly Day in Madrid" is an interesting science fiction kick-lit story written by the famous Spanish novelist, economist, and member of the the Royal Spanish Academy (*Real Academia Española*) José Luis Sam-pedro. The tale is narrated in the first person by an alien that is on an expedition throughout the universe. The alien tells the reader that he has convinced the captain of his expedition to allow him to make a quick stop at Planet Earth so that he can be brought up to speed with the present-day religious practices of the dwellers from the planet's most advanced areas. He states that, some years back, during his previous investigative expedition to Planet Earth, he witnessed the Catholic Church attempting to modernize itself in the face of a massive reform. This new expedition was to provide him with new findings to log before heading back to his planet.

The alien/narrator decides to conduct his investigation in the country of Spain for two reasons, the first being because during his last visit, Spain was the world's maximum embodiment of Catholicism. The Span-ish government (which was directly tied to the Church) disallowed all religious freedom except for Catholicism and considered all Spaniards to be Catholic by birth. The second reason was because he overheard that Spain had recently begun a political transition. The alien/narrator consid-ered this transition's religious repercussions to be very important to the aliens because if the people's religious faith were strong enough, the aliens could stage the appearance of a messiah to control the earth dwell-ers.[16]

The alien/narrator begins his investigation in high spirits because he recognizes that by pure coincidence, he has arrived in Spain on a Sunday, the country's day of worship. This leads him to believe that his findings, with regard to religion, will be very accurate, although the alien/narra-tor's entire account is inaccurate because what he perceives as Spain's

"new religious practice" is actually nothing more than a soccer match. Many writers and intellectuals have claimed that soccer is followed with religious proportions in modern-day society, not only in Spain, but also in other areas of the world. Karl Marx claimed that religion was the "opiate of the masses," and many now claim that religion has been surpassed by soccer in this regard. Some recent studies that shed light on this notion are Manuel Vázquez Montalbán's *Soccer: A Religion in Search of a God* (*Fútbol: Una religión en busca de un Dios*) (2005) and Juan Villoro's *God Is Round* (*Dios es Redondo*) (2006). Clearly, Sampedro's "That Saintly Day in Madrid" demonstrates soccer's present-day fanatical following in Spain to be of similar, if not of greater, proportions to what the practice of Catholicism once was. At the same time, the story offers the reader a glimpse into the modern-day soccer society from the outside looking in.

The alien is first led off course in his investigation when he incorrectly assumes that the masses flocking to the soccer stadium are heading to church for mass. Sampedro sheds light on modern man's worship of soccer. The alien claims that "the mere conduct of the masses of people showing up at the temples and practicing the cult stabilizes the indication of religiosity." The alien says that while flying over the capital city, he was able to detect an intense collective religious following with his psychosocial sensors that detected strong waves converging toward a concrete point in the city: the temple/soccer stadium (clearly Real Madrid's Santiago Bernabéu Stadium). When the alien realizes that as the moment of worship draws near, the influx of people coming in buses, cars, and trains and on the subway have seemingly no other preoccupations during their day of worship. He states that there is no doubt that he is witnessing "the celebration of the national cult."

The alien joins the masses and enters the stadium/temple and is immediately taken aback. He claims that the architecture of the temple is very different from that with which he had previously been in contact, claiming that nothing reminded him of the previous structure—"no vessels, no shrines, no altars," only an enormous open-air grandstand that circled around a large rectangular space covered with grass. The alien makes note of the fact that this new architectural system is more similar to that of a Roman circus than to that of the traditional Catholic churches he had previously encountered. This observation is correct, and it strengthens the readers' recognition of the evolution from "bread and circus" to "bread and bulls" to "bread and soccer" and the notion of "the opiate of the masses."

The alien decides that the only religious symbols are the goals at each end of the field, which he describes as follows:

> Three pieces of wood joined together and situated to form sides of a rectangle. Two vertical posts, a little taller than a man, and a longer traverse beam located horizontally above them. Curiously, a net fas-

tened to the pieces of wood seems to enclose the back of these door-like
structures.

The only connection the alien is able to make between this "new religion"
and the old is that the nets behind the goals might have some reference to
St. Peter's occupation as a fisherman. This causes the alien to hypothesize
that the new, prevailing religious practice in Madrid might simply be a
surviving ancient local cult.

Nevertheless, this new "religion" has left the alien stupefied. On the
one hand, the alien was sure that he was witnessing a religious ceremony
because "the gathering of the masses on the day of worship in such a
fervently Catholic city couldn't have any other purpose." On the other
hand, the alien questions whether or not it was possible for the cult to
have experienced such a radical transformation over the relatively short
period of time since his last visit. This observation by Sampedro of a
rapidly evolving social climate in Spain forces the reader to recognize
how drastically Spanish society has changed over the past 100 years—
with soccer now one of its central elements.

The alien continues to misconstrue basically every aspect of the game
as a new religious practice. For example, when the players come out of
the tunnel, the alien assumes they are a new form of priest. The age of
these youthful "priests" surprises him. He was logically expecting some
long-bearded fellows to control the ceremony. The alien further mistakes
the game for a religious ceremony, which he hypothesizes as a struggle
between good and evil. The alien comes to realize that the "good priests"
wear white (the home team) and that the "evil priests" wear dark red (the
away team). The alien recognizes these colors as being historically sym-
bolic on Planet Earth and states that white symbolizes purity and that red
symbolizes evil.

As the match (or religious procession) took place, the alien came to a
number of conclusions from his observations. He concluded that this
struggle between good and evil was being dominated by the good be-
cause the amount of followers at the procession supporting the priests in
white largely outnumbered the defiant supporters of the priests in red.
The alien recognized that the fundamental object, the sphere with which
the procession was carried out, was placed in the mathematical center of
the sacred ground and that the struggle between good and evil was to
begin.

The alien considers the "sacred sphere" (the ball) as representative of
the world, and the "priests" struggle to place the "sacred sphere" into St.
Peter's fishing net as representing the earthly struggle between good and
evil. The alien concludes that the beliefs of this telluric religion are clearly
represented through the worshiping ceremony, stating that

> for this reason the priests emerge from an underground hollow and;
> this is why they work with their feet, which is the part of the body that

is permanently in contact with the Earth. On the other hand, the act of touching the ball with one's hand constitutes a punishable sin, activating the sounding of the ritual whistle; an instrument, clearly, with many mythic antecedents, from the syringe of the God of faun and the Pan flute of those dervish dancers to the Piper of Hamelin.

Throughout his investigation, the alien is taken aback and not exactly sure what to make of Spain's "new religion," stating, "Certainly, the Spanish could have changed religion, but not the passion with which they profess it." At the end of the alien's investigative expedition, he is left with one overwhelming problem for which he cannot find the answer: "how could such an extreme change of religious faith be possible during a transition of only a few years."

This short science fiction story is very entertaining, and through it José Luis Sampedro addresses the notion that Spanish society embraces soccer with almost religious proportions and that its obsession, passion, and opiate has shifted from Catholicism to soccer. Through the story, Sampedro reminds the reader of the enormous changes that have occurred in Spanish society over the past one hundred years since the introduction of formalized soccer. "That Saintly Day in Madrid" argues that the proportions of the present-day fanatical following of soccer in Spain are similar to the previous following of religion. More importantly, it forces the reader to recognize soccer as one of the most powerful social phenomena of the twentieth century.

NOTES

1. Unless otherwise noted, all quotes in this chapter are from Jorge Valdano, *Soccer Stories* (Madrid: Extra Alfaguara, 1995).
2. A "derby" is a match between two teams from the same city, normally an intense rivalry.
3. *"El Fútbol Hecho Espectáculo"* ("Soccer Turned Spectacle"), www.fcbarcelona.com/web/english/club/club_avui/mes_que_un_club/mesqueunclub_historia.html (July 23, 2009).
4. Nuria Azancot, "David Trueba," 2008, www.elcultural.es/version_papel/LETRAS/24516/David_Trueba (January 16, 2009).
5. A bullfighting kill move in which the bullfighter runs toward (and then past) a still-standing bull to insert the blade.
6. A bullfighting kill move in which the bullfighter entices the bull to attack him. The bullfighter, standing still, inserts the blade as the deceived bull runs past him.
7. Ernest Hemingway, *Death in the Afternoon* (New York: Touchstone, 1996), 238.
8. Jorge Valdano, *Cuentos de Fútbol 2 (Soccer Stories 2)* (Madrid: Extra Alfaguara, 1998), 11.
9. Miguel de Cervantes Saavedra, *El Ingenioso Hidalgo Don Quijote de la Mancha* (Alcalá de Henares: Centro de Estudios Cervantinos, 1994), 29.
10. Clearly, the world that Hector lived in is meant as a parallel to the modern-day society of Spain.
11. While in English soccer matches have a "first half" and a "second half," in Spanish they use the term "part" instead of "half." Thus, "first part/second part" (*primera parte/segunda parte*).

12. *"Descanso,"* meaning "rest," "break," or "downtime" is the Spanish word for "halftime."

13. Manuel Vicente González, *Fuera de juego* (*Offside*) (Badajoz: Puma, 1988), 11.

14. Francisco de Quevedo, *Antologia poetica/Francisco Quevedo 1580–1645* (*Poetic Anthology/Francisco Quevedo 1580–1645*) (Buenos Aires: Espasa-Calpe, 1943), 63.

15. Something grotesquely undignified of respect.

16. The alien/narrator tells his findings to a third party. It seems as though this third party is not from Planet Earth, but interestingly, ironically, and for obvious reasons, he communicates his ideas through the Castilian Spanish language as opposed to his native alien language. This story is reminiscent of Eduardo Mendoza's science fiction novel *Sin noticias de Gurb* (*Without News from Gurb*), which also relates alien observations of Planet Earth. Although the observations in Mendoza's novel are satirical, Sampedro's are misconstrued.

TEN

Soccer Stories 2

After *Soccer Stories* was so well received in 1995, Jorge Valdano decided to take the project a step further, and three years later compiled another group of "kick-lit" stories for publication titled *Soccer Stories 2*. With *Soccer Stories 2*, Valdano decided to use stories of authors that had not contributed to *Soccer Stories*, with the exception of Uruguay's famed writer Mario Benedetti. All together, *Soccer Stories* and *Soccer Stories 2* consist of forty-seven kick-lit tales from some of the Spanish-speaking world's most reputable authors. With all of these stories placed in two volumes, it becomes impossible to deny the kick-lit genre's legitimacy. Through *Soccer Stories* and *Soccer Stories 2*, the reader can easily see the wide range of viewpoints from which the genre can be tackled: fiction, nonfiction, science fiction, personal accounts, and verisimilar anecdotes. In the prologue, Valdano states that in *Soccer Stories 2*,

> soccer is observed from such diverse curiosities that these stories seem to want to take into account the entire orbit of a ball, this world in miniature that bounces and stirs up joy, sadness, uncertainties, passions, odium, illusions, misguided rebellions, and nationalisms in search of identities. . . . Our writers stuck their foot in their mouths (yes, we strictly watch what we eat here) and they pulled out a story exhibiting soccer played through different approaches.[1]

Soccer Stories 2 consists of twenty-four kick-lit tales written by Spanish-speaking authors. Fifteen of the twenty-four tales selected by Valdano were written by Spaniards, and the other nine were written by Latin American writers: Mexico's Luis Miguel Aguilar, who wrote "The Great Touch"; Uruguay's Mario Benedetti, who wrote "Left-Side Striker" ("*Puntero izquierdo*"); Colombia's Álvaro Cepada Samudio, who wrote "Since Juana Bought the Blowpipe She Doesn't Get Bored on Sundays Anymore" ("*Desde que compró la cerbatana ya Juana no se aburre los domin-*

123

gos"); Argentina's Humberto Costantini, who wrote "Right-Center Mid" (*"Insai derecho"*); Uruguay's Javier García Sánchez, who wrote "The Uruguayan" (*"El Uruguayo"*), Argentina's Daniel Moyano, who wrote "Aunt Lila" (*"Tía Lila"*); Chile's Antonio Skármeta, who wrote one of my favorite kick-lit stories, "The Composition" (*"La composición"*); and Colombia's Pedro Sorela, who wrote "Grassology. Intensive Course for Illiterate Beginners" (*"Cespedología. Curso acelerado para inflabalones primerizos"*). Each of these stories is an interesting, enjoyable, and valuable contribution to the kick-lit genre, but for the purpose of this book, which focuses on the kick-lit phenomena in Spain, I will be leaving them aside for future investigation and focusing on the Spanish authors whose kick-lit stories appear in *Soccer Stories 2*. Along with Rafael Azcona's "Goal" (*"Gol"*), Martín Casariego's "Soccer and Life" (*"El fútbol y la vida"*), Ana María Moix's "One Day, All of a Sudden, It Happens" (*"Un día, de repente, sucede"*), and Juan Manuel de Prada's "Parallel Lives" (*"Vidas paralelas"*), *Soccer Stories 2* consists of eleven kick-lit stories written by Spaniards. In the following pages, I will give a brief summary of each of these tales to demonstrate the diverse manner in which the genre of kick-lit has been approached by Spanish authors. The stories that I have selected to analyze in depth are Rafeal Azcona's "Goal," Martin Casariego's "Soccer and Life," Ana María Moix's "One Day, All of a Sudden, It Happens," and Juan Manuel de Prada's "Parallel Lives."

The first tale to appear in *Soccer Stories 2* written by a Spaniard is Josephina R. Aldecoa's "The Best" (*"El mejor"*). Aldecoa is a famous Spanish writer and pedagogue who was the founder of Madrid's reputable Style Academy (*Colegio Estilo*):

> Style Academy was founded in 1959, during the height of the Francoise Dictatorship. It originated from the need for a free, modern, European school, and from its very beginning, welcomed young intellectuals, writers, artists, and in general, all those desiring a different education from what had previously been the norm in Spain. [2]

Aldecoa's "The Best" is a kick-lit tale told from the perspective of a grandmother recounting to an implied sports journalist the story of her grandson's rise to soccer stardom in Spain. The grandmother, named María, tells the interviewer about her soccer-playing grandson, Baldo; her husband, Juan (who had been a player for Real Madrid); and her son and her daughter-in-law whose names are never revealed. From the very beginning of the grandmother's account of Baldo's ascent to soccer stardom, we learn that she did not see eye to eye with her daughter-in-law, who adamantly opposed the notion that her son should chase his dream of becoming a soccer star in Spain. Instead, María's daughter-in-law preferred that Baldo become a doctor, a lawyer, an engineer, or an architect. But María, whose husband had been a player for Real Madrid with "The Blonde Dart," supported her grandson's dream at every opportunity. She

told the interviewer that she would often defend him by saying to her daughter-in-law, "There are many doctors and architects, but athletes like Baldo are few and far between." She then justified this statement by telling the interviewer, "No, I'm not saying that just for the money they make, although that's important too. I'm saying it because while they're young, they live like kings, like the kings of their world." María then tells the interviewer that her son, Baldo's father, was easier to convince than her daughter-in-law in this regard. "Dad was easier to convince. He said to Baldo: You keep training but also keep up with your studies, eh? Because the life of an athlete is short, it won't last forever."

María, like many Spanish grandmothers, felt she was the main force driving her grandson to be a soccer player and that she was the first to influence him to choose this path because she bought him his first ball. She begins the interview by saying,

> What do you want me to tell you? What could a grandma possibly tell you? I hardly know anything about soccer. But when it comes to that boy, I know everything. . . . It was me that got him his first soccer ball. He was thrilled! It was a real ball, not one of those toy-balls. I was surprised he was even able to actually kick the thing he was so small. But his mom was less impressed. She didn't even want to hear anyone say the word soccer.

However, María expresses that there had been a time when she questioned whether her role in influencing Baldo to become a soccer player was the correct decision. This was when Baldo was hospitalized after the opposing team brutally fouled him in the box. María describes the situation to the journalist by saying,

> He had just passed the ball to a teammate who scored and out of nowhere a defender came up and kicked him so hard in the leg it had *me* on the ground—you should see how brutal they play with one another. I saw the stretcher come out and the announcer was saying: that was bad, that was bad . . . and the pain on my baby's face . . . I thought I was going to die. When I was alone I thought, what must the poor grandmothers of bullfighters go through? My goodness! Taking a horn from a bull has to be much worse than a kick in the leg. My son called me right away to calm me down. They left him in the hospital overnight. His mom, who is also a nurse, never left his side. I couldn't sleep that night. All I could think was that it was all my fault for having bought him that first ball. But oh how happy that ball made him.

At times like these, when María questions herself, she remembers what her husband Juan once told her. He said, "Dang woman, can't you see? You haven't noticed yet, that during a game, whether you're lucky enough to watch it in person or listen to it on the radio, all your problems wash away." This reflective phrase shows that Aldecoa regards the notion of soccer as an "escape valve" as a positive attribute. María tells the

reporter that after his injury, she could not predict Baldo's future either as a soccer player or in any other regard. She had said, "With a few adjustments he could continue studying, even at night, and work during the day. It's not like he would be the first one to do it. And he will always have the memory of what he was."

At times during the interview, looking back nostalgically on Baldo's rise to stardom through commitment and struggle, María shows signs of emotion for the pride she holds for her grandson. At one point, she says, "No, no. That's not it. Those aren't tears. I'm not crying. It's those lights you have for the cameras." The final paragraph of Aldecoa's story is the most climactic and demonstrates the author's grasp of the passion that both men and women hold for the sport. Aldecoa ends her tale by writing that in the interview, the grandmother María said,

> Look, I once asked him the same thing you're asking me about why he wanted to be a professional soccer player. He answered: because I want to be the best at something and this is something I can do it in. I'm sure of it . . . O.K. Now those are a few tears that slipped out, because I just remembered what that Italian cyclist, Coppi, once told my husband: all men are the same, but some, more so than others. . . . And my boy wanted to be different than all of them. . . . If I believed in something, which I don't, but if I did believe that grandpa could see my little Baldo from above, through some tiny hole. . . . He'd see my grandson killing himself to be the best.

Josefina Aldecoa's "The Best" is an important contribution to the kick-lit genre not only for the literary technique used by the author, whose narrator tells the story through an interview in which the reader is offered only that which is spoken by the interviewee, but also because it reveals a female perspective of the sport. Through "The Best," Aldecoa demonstrates her grasp of the value that many individuals place on the game and at the same time shows that the sport can be appreciated on a number of levels. Through the grandmother's testimony, the reader can see the passion she has for this sport, which she claims to actually know nothing about. However, she does know that through soccer, she can watch her grandson chase his dreams and witness the commitment and dedication he exhibits. "The Best" is a well-rounded kick-lit tale because through it Aldecoa reveals a female perspective of the sport—that of a grandmother distanced from the actual sport itself. The tale also embraces and captures the passion that many of us have for the game and depicts the notion of the sport as an escape valve in a positive light. Aldecoa highlights the struggle between intellectualism and the world of soccer through the struggle she depicts between the soccer player's grandmother and the grandmother's daughter-in-law. Aldecoa offers her romantic vision, which defends the idea that chasing one's passion should be embraced when an individual is presented with the opportu-

nity. Through "The Best," Aldecoa covers many kick-lit themes, which is why it is such a beautiful tale.

The next story by a Spaniard in *Soccer Stories 2* is Juan José Armas Marcelo's "Like a Field Marshal" ("*Como un mariscal de campo*"). Juan José Armas Marcelo is a journalist, biographer, and novelist who received his degree in philology and classic literature in 1968 from Madrid's Universidad Complutense. Through "Like a Field Marshal," Armas Marcelo tells the sad story of Rafael Mujica, an actual ex-professional soccer player in Spain who, when his career ended, earned his living as a concierge. During this stage of his life, Armas Marcelo describes that Mujica spent the majority of his time reflecting on his days as a soccer star.

"Like a Field Marshal" tells the tale of the fallen soccer hero who is left to painfully live a mundane life. His pain is the result of having once lived a very different lifestyle—one that has now vanished and exists only in a handful of peoples' memories, the story's narrator being one of them. The argument is that his current situation would not be so painful if he had never lived the life of a soccer superstar because if that had been the case, he would not be so aware of the extreme differences of the two contrasting lifestyles. As a professional soccer player in Spain he was well respected because he dominated "like a field marshal." But now he is looked down on by many of his peers for his fall from grace. The narrator depicts him as an honorable man who maintains proper morals and values while living the life as an ex-soccer player. This is summarized in Armas Marcelo's opening sentence, in which the narrator says, "He never lost the flair of being a field marshal, neither on nor off the field." This statement is followed by a long description of the ex–soccer player in more specific detail:

> While he was one of the most celebrated and applauded on the field, everyone recognized his pedigree, his finesse, and distinction. And then, when he retired from soccer he had to take a job as a concierge during the evenings at the municipal annex of the *Puente de los Franceses* (Bridge of the Frenchmen) to survive. He was alone, nearly deaf, and he mumbled. When he was young, his athletic figure encompassed his masculinity and attractiveness and was sought after by every high-fashion store in Madrid. Later on, after the decision to hide the weariness of his memories and the gravity of years under the old English gabardine with which he masked himself each time he appeared in public, he would set off slowly walking up through Gaztambide until arriving at the Vallehermoso bar where he would soak it all in everyday for a few hours.

The narrator describes certain adverse situations that Mujica was forced to overcome during his life both as a soccer player and later as an ex-soccer player. The narrator related that Mujica would often eat lunch in a bar that had an old picture of him on the wall. This picture was taken during his triumphant years as a soccer player. The narrator witnessed

Mujica looking at the picture of himself in the bar of *Vallehermoso*, and after Mujica's death, at the end of the story, the narrator reflects on this encounter, stating, "I remember the last time I saw Rafael Mujica looking at himself in that photograph from the other side of the bar, as if he were looking at a mirror that he would like to enter, find himself once again, and stay forever."

"Sometimes it's Dangerous to Dial a Telephone Number" ("*A veces es peligroso marcar un número de teléfono*") by Juan Bonilla is the next short story by a Spaniard (after Rafael Azcona's "Goal") to appear in *Soccer Stories 2*. Bonilla is a Spanish author who has written a number of novels and short stories. Two of his works have been successful enough to be adapted to film. The first was his short story "No One Knows Anyone" ("*Nadie conoce a nadie*") and later his novel *The Night of the Skylab* (*La Noche del Skylab*). Although Bonilla is considered a very talented novelist, he has received the majority of his recognition as a short story writer. His first publication of short stories, titled *He Who Turns Off the Lights* (*El que apaga la luz*) (1994), was selected through a survey of critics, academics, and authors in the magazine *Chimera* (*Quimera*) as "one of the best short story books of the 20th century."[3] In 2000, the Spanish newspaper *The Country* (*El País*) included *He Who Turns Off the Lights* among the most distinguished works of Spanish literature of the past twenty-five years.

Bonilla demonstrates his talent for short story writing through his tale "Sometimes It's Dangerous to Dial a Telephone Number." The story is a fictional kick-lit tale told in the first person by the narrator, whose name is never revealed to the reader, but is implied to be Bonilla. Bonilla begins his tale by telling the reader that he had read that 666 is the devil's telephone number. He continues by saying, "I dialed it because I always believed the truth preferred to hide itself in some room in literature before submitting itself to the open air of reality, an obsolete place in which there are too many zombies." After dialing the number 666, he realized this was true because the devil's secretary answered the phone. Bonilla admits that upon realizing this, he quickly hung up because he hadn't properly planned anything to propose to the devil. Bonilla says, "At least I learned that 666 really was the devil's number."

The following paragraphs consist of Bonilla contemplating what sort of a deal he could make with the devil. He addresses the reader directly as he describes his thought process, saying,

> I made a list of all the things I was lacking in my soul to be happy. They were all the things we all want in order to be blessed with happiness. I'm a very up-to-date man, which is to say, I've got a sport's channel subscription, like most of you all, I have to save to be poor, like most of you all, I got excited at the last chapter of Peter Pan, like most of you all, I voted conservative, like most of you all, and I dated Marta Perramón for a few months like most of you all.

Bonilla's list of earthly desires initially consisted of having a house on the coast, an inexhaustible bank account, and enough sex appeal to seduce whomever he saw fit. After thinking it over a bit more, he thought, "Maybe it would have been better to have asked simply to be happy, or maybe, guide myself directly to the desired end, eliminating the middle-man and to gain access to him." After thinking this over, Bonilla abandons the plan, saying,

> In either case, I was concerned about the possibility that the devil could convert me into a Tibetan monk, or into someone who reads tabloids, or into a fan for my home town's soccer team, or one of those people that gets themselves all made up to seem perpetually happy instead of having better ways to spend their existence. I wasn't interested in any of these possible outcomes.

When Bonilla contacts the devil, he realizes the devil is unwavering in his negotiation and offers Bonilla only the opportunity to change a single detail of his past. After just a short time of contemplating what he would like to change, an apparition appears to Bonilla of his childhood rival, Tono. Bonilla describes to the reader that Tono was his rival "in every aspect and in every possible discipline." Bonilla says that the two competed in everything from mathematics to the hundred-meter dash. While Tono was the best goalkeeper in school, Bonilla was the school's most talented goal scorer. Both youngsters were also in love with the same girl, Aurora Longobardo. Bonilla claims that Aurora chose to date Tono not because he was nicer, more attractive, and more arrogant than Bonilla but because Tono heroically saved the final penalty kick (shot by Bonilla) of the school's soccer championship. Bonilla says, "I remembered it like this, and it's already known that memory is the place where things actually occur. On the other hand, the memory I used to have of that instant was definitely how it took place."

Bonilla states that after seeing the apparition of Tono, he realized the deal he was being offered by the devil was the opportunity to correct that missed penalty shot from his childhood in exchange for his soul. Since the devil told Bonilla his soul was worth about as much as "a second-hand sofa, a flash light, a medicine cabinet full of expired prescriptions, or an old edition of *Christmas Stories* by Dickens," Bonilla felt the devil was offering him a wonderful opportunity. Prior to making the deal, Bonilla said, "If he'd have offered me a Sharon Stone bumper-sticker with nice abs in exchange for my soul, I'd have accepted."

Once Bonilla realized that he could be afforded the opportunity to return to that moment in his life and vindicate himself, he jumped at it, saying, "That's what I asked for, and that's what they granted me; to return to that moment again." The devil then drew up the papers, writing, "From this moment on, your soul belongs to me. In exchange, I will take you back to that evening." Almost immediately after signing the

document, Bonilla found himself at the exact moment when the referee called the penalty kick for his team with only a few minutes left in the game. Bonilla says that as soon as the penalty was called, he insisted to his teammates that he take the shot because he was sure his attempt would be successful. Bonilla describes the situation as follows:

> I walk up to the penalty-kick spot. Strengthened by a sense of security: someone is protecting me, I know I can't miss. I can feel the setting sun on the back of my neck. I minimize my nervousness by exhaling all the air out of my lungs. I pick my path. I approach the ball with conviction. I look to one side and shoot to the other. Tono dives for the ball. Everything happens in slow motion. I see how he stretches out and I have faith that he can't reach it, but he manages to first block and then grab the ball. And in that moment I remember my pact with the devil, and I yell it can't be . . . that the play has to be overturned and I protest to the referee.

Unfortunately, Bonilla did not realize that the devil had simply afforded him the opportunity to return to that moment in his life. Nowhere in the pact did it say that Bonilla would score the goal and therefore change his life. In this moment, Bonilla realizes that he had been tricked by the devil and understands that sometimes it's dangerous to dial a telephone number. Bonilla's duality as a real-life author and the narrator of this fictional tale is exposed in the final paragraph. He describes the locker room setting and his frustration from having missed the kick and being tricked by the devil. He then emphasizes the dimensions in which a kick-lit novelist can enter into his craft. In this case, he does so to redeem a missed penalty kick that has haunted him for years. The final paragraph of the story reads as follows:

> I lay on the locker room floor while they scream for the winners outside. I close my eyes and prepare myself to get ready to wait all those years until the day I read that the devil's number is 666 in a *greguería*[4] by Pedro Jesús Luque. And I dialed it because the years tricked me into believing that literature is the place of refuge where one can finally alter a missed penalty kick from long ago.

The next story by a Spaniard to appear in *Soccer Stories 2* is "Shamrocks and Daisies" ("*Tréboles y margaritas*") by Jorge Cela Trulock. With "Shamrocks and Daisies," it is clear that Jorge Cela Trulock followed in the footsteps of his Nobel Prize–winning father, Camilo José Cela, and continued the family kick-lit legacy. "Shamrocks and Daisies" is a tale that embraces the beauty of soccer as seen through the eyes of someone who finds inner peace by escaping reality and entering into the soccer utopia. Throughout the tale, Cela Trulock's narrator shifts between recounting memories and events in the first person to recounting them in the third person. This technique of narration gives the tale a dream-like quality. This is fitting because through the tale, it's clear that Cela Trulock is

making a parallel between the peacefulness of a dream and what the goalkeeping protagonist considers the peacefulness of soccer. This is specifically the case during the warm-up before the referee's "alarm clock" sounds and the chaos of "real life"/"the game" begins. Cela Trulock makes this comparison obvious when his protagonist tells himself,

> Now, I have to take good care of this grove between the three poles. But above all, don't allow me to wake up from this dream of games and adventures in the grass and vegetation. It's the best way to spend life, without anything terribly bad, nor terribly great, obviously.
>
> Within an hour . . . when the sun climbs up to the mid-day height, right there, between those three poles and the grass, between those four tepid sides at dawn the goalie stretches out while waiting for the referee's alarm clock to ring, the ring of a clock, the signal that announces it's time to change activities, from rest to work.

Cela Trulock's protagonist is a goalkeeper who cherishes the hour during warm-up because he describes it as the only pocket of time when he is able to appreciate and reflect on his job as a goalkeeper. But as soon as the game begins, he is no longer able to reflect and relax because all of his attention is focused on the game. During the match, his nerves and the task at hand overcome him. However, it is the hour during warm-up that Cela Trulock's goalie truly cherishes, because it is during this hour that the six-yard box, a danger zone he must defend during the game, is simply a relaxing utopia filled with "shamrocks and daisies."

"Many Opportunities" ("*Muchas ocasiones*") by Manuel Hidalgo is the next story to appear in *Soccer Stories 2*. Hidalgo is a Spanish journalist who has worked for the magazines *Exchange 16* (*Cambio 16*) and *Photograms* (*Fotogramas*) as well as the newspapers *Diary 16* (*Diario 16*) and *The World* (*El Mundo*). Much of his journalistic work is dedicated to critiquing and analyzing film. In 1988, he was the director and host of the Spanish television program *As Such* (*Tal Cual*), which consisted of interviews and reports pertaining to Spanish culture. Hidalgo has written a number of novels, including *The Impeccable Sinner* (*El pecador impecable*) (1986), *Madonna, Who Plays Tennis* (*Azucena, que juega al tenis*) (1988), *Olé* (*Olé*) (1991), *All Y'all* (*Todos vosotros*) (1995), *The Princess Dances* (*La infanta baila*) (1997), *Days of August* (*Días de Agosto*) (2000), and *Unsettled Stories* (*Cuentos pendientes*) (2003). He has written screenplays and participated in the making of a number of films, such as *A Woman in the Rain* (*Una mujer bajo la lluvia*) (1992), *Great Occasions* (*Grandes ocasiones*) (1998), *Summer Clouds* (*Nubes de verano*) (2004), and *Women in the Park* (*Mujeres en el parque*) (2006). For this study, Hidalgo's most important work is his kick-lit tale appearing in his short story collection *Unsettled Stories*, titled "The Goalkeeper" ("El porter"). *The Goalkeeper* was adapted to the big screen by Gonzalo Suárez in 2000. Hidalgo has also written a number of notable film studies: *Carlos Saura* (1981), *Fernando Fernán Gómez* (1981), *Conversa-*

tions with Berlanga (*Conversaciones con Berlanga*) (1982), *Francisco Rabal* (1985), and *Pablo G. del Amo, Dream-Rider* (*Pablo G. del Amo, montador de sueños*) (1987). Clearly, Manuel Hidalgo possesses a passion for soccer, literature, and film, and he does not hesitate to overlap them when he has the opportunity.

Through "Many Opportunities," Hidalgo tells the tale of a man from Madrid named Antonio who uses the soccer match between Real Madrid and FC Barcelona as an excuse to escape his family for a few hours so that he can dedicate some "quality time" to his mistress, Teresa. Antonio had initially planned to watch the match with his twelve-year-old son, Toño; his wife, Julia; and his mother-in-law, doña Julia. But since he had been having a lunch-break affair with Teresa, an auditor who arrived at his office three months ago, Teresa was now asking him to spend quality time with her during the weekend. The narrator of the tale describes Teresa by saying,

> Teresa was an attractive girl, with a great body, although slightly over-weight. With dyed silver hair, she dressed a bit gaudy, with tall boots and such, and purple painted fingernails for no reason. Very pale skin. . . . Antonio was twenty years older, but what did he care?

When Teresa complained to Antonio that their relationship did not extend beyond their lunch break, he responded, "You'll see. Some Saturday we'll get together, you and I. Just let me get everything all lined-up."

Antonio plotted with his friend Jesús to get him out of the house on Saturday so that he could spend time with Teresa. He had Jesús call his house and claim to have an extra ticket to the soccer match between Real Madrid and Barça. Initially, he would pretend to be a good father, refuse Jesús's offer, and opt to watch the game with his family, knowing full well his wife would recognize the opportunity he was being offered and insist that he accept Jesús's ticket. Surely, she would console their son, Toño. The scheme went exactly as planned and seemed to completely fool everyone in his home, except, of course, his mother-in-law, who, after overseeing the entire situation, said to Antonio, "You, to your own devices."

When Antonio arrives at Teresa's apartment, she brings him a beer and a piece of *empanada gallega* (Galician pastry) that she made for the occasion. Almost immediately, Antonio says, "Hey, Tere, let's watch a little of the game, eh? Because obviously, I'm supposed to be there, you know? I'll have to have something to say when I get back home, no?" Teresa understands and accepts, and Antonio turns all of his focus to the match. Eventually, Teresa becomes annoyed with the lack of attention Antonio is giving her, and when he realizes this, he says, "Hey, sorry, Teresa, pardon, but this game's on fire. What do you say we do this. . . . Let's relax and watch the first half, and then at halftime we'll make it happen, sound good?" To this, Teresa responds, "So you're saying we're

just gunna get our rocks off in ten minutes?" Antonio realized Teresa's frustration and consoled her while watching the rest of the first half of the match.

During halftime, Antonio put the game aside and focused his attention on Teresa. As the two began to kiss, the doorbell rang. Teresa quietly went the door to see who it was, and Antonio reinstalled himself in the living room in front of the television. Teresa looked through the peephole of the door and saw that it was her mother. Shocked, Teresa said, "Antonio, my mom! My mom, Antonio, you're a work friend from the bank!" Teresa quickly opens the door as if she were casually watching the game with a friend from work. The narrator describes the scene by saying, "In the living room, next to Teresa, a woman of some sixty years had appeared, with an imitation pumpkin-colored Chanel-type suite and a purse from El Corte Inglés [Spain's most popular department store] in her hands." She had come to give Teresa two skirts that she had tailored for her daughter since Teresa had recently put on some weight. As she entered the room, Teresa introduced Antonio as a friend from work who had come over to watch the match with her. Antonio courteously greeted the older woman, going as far as to kiss her on the hand. The narrator describes that Teresa's mother then took a quick glance down toward Antonio's hands and found what she was hoping not to find: a wedding ring.

Teresa tried the skirts on to appease her mother and hoped to send her on her way so that she could spend the rest of the match alone with Antonio. But her mother, who was also a fan of Real Madrid and especially of the club's center-forward, Raúl, didn't hesitate to plant herself on the couch and watch the entire second half, talking the whole time. The narrator described her as "a Madrid-supporting fanatic, although, according to her, soccer didn't interest her." The second half of the match was uneventful, and the game ended in a tie. All parties were disappointed with the afternoon's outcome. The group said their good-byes, and Antonio headed for home.

Antonio arrived back home and was greeted at the door by his wife, who instantly laid into him by saying, "Where's your head at? Why do you do these things to me?" Unable to know exactly how to respond, Antonio simply asked, "Me?" Julia went on to say, "You. Yes you, who goes off to watch soccer on me in the middle of January without a proper coat. You must have caught pneumonia." Relieved, Antonio agrees with her and says that he was very cold throughout the entire match and thinks he caught a sniffle. Julia sits him down at the table, brings him some soup, and consoles him for having witnessed such a boring game. She says, "What bad luck you have, poor guy. When you finally get a chance to go to the game, they don't score any goals and they don't even win. You *madridistas* [Madrid supporters] never get lucky." His son, Toño, chimes in by saying, "What a crappy game, Dad." Antonio then

looked to doña Julia to get an impression of her take on the situation. She was reading the magazine *Hello!* (*¡Hola!*) in silence until Julia and Toño began questioning Antonio's abnormal lack of appetite for his wife's *empanadas* (meat-filled pastries). Julia says, "Man, for as much as you like *empanadillas* [little meat-filled pastries]. You go to the game and lose your appetite. . . . You make no sense. I'll tell you now, you don't make no sense." Toño then chimes in, "And we would have had a blast watching the game here at home!" Antonio responds by shamefully holding his head and saying, "You said it, kiddo. You said it." To this, doña Julia finally puts down her magazine and in an all-knowing manner ends the tale by saying, "Leave him be. Leave him be. Everyone knows full well just what suits their fancy."

Through this analysis, it appears that Manuel Hidalgo simply used the pretense of an important soccer match as an escape mechanism for Antonio to sneak away from his wife and family and participate in his extramarital affair. By the conclusion of the story, it's implied that Antonio shamefully recognizes the error of his ways and realizes that he is blessed with a loving family from which he should not stray. Although this is the central theme of the story, Hidalgo is also true to his goal of attempting to write a veritable kick-lit tale and gives a variety of in-depth soccer coverage of the match. For example, as Antonio watches the match, he speaks aloud in an effort to help Teresa gain an appreciation of the game by explaining certain tactics that he feels would lead the team to success. After Raúl launched the ball over the crossbar with only the goalkeeper to beat, Antonio exclaimed, "Y'all gotta take advantage of your opportunities, damnit!!! You can't give Barça any forgiveness. If they have a hole on the right, take it at them on the right and don't insist on bombing balls to the middle. Because Nadal's a big S.O.B., fuckin' A!" On a number of occasions, Hidalgo reverts to giving in-depth soccer coverage of the match through which he also demonstrates his ability and craftiness as a journalist.

The next story in *Soccer Stories 2* written by a Spaniard is Ramón Irigoyen's "Saving Is for Bumblebees" (*"El ahorro es de abejorros"*). Irigoyen is a philosopher, poet, author, and recognized Greek translator from Pamplona. The language he uses in his poetry is vulgar, aggressive, and at times full of rage, while other times his language is quite tender. This abnormal use of language has caused him to gain the reputation of being one of the counterfigures to the school of Spanish poets called *"los novísimos"* (the supernew ones). The *"novísimo"* poets are characterized as maintaining formalized freedom: rejecting traditional Spanish literature while using traditional literary techniques. Irigoyen's tendency to use language that borders on being offensive can be seen in "Saving Is for Bumblebees" when he mixes poetry with vulgarity and tenderness to describe the sensation that a soccer fan has when his favorite team scores. He writes,

Our passion of fans reached the normal limits that passions reach, which can only be described in sexual terms. For example, only the infinite pleasure that can yield sublime sex, like the sensation of having screwed all the best looking men and women from Europe, Asia, Africa, and Oceania at the same time can encompass what a fan feels when his team manages to slip the ball into the delicate vagina of the net, which embraces the three poles, as a storm of mad butterflies explodes in a frenzy howling and applauding under your shorts.

Through "Saving Is for Bumblebees," Irigoyen tells the story of how his protagonist, who seems to be Irigoyen himself, learned to properly manage his money. He begins his tale by explaining how, throughout his childhood, he despised his father for his extreme stinginess. As an adult, Irigoyen describes that he had trouble managing his money, that is, until one day when the new president of his beloved club, Osasuna, stated in an interview how he managed a feat that no other president in the league had been able to do: "finish the season in excess." Irigoyen recounts that the Osasuna president described the key to his success by saying, "It's very simple: you have to administer the club the same way as the domestic economy, which is to say, always spending less than what comes in." For the rest of the story Irigoyen describes the effect that statement had on his life. At one point, he describes the statement as being "fit for Epicurus, Buddha, or the half dozen geniuses whose doctrines changed the life of nations."

In addition to the multitude of ways in which Irigoyen describes how this statement changed his economic situation, this kick-lit tale is relevant for the depiction he gives of the state of Spanish soccer and his depiction of the club rivalries as they pertain to the country's historic political rivalries. Irigoyen's description, not surprisingly, reveals how these club rivalries are also prevalent in households that sit on the border of regions. He describes his family's situation by saying,

My mom was a super-fan for Zaragoza and I, on the other hand, was a hopping-mad fan of Osasuna and only a second-hand fan of Zaragoza. Like so many people from Tudela, she always concealed a secret antipathy for Pamplona and for all that the capital of the province of Navarra represents. She's extremely proud and would have loved it if the capital of the province were Tudela and her frustration that it wasn't, connected with the geographic proximity, had caused her to identify with Aragón, and consequently, as a soccer fan, she felt passion for Zaragoza.

Irigoyen also gives some insight and his opinion on the controversial and complex issue regarding the state of Basque Nationalism when he addresses the situation by saying, "We need to remember that Navarra is a fortunate province, as much for its countryside as for those crazy *fueros* (the Basque ancient law system) inherited from the Old Regime (*Antiguo Régimen*), and that they pretty much pulled this region's most reactionary

rights straight out of their ass." Irigoyen also sheds light on the Spanish National Team's lack of success in international competition when he hypothetically contemplates his death and how, after, there should be the economic well-being of his children by saying, "If one day I should suffer a heart attack from emotion, from the practically impossible final victory of the Spanish National Team in the World Cup—you might need this money saved."

Although "Saving Is for Bumblebees" consists of both memories and insight into the state of Spanish soccer, the tale is centered around Irigoyen's description of his youthful attitude of resenting his father for being so stingy and respecting his mother for mocking her husband's frugalness by saying, "Saving is for bumblebees." Irigoyen describes how, after being enlightened by the Osasuna president's statement, he gained a newfound respect for the penny-pinching ways of his father throughout his childhood. As the story concludes, Irigoyen states,

> This change in life also radically affected the value of my dad's character. Up until then, I had always seen him as a damned cheapskate. But ever since I squandered my entire savings account, I saw my dad as a very intelligent and hard-working citizen, who for his, and his family's well-being, exemplarily administered his income.

The next story written by a Spaniard to appear in Valdano's *Soccer Stories 2* is Joaquín Leguina's "The Goal of Triumph" (*"El gol del triunfo"*). Leguina is a Spanish politician and socialist intellectual who, aside from his political activities, has written over ten novels and a variety of essays. With "The Goal of Triumph," Leguina serves as yet another example of the Spanish intellectual class that has broken the taboo and openly demonstrated his passion for soccer through the medium of literature.

"The Goal of Triumph" is a story filled with intrigue, passion, love, mystery, deception, and jealousy. Laguina's tale is a detective story, recounted in the first person by the protagonist whose name is never revealed. The story begins with the narrator describing the buildup to the upcoming match between Real Madrid and FC Barcelona. Our narrator was invited to attend this match by his childhood friend José, who was a player for Real Madrid. The narrator describes that José had been going through a rough spell with the club. He was thirty-one years old, and many of the fans were recently expressing their disapproval of his play. Leguina demonstrates his knowledge of soccer and his skill for writing kick-lit through his narrator, who describes the relationship he has with José and José's abilities as a soccer player. The narrator says,

> Like anyone, I knew José, an international soccer player, since we were very young, when he still played in Oviedo. It was a highly anticipated signing, the offensive-center-midfielder that Madrid had been looking for. He had, and still has, skills that no one can deny; a supreme intelligence at managing the spaces on the field, which affords him the ability

to pass the ball into a gap so that it will arrive perfectly for a teammate in stride, or to be in just the right place at the right time to ruthlessly clear the ball out. On top of that, he also has an extremely strong shot and an exceptional control when it comes to playing long balls. But the practice of soccer, when one is on top, demands a concentration that only can be maintained by the lucky hair on your chin, both on the field and in life, and José's luck hand turned on him a few months back.

This story, which is focused on the life of José, begins with his entering his longtime friend's office (our narrator). José approaches our narrator, who is a lawyer in Madrid, because the soccer player is afraid that his beautiful young wife, Etelvina, might be cheating on him, and he wants to find out the truth. The narrator responds to this by saying, "It's all good. I'll head up an investigation. It's not expensive, but it could end up to be, how should I say, unpleasant." Immediately after the meeting, the narrating lawyer calls Mendiondo, his friend from law school, and asks him to work for them as a private investigator. A week later, Mendiondo returns to the lawyer's office and confirms that Etelvina is indeed having an affair with an older engineer named Fransesc Dexeus i Cerdá. Mendiondo says that besides dining in fine restaurants and dancing the night away, the two often attend Acuarela (Watercolor), a swinger's club.

The next day, the lawyer calls his longtime friend into his office to give him the bad news. After looking at Mendiondo's paperwork and photos, José says he wants a divorce. On hearing this, the lawyer tells him not to act too hastily and calmly explains that "people tend to be more complicated than we seem. Above all when it comes to our feelings being hurt. It's a blow, I'm well aware of this, but if you can swallow your pride, self-love, and anger a bit, you will feel better. She's probably no more miserable than you or I." To this, José responds, "Come on, she's been cheating on me since god knows when . . . and you come at me with this? Are you a lawyer, a priest . . . or a psychologist?"

The next day, Etelvina arrives at the lawyer's office, and he presents her with Mendiondo's findings. After perusing the paperwork, she tosses them aside and exclaims, "Knowing that you're being spied on is not pleasant." The lawyer cuts to the chase and asks Etelvina if she loves José or if she wants a divorce. To this, she proclaims that she loves her husband and explains,

> I didn't want to hurt him, nor hurt me. Sex is many things. It's posses-
> sion, expression of love, of passion, of affection, of tenderness . . . but it
> is also a heartbreaking game. It is heaven and hell. I owe my husband
> loyalty, but that doesn't mean that he owns my body, my soul, or my
> freedom. What I did has transcendence for me, but it wasn't my inten-
> tion that it would have it for him.

At the end of their conversation, Etelvina tells the lawyer that she will speak with her husband and explain the reason for her actions. She says

that she hopes that her husband will be understanding and willing to work with her because she loves him and is not ready to lose him.

One week after the lawyer's meeting with Etelvina, José calls his old friend and says, "We've decided to give ourselves some time. Maybe you were right, you always have to put yourself in the place of the other." A month later, the narrator explains that he saw the couple and that they seemed very happy, "like only those who are newly in love." They tell him they are happy and are even considering having a child. This drastic change in attitudes in the face of such a difficult situation causes the narrator to question how they were able to overcome their differences, so he again hires Mendiondo, this time to spy on the two of them. A week later, Mendiondo returns and says that Dexeus is out of the picture but that José and Etelvina now frequent Acuarela. But since José is a famous soccer player, they are careful to protect his identity. José waits in the car as Etelvina enters the club, where she invites a couple to join them back at their house. Mendiondo then concludes the description of his findings, saying, "I can't give you details of the orgy. Unless . . . but that's dangerous, and illegal, as you already know."

While recounting this investigation, the narrator jumps back and forth between the details of the investigation and the details of José's match against FC Barcelona. Explaining how José had entered the match as a substitute fifteen minutes into the second half and although he had been through a very rough month and a half, both on and off the field, his luck was changing. The narrator describes that after entering the game and getting involved in a few plays, "José dribbled and threatened, and with three players surrounding him, he threaded a silky pass through a forest of legs. Amavisca only had to touch it. The Bernabéu Stadium erupted. Etel hugged me, and leaning her head against my shoulder she whispered: He's the best . . . at everything."

After the game, in the car ride to meet with José, Etelvina asks the lawyer what he thought of the match's outcome and José's performance. The lawyer responds, "Phenomenal! I hope the girls at the Acuarela are too." To this, Etelvina broke into laughter and, much to our narrator's surprise, responds by saying, "I see you've been taking your craft as a spy very seriously. It would be convenient if you convert yourself from peeping Tom to a co-protagonist, from the armchair patio to the stage. I think I could help you out with that. Tonight's celebration might be rather long." Leguina ends his tale happily as the narrator describes how upon hearing Etelvina's proposal, the hair stood up on his arms and neck and his heart began to pump with excitement: "This miserly life, from one night to the next gives such wonderful surprises."

The next tale by a Spaniard in *Soccer Stories 2* (after Ana María Moix's "One Day, All of a Sudden, It Happens" and Juan Manuel de Prada's "Parallel Lives" [*"Vidas Paralelas"*]) is Soledad Puértolas's "From Zaragoza to Madrid" (*"De Zaragoza a Madrid"*). Puértolas is a well-respected

Spanish novelist and essayist who has published a great number of works throughout her literary career. Her contribution to the kick-lit genre is a verisimilar tale told in the first person, and the reader has no reason to believe these are not the real-life memories of Puértolas herself. Through this story, Puértolas recounts her memory of falling in love for the first time. The love story is intertwined with the description of her life while growing up in Spain, which, as she divulges, was greatly influenced by soccer.

Puértolas explains that when she was fourteen, her family moved from Zaragoza to Madrid. This move was difficult for her because the world as she knew it had been changed in more ways than she ever imagined possible. In Zaragoza, she spent her free time on the school's large playground getting dirty as she explored the garden or played ball with the other children. The playground of her new school in Madrid was much less conducive to a youngster seeking adventure. It consisted of a single basketball court, which was controlled by the school's dictatorial leaders and overrun by the masses of students. Puértolas describes, "I was always bored during recess at my new school. I felt so alone and neglected, and I didn't do anything except hope the time would hurry up and pass, or that it would either rain or the bell would sound announcing the end of recess."

Puértolas explains that her lack of participation during recess was actually what helped with her acceptance into a small clique of girls. This group did not consist of the type of girls she wanted to befriend, but since Puértolas was left with no other option, she accepted their friendship. Puértolas describes the girls, whom she calls "the flirts," as follows:

> These little girls, who also existed in my old school, didn't want to get dirty nor ruin their hair. They would secretly paint their fingernails, or at least they would cover them with clear fingernail polish, and they would talk in whispers about boys and secret dates.

Puértolas admits that normally she would not have chosen to be associated with this group of girls, but since she was desperate to be a part of something, she joined their clique.

Puértolas describes how it was through this group of "flirts" that soccer became a part of her life. She says that, much to her surprise, her new group of girlfriends in Madrid often talked about soccer and especially about soccer players. Many of the girls in the group had brothers who played the sport, and the girls therefore followed their brothers and their friend's brothers closely. According to Puértolas, the girls simply attended the matches and sang songs in an effort to animate their team and show support for the players they so admired.

After attending a number of these Sunday morning soccer matches, Puértolas admits that she secretly fell in love for the first time in her life with one of the players. Puértolas's problem was that she had hopelessly

fallen in love with Nacho, the best player on the team and the most popular boy in school. Two of the girls in her group were also seriously (and openly) in love with Nacho. The other girls in the group were at least partially in love with him. When he scored a goal, all the girls would jump up and down, hug each other, and scream in unison. Puértolas explains that Nacho, whose image never left her mind for an instant, was becoming more and more distanced from her with each goal he scored because, according to the author,

> He was the most sought after and admired boy and I was the simple, new girl who had just been admitted into the clique. Only if he broke down and became a failure, and only if the two deeply in love girls and the rest of his admirers stopped considering him the best of the men, would I have my opportunity.

Although Puértolas promised herself that she would wait for him for eternity, one day she found that Nacho had mysteriously vanished from her thought. The main reason for Puértolas's loss of interest in Nacho was that his parents had sent him to another country in an effort to force him to focus on his studies and leave his childish dreams of being a soccer player behind. Eventually, Puértolas also became distanced from the group of "flirts," and before she knew it, she was in the university, where she was happy once again. Her nightmares from high school seemed a thing of the very distant past.

While in the university, Puértolas recounts that she was gaining confidence and becoming more and more independent while putting all her focus into her studies. One day, while studying in the cafeteria of her department, she saw Nacho leaning up against the counter. She was shocked to see him there, and although she claims she was not attracted to boys at that time, she couldn't risk the possibility of losing touch with Nacho, so she invited him to have a cup of coffee. Puértolas remembers that Nacho seemed out of place in the university. He told her that he had spent a few years in the United States, where he studied law, but that he was not interested in what he studied nor the political energy that surrounded the universities in the United States at the time.

The two began to see each other quite frequently, and they would often sit in the cafeteria of her department and have a drink together. According to Nacho, he preferred the cafeteria of her department to that of his because there were more girls there. They often talked about the past they shared, which had been a glorious time for him. Nacho was shocked to hear that it was such a difficult era for her. Puértolas never revealed that she had been madly in love with him during that period. The feelings she once had for him seemed very distant to her, and now she simply saw him as a friend. Regardless, as they would sit and talk in the cafeteria, Puértolas often noticed other girls gazing at her jealously for being in Nacho's company.

Frustrated with his current situation, Nacho asks Puértolas if she thought he was a good soccer player and if she thought he should have dedicated himself entirely to the sport. She supported his dream and openly admitted, "I've never seen anyone play the way he played." Later, she informs us that eventually the two no longer crossed paths but that she learned he had returned to playing soccer. Shortly thereafter, she remembers hearing his name on the radio broadcast of a game and then saw him playing on television. "I thought of calling him because he should have been congratulated, but I didn't do it."

Puértolas eloquently concludes her story by relating that now, years later, she often hears Nacho commentating a game on television:

> When that happens, I follow the game intently for a bit, as intently as I used to follow it when I was hopelessly in love with him and was included in that group of girls that I had nothing in common with, but that I had to grapple with because I was alone in the world and didn't even want to think about it, and I think, above all, while I listen to him commentating about that slow morning, wrapped in smoke in my university's department bar in front of a bunch of glasses of hideous wine when we spoke about Marcelino and my friend from elementary school, possibly the last time our lives were face-to-face, maybe one influencing the other, and honestly I stay put for a while with my eyes glued to the television, listening to his voice, in case he appears on the screen.

Through "From Zaragoza to Madrid," Puértolas offers the reader what seems to be a nonfictional anecdote of her past. She describes the connection she had to soccer through Nacho, her first love. Puértolas's relationship with Nacho, although physically distant, stayed with her throughout her life and was an obvious link connecting her to soccer. This kick-lit tale also offers the reader a glimpse into the relationship that many women in Spain have with soccer. Although they may have little interest in the sport itself, they are at times connected to the game at the highest levels through the men with whom they are involved. This causes some men to be envious of these women because they have managed to become a part of the professional soccer environment without actually developing any expertise or knowledge of the game. Regardless, the women involved with soccer players play a very important role in their lives just as in any other profession. The most interesting aspect of "From Zaragoza to Madrid" lies in Puértolas's incorporating and questioning the existential elements of random chance and fate into her story. Had these elements not been a part of the anecdote, I doubt if Puértolas would have even bothered relating it. Through this tale, the reader and Puértolas are left to ponder whether the conversation she had with Nacho (in which she told him she supported his dream) played a role in influencing him to chase his dream and become a professional soccer player.

"Cela's Service" ("*El saque de Cela*"), written by the famous contempo-
rary Spanish author Francisco Umbral, is the next tale by a Spaniard to
appear in *Soccer Stories 2*. Through "Cela's Service," Umbral gives his
account of the evening Camilo José Cela was recognized for receiving the
Nobel Prize for Literature at an Atlético Madrid match. This night, desig-
nated to honor Cela's literary accomplishment, actually took place in
Atlético Madrid's Vicente Calderon Stadium and serves as another link
between soccer and literature in Spain. The fact that Umbral chose to
dedicate a short story about his experiences during the awards ceremony
furthers that link.

Umbral's nonfictional anecdote tells how he was invited, along with a
number of other honorable members of the intellectual community, by
the president of Atlético Madrid, Jesús Gil, to attend the match in the
presidential box and honor their colleague's achievement. The match was
against Real Valladolid, the club that Umbral supported, and he relates
that when he saw Gil, the Atlético Madrid president told him,

> You're going to see a thunderous game, Umbral. I know you like to
> bust my balls, but I also know you really love me. I actually wish you'd
> come around more often. Today you're going to see your boys from
> Valladolid, who are here to suffer, and the team I've got this season.
> The Pucelanos (Valladolidians) are all mine today.

Umbral describes that among those invited to the presidential box were
"illustrious Valladolidians," such as Miguel Delibes (another famous
Spanish figure of kick-lit), Joaquín Calvo-Sotelo, Marienma, Carril, and
Olano, along with many others. According to Umbral, in a telephone
conversation weeks earlier with Miguel Delibes, he asked Delibes if he
would be attending the match. Delibes responded by saying, "Why are
you going to that? If they lay down like blankets, Pacorris, the people
around here are a bunch of wet blankets." After being recognized, Um-
bral states that Cela sat down next to him to watch the match. Umbral
wrote,

> The match was really boring, like all matches, with that same sadness
> all Sunday sporting events and the bulls have, because there's no Cup
> nor League to resolve the sadness of Sunday evening. A Sunday eve-
> ning only excites the wife of a bullfighter, but this wasn't the case.

Shortly thereafter, Umbral began to notice that although he was in the
presidential box, the cold was still bothering his throat, so he went to the
bar to have a cognac. At the bar, he bumped into María Eugenia Yagüe
and Natanael, whom he describes as his "blonde angel; tall, skinny, beau-
tiful and crabby." Umbral and Natanael have a conversation about how
bored they are with the soccer match and the entire social gathering
while Umbral reflects on all the times he had kissed her. Eventually, she
asks, "What do you say we get out of here and go someplace else?" He

says, "Hang on, I just have to say goodbye to all the others." Natanael responds, "Don't say goodbye to anybody." The two escape the social scene filled with "illustrious Valladolidians" into Natanael's black Alfa Romeo, "happy and in a hurry to hide ourselves in one another." Umbral learns the next morning that Real Valladolid had lost 3–1 and says, "Like always. And it gave me that same old nasty twinge I'd feel on Sunday when I was young, without a girlfriend or a respectable team."

Patxo Unzueta's "The Nurse and the Soccer Player" ("*La enfermera y el futbolista*") is the penultimate story by a Spaniard in *Soccer Stories 2*. Unzueta is a journalist from Spain's Basque Country whose work is dedicated to defending Spanish nationalism and opposing Basque separatism and terrorist groups, such as ETA. With "The Nurse and the Soccer Player," which was published in the Spanish newspaper *El País* on August 28, 1986, Unzueta demonstrated his ability as an author of kick-lit. "The Nurse and the Soccer Player" is a strange tale divided into three parts, each told in the first person from the perspective of different narrators. "The Nurse and the Soccer Player" is an erotic, jaw-dropping tale that comes to a dark yet pathetic climax. Through this tale, Unzueta demonstrates to the reader just how much freedom an author can have when creating a work of literature.

The first section of the tale relates the fictional action of a youth soccer match that took place in Spain's Basque Country in 1959. This part of the story is recounted by one of the team's substitute players sitting on the bench. In this section, Unzueta demonstrates his talent as a journalist, his knowledge of soccer, and his skill for describing in detail the actions that take place during a match. This talent can be observed in the second paragraph, which Unzueta relates through the narrator on the bench:

> Vacas crossed the center-line and lifted up his head scanning the horizon. Asúa, unmarked, shook his arm to call for the ball. Right behind number 11, on the other side of the fence, Mari Asun and the others gave their typical roar. Vacas didn't have any problem side-stepping their number 8, leaving him out of the play. He then pushed the ball to the right as if he were going to continue the attack by himself, but instead of doing so, out of the blue he turned and sent a long cross to the left.

This entire first section is dedicated to recounting the events of the match that led up to Goyo Asúa's injury. Asúa's injury occurs while he is attempting to avoid the opposing team's goalkeeper, only to collide with the goalpost. Unzueta's narrator relates the event as follows:

> This big axe of a player, hacking everybody from behind, dragging his cleat through the grass like a scythe, found his target. Goyo, propelled by his own inertia, was catapulted forward, and in mid-flight he could see the goalkeeper's amazement, who came out for the challenge, just before Goyo's head smacked directly up against the right goal post.

With this description, the first section of "The Nurse and the Soccer Player" abruptly ends.

Goya Asúa recounts the second section of the tale in the first person as he looks back on the time that he spent in the hospital. It begins with Asúa stating, "This is how, in summary, I went flying though the air and crashed up against the goal post. Ending up with a concussion and a broken scaphoid on the right hand. I must have fallen funny." Asúa recounts how, during his first day in the hospital, he came to and passed out a number of times as a result of the pain in his head. Asúa describes how when he fully gained consciousness, he was delighted to find himself in the care of Nurse Mari Luz L. Echevarría, and for the first time in his life he fell in love. He was thirteen years old.

Asúa claims that later in the evening, the team came by the hospital to check on him and informed him that the match ended in a draw, 2–2. Asúa says, "But frankly, I had lost interest in soccer at that point. And anyway, I didn't have the head for so much commotion at the time." For this reason, Mari Luz asks the visitors to leave. As she fixes the blinds and serves Asúa coffee with milk, she asks him about his family situation. Asúa explains that his father is a chauffeur and will be gone all week, alluding to the fact that the youngster will be left in her care. This is all he tells Mari Luz, keeping the rest to himself because, as he explains to the reader, "after everything with my mom in August, and since they'd sent me to live at the Piarists of Bilbao." This side note implies to the reader that Asúa's father was out of the picture and that his mother had recently died, leaving him orphaned.

As the days go on, Asúa secretly watches Mari Luz's every move and becomes extremely attracted to the nurse. One night he is so infatuated with her that he cannot sleep. He is anticipating her return in the morning when he will confess his love for her. But the next morning, a nun was working in her place. She gave him some painkillers that made him sleep. When he awoke again, Mari Luz greeted him. She noticed that the bandage around his head was falling off, so she sat down beside him and began rewrapping it. Looking back on the situation, Asúa recounts the day's events as follows:

> She came up to the bed and just like she had done the evening before, she fixed my pillow and properly readjusted the bandage around my head, which had gotten a little loose overnight. Once again the packages were rising up and down, up and down. She had a special odor, like freshly washed clothes hanging in a field. I gave her another kiss on the left breast. . . . It was then that, instead of stepping back and saying, "What the heck's wrong with you kid!," she twisted a little and brought her other breast closer, so I kissed that one too.

Asúa explains that this happened again the next day and the day after. Each day, their encounter became more and more erotic, and the second section of the tale ends.

The third section of "The Nurse and the Soccer Player" is told in the first person from nurse Mari Luz's perspective. Her narration opens by stating, "It's silly, but the truth is, I was glad when I went into room 202 and saw the soccer player didn't have any visitors, and that they had taken off his bandage, and that he smiled when he saw me." Mari Luz reveals how during every encounter with the adolescent, she was aware of his watching her. She also hoped to ease his pain in any way she could. In doing so, she alludes to the fact that she is suffering from a lost love, which caused her to become quite angry at times. She substitutes the anger she holds for the man she refers to as "Alberto the ungrateful" by showing love to Asúa.

The story's strange twist comes in the last paragraph after Mari Luz describes the sad gaze on Asúa's face as being comparable to that of "Toy." Unable to help herself, she sits next to Asúa on the bed and says, "Don't worry. Even though your dad hasn't come to visit, and neither has that girlfriend of yours out there, I'll stay here by your side." After saying this, Mari Luz describes the following:

> Having said that, I noticed that his eyes were also shining bright and that a little bit later he looked directly at my breasts. And this is why I brought him toward me once again and told him to give me kisses, but not one, nor two, but a dozen or more. Which he did as I gently held the back of his head, like I used to do with Toy when I would let him bite me in the same place. And I remembered him as much as Alberto the ungrateful when, in a strange upsurge, I unhooked my robe, and I alone, put my nipple between his lips, allowing him to put his face among the meat while thinking to myself that I hope the soccer player knows how to be as loving, tender, and as affectionate as my little doggy, Toy, who it's almost been three months since we had to put him underground after he was hit by that street car in Santurce, and not as brutal as that ungrateful industrial engineer from San Sebastian.

Patxo Unzueta's "The Nurse and the Soccer Player" is a strange tale that deals with a wide variety of cultural taboos: pedophilia and zoophilia — the harshest taboos that he alludes to in the tale. But by combining these erotic situations and dividing the tale into three parts, told by three different narrators, each more strange than the previous, one could possibly assume that in his tale Unzueta was attempting to portray the young Asúa having dream-like hallucinations while he lay in his hospital bed. In "The Nurse and the Soccer Player," Unzueta attempts to break many cultural and literary taboos, the most obvious (for the sake of this study) being that of combining literature with soccer, as he does so descriptively in the first section of the tale.

The final tale by a Spaniard to appear in Jorge Valdano's *Soccer Stories 2* was written by one of Spain's most famous contemporary figures of literature, Vicente Verdú. Verdú was born in Elche of the Alicante Province in today's Valencian community. Through his contribution to *Soccer Stories 2*, titled "The Elche Soccer Club" ("*El Elche C. de F.*"), Verdú proudly demonstrates the place he holds in his heart for his hometown club. Through "The Elche Soccer Club," Verdú exposes himself as an intellectual who is not afraid to proclaim his passion for soccer in Spain, the lifelong connection he has with his hometown club, or how (like many people) he superstitiously looks to soccer to predict outcomes for situations in his life that are out of his control.

Through "The Elche Soccer Club," Verdú tells a verisimilar tale in which he watches his hometown club, Elche, play the county's most powerful club, Real Madrid, in Madrid's Bernabéu Stadium. Realizing that Elche was very much the underdog, Verdú's narrator describes to the reader that he had superstitiously made a deal with himself claiming that should his club pull off a win or a draw, he would in turn receive word that he had been hired for the job at Price Waterhouse he had recently applied for. Connecting the outcome of one activity with the outcome of another completely unrelated activity, both out of the control of an individual, seems to be a common activity among those who passionately follow soccer. Verdú describes the deal he made with himself in the opening line of the tale, writing, "Being an *ilicitano* (an Elche supporter) I had a revelation: if Elche manages to win, or at least tie with Real Madrid in the Bernabéu, I would get the job that I applied for at Price Waterhouse."

Verdú describes the roller coaster of nervous emotions he experienced during the last thirty minutes of the match, from the moment Elche went ahead 2–1 until the end of the match. During this time, he conversed with his children who were in attendance with him. His children had been born in Madrid, and Verdú believed them to be Real Madrid fans. But on this day, he thought that maybe they would be rooting for the underdog from their father's hometown. With not even fifteen minutes remaining, Verdú tells the reader that his youngest son looked up at him and said, "It seems to me like they're going to win the game, Papa." To this, Verdú responds, "Who's going to win? It's us that's going to win over them." Verdú questions whether his son's comment was a premonition. Anxiously questioning himself and continually modifying whether the pact he made with himself would be more effective should Elche win or tie, Verdú watches the final ten minutes of the game in agony. With just minutes remaining, Real Madrid scores a goal, and then in the eighty-ninth minute, they score the game winner. All the confidence and self-esteem that Verdú was ready to take home with him had vanished. After the goal was scored, he recounts, "Some of the dejected players laid on the grass and others crouched down with a hand on their foreheads. I

focused on their disgust and that momentarily minimized my pain. The next morning I would surely hear from Price Waterhouse."

The following day, Verdu describes the hopeless feelings he experienced waiting by the telephone for the call from Price Waterhouse. He explains that his wife had been losing confidence in him over the past few months. He wished he could somehow overcome the fate that he was destined to suffer from being an Elche supporter: like many superstitious soccer fans, Verdú believes his life will somehow magically resemble the success or failure of the soccer club he supports. By the tale's conclusion, Verdú never reveals whether he received the call from Price Waterhouse, but he portrays a peacefulness regarding his existence by describing a newfound beauty that he noticed in his wife.

Through this brief summary of the works of kick-lit by Spanish authors that make up *Soccer Stories 2*, my goal was to demonstrate not only the distinguished literary figures who dedicated works to the genre, but also the enormous possibilities through which the genre can be tackled. The kick-lit tales by Spaniards in *Soccer Stories 2* demonstrate that the genre can be approached through a fictional and nonfictional tale, an anecdote, a detective story, or an erotic tale and can be told from the perspective of men as well as women. The possibilities within the kick-lit genre are endless. Before offering my in-depth analysis of the remaining four tales by Spaniards that appear in *Soccer Stories 2*, I'd like to end this section with a quote by Jorge Valdano that can be found in the book's prologue. The quote demonstrates what Valdano's overall intention was when he decided to compile these stories for *Soccer Stories 2*:

> *Soccer Stories 2* began as an escapade with the intention of allowing thought to stop mistrusting muscle and this contribution made us proud, because we found participation from revered authors who were ready to break the taboo. But projects are only successful when they're long-lasting, and prejudices are only overcome through insistence.

"GOAL"

"Goal" is the fourth story that appears in *Soccer Stories 2*. It was written by Rafael Azcona and was initially published in *The Country Weekly* (*El País Semanal*) on July 20, 1997. Rafael Azcona spent his career as a screenwriter who wrote scripts for a number of highly regarded Spanish films, including *The Little Coach* (*El cochecito*) (1960), directed by Marco Ferreri; *The Executioner* (*El verdugo*) (1963), directed by Luis Garcia Berlanga; *Year of Enlightenment* (*El año de las luces*) (1986), *Beautiful Era* (*Belle époque*) (1992), and *The Girl of Your Dreams* (*La niña de tus ojos*) (1998), all directed by Fernando Trueba; *Ay, Carmela!* (*¡Ay, Carmela!*) (1990), directed by Carlos Saura; and *Butterfly* (*La lengua de las mariposas*) (1999), directed by José Luís Cuerda. Azcona's scripts often contained elements of soccer, and

some even used the sport as a central theme. One particular film, *The Little Coach*, which is now a cult classic, was an adaptation of a novel by Azcona dealing with soccer. He eventually co-wrote the script with director Marco Ferreri. *The Little Coach* is a black comedy about a man whose paraplegic friend gets a motorized wheelchair (a *cochecito*); our protagonist then becomes obsessed with obtaining a motorized wheelchair of his own, so he can thus form part of the subculture of motorized wheelchair owners. Eventually he does, and the "motorized wheelchair gang" attends a soccer match together.

Azcona began as a novelist and eventually evolved into a screenwriter, claiming, "I write scripts because it's easier for me than writing novels."[5] Nevertheless, through "Goal," a short story about a scorned soccer player determined to take revenge on all those who had done him wrong throughout his career, Azcona made a reputable contribution to the kick-lit genre. The omniscient narrator of the story offers the reader a glimpse into the protagonist's inner thoughts. The entire tale takes place in a matter of seconds as our protagonist, Panocha, runs down the field with the ball in his possession. But during this extremely short period of actual time, our narrator, Panocha, takes the reader back through almost a lifetime of soccer memories and frustrations. "Goal" begins in the ninetieth minute of a soccer match with the score tied 0–0. The narrator informs the reader that if the game ends in a tie, Panocha's team will not advance to the first division of the league for the upcoming season, but they will advance if they manage to win.

Panocha is a longtime player for the club who had at one time been the team's most celebrated star. However, the past few seasons had been very different for Panocha, who now finds himself the oldest player on the team and subsequently the scapegoat for many of the club's problems. During the current season, Panocha's reputation as a goal-scoring star had dissolved. He was now regarded as a washed-up, old player. The respect he once had among his teammates and the club's administrators has now vanished. The honor he once had among the fans and the people in town was now seemingly long forgotten. To compound his bad situation with his profession, his wife had also recently left him for a professional basketball player. Panocha reflects on his current social situation and hypothetically addresses his adversaries, saying,

> Assholes. Before no one would let me pay in the bars, and now they avoid making eye contact with me so they don't have to talk to me. Guys who used to offer me their sisters and girlfriends, today raise their index and pinky fingers to call me *cornudo*[6] behind my back.

As the story begins, Panocha finds himself on the field as a recent substitute because the coach, whom Panocha describes as an "incompetent coach who couldn't differentiate between the chalkboard and the field," felt his experience might be needed. Over the years, Panocha had scored

many penalty kicks, and for this reason the coach felt it would be advantageous to have him in the game should it end in a tie and go to a penalty shoot-out. On taking the field, Panocha is well aware that he is experiencing the last few minutes of his career. But instead of attempting to use these final minutes to regain his reputation, he decides he wants revenge on all those that had wronged him over the years, and he knows exactly how he will get his revenge.

After the opposition's corner kick is sent up the field to Panocha, who is sprinting through the mud on a counterattack, he envisions how his plot for revenge will take place:

> All I have to do is lift it out of the mud, carry it to the opposing goal, wait for the goalie to come out, leave him in the dust with a dribble, and when those shit-eaters in the stands begin to scream for the goal, I'll turn around to flick 'em off, or even better, show 'em my balls, and then I'll gracefully knock it wide with a Charlie Chaplin heel-click.

Panocha's plan miraculously begins to unfold exactly as he had foreseen. He pokes the ball ahead perfectly into the space between himself, the defenders, and the goalkeeper in order to draw them out so he can slip past them at the last second and leave himself facing an open goal. As Panocha is running down the field with the ball at his feet, he imagines how sweet his revenge will be and says to himself, "Now let's settle the score with soccer . . . and life." His revenge is near, and he thinks how through this act no one will ever forget his name; not the club's directors, not the coaches, not the players, not the media, not the fans, not all the other miserable people who he describes had used him as a means to their own ends:

> First as a promise without any compensation other than the pleasure of playing, then as an enslaved figure and poorly paid, and then finally as an example of a stagnant figure to be extinguished, swindled by the presidents, humiliated by the coaches, brushed aside by teammates, discounted by critics, ridiculed by the public, and fucked-over by my own wife.

As Panocha's revenge comes closer to becoming a reality, the crowd roars. As he attacks down the field, he draws the goalkeeper out and gently pokes it beyond him (exactly as he had envisioned), and with the ball three yards from the open goal, Panocha turns toward the presidential suite and the fans, extends his right arm, and with his left hand smacks his bicep and lifts his right forearm to the sky. Then, with all the poise of a natural goal-scorer, he lifts the ball up to his waist and, just before the defenders come crashing in, he clicks the ball just wide of the goal with a Charlie Chaplin heel click. The crowd cheers "¡Gooooool!," exactly as he had imagined, but instead of being mistaken, the crowd was correct and continues to cheer. Panocha had accidentally put the ball in

the net and scored the goal he so desperately wanted to miss. The narrator describes the final moments of the match as the following:

> He couldn't even unleash his anger in blasphemy because his teammates had already fallen on top of him hugging and kissing him. *How bad you are, Panochita*, he thought to himself. But as he fell to the ground, crushed by the mass of sweaty and greasy carnage, in the stands they began to sing the hymn:
> ¡Panocha, Panocha, Panocha the pimp! When it comes to Panocha, there's no one like him!
> And unable to keep from crying, old Panocha, *Panochita* began to melt into the delicious swoon and basked in the glory as if it had been centuries since he'd last had the opportunity to bask in the glory of being the hero.

Through his kick-lit tale "Goal," Rafael Azcona offers the reader a vision of the game from the perspective of the fallen hero. This is a recurring theme in the kick-lit genre because the sport is perfect for encompassing all the aspects of a literary tragedy. The story that precedes "Goal" in *Soccer Stories 2*, "Like a Field Marshal," written by Juan José Armos Marcelo, also approaches the genre from the tragic perspective of the fallen hero. The massive attraction to soccer lies in the fact that the game offers its spectators all the aspects and possibilities of a theatrical drama but without the predetermined outcome. The sport's connection to, yet separation from reality, is what has drawn so many people to it and established it as one of the most recognizable of the world's cultural phenomena of the past century. Of soccer's ineffable ability to captivate, Jorge Valdano wrote,

> Its capacity to fascinate is, above all, sentimental (it has been defined as a passion of multitudes, like the emotion with which one plays the game, like a feeling that wins or loses), this is why, maybe, the intellectuals never managed to decipher its mysteries through reflection.

Azcona communicates the frustration that many players and fans have with the present state of the sport. This frustration is due to the sport's transformation from being an innocent game to a formalized sport that is controlled by administrators, executives, and the mass media. This reality is communicated in David Trueba's *Knowing How to Lose*, Manuel Vicente Gonzalez's *Offside*, and many other works of kick-lit that communicate the sport's loss of innocence and integrity. As previously mentioned Eduardo Galeano puts it, "This beautiful spectacle, this feast for the eyes, is also a nasty bitch of a business."[7]

The climax of Azcona's "Goal" comes when he accidentally scores the goal at the end of the game that sends his team to the first division the next season. Panocha is initially devastated that his plan did not go as he had envisioned. But his frustration quickly melts away when he is reminded how inexplicably sweet it feels to be overcome with euphoric

pandemonium after scoring such an important goal for the system he had come to despise.

"SOCCER AND LIFE"

"Soccer and Life" is a short kick-lit story written by Martín Casariego. Casariego is an extremely versatile writer. He has written novels, screenplays, children's stories, essays, and many articles as a journalist. His contribution to the kick-lit genre helped strengthen his reputation as a versatile writer. Through "Soccer and Life," it's apparent that he spent a substantial amount of time as a soccer player. Casariego offers the reader a glimpse into some of the actualities of the sport at the regional level in Spain. He demonstrates very clearly that he knows the pain of suffering through the sport's injustices. He offers the reader the philosophy a player needs to possess to keep his or her sanity in these situations.

"Soccer and Life" is told through an omniscient narrator that seems to be the voice of Casariego. It is a fictional tale, and the numerous comical aspects that Casariego adds give it more flavor. The reader is given the sense that the story is compiled of a variety of experiences that Casariego had lived through during his life as a soccer player in Spain, playing for a modest club in a modest league. Casariego communicates his love for the purity of the sport at this level, playing in regional competitions throughout Spain. Through the story, Casariego's narrator communicates why he appreciates the game at this level. He claims it to be void of the corruption that comes with playing at higher levels when he says,

> Soccer at this level was pure, with extremely modest economic interests but with all the passion to produce both enthusiasm and hatred at moments, which disappeared, or were at least mitigated, every Sunday after the last whistle and left to regenerate throughout the next week until reaching their fever pitch again during the following week's match.

However, by the end of the story, Casariego communicates a different opinion and indicates that no matter how modest the league, when passions run high, there will always be people who attempt to manipulate the rules in order to achieve the outcome they so desperately desire. Unlike in most theatrical plays, in soccer (and in life), good morals do not always prevail over bad morals, and the law of poetic justice does not exist.

The match that Casariego's narrator relates is very important for his team. It is the last game of the season, and if our team of protagonists obtain a tie, they will ascend to a higher, more respected league in the upcoming season. The match is to take place at the opposing team's stadium, which has the reputation of being a very hostile environment for visiting teams. The fans' hostility serves as the home team's greatest

advantage since they have the reputation of not being the most tactical, technical, or talented team in the league.

During the first half of the story, we are offered a bird's-eye view of our team's arrival to the stadium on the bus and then in the locker room during the coach's pregame speech. The coach reminds his team of the difficulties they will have to overcome while playing at the opposing team's grounds. He addresses his team by saying,

> –We're going to do the diamond, got it? Quick touches. Make 'em dizzy, *pim, pam, pim, pam*, yours, mine, without forcing or rushing anything, because a tie works for us. Let's make 'em run. Work in triangles and diamonds, *pim, pam, pim, pam*, yours, mine, and they won't even get a touch busting their guts workin' for it. But no nutmegs or heel-clicks, eh? Let's stick to the fundamentals. No showin' off for the crowd. Especially since today's show is for this hillbilly, hick-town. We already know the ref, and he's part theirs and part the mother who bore him. But we're better. This match will be won by playing with balls, got it? Cuz they're going to come out to play with the balls of a giant bull, but we're going to bring even bigger balls to the table. If they bring out two giant bull's balls, well we're going to bring out three giant bull's balls.

Casariego's narrator reveals the hilarity of this pregame speech by pointing out that the coach "helped out by using fingers to explain the complicated arithmetic." Although this pregame speech is very comical, it also has a verisimilar quality. Many funny things take place behind the scenes of a game, in places like the locker room, on the team bus, and on the bench. It could be argued that a team's strongest bonds are formed in these behind-the-scenes places (and not as much on the field), where the standard set of rules by which we live are no longer at the foreground. These areas are essentially the spaces that exist between the game and our everyday reality. Jorge Valdano describes the role of the locker room as follows: "The biggest enemy of a good locker room is silence. Speaking, arguing, or fighting is better than incubating a problem."[8] From another perspective, he writes, "A transparent locker room that shares its dirty laundry with the entire world, incubates a more dangerous cancer than an own goal."[9] Clearly, the term "locker room" is used as a metaphor to describe the team's camaraderie and bond. Simply because the locker room is a designated place where many of a team's issues can be resolved behind closed doors, it does not mean it is the only area where these things take place.

When the teams take the field and are ready for the game to commence, the referees come out, and instantly the home crowd begins to whistle at them, curse at them, and threaten them. As the referees pass the stands, one of our protagonists overhears a man say, "Ref, son of a bitch, you brought a red Opel Corsa with license plates from Madrid, 1904-FF and you parked it in front of the Chony perfume shop." This

threat plays an integral role in the game's outcome and is a very real and very negative aspect of the sport at this level in Spain, demonstrating that it is clearly not free of corruption.

Late in the second half, with the game still tied at zero, the visiting team (with whom we are associated) makes a play that the narrator describes as follows:

> Julito stole a pass and he gave it up to Navarro. Navarro checked back to get free from the man marking him, who was caught off guard. Navarro finally had the defender out of his back pocket. But the defender grabbed his jersey a second later and ripped it as Navarro shook his arm free and then did a wall-pass with Juancho. When Juancho returned the ball to him, Navarro, running free, made a beeline for the goal, with his shirt ripped half off and gaining velocity with every step. The goalie came out like a bullet toward him, but Navarro, who saw him, gave the ball a quick little touch and raised his arms high in the air just before the ball hit the back of the net. He turned to celebrate the goal and saw how the rival team was surrounding the line-judge and the center ref, who huddled up and came to an agreement. The final decision, made between dorks, memories of the license plate of his car, and allusions of his mother, was to nullify the goal because of offside. Navarro got right in the ref's face. . . . And was subsequently expelled from the game.

Just ten minutes later, a forward from the home team finds himself in the box with the ball, and rather than attempting to go to goal, he opts to take what the narrator describes as a blatant theatrical dive. The referee, who had been instructed during halftime to maintain the order of the hostile crowd, blew the whistle and awarded a penalty kick to the home team, which was successfully finished. The home team then spends the rest of the game executing every stalling technique imaginable and the game ends. Our team is forced to face the harsh reality that they will not be promoted to the next level the following year.

The narrator describes the scene after the game saying, "In the locker room, some were crying and everyone bitterly complained. No one spoke on the bus. Many were even still finishing up dressing themselves like souls in agony." When they get on the bus, they noticed that the team's newcomer, Navarro, who scored the goal that was disallowed, was missing. Juancho, the team's eldest veteran, got up from his seat and went to look for Navarro and found him still sitting in the locker room with his head in his hands. Juancho, whose fifteen-year career had come to an end with this loss, consoles the youngster. Juancho expresses his frustration with the match and the team's current situation due to the elements of corruption that plague the game, but at the same time, he cannot deny that he will desperately miss being a part of it all. He expresses that the beauty of playing for a team like this involves so many things: "The training, the matches, the beers after the matches, the commentary, the

squabbles, the friendships, the jokes, the fans, the whole little world that was formed around those three wooden posts." As Navarro sits there disgusted with the result of the match, Juancho offers him a piece of advice regarding the game of soccer, how to approach it, and how to deal with its injustices. He says,

> You'll see, today you learned nothing about soccer, about soccer with regulations, nor of what you imagined soccer to be like as a kid. But you did learn about life. In the end, or very soon, you will recognize that soccer and life are the same thing. If only you, me, Germán and the others played, it would be fantastic, it would be a better world. The problem is that everyone plays, and they convert it into what it is; into a piece of shit: the coach, the president, the fans, the refs, the Toñetes[10] and company. . . . You have to continue playing. . . . It's you who they envy, not those who won that shit match. They don't even deserve having you on the field in matches like that.

The story ends as the two players get on the bus feeling a bit better. One of the players stands up and gives the team hope again by saying, "Come on, guys! Get your heads up! Next year, we advance! Fuckin' A!" and the bus heads back home. With "Soccer and Life," Martín Casariego approaches the sport from a variety of archetypical kick-lit angles, the most obvious being his description of sport as being a metaphor for life, which can easily be found in the title and in the final conversation between Juancho and Navarro. Casariego also uncovers the negative, corrupt, and unjust aspects that accompany both the sport and life. Through this tale, it becomes clear that soccer is an area where people chase their dreams and passions, and even at the most modest levels, one will encounter all the most frustrating aspects of life.

In the final conversation between Juancho and Navarro, Casariego addresses the ongoing debate within the soccer community (especially in Spain) that questions whether it is better to win or play well. Jorge Valdano, "The Soccer Philosopher," addresses this very question in the final page of his book *Notes of the Ball* when he writes, "I'm tired of people asking if I prefer to play well or win, I'll respond with an equally brilliant question: What do you prefer, to play bad or lose? . . . Well, me too."[11] This quote from Valdano forces us to look at the question from another angle. At the end of "Soccer and Life," we recognize that our integrity is what stands the strongest, not whether we win or lose. Although we always want to play well and win, Casariego communicates that the most important thing is that we continue to play, even in the face of injustice and corruption.

Jorge Valdano also considers the players' burning desire to fulfill their dreams as one of the most important aspects of soccer, to never stop dreaming and to always work toward a positive future. Casariego expresses this when one of the players attempts to re-instill hope in the

team for next year's effort at the end of the story. Valdano addresses the importance of this idea by saying,

> I'm a supporter of dreams and I tend to recommend them to those who want to be successful. In soccer everything gets old very quickly with the exception of dreams, and the summer is the time of year where they grow. In every player there is a sense of promise. In effect, he who in preseason doesn't say to himself: "This will be my year," is not all together a soccer player. [12]

This mentality could be incorporated into any aspect of life where the individual wishes to progress, achieve success, and be recognized for doing so. To leave the past behind and look to the future could be considered a trait of the "man of action."

In the end, Martín Casariego's short story, "Soccer and Life," demonstrates the game as a phenomenon that encompasses our dreams, our fears, and our frustrations with the world. It has a positive message that encourages us to act with integrity in our everyday lives. However, doing so will not always guarantee the sought-after result. Essentially, this tale reminds the reader of the old adage, "It's not whether you win or you lose. It's how you play the game." This approach to soccer can easily be adapted to the "game of life." Jorge Valdano addresses this approach with a question:

> Is what matters, the final result? This is a bastard of a way to look at the game of soccer. What matters is ambition, audacity, adventure, the generous dedication of everyone in defense of a great idea. The language of some coaches has become such that they call him a professional and responsible for sterile and miserable soccer, which they put forward. I applaud Toshack, Van Gall, Camacho, Victor Fernandez and everyone who knows that to play is to risk. [13]

"ONE DAY, ALL OF A SUDDEN, IT HAPPENS"

Ana María Moix is a writer from Barcelona who is a recognized contemporary Spanish poet and novelist. She has received a number of literary awards for her poetry, and she currently works as a director for the Spanish editorial Plaza y Janés. Moix, Soledad Puértolas, and Josefina Aldecoa represent the female writers who have contributed to *Soccer Stories 2*. Their contributions to the kick-lit genre demonstrate the ever-growing presence and appreciation of women in soccer, an arena that is no longer a social space designated solely for men. Through Ana María Moix's tale "One Day, All of a Sudden, It Happens," it is very easy to recognize the importance she feels the game has in our lives as a generator of passion that provides many with a reason for living.

Many soccer enthusiasts consider the sport an escape from reality. Some call it a social drug that numbs us to the realities of life, while

others contend that the soccer arena is the all-encompassing Petri dish of life. There are even those who embrace both contrasting notions of the sport and in doing so defend it as a true social phenomenon. Many critics of soccer claim that the people's overzealous passion for the sport distorts their vision of reality. Ana Moix is of the school of thought that defends the notion that through our passions, we truly experience life. She claims that our passions are what drive us and what give us purpose in this life no matter how absurd either our passions or life itself may be. With "One Day, All of a Sudden, It Happens," Moix offers the reader an existential approach to soccer, a passion that offers a great number of people around the world the ability to feel like they can transcend the absurdities of the natural world and enter into the world of soccer. Through the inexplicable element of passion, these individuals find an outlet through which they can be occupied and escape life, which existentialists claim to be nothing more than an absurdity. The irony of this theory lies in the fact that since soccer and life mirror one another, if life truly is an absurdity, then soccer surely is too, and these fanatics are essentially substituting one absurdity with another. The difference is that soccer offers us a more condensed version of the elements of life with seemingly higher highs and lower lows. This theory is centered around the element of passion, thus making it a trait that is not simply unique to soccer, although soccer is one of the greatest generators of passion of both the individual and the masses in the modern world.

In "One Day, All of a Sudden, It Happens," an omniscient narrator relates the story of a man who has lost his passion for the soccer club that he had supported his entire life. We are never offered the name of the protagonist, his wife, children, friends, or the soccer club in question; rather, the narrator simply tells the reader about these anonymous subjects in the third person. The story begins with the narrator telling us that whenever someone confronts our protagonist to question how it could be possible that he lost his passion for his soccer club, he avoids going into detail by simply telling them, "One day, all of a sudden, it happens." The narrator then proceeds to describe the incidents that took place (that the protagonist prefers not to express to his friends and family) that slowly resulted in him losing his passion for soccer. The narrator describes it as follows:

> One day, all of a sudden, it happens, with nothing more. It's been said and re-said, it's tiresome to say it and repeat it hundreds of times over when one tries to explain the loss of his gusto for soccer. But in reality, he ignores how it happened, as if it were a sudden loss, as he tells anyone who cares for his well-being, or the opposite, the result of a process that has been developing itself little by little. He's opted for this brief answer, "one day, all of a sudden, it happens," knowing full well of the possible falsehood he uses to justify the phenomenon which so painfully altered his existence.

The narrator recounts the numerous occasions that the protagonist be-
lieves might have led up to his lack of interest in the sport he once loved
so much. He regrettably remembers the embarrassing outburst he had in
front of his wife, friends, and children. He uncontrollably blurted out an
array of less-than-admirable profanities designed to insult the referee of a
match. Using this language in such company surprised him—and all
those present—that he was capable of being so vulgar and outlandish. It
also embarrassed the entire party, especially his wife.

The protagonist also remembers the empty feeling he had the day he
realized that the striker he had once admired so much was actually not as
extraordinary as he had always perceived him to be. This is similar to the
loss of admiration Carlos Casares expresses through the account of his
encounter with Alfredo di Stéfano in his autobiographical kick-lit anec-
dote that appears in the first version of Soccer Stories, titled "How Old
and Fat You Are." The protagonist of "One Day, All of a Sudden, It
Happens" also remembers the frustration he felt after witnessing a ter-
ribly boring match between his club and their bitter rivals. The narrator
describes that the match seemed like it would never end to our protago-
nist, who "was looking at his watch incessantly, the shouting of the sta-
dium was overwhelming, the play had been reduced to constant goal
kicks and tiresome fouls that interrupted any attempt to coordinate an
attractive play."

The narrator reveals that the protagonist was ashamed of this loss of
interest in the club he had supported so passionately for so many years of
his life. He was afraid to tell his friends and his wife for quite awhile
because he thought they might think he was crazy. There was a period
when he would tell his wife and family he was going to watch the game,
but secretly he would go to the movies. The narrator describes that the
protagonist "didn't want to raise suspicion. How could he tell them the
truth? What wife would believe her husband spends Sunday evenings
alone, at the movies, for not having the guts to confess the truth to his
friends, his children, or his workmates?"

The protagonist expresses a fear that if his friends and family discover
his loss of interest in his soccer club, it will lead them to not only question
his masculinity but also his mental stability and even his morals and
values because he feels that "a man who no longer feels solid with the
soccer team that always held his heart, inspires distrust."

The protagonist's wife was the first to discover his "condition" when
she overheard him say, "Yeah, I swear, I could care less if they win or
lose." On hearing this, the narrator describes how the wife immediately
covered her face with both hands in anguish as if to deny that such a
terrible statement could come out of her husband's mouth. She immedi-
ately recognized the reality and the severity of the situation and had him
sent to a psychoanalyst in an effort to help her husband rediscover his
passion and resolve the situation. After twelve years of psychoanalysis,

he was still completely indifferent toward his once-beloved soccer club. His wife came to accept the situation and would often justify it by telling her friends, "One day, all of a sudden, it happens and any man can no longer be interested in soccer."

Understanding that his condition was irreversible, people began to treat him differently, and many made a point to avoid him completely for fear of contracting his illness and being forced into an existence of indifference. The narrator ends the story with how this poor man's life turned out by saying,

> In reality, he had begun living a placid, lackluster, and monotonous existence, shut down better, with a deep-down sadness so misguided which only every once in a blue moon was accented, in festive occasions above all. On nights in which, like tonight's, his wife and daughters get ready to leave the house and hit the streets to celebrate the league title won by the team for which they are paying members, a team who's name he can't even remember, and therefore they look at him from the door with a melancholic smile, as if they're saying goodbye.

The severity of the protagonist's condition is obviously intended for humor, especially with the reference in the last sentence to the opening line of Miguel de Cervantes's *Don Quijote de la Mancha*, which reads, "Someplace in La Mancha, whose name I don't care to remember."[14] Although Ana María Moix's "*Un día, de repente, sucede*" is a very humorous tale, it also communicates a more serious side of life that questions the relevance of human existence without the element of passion to inspire us and to make us tick and to feel as if life is something worth living.

"PARALLEL LIVES"

"Parallel Lives" is a short kick-lit story by one of Spain's most recognized contemporary writers, Juan Manuel de Prada. From the title of his story, it's clear that de Prada's tale is based on the ancient Greek historian, biographer, essayist, and Middle Platonist turned Roman citizen, Lucius Mestrius Plutarchus. His literary masterpiece is titled *The Lives of the Noble Grecians and Romans*, which is also more commonly known as either *Plutarch's Lives* or *Parallel Lives*. *Parallel Lives*, or *Bioi parallèloi* (as it is written in Greek), is a series of biographies of famous Greek and Roman men who Plutarch arranged in tandem to bring to light their common moral virtues or vices. Plutarch is considered one of the earliest moral philosophers, and his work is recognized as having a heavy influence on English and French literature. For example, Shakespeare often made reference to *Parallel Lives* in his plays and often quoted from them directly. Ralph Waldo Emerson and the Transcendentalists are recognized as having been greatly influenced by Plutarch's work, especially his *Matters*

Relating to Costumes and Mores (*Moralia*). The French writer Michel Ey-
quem de Montaigne is said to have made more than four hundred refer-
ences to Plutarch's works in his *Essays*. Others who either admired or
were influenced by Plutarch's work were James Boswell, John Milton,
Francis Bacon, Ben Jonson, John Dryden, Alexander Hamilton, Cotton
Mather, Robert Browning, and, now, Spain's Juan Manuel de Prada.

Juan Manuel de Prada is one of Spain's most respected contemporary
writers not only for his talent and skill in the art of writing but also for
the strong connection to historical literary figures and texts that he refer-
ences throughout his work. De Prada's first publication in 1994, titled
Twats (*Coños*), is a book of lyrical prose considered an homage to Spain's
eighteenth-century writer Gomez de la Serna's *Breasts* (*Senos*). De Prada's
next publication, *The Skater's Silence* (*El silencio del patinador*) (1995), is a
collection of twelve short stories that is unique for its baroque prosaic
style that demonstrates a stronger connection to historical figures of
Spanish literature than the work of his contemporaries. De Prada's 1996
novel *The Hero's Masks* (*Las máscaras del héroe*), is a semifictional re-crea-
tion of Bohemian Spain from the beginning of the twentieth century to
the Spanish Civil War. The two principal characters are the less-than-
glamorous historical Spanish poet Pedro Luis Gálvez and the fictional
character Fernando Navales. Through *The Hero's Masks*, de Prada made
reference to a number of obscure historical Spanish literary texts, like
Rafael Cansinos Assens's *The Novel of a Literary Man* (*La novella de un
literato*) and Gómez de la Serna's *Automoribund* (*Automoribundia*). De Pra-
da's next publication, *The Corners of The Air* (*Las esquinas del aire*), follows
the accomplishments of the athlete and Spanish writer Ana María
Martínez Sagi, while his *Unashamed and Eccentrics* (*Desgarrados y excéntri-
cos*) is a collection of biographies of obscure and eccentric figures of Span-
ish literature like Armando Buscarini and Pedro Luis de Gálvez.

With "Parallel Lives," de Prada again makes his profound connection
to the figures of classical literature apparent by bringing the multifaceted
influence of Plutarch on literature to the foreground. Manuel de Prada's
"Parallel Lives" is a fictional tale narrated in the first person by a priest
looking back on his early years after just finishing the seminary. This
priest, whose name is never revealed, recounts his memory of the ex-
traordinary yet tragic lives that he encountered as a priest. After complet-
ing the seminary in a small town in northern Spain, the priest was as-
signed the task of mentoring a group of troublemaking adolescents. He
describes the situation as follows:

> Back then I was what you could call a priest-in-bloom, respectful of the
> robe with a fondness for sport and a certain social conscience. The
> Salesian Order, to which I still pertain today, though nominally, had
> installed a youth center with sport fields, a library, and a cinema in the
> slums of that city in the north with the more-or-less benevolent pur-
> pose to attract that entire legion of rogue children that wandered the

streets, children with premature and sad faces who, shaken by poverty or eradication, practiced a united, although unorganized vandalism. My superiors, informed of my athletic flightiness, suggested that I shift my energies from punishing these adolescents to the disciplined channel of soccer.

Our priest describes his efforts as having a positive effect on these youngsters' lives by distancing them from their previous lifestyles that he describes as being filled with *picardía* (rascality), unemployment, and familiar scuffles. These misfits also proved to be quite successful on the soccer field and began garnering a more respectable reputation in a town that we know only as "the town in the north." On this team of misfits, there was one individual, Julio Guerra, who stood out the most. According to the priest, Julio Guerra "was a shy boy, blonde without ostentation, at times unruly, with traits that seemed to defy the contingencies of time." The priest then reinforces our suspicions of what seems to be a homoerotic admiration for Julio Guerra when he compares the youngster's beauty and youthful nature to Dorian Gray, Oscar Wilde's famous protagonist who defies the aging process. The priest describes Julio Guerra as coming from a very poor household with less-than-sanitary living conditions and his ability to maintain his health in such conditions as one of the most amazing of his many qualities. As a soccer player, the priest describes that "with the ball at his feet, Julio exhibited those doses of ability and talent that any coach would want to embed into a society composed of ten other men, rude and Spartan-like, whose function is none other than that of mere supernumerary genius."

After a successful season in the local soccer league, the team, called Sociedad Salesiana (Salesian Society), after the ecclesiastical order of their founders, was preparing for the upcoming season in which they were to compete in the regional league. This was a more prestigious league comprised of teams that played at a higher, more competitive level than that of the local league. Just prior to the league's commencement, our priest received word that he was to travel to Torino and complete his studies of theology. He describes his situation as follows:

> I had just turned twenty-five, an adequate age to have me ordained as a presbyter and to tighten my links within the Salesian Community (links too onerous for someone like me, who lived between the enthusiastic clamor of goals and the nostalgia of a childhood wasted between votes of poverty, chastity, and obedience). I accepted the invitation from Father Ricaldone, without any other contrariness than to abandon the children right when league play was about to begin.

On relating the news of his departure to the team, Julio Guerra reassures the priest by telling him not to worry, that they will continue to follow his advice and that they will stay in contact while he is in Torino.

After a short time in Italy, the priest begins to follow a local boy's soccer team in Torino that in many ways reminds him of the club he formed and coached in Spain, stating that, "The team from Torino used strategies similar to the ones I had inculcated to the kids from the slums, and their players assembled the same conditions as my guys." The priest quickly recognizes one of the Torino club's standout players, Mazzola, as having similar attributes as Julio Guerra. He describes that this Italian soccer player "had a certain physical similarity to that of Julio, aside from almost identical attitudes on the field (both celebrated goals the same way: hoisting up their fists and running against the wind so their manes would flow)." The priest states that the similarities between these two caused him to believe in "the existence of quirky genetics, or if it's preferred, in profound miracles." He makes note of the fact that Mazzola even had the same "nose for the goal," mixing "frigidity and roguery" to find the back of the net.

After watching a game in which Mazzola scored three goals, each reminiscent of Julio Guerra's style, Mazzola was honored by the fans with waiving handkerchiefs. The priest says that "from absent-mindedness or negligence I didn't bring my handkerchief, so I joined in on the revelry shaking my celluloid clerical collar. Fortunately, no superior noticed this reaction of such little reverence." Two days later, the priest receives word from Julio that he too had scored three goals, all of which mirrored the description of those that he had witnessed by Mazzola. The priest describes this abnormal experience, stating,

> It was then that the figure of Julio Guerra superimposed itself over that of the Italian Mazzola, like the image of a mirror superimposes itself over its model. I remembered with a slight chill that, among the theories of some medieval arch-heretics, I imagined the "complementary spirits," people connected by an indecipherable system of actions and omissions, of sin and pertinence, like the obverse and reverse sides of the same coin: the death of one would irremediably lead to the extinction of the other, by law of symmetry or whimsical divinity.

The priest relates to the reader that Mazzola, after scoring two goals for his team, one in the last minute to defeat the superior cross-town club Juventus, was approached by the president of Juventus. The president offered Mazzola a place on his club for the upcoming year. He even told Mazzola that he could name his price. The priest continues to relate the experience of his new discovery by stating,

> Returning to the seminary, the intolerable lucidity of fate came down over me. That superstition, which until then had accompanied me and had emerged through a resemblance of strategies between Torino and my team from the slums, through an almost exact similarity between Mazzola and Julio, stopped being a superstition and converted itself into a certainty: I understood, not without horror, that to sculpt the

incoherent and dizzying material of life is not, in all, impossible, that there are underground laws that, in the manner of tunnels or frame-workings, we all are connected with other beings, with people unaware of our existence, just as we are unaware of their lives, but that through their actions, our destinies are determined.

Convinced that Mazzola and Julio Guerra were, unbeknownst to one another, living parallel lives, our priest waited for the precise hour on Sunday to call Julio Guerra to catch him after the game and all the post-game activities to learn the news of the match and hopefully confirm his hypothesis. Although there are difficulties, the priest's call finally goes through, and he is able to speak with Julio, who tells the priest he has such great news that he was heading to write him a letter at the very moment the phone rang. Julio tells the priest that they played a wonder-ful game against Athlétic and that they won in the last minute. On hear-ing this, the priest interrupted Julio and said, "Yes, I already know . . . you scored two goals, you had a heck of a game, and in the locker room the president of Athlétic expressed his desire to sign you." Completely taken aback by the priest's knowledge of what had so recently taken place in a different country, Julio says, "But . . . Gol-ly! How did you know?" Immediately after expressing his surprise, the telephone line cut out, and their conversation was over. From that point on, the priest knew he could watch Julio through Mazzola.

A few weeks later, the priest's superior, Father Ricaldone, organized an excursion for future members of the seminary through the Alps to the Superga side of the mountain. While inside a cave, Father Ricaldone was speaking to the young seminarians when all of a sudden a loud explosion shook the mountain and ended their conversation. All those attending immediately ran outside of the cave for fear they could be trapped inside. On exiting the cave, they noticed that an airplane had crashed. The semi-narians feared the plane was carrying the Torino soccer players who were scheduled at precisely that time to be arriving home from Napoli. The narrating priest describes the scene as follows:

> On the skirt of the hill a group of hermetic philosophers gathered around a smoking piece of scrap metal. The fuselage of the plane, torn apart like a rag, left remnants of the unrecognizable features of its passengers, gestures condensed by surprise or horror, polished by a fire that had burned their flesh like a cannibal barbeque. It was hot, but in the sky a distant storm began to roll.
>
> "There are no survivors," said a nurse who shuffled through the twisted metal, painfully containing his nausea. They all died, including Mazzola.

Recognizing the severity of the tragedy, the priest rushed home to see if his greatest fear had become a reality. Although he wanted to deny the possibility that Julio Guerra had been subjected to the same fate, deep

down he knew Guerra and the other players were destined to the same tragic ending. The priest describes his memory of the tragedy as follows:

> I meticulously imagined a similar accident, only more modest (the kids didn't travel by plane, they made due with a bus that gasped like an asthmatic); I imagined their return, through back roads, as they came back from a match that would have resulted decisively for their aspirations; I imagined the bus driver, sleepy and dizzy, miscalculating the slope of a curve; I imagined the bus falling slowly, rolling over a cliff; I imagined the orphan look on Julio Guerra's face in mid-fall, possibly dedicating a final thought to me (I often sin with pride or sentimentalism); I preferred not to imagine more, to avoid the harassment of insanity. Days later, they confirmed my intuition, when I no longer had tears to shed nor blasphemies to let fly; they told me that the lifeless bodies of Julio Guerra and the other children had waited more than ten hours, disseminated in the bottom of a ravine, like cadavers that became dark brown from the sun, like symmetric cadavers of those others who had been left sporadically on the back-face slope of Superga.

There are a variety of similarities between Plutarch's *Parallel Lives* and Juan Manuel de Prada's "Parallel Lives." However, one main difference is that Plutarch wrote biographies of famous figures from Greece and Rome to demonstrate parallel morals and values the two individuals possessed. Juan Manuel de Prada tells a fictional tale of two modest, handsome soccer-stars-to-be whose lives were tragically cut short. They were never afforded the opportunity to reach the level where they could have been famous in their field. Plutarch often drew on similarities in his subject's physical features and demonstrated how they represented the person's morals, values, and lifestyles. Manuel de Prada also did exactly that, describing both Julio Guerra and Mazzola as angelic figures whose innocence was visible in their youthful faces and demeanor. At the end of the story, Manuel de Prada reinforces the importance of his characters' physical features. He reiterates his description of the soccer player whom he so adored as being demonstrative of his innocence and character by describing him as "that shy boy, blonde, without ostentation, at times unruly, with traits that seemed to defy the contingencies of time."

NOTES

1. Unless otherwise noted, all quotes in this chapter are from Jorge Valdano, *Soccer Stories 2* (Madrid: Extra Alfaguara, 1998).

2. *"Colegio Estilo"* ("Style Academy"), www.colegioestilo.com/historia.htm (March 4, 2009).

3. "Juan Bonilla," http://es.wikipedia.org/wiki/Juan_Bonilla (April 5, 2009).

4. A *greguería* is a short form of poetry, usually a short statement or a "one-liner" in which the author expresses a philosophical, humoristic, or pragmatic idea in a witty or original way. The Spanish writer, dramatist, and avant-garde agitator Ramón Gómez de la Serna of the early 20th century is considered the "father of the *greguería*."

5. "Rafael Azcona," http://es.wikipedia.org/wiki/Rafael_Azcona (April 5, 2009).

6. *Cornudo* literally translates to "horned," and in many Spanish-speaking countries the term is used to describe a person who is being or has been cheated on by his or her partner. Some believe the term originated because when one is being cheated on, he or she becomes upset and therefore grows horns like a mad devil or bull. When using the term, people often extend their index finger and pinky to make a hand gesture resembling horns.

7. *"El Fútbol Hecho Espectáculo"* ("Soccer Turned Spectacle"), www.fcbarcelona .com/web/english/club/club_avui/mes_que_un_club/mesqueunclub_historia.html (July 23, 2009).

8. Jorge Valdano, *Apuntes del balón* (*Notes of the Ball*) (Madrid: La Esfera de los libros, 2001), 190.

9. Valdano, *Apuntes del balón* (*Notes of the Ball*), 190.

10. Toñet was a rival opponent in the match they had just played.

11. Valdano, *Apuntes del balón* (*Notes of the Ball*), 223.

12. Valdano, *Apuntes del balón* (*Notes of the Ball*), 18.

13. Valdano, *Apuntes del balón* (*Notes of the Ball*), 20–21.

14. Miguel de Cervantes Saavedra, *El Ingenioso Hidalgo Don Quijote de la Mancha* (Alcalá de Henares: Centro de Estudios Cervantinos, 1994), 29.

III

The Phenomenon of
Spanish "Kick-Flicks"

I was always under the impression that soccer is a beast that resists film without knowing very well the reasons why two of the largest elements of leisure and culture of our time repel one another. It's true that in recent years there has been a renewed effort to revisit the difficult relationship between these two universes.

—Santiago Segurola

Two of the world's most influential passions for the past one hundred years are the sport of soccer and the art of cinema. These social phenomena have swept over the planet like wildfire and have been embraced by the masses for their capacity to captivate our globalizing society. The influence of these two social phenomena can most clearly be seen in the planet's more modern nations, mainly in the Western world, and definitely in Spain. During approximately the past one hundred years, Spanish society has gone through a number of drastic social changes: the disaster of 1898, the Spanish Civil War, Francisco Franco's dictatorship, and the transition to democracy. These heated and complex sociopolitical changes have heavily influenced all sectors of Spanish life. Soccer and the art of cinema have accompanied the Spanish people through each of these phases, except for the disaster of 1898, which occurred almost precisely when these two social phenomena were first taking shape in Spain. The presence and importance of the disaster of 1898 on Spanish society is, however, clearly recognizable in both Spanish soccer and cinema.

If there is one aspect that stereotypically characterizes the people of Spain and Spanish culture (as multifaceted and complex as it is), it would have to be the element of passion. The Spanish ideology, from the *reconquista* (the Christian reconquering of the Iberian Peninsula over the Islamic kingdoms collectively known as *Al-Andalus*) to the conquering of the Americas, and the Spanish Civil War, has been driven by the Spanish people's passion for what they believe. The same is true when analyzing the Spanish people's approach to celebrating their culture, from the pride they historically have in their food and wine to their love for flamenco

music and dancing, from the bulls, to soccer, to the arts. Living for one's passion is an unbreakable Spanish bond that transcends Spain's disputes over regional/national identities, political ideologies, and cultural differences. The Spanish people's romantic and unwavering need to "follow their passion," no matter how conflicting this pursuit may be, could be considered one of the defining elements of the Spanish people.

With the turn of the twentieth century, Spain (like many other countries around the world) was carried away by these two new cultural phenomena. Many of the people of Spain saw their passion shift from bulls and flamenco to soccer and cinema. Like soccer (and every other aspect of Spanish life), Spanish cinema was heavily influenced by the political climate of the times, namely, all that led up to the Spanish Civil War, the Civil War itself, Francoism, and the transition to democracy. The work of some film directors supported the political climate and fascist ideology of Spain, while the work of other directors opposed it. Some of the filmmakers who opposed Spanish fascism managed to work within the confines of the censors and were still able to get their message across. Those who chose to make films that more blatantly opposed the doctrine of fascist Spain's political and social ideologies were left with no option other than to leave the country and work in exile. However, no matter what side of the controversy the Spanish filmmakers (and Spanish people) were on, their actions were dictated primarily by following their passions, ideals, and beliefs.

Similar to the distrust between the soccer advocate and the intellectual, there is also a conflict when it comes to combining soccer and film. However, as I defended in the previous section, soccer and literature are most definitely compatible. Presently, there is a "kick-lit" wave rushing over the Spanish-speaking world, and to further justify the genre's legitimacy, some of the Spanish language's most reputable writers have produced brilliant works within the genre. However, it seems that soccer, for one reason or another, has not been as successfully adapted to the big screen. Carlos Marañón tackles this problem and offers his readers an explanation as to why this might be the case. In his 2005 publication *Soccer and Film: The Beautiful Game on the Big Screen*, Marañón describes the problem by writing, "The two greatest passions of our time maintain a strange and difficult relationship. Despite sharing the essence of dreams and emotions, soccer and film never saw eye-to-eye. Or so it seems."[1] Marañón's defense of soccer as a suitable topic for film lies in the fact that there have been countless films throughout the world based on other sports that have been highly successful in every regard. This provides him with some reassurance that soccer, like any other sport, can be adapted to the big screen successfully. Santiago Segurola also addresses the issue from the same perspective by underlining the fact that there have been what he calls "marvelous" movies centered around the sports of baseball, boxing, race car driving, horse racing, golf, and so on. In the

book's prologue, Segurola approaches the problem by asking, "So, why is there this sensation of rejection, of friction, of discomfort between these two arts?" Could the answer lie in the fact that many of the aforementioned sports are strongly embraced by the culture of the United States, which has the reputation of not embracing or understanding soccer, and that the most powerful institution for reinforcing the culture of the United States is Hollywood? Segurola claims that

> the answer could be found precisely in films like *Days of Soccer* or *Bend It like Beckham*. They are films that approach soccer from a lateral position. . . . Film has managed to approach soccer to portray the fans, the small town matches, the girls that embrace a game that had previously rejected them until now. It's good that soccer serves as a metaphor of life and that it serves as an alibi to explain passions, poor social adjustments, dramas, or comedies. The problem, at least in my opinion, is the play, the beauty of the play. This summit has not yet been conquered on the big screen.

Many experts and critics of film consider sport to be a less-than-adequate subject matter for film. However, as with the kick-lit genre, films that use sport as the point of departure are experiencing a newfound appreciation. The 2009 Tribeca Film Festival dedicated one section to sport films: the Tribeca/ESPN Sport Film Festival. It had screenings of documentaries and fictional films dealing with people's passions in the arena of sport from around the globe. One of the films was a documentary about a high school basketball team on an Indian reservation in Wyoming titled *Chiefs*. Another film was about "the greatest basketball player never to make the NBA [National Basketball Association]" titled *Hooked: The Legend of Demitrius "Hook" Mitchell*. Other documentaries dealt with the lives and struggles of boxers, surfers, and an American baseball manager in the Japanese league. There were also a variety of films screened that I call "kick-flicks." Like kick-lit, kick-flicks are films that use soccer as either a central theme or a point of departure. One such kick-flick screened at the Tribeca/ESPN Sport Film Festival of 2009 was *Once in a Lifetime: The Extraordinary Story of the New York Cosmos*, also known as *Once in a Lifetime: The Rise and Fall of the Team That Brought Pelé to America*. This is a highly recommendable kick-flick showing actual footage of the world's greatest players of the 1970s and a view of real-life conflicting egos, both on the field and in the locker room. At the same time, the film offers a behind-the-scenes view of the front office and its failures when attempting to market the sport for the first time in the United States. Another kick-flick that screened at the festival was the newly released Mexican film, *Rudy and Swears* (*Rudo y Cursi*). This film tells the tale of two siblings, played by Gael García Bernal and Diego Luna, who rival one another in the world of Mexican professional soccer. Another film screened at the festival worthy of mention was Spike Lee's *Kobe Doin' Work*. This film was in-

spired by Douglas Gordon and Phillip Parreno's kick-flick, *Zidane, a 21st Century Portrait* (*Zidane, un portrait du 21e siècle*), which followed Real Madrid superstar Zinedine Zidane's every movement through an entire soccer match against Villareal, utilizing over twenty different camera angles. The American film director Spike Lee was inspired by the film and decided to do a similar project with the Los Angeles Lakers and NBA superstar Kobe Bryant in a game against the San Antonio Spurs. Another sport film that received considerable attention was *The Wrestler* by Darren Aronofsky, starring Mickey Rourke and Marisa Tomei. *The Wrestler* told the melodramatic tale of a broken-down, big-time wrestler whose career in the arena became the only realm of reality in which he could bear living. *The Wrestler* was nominated for a number of Academy Awards, and I feel that this is due to the fact that, as Santiago Segurola defends, it approaches the sport "from a lateral position." The most successful sport films are not necessarily "sport films" in the traditional sense. They are often designed to capture the drama that surrounds the game and not necessarily the drama of the game itself or the complexities of the skills required to succeed in the sport.

Carlos Marañón and Santiago Segurola consider the greatest kick-flick ever made to be *Victory* by John Huston. This film is great for its depiction of the role that politics plays in soccer around the world and especially while fascism was rampant throughout Europe. Segurola points out that the only negative aspect of *Victory* lies in the fact that "the game is filmed with a grotesque tone, childishly, in a line more closely connected to a comic [with] Pelé doing circus pirouettes [and] Stallone disowning himself as a goalkeeper." Segurola states that this is not comparable to the work that Huston did as the director of one of the greatest boxing films of all time, *Fat City*. However, all of the films from the *Rocky* series are also grossly inaccurate in their depiction of the realities of boxing, but for some reason *Rocky* had no problem being embraced by the world at large. Possibly, this is because the brutality of a sport like boxing is more easily digested by the masses than the beauty of a sport like soccer. These are some of the problems that directors have faced when attempting to make a kick-flick.

In the history of Spanish cinema, the kick-flick genre has been attempted on numerous occasions. Many Spanish directors have made reference to soccer in their films simply because soccer has such a presence in Spanish culture and plays such an important role in the Spanish lifestyle. One of the earliest and most famous Spanish films to touch on the subject of soccer is Marco Ferreri's *The Little Coach*, which was written by Rafael Azcona. As I mentioned in the previous chapter, Azcona was also the writer of "Goal," a kick-lit story that appeared in *Soccer Stories 2*. Azcona is considered one of Spain's greatest scriptwriters and was clearly an advocate of including soccer in his work. *The Little Coach* is a black comedy that tells the story of an elderly genius who, more than anything

in the world, wants to be relegated to a wheelchair, like his friends, so that he can do all the things they do and no longer be left out of their activities. At one point in the story, the group of senior citizens forms a sort of wheelchair gang and attends a professional soccer match. *Welcome Mr. Marshall! (Bienvenido Mister Marshall)* is another famous Spanish film whose script was initially written with a scene dedicated to soccer, but while filming, the scene was dropped. A great number of other films have touched on the importance of soccer in Spanish culture, from *Torrente* (which has a cameo of Real Madrid stars Iker Casillas, Guti, and Iván Huelguera) to David Trueba's *Welcome Home (Bienvenido a casa)* (which mocks a stereotypical idiotic goalkeeper during a photo shoot in Real Madrid's Bernabeu Stadium).

Another figure of Spanish cinema and literature who has been a strong advocate of using soccer in his work is one of the pillars of the Spanish arts community, Fernando Fernán Gómez. Fernán Gómez is famous not only as an actor, but also as an author and playwright. His most famous play is *Bicycles Are for the Summer (Las bicicletas son para el verano)*, which later became a feature film. Fernán Gómez also wrote the short kick-lit story that appeared in *Soccer Stories* titled "The Manager." In 1991, he wrote and directed the Spanish kick-flick *Offside*. This film, like many other Spanish kick-flicks, was quickly swept under the rug. I find it hard to believe that it could not have been a legitimate contribution to the world of cinema when looking at the incredible body of work that Fernán Gómez has been involved in over the years. But, like so many other soccer-related stories, this one is essentially unable to be found. One of the most interesting facts about Fernando Fernán Gómez (with regard to this study) is that, aside from all of this, he was also an actor in one of the very first Spanish kick-flicks, *The Pelerín System (El sistema Pelgrín)* (1951). The film was an adaptation of the early Spanish kick-lit novel, *The Pelegrín System: Novel about a Professor of Physical Culture (El sistema pelgrín: Novela de un profesor de cultura física)*, written in 1949 by Wenceslao Fernández Flórez. Up until his death in 2007, Fernando Fernán Gómez was, without a doubt, one of the most important figures in the Spanish film industry, and he continues to be regarded as one of the most important intellectuals in the Spanish art world. Throughout his career, he has always demonstrated his desire to use soccer as a central theme in his work.

Another fun-loving Spanish film that used soccer as a point of departure is *The Red Cross Three (Tres de la Cruz Roja)*. This film was directed by Fernando Palacios in 1961 and starred Tony Leblanc, José Luis López Vázquez, and Manolo Gómez Bur, who portray three Real Madrid fanatics who decide to go through the hardships of becoming members of the Red Cross simply so that they can enter the Bernabéu Stadium as volunteers and watch Real Madrid play. This film offers many glimpses into Madrid's society of the 1960s and offers the viewer actual soccer footage.

It is the passion that these men possess that is of most interest to the kick-flick advocate, and, as Santiago Segurola claims, this film also approaches the sport of soccer "from a lateral position."

The aforementioned Spanish films are just a few of the many films that have addressed soccer, some successfully, others not so successfully. The following chapters will be dedicated to analyzing a number of Spanish kick-flicks. The first film to be analyzed, *Blonde Dart* (*Saeta rubia*) starring Alfredo di Stéfano as himself, serves as an example of how the Franco regime used soccer to defend its legitimacy and as a way for youths to learn the necessary morals to become "good men." The second film, *The Goalkeeper* (*El portero*), staring Carmelo Gómez and Maribel Verdú, provides insight into the corruption of soccer on the part of the Franco regime and on the part of the historic nationalities (that used the sport in an effort to rebel against the fascist regime). The third film, *Soccer Days* (*Días de fútbol*), tells the hysterical tale of a group of middle-aged men frustrated with their lives that attempt to relive their youth and solve their problems of adulthood. They form a soccer team in order to bolster their own self-esteem and gain the respect of the members of their neighborhood. These films will provide a different perspective of the numerous possibilities of how a director can approach the kick-flick genre.

NOTE

1. All quotes in this chapter are from Carlos Marañón's *Fútbol y cine: El balompié en la gran pantalla* (*Soccer and Film: The Beautiful Game on the Big Screen*) (Madrid: Ocho y Medio Libros de Cine, 2005).

ELEVEN

The Early Years

Blonde Dart

The early years of Spain's "kick-flick" phenomenon were modeled after Hollywood's successful star system. The star system was based on the premise of attracting people to the theater with no tactic other than the tantalized masses' overwhelming desire to see their favorite movie stars on the big screen. Ironically, most of the stars in this system were creations of the star system itself. During the 1950s, Spain's kick-flicks were undoubtedly modeled after this approach, which was first presented by California's booming film industry. But rather than taking promising young actors and creating personas for them, hoping they might become stars capable of garnering large audiences, the Spanish kick-flicks during this period simply took already existing soccer stars, put them on the big screen, and watched the masses flock to the cinema. In one way, this may be considered an attempt by these Spanish filmmakers to exploit the people of Spain's obsession with soccer and the Spanish League's soccer stars. However, from a different point of view, it can easily be argued that Spanish filmmakers of the time simply recognized and provided the Spanish people with what they wanted—the opportunity to feel closer to their favorite soccer star.

The first and probably most successful Spanish soccer player to double as a film star was the famous Catalan-born goalkeeper Ricardo Zamora. Zamora played for a number of clubs throughout Spain during his career, including the Spanish National Team and Catalan XI—Catalonia's "National Team," which, like the Basque "National Team" of the time, also took an international tour to raise social awareness during the Civil War. Zamora was, without a doubt, one of the earliest and most famous heroes of Spanish soccer. His extreme popularity quickly brought him to

171

the big screen even before feature-length films with sound had been invented. *Zamora's Finally Getting Married!* (*¡Por fin se casa Zamora!*) is a Vaudeville-style silent movie that was directed by José Fernández Caireles and Pepín Fernández in 1926. In the film, Zamora plays himself, a goaltender of the Spanish League whose uncle persistently attempts to persuade him to marry one of his distant cousins in the United States. Zamora is initially uninterested because the only knowledge he has of this girl is through his uncle's descriptions and a photograph. But after certain manipulations on the part of his uncle that lead to a series of convenient coincidences, Zamora eventually falls in love with the girl he had once known only through a photograph.

Three years after *Zamora's Finally Getting Married!*, another Spanish film was released in an attempt to capture the same audience. This film, titled *Soccer, Love and Bulls* (*Fútbol, amor y toros*) (1929), was a clear effort by the director, Florián Rey, to embrace/exploit the Spanish people's passions of the era. It told the story of a young Spanish goalkeeper who fell in love with a girl from a rival family. He was forced to prove his love for her through his goalkeeping and bullfighting abilities, which he did successfully. Although Rey used a professional actor for the role instead of casting Zamora, it was rather convenient that the actor he used, the character of the film, and Spain's most famous goalkeeper were all named Ricardo.

After the era of silent film had ended, one of the first Spanish filmmakers to bring the star approach in full force to Spanish kick-flicks was Ramón Torrado. Torrado directed the film titled *Champions!!* in 1943, which Carlos Marañón describes as the "first reunion of Spanish soccer stars on screen." *Champions!!* was comprised of a cast of the most famous Spanish-speaking soccer players of the era, namely, Jacinto Quincoces, Guillermo Gorostiza, Igor Iturain, José María Rodriguez, Carlos Muñoz, Ramón Polo, Pedro Barreto, Jesús Abrego, and, again, Ricardo Zamora. Aside from being a film designed to attract soccer fans to the theater, *Champions!!* is also regarded as a film that exploited these soccer fans in an effort to promote fascist Spain's ideologies. *Champions!!* tells the story of a group of modest laborers from the fields of Spain who compete in a soccer tournament against other laborers of the region. Marañón describes the film as *"falangismo*[1] applied to soccer."[2]

Another film, titled *The Aces Search for Peace* (1954), was designed to draw soccer fans to the box office and at the same time glorify the Franco regime. The film was directed by Arturo Ruiz Castillo and told the story of the hardships that FC Barcelona's Hungarian superstar Ladislao Kubala faced in escaping his socialist country of Hungary (which was under the control of the Soviets after World War II) before arriving in Spain, "the promised land." Kubala played himself in the film, which portrayed Franco's Spain as a humble country where an individual could live freely and happily. In one of the lines of the film, Kubala proclaims, "That's

when I learned that in Spain I had found peace."[3] Marañón describes the film as follows:

> An enormous propagandist triumph for the Franco Regime. This is why it had to be told to the Spanish people in a film that . . . explores the most political details, such as the escape of the Hungarian from Vienna to the poverty of those who were subdued for not declaring themselves as being part of the communist regime or the political commissary of Hungary.[4]

Eleven Pairs of Boots, directed by Francisco Rovira Beleta in 1954, is another film whose major appeal was the nearly endless cast of soccer stars from the Spanish League. The number of players to appear is too long to list, but the film contains names such as Zarra, Venancio, Teruel, and the Real Madrid superstar Alfredo di Stéfano. Marañón describes *Eleven Pairs of Boots* as "the great film about soccer in Spain. All of the levels are represented, even the clumsy forward who arrives at international play."[5] In 1952, three years prior to the release of *Eleven Pairs of Boots*, Ignacio F. Iquino directed the film *The Pelegrín System*. Although the film was not made up of a star-studded cast of professional soccer players, it is relevant to this book because the story, initially written as a novel by Wenceslao Fernández Flórez, was later turned into a screenplay by the author. Marañón describes the Spanish desire to consume kick-flicks during the 1950s and 1960s as follows:

> The abundance of films like *The Pelegrín System* (1951), *The Aces Search for Peace* (1954), *Eleven Pairs of Boots* (1954), *Blonde Dart* (1956), *The Phenomenon* (*El fenómeno*) (1956), *The Fan* (*El hincha*) (1957), *The Angel Is on The Summit* (*El ángel está en la cumbre*), *The Soccer Pool* (*La quiniela*) (1959), *The Economically Weak* (*Los económicamente débiles*) (1960), *The Red Cross Three* (1961) and *Sunday's Battle* (*La batalla del domingo*) (1963) couldn't be the fruit of mere coincidence. And so soccer converted itself into one of our country's cinematographic genres. Films in which the popular side of soccer served to divert into comedies of local customs and manners, to indoctrinate into sporting dramas, or even to expose the best essences of the country.[6]

Spanish kick-flicks of the early years were extremely popular because everything to do with soccer was being marketed as a "spectacle," coinciding with the influx of international superstars who were being signed to the Spanish League. In this sense, the Spanish Soccer League was nurturing its own star system and offering the Spanish consumer the opportunity to embrace his or her idols through the two fastest-growing cultural phenomena of all time. The kick-flicks from the 1950s and 1960s are now characterized as black-and-white films centered around defending morals and values of "good men" during the Franco regime. In these films, Spain's soccer heroes were depicted as possessing and upholding an exemplary character for all to follow, always knowing the difference

between right and wrong, and always seeing to it that good prevailed. One of the most famous films of this era that encompassed the aforementioned aspects of Spanish kick-flicks is *Blonde Dart*, which starred Alfredo di Stéfano, Real Madrid's poster child and the club's most famous and decorated player of all time.

While FC Barcelona's imported soccer star Ladislao Kubala seized the opportunity to win the hearts of Spaniards and promote the club by recounting the struggles he faced while escaping socialism as the star of *The Aces Search for Peace* in 1954, Real Madrid responded by making *Blonde Dart*. The film, directed by Javier Setó, was dedicated to celebrating and promoting Real Madrid's star player Alfredo di Stéfano and the club itself. Di Stéfano was known as "The Blonde Dart" for his blonde head of hair and his speed on the field. The film *Blonde Dart* was designed not only to promote di Stéfano and Real Madrid, but also to depict di Stéfano as a man whose soccer abilities serve as the foundation of his exemplary moral character, which he utilized to be a leader in the community. *Blonde Dart* was an attempt to demonstrate that through soccer, an individual can learn all the skills necessary to become a responsible, morally sound, and respectable citizen in Franco's Spain.

Blonde Dart tells the story of a group of poor, unsupervised youngsters who roam the streets of Madrid looking for any situation they can manipulate or take advantage of in order to obtain either money, valuables, or food.[7] The story begins with the youngsters playing soccer in the street. When a car comes that is forced to brake abruptly to avoid an accident, one of the youngsters (out of the driver's vision) pretends to have been hit and puts himself under the front bumper. The driver gets out to assess the situation, and the youngsters quickly realize that it is the Real Madrid superstar Alfredo di Stéfano. As di Stéfano speaks with the children to see if they are okay, the group of street urchins crowd around him, and one of them slyly steals his wallet. When the youngsters return to their clubhouse with their day's loot, they are visited by el señor Justo (Mr. Fair), an elderly man from the neighborhood. He brings Andrés, the oldest member of the group of street urchins, pictures he had taken of Andrés's father during his years as a professional soccer player in Spain. El señor Justo describes to the street urchins that Andrés's father was the greatest soccer player he had ever witnessed during his fifty-year career as a sports photographer. Unfortunately, his career as a photographer came to an end when his camera was stolen. Touched by el señor Justo's story and kindness, Andrés, as the leader of the group, decides that they will find a new camera for their elderly friend and return the wallet they stole from di Stéfano. When the group protests, Andrés stands up and says, "I'm the boss. Isn't that right? That money is di Stéfano's, a soccer player . . . just like my father was."[8]

Later that night, some of the street urchins set out to find a new camera for el señor Justo. They find a cab driver parked on the street

listening to an interview with Alfredo di Stéfano. They tell the cabby that they are soccer players and ask permission to listen in on the interview. Eventually, the street urchins distract the cab driver, and one of the youngsters sneaks around through the passenger-side back door without making a sound and steals the camera that had been sitting in the back window. Shortly thereafter, the other street urchins end their conversation with the cab driver and head back to their clubhouse.

Meanwhile, other members of the group of street urchins wait outside di Stéfano's house for the opportunity to return his wallet. Di Stéfano and his wife, María, are returning from an elegant dinner where the star soccer player's ex-girlfriend and famous singer Julia Rey provided the entertainment. Although di Stéfano insists that he was unaware that Julia was scheduled to sing at that particular restaurant, his wife is rather skeptical, and during the car ride home, she expresses that her concern is not as much with him as it is with Julia by stating, "It's just that Julia was your girlfriend and a wave can mean many things." When the couple arrives home, the youngster (who initially had pretended to be struck by di Stéfano's car) approaches the soccer player, returns his wallet, and apologizes for having stolen it. Di Stéfano recognizes the child as being in need and decides to offer him a reward for having chosen to do what was morally correct. Di Stéfano and his wife invite the youngster, called Chispas by his friends, into the house and offer him all the food he can eat. As Chispas fills his pockets with expensive cuts of ham to share with his friends, di Stéfano and María inquire about his living situation. Chispas explains that he lives in a modest, close-knit community alongside the river. Chispas then informs di Stéfano that the leader of their group, Andrés, who is dating Chispas's sister, is an undiscovered soccer talent.

Shortly thereafter, María visits the small village next to the river. She is immediately overcome with desire to help the people of this village, especially the newborn babies who seem to be outnumbering the adults. While María is in Chispas's house helping with the babies, the children are out front playing soccer. El señor Justo passes through their game and heads to church. As soon as el señor Justo is out of sight, the youngsters stop the game. Andrés hurries home and grabs the stolen camera, and the children follow el señor Justo to the church. While el señor Justo is on his knees at church praying to San Expedito, the street urchins slide the camera (marked "for el señor Justo") next to the old man. He finds it, picks it up, and believes it to be a miracle from San Expedito.

Meanwhile, di Stéfano was on the road in Catalonia to compete against FC Barcelona. When he returns, he finds a man from Chispas's village working on the house. Di Stéfano asks his wife who this man is, and she explains that he is from the poor town by the river and that he was in need of work, so she offered him the opportunity to take care of some chores around their house in return for a modest wage. She says, "You'd never imagine how these poor people live, . . . I made them a

promise that you'd do something for them." Although di Stéfano does not protest, the idea proposed by his wife seems to cause the soccer star a slight discomfort.

The group of street urchins continues to rob and steal throughout the city until one day they are caught and detained by the authorities, who know they are responsible for the taxi driver's missing camera. Unable to provide the police with the missing camera, Andrés and some of the others are taken into custody. While this is taking place, María and di Stéfano are visiting the riverside village. María shows di Stéfano around and introduces him to some of the members of the community. Andrés's father, who is played by the ex–Real Madrid star Jacinto Quincoces, introduces himself to di Stéfano and says, "Pardon my interruption, but I wanted to meet you. There's no one like you with the ball at their feet these days. . . . There's only one who used to do it like you—me. Ask Ignacio Sancho." On saying this, Sancho sadly draws attention to his broken-down state and tattered clothes before walking away. Although di Stéfano expresses a desire to continue the conversation with the broken-down ex–soccer player, they are interrupted and informed by the street urchins (who were not detained) that Andrés and some of the others are in the custody of the authorities for stealing. Upon hearing this, Andrés's mother weeps. Di Stéfano's wife then proposes that he do something to help the youngsters. He replies, "I don't know. I will have to go see the judge."

When di Stéfano meets with the judge, he characterizes the youngsters as having good intentions, but that they come from a poor village and are at the age when they have trouble distinguishing right from wrong. On hearing this, the judge says, "Here's the danger, when are they going to know what is right and what is wrong?" Di Stéfano continues to defend the dignity of the people of the village, stating that the youngster's parents are honorable people and that the children simply need a little extra guidance. The judge agrees and makes his judgment by telling di Stéfano,

> These kids have a dream—soccer. And you are an idol to them. Now that they are making so many scientific discoveries, why don't we issue soccer as medicine? Come on. Think of the kids and their families waiting for you outside.

The judge then brings the delinquents into his office and tells them that even though the missing camera has not yet been returned, they will be allowed to go free because di Stéfano has taken responsibility for the group and will serve as their mentor. The youngsters thank the judge, and di Stéfano reassures him by saying, "They will be good kids. And that camera will turn up." He asks the youngsters, "Right?" To this, they all bow their heads in shame because they know that they couldn't possibly take the camera back from el señor Justo. The judge responds by saying, "Let's hope that's the case. Di Stéfano, my friend, I hope one day

you can tell me that these kids have turned into honorable men." The youngsters then return to their families and tell them the good news. Di Stéfano then announces that he has decided to take on the responsibility of coaching them in soccer. When they cannot believe their ears, di Stéfano says, "I have to keep my eye on them and know what they're up to. So we don't get bored, we'll play soccer." This news is received with cheers of celebration, at which point Andrés turns to his father and says, "The Blonde Dart, my mentor!!" Di Stéfano then says, "I can be a figure like your father." To this, Andrés's father modestly responds, "No. The example, all in all, should be . . . you." At this point, all those in attendance begin to cheer "Long live Don Alfredo di Stéfano!"

At the next Real Madrid training session, di Stéfano approaches his teammates and other members of the club to see if they can help the poor neighborhood in any way. As a result, a few of the people from the neighborhood secure jobs working for the members of the club. He also arranges for Andrés's father, Ignacio Sancho, to become a chauffeur for one of the players. Di Stéfano also asks one of the team's trainers if he can find the youngsters some secondhand equipment to use while playing. The trainer finds them shirts, shorts, shoes, and a decent ball.

The training sessions conducted by di Stéfano seem to be more focused on him demonstrating his own soccer talents (to appease the audience) than on allowing the children the opportunity to play. However, one of the youngsters is featured demonstrating his superior skill in the art of juggling. At the end of the first training session, di Stéfano and the group are approached by el señor Justo, who asks di Stéfano for his permission to take their photograph with his new camera. Di Stéfano quickly deduces that this is the missing camera. El señor Justo explains that his camera had unfortunately been stolen but that since he was such a devout Catholic, he received a new camera through prayer to San Expedito—a miracle.

Understanding why the youngsters stole the camera, di Stéfano decides to make the situation right without destroying el señor Justo's belief that the apparition of the camera truly was a miracle. The next day, while el señor Justo is again praying to and thanking San Expedito, the group returns to the church (this time with di Stéfano), and Chispas sneaks up behind the old man and quietly replaces the camera by his side with a new camera that was purchased by di Stéfano. When el señor Justo finishes his prayer, he looks down and sees the package, then opens the note that reads, "In return for your devotion, this new model . . . —San Expedito." The old man, overwhelmed with joy, begins to shout throughout the church, "A miracle! A miracle!" The priest notices the commotion and approaches the scene, but is quickly diverted by di Stéfano, who says, "Pardon Father. Don't tell him anything." To this, the priest says, "It's a trick!?" But di Stéfano justifies his actions by saying, "There's no trick. We only want to maintain his belief, it makes the old man happy."

With the problem of the camera finally resolved, the team continues to train, and the members of the poor village demonstrate they are sincerely grateful for all the good deeds that di Stéfano has done for them. Time passes, and we see di Stéfano and Real Madrid in actual game footage. At one point, while the team is reviewing film footage of Real Madrid's games and di Stéfano's glories, Julia Rey calls his house and tells di Stéfano that she has a movie deal for him. In an attempt to cut all ties with his ex-girlfriend, di Stéfano expresses that he has no interest in the project. Julia is persistent in approaching di Stéfano about the film, and although at the beginning he goes out of his way to avoid her, he eventually begins meeting with her, and although he tries to keep each encounter professional, she manages to get closer and closer to him. Andrés and the other youngsters are aware of Julia's advances, so they plot to push her away from di Stéfano in an attempt to maintain María's honor and happiness with her husband. The scheme consists of the group of street urchins posing as workers at Julia Rey's dinner concert (where di Stéfano will be in attendance). They will deliver a package to each table of guests as a gift from Julia herself. When the guests open the package and find that it is filled with mice, the audience will be shocked and panic will set in. Julia will then be devastated by the crowd's reaction and look for someone's shoulder to cry on, at which time she will find Andrés, who she knows as a strapping young delivery boy. The youngsters hope that di Stéfano will see her in the arms of Andrés and that he will in turn no longer want to have anything to do with her. When the scheme goes exactly as planned and di Stéfano attempts to console Julia but finds her in the arms of Andrés, rather than being upset with Julia, he's upset with Andrés and scolds him by slapping him across the face. Andrés leaves the scene thinking the entire plan backfired. The next day, Andrés's father goes to di Stéfano's house and divulges that the youngsters' scheme was actually meant to create a permanent separation between di Stéfano and Julia in order to protect María's well-being. Di Stéfano is quick to forgive Andrés and the others, and everyone is happy once again.

The youth soccer team named Dart (*Saeta*), coached by di Stéfano and captained by Andrés, is now winning every match they play. In the end, Dart wins the championship, and Andrés thanks di Stéfano and his wife as he raises the cup. Not only has the soccer success and expertise of di Stéfano rubbed off on the youngsters of Dart, but through coaching the youths in soccer, his efforts as a mentor have also proved to be successful. The youngsters have seemingly learned the difference between right and wrong.

One of the defining scenes of the film is when di Stéfano and the members of Dart visit a hospital and offer gifts to the sick children. One of the patients expresses that he is extremely grateful for all that di Stéfano has done for him. Then the soccer star promises that as soon as he is

better, he can come and play for team Dart. The sick youngster, overcome with joy, informs di Stéfano that he and the other children from the hospital have written a song in his praise. The child then breaks into song and the others join in, singing in unison,

Argentino y madrileño en una pieza	Argentinian and Madridian in one piece
Argentino como Fiero y San Martín	Argentine like Fiero and San Martín
Madrileño de los pies a la cabeza	Madridian from head to toe
Bautizado en Chamartín	Baptized in Chamartín
Y los detalles de sus piernas cuando juega	And the statements of his legs when he plays
Demostrando valentía y corazón	Demonstrating bravery and heart
Y se llama la saeta porque llega	And they call him The Dart because
Como una flecha de caracol	He arrives like cupid's arrow
Hala Saeta Rubia	Praise The Blonde Dart
Que el árbitro deje acullá	Let the referee leave him be
Acecha tocando ese balón	Lurking with the ball
Anima el clamor de la afición	He ignites clamor and love
Hala Saeta Rubia	Praise The Blonde Dart
El equipo seguro campeón	The team surely champions
Por fin se canta nuestro barrio	Finally our town sings
¡Alirón! ¡Alirón! ¡Alirón!	Champions! Champions! Champions!
Los muchachos siempre sueñan con ser famosos	Kids always dream of being famous
Y estrellas en el fútbol español	And stars of Spanish soccer
En la meta de su estilo prodigioso	With the goal of his prodigious style
Que demuestra su ambición	Which demonstrates his ambition

Su admirable servicio en el Millonarios	His admirable service in Millonarios
Que le permitiera llegar al Real Madrid	Which allowed him to arrive at Real Madrid
Y la racha sin igual en el River Plate	And the gale without compare in River Plate
Como un milagro, brillar en ti	Like a miracle, shine in you
Hala Saeta Rubia	Praise The Blonde Dart
Que el árbitro deje acullá	Let the referee leave him be
Acecha tocando ese balón	Lurking with the ball
Anima el clamor de la afición	He ignites clamor and love
Hala Saeta Rubia	Praise The Blonde Dart
El equipo seguro campeón	The team surely champions
Por fin se canta nuestro barrio	Finally our town sings
¡Alirón! ¡Alirón! ¡Alirón!	Champions! Champions! Champions!

Clearly, *Blonde Dart* was produced in an effort to demonstrate that soccer is a positive activity for youngsters. If nothing else, playing soccer would keep them off the streets and out of mischief. But *Blonde Dart* also depicted the players of Real Madrid not only as community leaders but as charitable, modest, and caring humanitarians. Through the film, being the soccer superstar of Madrid at the time, di Stéfano assumed the responsibility of being a role model who through soccer was able to teach the children from this poor neighborhood not only to be respectable citizens, but also that in doing good, they became champions in their own right. Di Stéfano was obviously promoted by Real Madrid, which was supported by the Franco regime, as being an exemplary soccer player and role model for all to follow. This image is in sharp contrast to the picture that Carlos Casares painted of di Stéfano in his short "kick-lit" story "How Old and Fat You Are." Regardless of which is the "real" di Stéfano, certain individuals become idols through soccer, which in turn will cause them to be loved, criticized, manipulated, or exploited in any number of ways. Becoming a superstar will require certain responsibilities of them, but it will also offer them a range of opportunities in other fields. This is the case with soccer players like Alfredo di Stéfano, who, in becoming a cultural icon in Spain through soccer, was given the opportunity and

responsibility of acting in films designed to promote himself, his club, the Spanish League, and the values and morals of good Spanish men.

NOTES

1. *El Falangismo* was Spain's right-wing political ideology that began in the 1930s. It is often referred to by outsiders as "fascism," Italy's political movement of the time with similar ideologies.

2. Carlos Marañón, *Fútbol y cine: El balompié en la gran pantalla* (*Soccer and Film: The Beautiful Game on the Big Screen*) (Madrid: Ocho y Medio Libros de Cine, 2005), 323.

3. *Los Ases buscan la paz* (*The Aces Search for Peace*), dir. Arturo Ruiz Castillo (Madrid: Titán Films, 1955).

4. Marañón, *Fútbol y cine* (*Soccer and Film*), 86.

5. Marañón, *Fútbol y cine* (*Soccer and Film*), 322.

6. Marañón, *Fútbol y cine* (*Soccer and Film*), 163.

7. Youngsters of this character in Spain are known as *pícaros* or *golfitos*.

8. Unless otherwise noted, all quotes in this chapter are from *Saeta Rubia* (*Blonde Dart*), dir. Javier Setó (Madrid: Unión Films, 1956).

TWELVE

The Goalkeeper

The Goalkeeper is a contemporary Spanish "kick-flick" made in 2000 but set in a beautiful mountain village of Asturias during 1948. The film was written and directed by Gonzalo Suárez, who adapted the story from a short "kick-lit" tale by Miguel Hidalgo. Suárez's cinematographic adaptation relates the tale of a famous ex–Real Madrid goalkeeper (clearly modeled after the legendary Ricardo Zamora) named Ramiro Forteza. Forteza is famous for having saved nine consecutive penalty kicks during a season. Due to the outbreak of the Spanish Civil War and its aftermath, Forteza (played by Carmelo Gómez) was forced to leave his profession as Real Madrid's goalkeeper. He is now left to earn his living by traveling from town to town in an effort to rekindle the legend of his soccer stardom, offering people he meets a chance to pay him for the opportunity to attempt penalty shots against him, "The King of the Penalty."[1] He keeps the money if they miss, but if they score, he pays them nearly double their wager. Although "The King of the Penalty" suffers from an injured shoulder, "Forteza is a strong fortress," and he blocks many more shots than he concedes.

In the opening scene of the film, while traveling through the mountains of Asturias toward the town of Río Luna, a bleeding *maquí*[2] warrior stops Forteza at gunpoint. We soon find out that this wounded *maquí* is named Nardo and that he is one of the region's leaders of the anti-Francoist militant movement. Nardo is well known and respected by all of the people of the region. Forteza stays calm at the sight of the gun and allows the bleeding *maquí* to quietly climb into the back of his truck and catch a ride with him to town. Not much farther down the road, Forteza is stopped again, this time by officers of the Spanish Civil Guard (*La guardia civil*), who immediately demand he provide them with proper documentation. When the commanding officer, Sergeant Andrade, discovers he is

face-to-face with the legendary Ramiro Forteza, "The King of the Penalty," his tone changes from interrogating a stranger to celebrating the ex–Real Madrid star's arrival to town. Nardo, still hiding in the back of the truck, narrowly avoids being detained by Franco's men of the Spanish Civil Guard, and the two are back traveling down the mountain road. As Forteza comes closer to town, Nardo signals him to stop the truck. Nardo gets out and takes a bite of an apple. He tells Forteza that if he finds the inn called The Lame Rabbit (*El conejo cojo*) and presents the owner with this partially eaten apple, he will be treated with hospitality and offered a hot meal.

At The Lame Rabbit, Forteza quickly befriends a worker named Manuela (played by Maribel Verdú). Manuela is Nardo's sister, and she is grateful for what Forteza has done for her brother. She protects her injured brother from the Franco regime's local authorities by hiding him in The Lame Rabbit's attic, where they have a warm bed set up. From this position, he can receive hot meals and medical attention from the local doctor/veterinarian who supports their cause. Manuela struggles as a single mother in Río Luna. Her inquisitive and enthusiastic son, Tito, seems to be the only positive thing in her life. Tito was conceived because she had been raped by a group of Moroccan mercenaries fighting for Franco during the Civil War. Being a rape victim and the single mother of a dark-skinned child, Manuela has been ostracized by almost everyone in the town.

After stopping by The Lame Rabbit, Forteza goes to the beach and sets up camp and his goal. He then reflects on better times in Spain, prior to all the turmoil and atrocities that accompanied the Civil War and its aftermath, when he was a star goalkeeper playing in crowded stadiums. The next morning, Forteza heads into town to make his presence better known. In front of the church entrance, he sets up a display case comprised of pictures and newspaper articles pasted on cardboard to promote himself as "The King of The Penalty" and, it is hoped, to entice some of the town's people to place bets and attempt to score a penalty kick on him. His display draws the interest of the priest, Father Constantino, who approaches him and asks what his intentions in the town are. Forteza responds by saying, "The same as in every town—exhibitions. I take bets. People shoot penalty shots at me and if any happen to go in, the money is for them. And if I stop it, it's for me. This evening I'll be at the beach." On hearing this, the priest says he would like to try. Forteza tells him to bring his money and come by the beach that evening to give it his best shot. Father Constantino then decides to make a deal with the goaltender. He says that if Forteza helps him clean the vestry, he will announce Forteza's penalty kick proposal after mass. Forteza gladly accepts, and the two shake hands.

Forteza goes out to where he has set up his display and gives his self-promotional "dog-n-pony show" to all those coming to attend mass. He

tells them about some of the incredible penalties he saved over the years and glorifies his image as a superstar who saved penalties with multiple broken fingers, hoping the word will spread and he will have a large crowd of people to shoot against him in the afternoon. He ends his speech by saying, "Anyone who wants to try, can come this evening to the beach. Three shots—six *pesetas*.[3] And a ten *peseta* reward to he who scores a goal."

While helping Father Constantino bury a man to "clean out the vestry," the middle-aged men have an interesting conversation, and although Forteza experiences the priest's manipulative ways firsthand, the two begin forging a friendship. They then head to the beach, where Father Constantino is the first to put his money down for a shot at scoring a goal against "The King of the Penalty." On the priest's first attempt, he kicks more of the ground than he does of the ball, and everyone in attendance laughs. The priest sets up again trying to redeem himself. He shoots and scores. But Forteza never moved. This causes the priest to become embarrassed again because he feels Forteza simply allowed the goal to pass. Father Constantino storms off. Jacinto, one of the town's aspiring soccer players, is the next to attempt, but Forteza swiftly blocks his shot. Immediately after Jacinto's shot, Sergeant Andrade and other military men on horseback approach the group and put an end to the contest. Andrade tells Forteza they are going to need him healthy because they have big plans for him. He invites both Forteza and the priest to their barracks, where they will have a get-together to discuss the plan.

At the cocktail party, Sergeant Andrade introduces Forteza to Lisardo, who is the mayor of the town and the town's soccer coach. With everyone present, Sergeant Andrade explains his idea of having a penalty challenge. The penalty challenge he describes will consist of two teams: one made up of the townsmen, coached by Mayor Lisardo, and the other comprised of military men under the command of Andrade. Andrade proposes that the two teams ante up two hundred *pesetas* and that the winner will take all. Forteza will be the goalkeeper for both teams and has nothing to gain but the risk of injury. He therefore rejects Andrade's proposal. Andrade claims he is attempting to strengthen the ties between the military and the townsmen, but clearly pitting these two enemies against one another on the soccer field will nurture their animosity. Andrade explains to Forteza that this will simply be another opportunity for the goalkeeper to serve his country through his soccer abilities. Forteza asks what money he will receive in this penalty challenge. After a bit of negotiating, it is decided that he will receive 10 percent of the pot before the challenge takes place and 10 percent after. At this point, Father Constantino steps in and says, "And another ten for the Church." Andrade then steps in and says, "But the Church isn't going to play, Father." To this, Father Constantino responds, "The Church will be the referee. This way we will have the guarantee of impartiality." With the meeting ad-

journed, Father Constantino accompanies Forteza to the doctor, who will give his injured shoulder a look. At this point, Andrade is approached by López, a lower-ranking and simple-minded soldier who had been listening in on the group's conversation. López says, "This Forteza is no patriot." Immediately Andrade scolds López for his comment by saying, "Let's get one thing straight, López. . . . Any man who has played for Real Madrid, even if he is paid like a professional, is a patriot. Are we clear?"

In the days leading up to the penalty challenge, Forteza learns of Manuela's disgust with Franco's conservative military presence in the town and her plans to flee with Tito to France. He learns that she has been working with the town doctor to get the necessary documents forged for the two of them to travel. Forteza, having quickly fallen in love with Manuela and Tito, convinces Manuela that they should escape with him in his truck. The doctor gets word back to Manuela that he will have their papers ready immediately after the penalty contest.

Ever since the announcement of the penalty contest, Forteza has been approached by a number of members of the Spanish Civil Guard who attempt to persuade him to throw the competition and ensure their victory. On hearing this, Manuela tells Forteza she would hate him if he threw the contest for either side. She says she will wait to see the conclusion of the contest, in which she hopes, with all her heart, the townsmen are victorious over Franco's men. But above all, she adamantly communicates she simply hopes for a fair contest. And then the three will quickly convene with the doctor at the truck to get their papers before heading for France.

The day of the penalty contest, the entire town is present. On one side of the field are the townsmen and on the other side the members of the Spanish Civil Guard. The priest is between the two trying to keep the peace and maintain his good (and profitable) relationship with both sides. Forteza, the goalkeeper (like many soccer players of the era), attempts to put all political ideologies aside and simply play his best. But since he is a soccer player, he is caught in the crossfire. At every opportunity, Sergeant Andrade makes a conscious effort to promote his side, from painting the ball with the red and yellow stripes of the Spanish flag to extorting the opposing team's coach, forcing him with no option other than to demand that his player purposely miss the kick. This is clearly an attempt by Gonzalo Suárez to demonstrate the corrupt role that politics played in manipulating soccer in Spain, not only during Franco's reign but for many years after.

At one point late in the penalty contest, the *maquís* come out of hiding and surround the members of the Spanish Civil Guard. Instead of shooting and starting a battle, Nardo expresses that he is a citizen of Río Luna and that he also wants to represent his political beliefs by shooting in the penalty contest. As the penalty contest continues, no one truly knows the score. The lack of clarity in this regard by Gonzalo Suárez is frustrating to

the viewer, but is very representative of the political climate during this era. Sergeant Andrade disregarded the designated roles that people were to assume in the contest (as coaches, players, and officials) and took advantage of his military rank and political power to control the proceedings. He did so because all present were aware that after the contest (and even during the contest), he would still be the highest-ranking official, backed by the dictator, and therefore capable of controlling their lives in any capacity he saw fit. This was even the case with Lisardo, who was not only the opposing team's coach but also the mayor of Río Luna. Sergeant Andrade also consistently overruled the priest, who was supposed to play the role of the unbiased referee. However, it was easy to see that the priest was ready to side with whomever was willing to help him the most. The only people that were prepared to stand up to Andrade and his men were the *maquís*, led by Nardo. At one point, pistols are drawn, each group pointing at the other with the soccer field and Forteza (representing the sport of soccer) and the priest (representing the church) in the middle. This scene could be considered a cinematographic portrait painted by Gonzalo Suárez depicting the social climate of northern Spain of the era, which defends the notion that soccer is the all-encompassing Petri dish of life and society. For example, like the players for many teams throughout Spain, Forteza simply wanted to play soccer and leave politics aside, but he could not dismiss the fact that no matter what result his actions caused, there would be political implications.

After many shots, the priest declares the match a tie, but López insists he still deserves one more shot. When he lines up to take the final shot, all the townsmen and the impartial spectators slowly walk toward the goal to form a blockade. They eventually pick the goal up and carry it away, preventing him the opportunity to even attempt a shot. While all this is taking place, *los maquís* flee the scene, causing the Spanish Civil Guard to chase after them and in turn allowing Manuela, Tito, and Forteza time to get to their truck, receive their forged documents, and flee toward France. As they did, the impartial priest helped them and made sure Forteza received his cut of the money before they left. While on the road, Forteza told Tito to look in the box and count the money that the priest had given them. Upon doing so, Tito finds the priest had left them with only two pesetas. Realizing this, Forteza ironically says, "Damned Priest," and they all laugh as they drive away.

Gonzalo Suárez's skill for symbolically representing Spain's political and social climate of the era, putting it into such a small and nicely wrapped package, is without a doubt the film's greatest attribute. The soccer scenes are ridiculously childish, but, as Suárez said, "It's a western, not a film about soccer."[4] It was surely due to his ability to represent Spanish society after the Civil War (through a series of symbols and metaphors) that resulted in the film winning the Sant Jordi Best Spanish Film of the Year in 2001. His depiction of soccer could not have been

what won him the award. Suárez's representation of Spain during this era clearly shows that he supported the rebellious effort because throughout the film, the rebels were depicted as the upholders of all that was good and just. They were continually oppressed by the Franco regime and victimized by the regime's actions. During the penalty shootout, Manuela and other members of the *maquís* adamantly expressed that they simply wanted a fair competition. Suárez revealed that the rebels of the time simply were fighting for a world that was free of manipulation and corruption. To them, this was the first victory they needed to achieve before focusing on achieving a victory in the traditional sense. Above all, Gonzalo Suarez's *The Goalkeeper* demonstrates, through a story-like depiction of society and soccer as a social phenomena, that no matter how impartial it would like to be, soccer has an uncanny knack of being immersed into the political and social disputes of Spain.

NOTES

1. Unless otherwise noted, all quotes in this chapter are from *El Portero* (*The Goalkeeper*), dir. Gonzalo Suárez (Madrid: Lolafilms, 2000).

2. *Los Maquís* were groups of people (mainly men) from the north of Spain who after losing the civil war took to the mountains and fought as guerillas. They lived off the land and dedicated their lives to sabotaging anything that had to do with the Franco regime's progress. Ernest Hemingway's novel *For Whom the Bell Tolls* offers a glimpse into the operations of a group of *maquís* working from the *sierras* just north of Madrid. Similarly, Guillermo de Toro's film *El laberinto del fauno* also offers a glimpse into the firm and rebellious attitudes of *los maquís* who fought against the Franco regime after losing the Civil War.

3. The *peseta* was Spain's monetary unit before the introduction of the euro in 2002.

4. Carlos Marañón, *Fútbol y cine: El balompié en la gran pantalla* (*Soccer and Film: The Beautiful Game on the Big Screen*) (Madrid: Ocho y Medio Libros de Cine, 2005), 317.

THIRTEEN

Days of Soccer

Days of Soccer is considered one of the most successful "kick-flicks" not only in Spain but also throughout the world. The idea to make *Days of Soccer* was first conceived on the set of the 2002 Spanish comedy/drama/musical/romance *The Other Side of the Bed* (*El otro lado de la cama*). Tomás Cimadevilla, the producer of *The Other Side of the Bed*, and members of the film's cast approached David Serrano, the writer of *The Other Side of the Bed*, and asked him to write and direct *Days of Soccer*. Although Serrano is considered the "mastermind" behind the *Days of Soccer* project, he allowed his cast (which was made up largely of the cast from *The Other Side of the Bed*) to express their creative voices and add ideas freely to the script. In this sense, *Days of Soccer* was a collaborative project. Some of the members of *The Other Side of the Bed*'s cast who also worked on *Days of Soccer* are Ernesto Alterio, Natalia Verbeke, Alberto San Juan, María Esteve, Nathalie Poza, Secún de la Rosa, Cote Soler, and Luis Bermejo.

Days of Soccer is a comedy that, first and foremost, offers its audience a hysterical view into contemporary Spanish society. This comical vision of Spain can in many ways be compared to the Spanish masterpiece *Don Quijote de la Mancha* in that it too is a parody of the Spanish people's obsession. In *Don Quijote de la Mancha*, the author, Miguel Cervantes, made a parody of Spanish society's obsession with *novelas de caballeria* (chivalric romances) during the late sixteenth century. Through *Days of Soccer*, David Serrano follows Cervantes's approach and makes a parody of contemporary Spanish society's obsession with soccer. The influence of Cervantes's *Quijote* on *Days of Soccer* can be found in many aspects of the film. This is much of the reason for the film's success. This approach is also what makes the film even more profoundly Spanish. However, one of the film's lead actors, Ernesto Alterio, attributes *Days of Soccer*'s success to the fact that the cast was comprised of Spanish comedic talents who

enjoyed working together and who, through working together on *The Other Side of the Bed*, had come to understand each other's abilities and senses of humor. He claims this gave the film a cohesion and direction that otherwise would not have been possible. In making a parody of Spanish society and the people's obsession with soccer, the cast and crew of *Days of Soccer* took on the daunting task of dealing with a film centered around soccer, a task that over the course of film history has proven to be very difficult. It is my belief that *Days of Soccer*'s success as a kick-flick lies in the fact that the group approached Spain's present-day obsession with soccer in the same way that Cervantes had approached Spain's obsession with *libros de caballería* (chivalric romances) and because (as Santiago Segurola pointed out in *Fútbol y cine*) the cast and crew of *Days of Soccer* tackled the theme of soccer "from a lateral position."

Days of Soccer is a story of a group of profoundly typical middle-aged men in Spain who grew up in the same neighborhood. Each of these men is struggling, in one way or another, with finding happiness in modern Spain. Some of the individuals struggle with their life at work, others with romance, and others with money and success; these difficulties result in their struggling with their grasp of reality. They have been living in their neighborhood since childhood, and although they do not express a desire to get out of the neighborhood, they do express a desire for change. The story begins with Jorge (the film's central character) attempting to make a change in his life by asking his girlfriend of eight years, Violeta, to marry him. She responds by scolding him, saying, "¡Jorge! You can't just ask out of the blue like that!"[1] and tells him she needs time to think about it. Stuck in a job that seems more like "office torture" than office work, Jorge is a typical middle-aged Spaniard who has been laid off, unable to achieve what society asks of him and unable to do what he wants. Jorge's longtime friend from the neighborhood, Antonio, is a recently paroled felon. Antonio is convinced that his anger problem has been completely rehabilitated through his incarceration. It was also during his incarceration that he first began having delusions of becoming a psychologist. Even though Antonio is not fond of the university system, he realizes that earning his degree is the only way to become a certified psychologist. He follows his dream by studying the material the university requires while at the same time driving a taxi for income. While studying psychology, he provides his friends with what he considers sound advice and therapy, even when they don't ask for it.

After Antonio's release from prison, he confronts Jorge about the poor state in which he has found each of his friends since his incarceration. While watching a soccer match, Antonio tells Jorge that he feels Jorge needs therapy. Antonio proceeds to search for the root of Jorge's problems. Jorge says he does not want or need therapy, but Antonio insists and approaches the problem through Jorge's love for soccer. Antonio says, "Jorge, your dad is bald." Jorge replies by saying, "Yep . . . he has

been forever." Antonio continues by asking, "And when you watch soccer, what do you think about?" Jorge says, "I don't think, I watch soccer, Antonio—if the people around allow me to." Antonio corrects Jorge and offers his psychoanalytical hypothesis by telling Jorge, "When you watch soccer . . . you think the ball is your dad's head and you want to kick it." Jorge is shocked by Antonio's misconstrued psychoanalysis and says, "No. No. No. Don't come to me with your weird ideas, Antonio. I'm doing great. My only problem is worrying about you."

Antonio's separation from reality and his persistence in uncovering his friends' psychological problems is reminiscent of Cervantes's character Don Quijote and his separation from reality. Don Quijote's break from reality caused him to hysterically turn a normal sixteenth-century situation of Spanish society into a chivalrous battle over honor, love, or the good of mankind. There are many characters in Spanish literature and film who, like Don Quijote, are frustrated or unhappy with their lives and opt to live inside their invented/fantastical realities. The irony (and genius) of this Spanish theme is that when an individual truly lives out his or her fantasy (no matter how far-fetched or ridiculous it may be), the fantasy becomes a reality. This is the case with *Days of Soccer*. When Antonio discovers that Violeta has rejected Jorge's marriage proposal, he decides that if the group were to form a soccer club to compete in the neighborhood tournament, it would be therapeutic for Jorge. In Antonio's amateur opinion, not only would this ease Jorge's pain from having lost Violeta, but it would also help him with the angst Antonio claims Jorge feels toward his father. Like the characters who cross paths with Don Quijote, each of the men in crisis in *Days of Soccer*, without a better plan to ease the pain of their reality, follow Antonio's lead. They therefore enter, to an extent, into Antonio's harmless state of lunacy by forming a soccer club like the one they had when they were teenagers.

The team will consist of Antonio at the helm; Jorge; Gonzalo, the overweight goalkeeper who lives with his parents, is unemployed, and subsequently without a girlfriend; Carlos, an infomercial actor who has delusions of "big screen" grandeur and stardom; Miguel, a police officer and frustrated musician who is mistreated by his wife and disrespected by his coworkers; Ramón, a school bus driver who is constantly ridiculed by the students for being bald; and Serafín, a friend of Antonio's from prison who is always scheming and claiming to be a "man that knows how to get things." The group enters the seven-a-side neighborhood tournament, and at their first training session (that lasts four minutes due to their lack of physical fitness) they realize they need a team name. After the members of the group blurt out a few names off the top of their heads, Antonio presents the name he has been working on. He pulls a paper from his pocket and in a very serious tone says, "Hang on, hang on, please. I've been thinking of a name. The thing is . . . it has to be a very special name . . . a pretty name . . . a winner's name." Antonio then looks

to his sheet of paper and pauses before announcing it to them: "Brazil" he says. The name is received with rave reviews by his teammates, and like Don Quijote, who named his broken-down horse Rocinante,[2] this midlife crisis soccer team will compete in the seven-a-side neighborhood tournament under the name of arguably the most successful international soccer nation of all time—Brazil.

When filming the soccer scenes of *Days of Soccer*, David Serrano, as director, made his best decision; rather than attempting to capture the beauty of the game while filming the soccer scenes, which is where many other kick-flicks have failed, the soccer scenes in *Days of Soccer* are hysterically ridiculous. Rather than fighting the uphill battle of filming well-played soccer, which Santiago Segurola describes as a task as difficult as conquering Mount Everest, Serrano and his cast succeeded by taking a different approach. Instead of attempting to make the plays seem beautiful and demonstrating the players' talent, *Days of Soccer* purposely highlighted the team's lack of skill. Many of the soccer scenes are filled with absurdities that have no place in any realistic soccer match. Tomás Cimadevilla describes this as giving the film "an esperpentic[3] touch . . . which is so unique to our country and our country's cinema." One ridiculous example is that Serafín wears his mobile phone on the waistband of his shorts while playing and at one point even answers a call while dribbling through midfield. In another scene, the goalkeeper, Gonzalo, is scored on because he had stepped off the field to urinate behind the goal. The players from Brazil smoke cigarettes throughout their matches and in the locker room, as if smoking were something completely normal and acceptable in these soccer situations. Brazil's lack of skill and soccer experience leads them to resort to cheating in order to achieve a victory—their ultimate goal. Examples of Brazil's cheating tactics include Serafín blowing chalk in his opponent's eyes, pricking their opponents with pins (as proposed by Antonio, but the pinpricking plan backfires, and instead they give up a goal), and Antonio and Serafín paying the referee to give them every advantage (but when the opposing team's goalkeeper saves the penalty kick that Brazil was unjustly awarded, our group of pathetic antiheroes quickly gives up a goal on a counterattack, making clear that Brazil is not even capable of cheating successfully).

In the footage of extra scenes and interviews on the DVD, David Serrano describes that in his approach to making the soccer scenes, he wanted to make them enjoyable for the people who are not soccer fans. He said that, above all, he wanted the people to laugh through the soccer scenes because, as he describes, "you're not going to see a Madrid–Barça match." Interestingly, most of the actors of *Days of Soccer* openly admit that prior to making the film they were "anti-soccer" and that many of them even hated the sport. However, through their training sessions, which were designed to help them better grasp the game, they gained a newfound respect for the skill, discipline, and physical fitness necessary

to play the sport, even at the lowest levels. Ernesto Alterio even said that "all that month of training was very good for the people to bond and for the relationships to solidify" and that in the end he would really miss playing soccer because he had such a great time doing so with the members of the cast and crew. Secún de la Rosa, who prior to filming claimed to detest the sport, said, "I came to like being goalie and to be on a team and to learn to enjoy the game and work together as a team." On the other hand, after the filming, Fernando Tejero continues to dislike the sport and claims he will not miss playing it at all. The making of *Days of Soccer* served to open the minds of many of the film's actors and offered them the opportunity to see the sport in a new light, leaving them with a better understanding as to why so many people are so passionate about soccer and its many dimensions not only in Spain but around the world as well.

The tale's complex cast of characters offers the audience a very rich and multifaceted story line filled with one laugh after another. In the end, *Days of Soccer* offers the audience an anticlimactic resolution in its depiction of Brazil and the cast of characters who each achieve a personal victory in one way or another. In Brazil's final match of the season, after manipulating the referee, they were again awarded an unjust penalty kick. Jorge, who after being abandoned by his girlfriend has been struggling to find something positive in his life and possibly for this reason, insists on taking the penalty kick. Throughout the season, things seemed to be looking up for Jorge. He was forging a very happy and healthy relationship with Bárbara, a neighborhood girl on whom he had always had a crush. She was helping him look beyond the realm of his terrible office job and seek out the beauty of life and living. When Jorge demands to take the final penalty kick of the season (which will provide Brazil with not only its first victory but also a sense of having achieved something positive), it seems that Jorge is confronting his fears of failure head-on. Antonio approaches Jorge and says, "This is a super fucking important moment in your life, in my life, and in everyone's life. Look at the ball and think of your dad's head." Upon hearing this, Jorge explodes and shouts, "Antonio! Leave my dad out of it! Leave him! Forget my dad!" Jorge approaches the ball, kicks it, and scores and then immediately enters into what seems to be a state of serenity and peacefulness as his teammates celebrate around him.

At the end of the film, the other members of Brazil also find some form of resolution to the problems that have been confronting them. Although Antonio's notion of entering the seven-a-side neighborhood tournament for therapy seemed absurd, the strengthened bond formed among the teammates, and a single win was all the positive reinforcement they needed to consider themselves something more than perpetual losers. In this regard, Antonio was correct in that forming Brazil and entering the seven-a-side neighborhood tournament not only offered

them the opportunity to return to their childhood and relive their dreams, but it also was an opportunity to prove to themselves that they were capable of being successful at something, no matter how pathetic it may have been. The film ends with the team celebrating at Antonio's wedding reception (since he had reconciled with his former girlfriend) and Miguel going onstage to play the song he had written for the wedding. The song's chorus repeats, "And now what? And now what? And now what? And now what?" reinforcing the anti-resolution theme that has become common in many works of contemporary Spanish literature and film. This theme is based on the theory that life consists of a series of small struggles and that winning or losing is not always the most important factor but that experiencing and embracing the setbacks as well as the victories is where we can find the essence of life. The final shot of the film shows Antonio at his wedding reception staring off into the distance with a crazed look in his eye; he then murmurs, "I'm seeing the light." This final scene draws light not only to his Quixotic lunacy but also to the notion that the difference between success and failure lies in the eyes of the beholder. In this sense, like Don Quijote, the members of Brazil were convinced that they had finally achieved at least some level of success in their lives, thanks to Antonio's idea of forming a soccer team with the purpose of providing his friends with social and psychological therapy.

NOTES

1. Unless otherwise noted, all quotes in this chapter are from *Días de fútbol* (*Days of Soccer*), dir. David Serrano (Madrid: Telespan, 2000).

2. *Rocinante* roughly translates as "once a work horse."

3. *Esperpento* is a uniquely Spanish literary style created by the most radical dramatist of the Generation of '98, Ramón del Valle Inclán, in which distorted visions of reality are used to criticize society.

FOURTEEN

The World's Longest Penalty Kick

The World's Longest Penalty Kick is one of Spain's more recent "kick-flicks." The director, Roberto Santiago, has proven to be a promising new Spanish filmmaker due to the ability he has for achieving commercial success. He has been successful not only with *The World's Longest Penalty Kick*, but also with his previous film, *Happy Men* (*Hombres felices*) (2001). *The World's Longest Penalty Kick* was one of Spain's most successful box office hits in 2005, grossing over $6.5 million. The film's success is largely due to the success of its recent Spanish kick-flick predecessors, *The Goalkeeper* (2000) and *Days of Soccer* (2003), which paved the way for *The World's Longest Penalty Kick* and proved to Santiago and his cast and crew that films using soccer as a central theme are clearly capable of capturing a large-scale market in Spain. These three films and their commercial success demonstrate a resurgence of the popularity of kick-flicks in Spain since the earlier era of their popularity during the mid-twentieth century.

Rather than casting superstars of soccer as the protagonists in today's era of Spanish kick-flicks, the popular approach has been to embrace the struggles of fictional situations that take place in the lowest-level leagues, known as *"fútbol regional"* ("regional soccer"). For these films, directors use actors who are able to identify with and portray everyday people from typical neighborhoods that have the stereotypical big small-town dreams. For this reason, Santiago wisely cast Fernando Tejero as *The World's Longest Penalty Kick*'s protagonist. Tejero received the Goya Award for "Best New Actor" for his role in *Days of Soccer* and now seems to be typecast as the pathetic Spanish kick-flick antihero. *The World's Longest Penalty Kick* is also proof of the power of "kick-lit" because, like *The Goalkeeper*, *The World's Longest Penalty Kick* was a short story before being adapted to the big screen. Earlier, I gave a brief summary of the

Argentinean author Osvaldo Soriano's short story to provide a foundation for the analysis of the film.

The film version of *The World's Longest Penalty Kick* is different from the original tale in a number of ways, the most obvious is that rather than being set "in some long lost place of the Black River Valley, in Argentina, on a Sunday evening in an empty stadium,"[1] Roberto Santiago's film is set in Spain's working-class neighborhood of Carabanchel, Madrid. The protagonist of Soriano's tale is known as Gato Diaz, the starting goalkeeper of the small-town club, Polar Star. But in the cinematographic version, the protagonist is known simply as Fernando. Rather than being the club's starting goalkeeper, Fernando is Polar Star's bench-warming backup goalie and the neighborhood's consummate "loser." Fernando (played by Tejero) spends most of his time on the bench drinking beer, smoking cigarettes, and badmouthing his team's starting goalkeeper, Román. Román seems to have everything. He is good looking and is the manager of the supermarket, Polar Star, which sponsors the club. Román is dating the coach's beautiful blonde daughter, Cecilia. He rides a motorcycle and is the envy of everyone in town for his goalkeeping skills. In the film's opening scene, Santiago shows Fernando sitting on the bench next to one of the club's overweight benchwarmers, Bilbao. Together with the rest of the crowd, they watch Román make a diving save and then blow a kiss to Cecilia as she works the concession stand. Fernando, disgusted with his personal situation, says, "But have you seen how Román looks at Cecilia? He could tone it down a little, no?"[2] To this, Bilbao responds, "Fuckin' A. . . . Chill out, Fernando. What can I say? Life is like this. Some are starters, others are bench warmers." Unable to accept this role in life, Fernando says, "Life? Life is shit. I shit on Román. I shit on his hair gel. I shit on everything." Shortly thereafter, Fernando is afforded his first opportunity of the season to play for Polar Star because Román is injured on the last play of the season. The injury takes place when the opposing team's captain commits a vicious foul against Román. Rather than calling the foul on the opposing team, the referee calls the foul on Román and awards an unjust penalty kick to Sporting Belgrano. The fans are outraged. With no other option, Polar Star's coach, Santos, substitutes Fernando in the goal to defend the team's 1–0 lead. If Fernando can manage to block the kick, Polar Star will win the Third Division Championship and advance to the Second Division the following year. This will enable the club many more opportunities to make money and give them the ability to buy better players and be more successful in the future. This will in turn afford everyone involved a better lifestyle, more money, more success, and more respect. Although Fernando spends most of his time "in the clouds," he is well aware of the importance that his performance will have on the future of his club. As Fernando lines up to block the kick, he is so nervous that he has to ask the referee for a moment. He then steps to the side of the goal and vomits. Meanwhile, the local fans'

frustration is mounting due to the referee's terrible call, and before the shot can be taken, the townspeople rise up and take control of the situation themselves (in a manner reminiscent of Lope de Vega's famous Golden Age play *Fuenteovejuna*) and storm the field. This forces the referees to flee to the safety of their dressing room, where they lock themselves inside.

This uprising resulted in the game being stopped before the shot could be taken, and a committee of league officials is left to decide what actions should be taken in order to determine the final match's outcome. The next day, the members of Polar Star meet at a local bar and discover from the coach that the committee has decided that the final penalty kick will be taken on the following Sunday in the same Polar Star stadium but without any of the turbulent fans in attendance. Since Polar Star's star goalkeeper, Román, was subbed out for Fernando at the end of the game, he is ineligible to return to the match, and the club's future is left in the hands of the neighborhood loser, Fernando.

As soon as Fernando finds himself in the spotlight, he immediately begins to notice the people around town not only paying attention to him but actually treating him with respect and offering him their every support. Polar Star's coach, Santos, and owner, Adrián (who are also the co-owners of the grocery store Polar Star, where most of the team's players work), begin offering Fernando special favors in an effort to keep him sound of mind and body during the week leading up to the penalty kick. Santos and Adrián offer Fernando all he can eat and drink at restaurants and insist he refrain from straining himself at the grocery store, where he works as a stock boy. Fernando quickly realizes that no request is beyond his reach, and he then asks Santos if he can take Cecilia, the owner's daughter and the neighborhood's most beautiful blonde, out on a date. Wanting to keep Fernando's spirit and self-confidence as high as possible, Santos bribes his daughter Cecilia to betray her actual boyfriend, the club's injured goalie, Román, and humor the pathetic Fernando with a few dinner dates during the week leading up to the penalty shot.

It's evident that some of the aspects of the film follow the theme of Soriano's short story, while other aspects have been either molded, modified, or changed completely to better fit the characteristics of a feature-length film. Fernando's desire to date the town's beautiful blonde girl coincides with Soriano's short story, but the way Fernando secures the date is very different from the way Gato Diaz secures his date. The desired female in Soriano's tale is not the daughter of Polar Star's coach, and Polar Star is not a grocery store that serves as the place of employment for most of the team's members, as it is in the film. It is, however, the name of the club in both the story and the film. Sporting Belgrano is also the name of the rival team in both the story and the film. However, the film is very different from Soriano's story in that there are a multitude of characters and side stories in Santiago's film, making it more appli-

cable to the big screen. All the characters in the film have secrets to hide from one another, causing them to plot and scheme throughout the week leading up to the penalty shot. For example, Fernando takes Cecilia out on two dates, and both times they come in contact with Román. Fernando has to hide Cecilia and make up a story to avert Román's suspicions. Also, Bilbao recently lost his job as a gas station attendant and is waiting for the right moment to tell his wife. In order to keep his situation a secret, he pretends to go to work every day. When his wife goes to the Polar Star grocery store, he secretly waits around the corner and takes the money she spends back from Adrián, who marks the debt on his ever-growing tab. Fernando's sister, Ana, also begins forming a secret relationship with the team's coach and grocery store co-owner, Santos, behind the back of Khaled, her Moroccan boyfriend with whom she has a child. Khaled is also on the Polar Star soccer team and works at the grocery store as a butcher. His laissez-faire attitude toward his relationship with Ana leads her to look elsewhere for companionship. All of the secrets the characters keep from one another are made evident to the audience and lead to a variety of comical situations. From this perspective, *The World's Longest Penalty Kick* approaches the sport "from a lateral position" and could be considered a situation comedy that uses this fictional circumstance of the Third Division of Spanish soccer as the point of departure.

The central theme of the story is Fernando's change in social status. He uses soccer to help him become the person he wants to be in society, and what he wants more than anything is for Cecilia to fall in love with him. At first, this seems like an unattainable goal, but since his first date with the girl of his dreams was disastrous, he asks his sister Ana what it is that women want. Ana tells him that more than anything women want to laugh and that he should simply try to make Cecilia laugh. From this moment on, Fernando's confidence begins to soar because he is confident in his ability to make people laugh. The next time he sees Cecilia, it is the night before the penalty kick, and he asks her to give him a kiss for good luck. But she refuses his request. He then proposes that if he can't have a real kiss, he should be allowed to show her a magic trick. Cecilia shows an interest. So Fernando says, "I'll give you a kiss, but without touching your lips." Annoyed, Cecilia responds, "I'm not giving you a kiss." Fernando reminds her, "But I won't touch your lips!" She says, "But that's impossible." Fernando says, "That's why it's a trick!" He tells her that she needs to close her eyes and he will give her "a sort of . . . magical kiss." She finally agrees, although she is skeptical. As it turns out, Fernando gives her a long kiss directly on the lips, and when it's over she says, "But you touched my lips." Fernando responds, "Yeah, I screwed it up." Cecilia, in good spirits, bursts out laughing. Fernando then asks if he can try the trick again to see if he can do it properly this time, but she laughingly responds, "No!"

The next day, Fernando is approached by Rodríguez, Sporting Belgrano's owner, who offers Fernando a ride to the stadium before the penalty shot. In the car, Rodríguez offers Fernando a bribe. He gives him a sizable check and says, "All you have to do is not do anything." Fernando says, "Man, not doing anything is my specialty." Fernando then takes the check and slides it into his shirt pocket. The conversation continues under the pretense that Fernando will allow the kick to go in, but as soon as he steps out of the car, he leans to the window and says, "Hey, Rodríguez, one more thing. . . . All my life. . . . Since I was little, eh? All my life, I've wanted to do this." And he pulls the check from his pocket, rips it up, and tosses it on the street. To this, Rodríguez says, "You're really screwing up here." Fernando responds, "Good day, gentlemen." As Fernando walks toward the stadium, the camera pans down to the torn-up check on the ground, and we discover that instead of having ripped up the check, Fernando actually ripped up a six-euro coupon for the Polar Star supermarket, which looked like the check. Therefore, Fernando still has the check from Rodríguez safe in his pocket, and he is free from the obligation to allow the shot to pass.

In the end, Fernando blocks the penalty kick, and, just as in Soriano's literary version, the referee (although not epileptic in the film) passes out before the shot is taken due to the stress of the situation and from blowing the whistle with too much force in the hot sun. When the two teams' argument over the referee's final decision turns into a shoving match, Fernando (like Gato Diaz in the short story) breaks up the fight and displays his self-confidence and courage to all those attending. He says, "If we have to do another penalty, lets do it as soon as possible because I'm in a bit of a rush. If you don't mind, lets not waste more time because I have a date later on." Fernando then turns his attention to the referee and asks the official if he needs anything, "water . . . or anything else?" The referee responds, by saying "No, no, no. . . . Thanks a lot though, eh!" Fernando says, "O.K. lets take the penalty once and for all. This time don't fall." The referee responds, "So let's shoot it!" Fernando then approaches the shooter, Sporting Belgrano's captain, and offers him the ball. The shooter whispers to Fernando, "Where am I going to shoot this time?" With all the confidence in the world, Fernando responds, "Shoot it wherever you like. I'm going to block it one way or another." Sporting Belgrano's captain finally takes the shot, which hits the crossbar, and Fernando catches the rebound. Polar Star's victory is finally official, and the fiesta begins.

The film ends happily, and almost everyone's problematic side story is resolved. Khaled demonstrates that he is ready to make a more stable commitment to his relationship with Ana by arranging to build a house with her. Although Santos is upset about this, he recognizes and appreciates their happiness together. Bilbao and his wife come to terms, she forgives him for his mistake, and he promises to find work and lose

weight. Adrián offers to take the entire Polar Star team and friends to stay at his brother-in-law's hotel in La Manga for a week. But most importantly, instead of being a loser, Fernando is now the neighborhood hero, and Román, the goalkeeper who had been everyone's favorite, is now brushed aside. At the team's victory party, Cecilia leaves early, telling her father, Santos, that she has a date with Fernando. Santos is shocked that she has actually fallen for him but supports her choice, and as she walks out the door, Santos distracts the depressed Román from following her. Back at Fernando's house, the neighborhood's "man of the hour" offers Cecilia an envelope containing two plane tickets to Paris. He bought the tickets with the money he kept from the bribe that Sporting Belgrano's owner, Rodríguez, had offered him. He says, "Well, I've thought, while these folks are going to La Manga, and since I don't much like the beach, I figured you and I could go to Paris." Cecilia responds by saying, "Oh, la, la. Paris!" She then comes back to reality and says, "But you and I. . . . What are the two of us going to do in 'the city of love'?" Fernando says, "Well, many things. . . . Because between you and I there's a very special connection and we laugh a lot together. And in Paris we're going to crack our asses up!" Cecilia interrupts him and says, "But I don't laugh with you." He says "Yes you do!" She repeats, "No I don't." Fernando then makes her a deal that if he can make her laugh, she has to come to Paris with him, and if he can't, he will leave her alone forever. He then says, "What do you have to do to a girl so that she will laugh on Sunday?—What?—Tell her a joke on Friday." Cecilia doesn't find the joke funny at all. Fernando says, "O.K. What's long and hard for a girl?—What?—The Third Grade." Cecilia still will not laugh, but Fernando says, "Of course you're laughing on the inside." On hearing this, Cecilia actually bursts out and laughs aloud, to which Fernando says, "Hey! There you have it! There it is!" She says, "That doesn't count! I wasn't ready!" He says, "You lost. We're going to Paris, the Eiffel Tower, the Champs-Élysées, the museum whatever-its-name-is . . . with the Mona Lisa." And the camera backs away from their conversation and floats out of the window to end the story.

The World's Longest Penalty Kick is a fun-loving movie designed to be enjoyable for soccer fans and non-soccer fans alike. Roberto Santiago was wise to use Osvaldo Soriano's short kick-lit story as a basis for the film. The extremely rare situation of having a week for a team to prepare for one penalty kick leaves plenty of room for stories to develop that are not directly linked with soccer. In this sense, Santiago tackled the sport "from a lateral position" and turned it into a situation comedy kick-flick. There are very few scenes in which Santiago had to portray people realistically playing soccer. In Soriano's tale, Polar Star was a group of pathetic players in a men's league that (in a Quixotic manner) acted as if they were truly living the life of professional soccer players in Argentina. In Santiago's film, the players of Polar Star also possessed this distorted

vision of themselves, even though they were Third Division profession-
als. However, Santiago's depiction of the ability of the Polar Star players
in the film in no way corresponds to the level of ability that real players
from the Spanish Third Division possess. With *The World's Longest Penalty
Kick*, we witness how our antiheroic protagonist achieves what he desires
in life by taking advantage of the opportunity he is presented through
soccer. Because soccer is like life, and, as the cover of the film reads,
"There isn't always a second opportunity in the game of life."

NOTES

1. Jorge Valdano, *Cuentos de Fútbol* (*Soccer Stories*) (Madrid: Extra Alfaguara, 1995),
323.
2. Unless otherwise noted, all quotes in this chapter are from *El Penalti mas largo del
mundo* (*The World's Longest Penalty Kick*), dir. Roberto Santiago (Madrid: Ensueño
Films, 2005).

Conclusion

My goal with this book was to expose the myriad of levels into which soccer has infiltrated and has been embraced by Spanish society. Soccer is one of contemporary Spanish society's greatest passions. Soccer's capacity for having so many aspects of culture infused into its very state of being is what makes the sport a cultural phenomenon, one that, as Ezequil Martinez Estrada states, encompasses "all of the integral forces of the human personality: religion, nationality, blood, animosity, politics, retaliations, longing for success, frustrated love, odium, everything on the verge of the most passionately unfounded delirium."[1] Through this study, the connection that Spanish soccer has with the historical sociopolitical struggles of Spain and the infiltration of politics into the sport should become clear.

Through this study, I have demonstrated that soccer is in fact compatible with intellectualism, literature, and film. Since its inception, soccer has had a very close and public relationship with the politics of Spain. Similarly, soccer in Spain has had a very close relationship with literature that stems back to the earliest form of the sport, which began to take shape during the time the art of literature began developing on the Iberian Peninsula. The difference lies in the fact that the relationship between soccer and literature has not been as public as that of politics and soccer until now. Recently, there has been a growing appreciation for literature on the topic of soccer, and many great authors of Spanish literature have contributed to the genre. Also, many lesser-known writers have contributed, and even a number of soccer players have contributed. Finally, it is preposterous that this vast body of literature (which stems back to the very earliest age of literature in Spain and has sustained itself ever since) does not have a formal name. For this reason, I have proposed the term "kick-lit."

The kick-lit genre can be tackled from a wide variety of creative angles. It is refreshing to have something so new that can be approached from so many different angles coming of age in the world of literature. Javier Marías brought a fun and creative approach to this genre by making a fantasy soccer lineup of authors from the twentieth century. Marías compiled their kick-lit texts in his book *Savages and Sentimentals* (*Salvajes y sentimentales*). Marías's lineup appeared in Winston Manrique's 2006 article published in the Spanish newspaper *The Country* (*El País*), which covered the Sixty-Fifth Book Fair of Madrid. The article was titled "Books

Give Court to Soccer: The Writers Unravel the Mystery of the Passion for the Most Global and Popular Sport of the Planet" (*"El libro da cancha al fútbol: Los escritores desentrañan el misterio de la pasión por el deporte más global y popular del planeta"*). Marías's fantasy soccer team, as it appeared in the article, is listed below:

> Goalkeeper. Two who actually played this position in real life: Vladímir Nabokov and Albert Camus.
>
> Defenders. Wide right, Henry James for his ability to make such long runs. In the center, Dashiell Hammett because he always seemed like a tough guy. And at left back, Malcolm Lowry who, since he's a drinker he's probably one of those guys that doesn't let anyone by. Wide left, Valle-Inclán, a very alive author with a chip on his shoulder at times.
>
> Center midfield. Three with big lungs: For his work ethic Thomas Mann; as #10, the brains of the team with a clear mind and organizer of play Marcel Proust; and W. Faulkner who has a lot of breath.
>
> Upfront. We'll play with wingers: extreme right as #7 Joseph Conrad, capable of creating great confusion and admiration in just a few meters; offensive center-mid, Thomas Bernhard because he was very aggressive; and with #11, extreme left, one of those silky and creative players like Lampedusa.
>
> On the bench. As goalie either Camus or Nabokov who alternate as starters with equal solvency. For moments of crisis Conan Doyle wouldn't be bad because he had such a great capacity for play at midfield. Defender, Raymond Chandler. And upfront, a poet: W. Yeats.

Like Javier Marías, the famous Mexican writer Juan Villoro, who is also a kick-lit enthusiast, advocate, and author, made a similar soccer lineup of famous literary figures. Villoro's lineup appears as the following in Jesús Castañón Rodríguez's article "Fantastic Realism: Forty Years of Literary Anthologies of Soccer with a Focus on Latin America (1967–2007)" (*"El realismo fantástico: Cuarenta años de antologías literarias de fútbol con enfoque iberoamericano [1967–2007]"*):

> Camus as the goalkeeper, Dostoyevsky and Tolstoi in the middle, Hemingway and Faulkner as marking backs, Borges to gather balls and have strange ideas, Cervantes as the organizer, Nabokov as the versatile offensive link, Kafka and Calvino out wide and Chékov as the deceptive striker.

Villoro was so entertained while making his fantasy soccer lineup of famous authors that he took the fantasy a step further and wrote a short kick-lit story in which these authors compete on the soccer field together. The story is titled "I Am Fontanarrosa" (*"Yo soy Fontanarrosa"*), which appeared in Jorge Valdano's latest compilation of kick-lit stories *The Fans Joyously Solute You* (*La hinchada te saluda jubilosa*) (2007), which was created to celebrate the life and passion of Roberto Fontanarrosa, the reputable kick-lit author from Argentina.

These fantasy soccer teams, which combine famous literary figures with soccer, demonstrate yet another fun and creative approach through which the genre of kick-lit can be tackled.[2] Marías's and Villoro's fantasy teams shed light on the fact that there are endless possibilities through which authors of the future can be creative and imaginative with this genre that combines our passions.

Much like the genre of kick-lit, films connected to soccer stem back to the very introduction of the artistic medium in Spain. These films dealing with soccer are also lacking a proper name, so I have proposed the term "kick-flicks." In the early kick-flick years, Spanish directors cast soccer stars in their kick-flicks to attract an audience comparable to that of the sport. Spanish kick-flicks of today, for the most part, abandon this approach and instead focus on the passion of fictional characters in low-level leagues. Although there is much room for improvement, mainly in relation to filming the sport in a manner that justifies the beauty of the game, the kick-flick genre's future looks bright. Through this study, I have proven that when approaching the sport "from a lateral position," the possibilities are endless, and that two of the greatest passions of the past one hundred years are compatible.

Although for years it seemed that soccer was not a suitable topic for the intellectual classes, the enormous body of work dealing with soccer in both literature and film that I have brought to the foreground proves that the taboo has been lifted. As Jorge Valdano puts it, "Soccer is inexhaustible . . . and literature is the perfect vehicle to raise it above stupidity, meanness, and the violence of everyday."[3] Although this study focuses on soccer's connection to politics, literature, and film in Spain, there is much room to study soccer's relationship to these aspects of culture in many different countries and cultures throughout the world. This is especially true in Latin America, where the sport's connection to politics, culture, literature, and film is enormous. "Soccer is a generator of fiction for all of Latin America."[4]

Many have written that soccer has not yet found its Hemingway,[5] but the body of kick-lit is much larger than the few books that Hemingway wrote on bullfighting. As long as the people of the world are passionate about soccer, literature, and film, we will always find these passions, pastimes, and escape valves overlapping one another in new and creative ways. Soccer captivates us because it encompasses all three of these aspects and can be approached in countless ways. The enigma of the sport is difficult to pinpoint. I believe that its multifaceted ability to connect with so many aspects of our culture is a key element, as is the sport's capacity to serve as a metaphor for life and encompass all of life's positive and negative attributes. I feel the magic of soccer was best captured by one of the sport's most successful players and advocates, Jorge Valdano, who wrote that, in the end, we love soccer because through it we somehow feel as though we are able to "return to our childhoods." From

a different perspective, Manuel Vázquez Montalbán summed up the social climate of the last century in Spain in the following poem:

Fútbol, fútbol, fútbol.	Soccer, soccer, soccer.
Es el deporte	Is the sport
que apasiona la nación.	that impassions us all.
Fútbol, fútbol, fútbol,	Soccer, soccer, soccer,
en los estadios ruge	the stadiums roar,
enardecida la afición.	the frenzied fans call.
Fútbol, fútbol, fútbol	Soccer, soccer, soccer
hoy todo el mundo	today the entire planet
está pendiente del balón. [6]	is dependent on the ball.

—Manuel Vázquez Montalbán

NOTES

1. Ezequil Martinez Estrada, in Jorge Valdano, *El miedo escénico y otras hierbas* (*Stage Fright and Other Herbs*) (Buenos Aires: Aguilar, 2002), 274.

2. After being inspired by Marías's and Villoro's fantasy soccer teams made up of literary figures, I decided to create my own fantasy soccer team. However, for the sake of this study, I have decided to select only Spanish kick-lit authors. The authors/players whom I have selected earned their place on my team for their varying combination of literary abilities, their literary contributions, their demonstrated soccer knowledge and/or skill, their youthful nature as writers/players/people, their versatility as writers/players/people, their creativity as writers/players/people, and their varying degrees of courage as writers/players/people. My Spanish kick-lit squad of eighteen players and two coaches is the following:

Jorge Valdano	David Trueba	
Martin Casariego		
Manuel Vázquez Montalbán	Javier Marías	Rafael Alberti
Camilo José Cela		
Francisco Umbral	Rafael Azcona	
Miguel Hernández		
Fernando Fernán Gómez		

Substitutes: Vicente Verdú, Carlos Casares, Manuel Hidalgo, Juan Manuel de Prada, José María Pemán, Juan Bonilla, Patxo Unzueta.
Head Coach: Lucio Anneo Séneca
Assistant Coach: Juan Ruiz el Arcipreste de Hita

3. Jorge Valdano, in Roberto Fontanarrosa et al., *De puntín: Cuentos de fútbol.* (*Toe-Poke: Soccer Stories*) (Buenos Aires: Al Arco, 2003), 10.

4. Jesús Castañón Rodríguez, *"La pasión del fútbol infinito, según Valdano"* ("The Infinite Passion of Soccer, According to Valdano"), 2006, www.idiomaydeporte.com/scher.htm (January 2, 2009).

5. Jorge Valdano, *El miedo escénico y otras hierbas* (*Stage Fright and Other Herbs*) (Buenos Aires: Aguilar, 2002), 274.

6. Julian Garcia Candau, *Épica y lírica del fútbol* (*Epic and Lyric of Soccer*) (Madrid: Alianza Editorial, 1996), 251.

Index

About the Author

Timothy J. Ashton is an assistant professor of Spanish literatures and cultures at the University of South Carolina Aiken. He earned his PhD from The Ohio State University where he also worked as the assistant editor for the scholarly journal *España Contemporánea*. He earned his master's and his bachelor's degrees from Bowling Green State University after graduating from Perrysburg High School. Professor Ashton has studied at Creighton University, Bowling Green State University, Miami University, The Ohio State University, *Universidad de Alcalá de Henares*, and *l'Institut de Touraine*. He has taught at Bowling Green State University, Columbus State Community College, The Ohio State University, *Universitas Castellae*, and the University of South Carolina Aiken. Professor Ashton has lived in various regions of the United States, Spain, France, Mexico, and Ecuador playing and following soccer all the while. He currently participates in the recently formed Football Scholars Forum.